*The Crowning of
the American Landscape*

The Crowning of the American Landscape:

EIGHT GREAT SPACES AND THEIR BUILDINGS

WALTER L. CREESE

PRINCETON UNIVERSITY PRESS

PRINCETON, NEW JERSEY

Copyright © 1985 by Princeton University Press
Published by Princeton University Press,
41 William Street, Princeton, New Jersey 08540
In the United Kingdom:
Princeton University Press, Guildford, Surrey

ALL RIGHTS RESERVED
Library of Congress Cataloging in Publication Data
will be found on the last printed page of this book
ISBN 0-691-04029-x

This book has been composed in Linotron Janson
Design by Janet Tingey

Clothbound editions of Princeton University Press books
are printed on acid-free paper, and binding materials
are chosen for strength and durability

PRINTED IN THE UNITED STATES OF AMERICA
BY PRINCETON UNIVERSITY PRESS
PRINCETON, NEW JERSEY

For Professor Emeritus Alan K. Laing
A Fine Friend, An Exemplary Colleague

Contents

Acknowledgments

THE opportunity for a firsthand investigation of the subject considered here was made available through a Rockefeller Foundation fellowship in the Humanities. The humanistic designation meant that the study could be less professional or technical; more one that opened vistas into the social, political, and esthetic aspects of society. The investigation began with a seed grant in 1968-1969 from the American Council of Learned Societies. The Graduate College of the University of Illinois helped with a graduate assistant during the summer of 1983 and a grant for photographs and maps to finish what was mainly begun with Rockefeller funds in the collection of a corpus of pictures. Without the superb library of the University of Illinois, third only to those of Harvard and Yale in numbers of volumes, the text could not have been put finally together. Several of its librarians guided me through their divisions, most notably Delores Wallace of the Ricker Fine Arts Library.

In the first, Jefferson, chapter, I owe much to Professor Emeritus Frederick D. Nichols of the University of Virginia especially, to Professor Robert Bruegmann of the University of Illinois at Chicago Circle, and to William Buffum, Architect, of Providence, Rhode Island. William Beiswanger and James Bear of the Thomas Jefferson Foundation also shared valuable information with me while I was on the grounds at Monticello, as did Professor Donald Jackson and Dean Merrill D. Peterson at the University of Virginia. Professor Emeritus William B. O'Neal kindly checked some facts.

For the Hudson Valley I had immediate assistance from Dr. John Zukowsky, then associated with the Hudson River Museum to which I went on my first field trip, and now Curator of Architecture at the Art Institute of Chicago. David P. Schuyler, then a graduate student, but now a professor at Franklin and Marshall College, shared a quantity of ideas and information with me, including his exciting Columbia University Ph.D. thesis on "Public Landscapes and American Urban Culture 1800-1870: Rural Cemeteries, City Parks, and Suburbs." I met him at the local history section of the Free Library of Newburgh, New York, Downing's home town. That special collection was very ably presided over by Ms. Jeanne Sharp, who introduced us. James Ryan, manager of the Olana State Historical Site, read the section on that house and gave a number of valuable suggestions about it. Robert Rainwater of the New York Public Library was particularly helpful in locating fugitive material, as was Adolf Placzek, the distinguished Avery Librarian at Columbia University, now retired.

To study Yosemite Valley, one must look in the records of the Library of Congress and National Archives, as well as into the small museum-library of the Valley itself. Much of that research was also conducted at the California State Archives in Sacramento,

where David L. Snyder was especially helpful. For Mt. Hood, Richard Kohnstamm, Manager of Timberline Lodge, remained ever encouraging.

For the Fens, the Boston Public Library, the Massachusetts Historical Society, the Boston Atheneum, and the Massachusetts Horticultural Society provided information, along with the library of the Graduate School of Design at Harvard University. Cynthia Zaitzevsky very kindly shared her authoritative *Frederick Law Olmsted and the Boston Park System* with me several months before it was published.

Edward J. Bauer, Secretary of Graceland Cemetery, assisted as much as he could with its remaining records, most of them having been destroyed in the Chicago Fire of 1871. For Riverside, Dorothy H. Unger gave many valuable suggestions. Other residents, such as Harriet Kweton, Doris Miller, Sandra L. Higgins, and architect Myron Wimmer, my former student, rendered aid, too.

For the two Taliesins, Bruce Brooks Pfeiffer, Archivist of Taliesin; John H. Howe, Architect, of Burnsville, Minnesota; and author-architect Edgar Tafel of New York were most generous with their experiences with Wright, as was Professor Edgar Kaufmann, Jr., of Columbia University. Professor Henry-Russell Hitchcock, already knowing so much about Wright as a personality, advised me at the outset of the Taliesin chapter, as did Professor Kaufmann. Their studies of Wright's life and works remain as fresh, informative, and accurate as in the days that they were written.

Frederick Nichols; John Zukowsky; Thomas Vaughan, Director of the Oregon Historical Society; Dorothy Unger; and John H. Howe all took the considerable trouble to read the last draft of the chapters which related to their special knowledge. If those chapters still contain errors of fact, it

is due to my carelessness rather than their scrutiny, for they all were most conscientious in the task. Christine Ivusic, who tragically passed away before this book appeared, gave unstintingly of her thought and time as Fine Arts Editor of Princeton University Press.

I have drawn on a succession of graduate students for insight and aid. Along with the resources of the library, they have made teaching at Illinois eminently worthwhile. Among those who have chiefly helped with all the running about and checking have been Dominic Adducci, Randall Biallis, Alan Bombick, Wayne M. Charney, Jamie De Vol, Constance Fukuda, John Garner, Roula Geraniotis, J. Murray Howard, Christopher Hudson, Scott Javore, Marietta Joria, Bruce Lynch, Narciso Menocal, David Miller, Gregory Miller, Phillip W. Neuberg, Martin J. Rosenblum, Theodore Strand, Debbi Totten, Ellen Weiss, and alphabetically last, but functionally far from least, Craig Zabel. David Ashby and Deborah Slaton carried a considerable time burden with the last-minute checking and looking. Carole L. Couch and Barbara Prahl assisted us often and cheerfully when we needed to duplicate text or pictures.

Without the photography of Thomas A. Heinz, and his unequaled knowledge of the lore of Frank Lloyd Wright, I could never have delved so deeply nor ranged so far conceptually. His photographs gave extra dimension in which to work. He patiently took my orders of where to go and what to get, and then went on to uncover other aspects I had neglected. He is one more former student to exemplify my good fortune.

My son, Guy, and my wife, Eleanor, sat long hours on hard seats in remote libraries, taking notes off obscure and difficult-to-read manuscripts. My wife has greatly assisted in the preparation of the book, besides the long

period of research and travel. My son's continuing interest in my intellectual efforts and field of endeavor has remained a great encouragement.

I recall many who, through their writings and lectures, have fostered in me the belief that architecture and landscape architecture can interact, and reach into other arts and sciences—into urban and regional planning, into literature, geography, botany, and ecology. It is hoped with this essay that such awareness of the past might again aid in opening doors to a more humanistic and less intensely specialized future.

The Crowning of
the American Landscape

Introduction

THIS book is about irregular spaces made intriguing by their creators' visions of them as improved entities. It suggests that the intellectual has been more effective in shaping the American countryside than might be supposed, has indeed often led in its reformulation. The spaces represented early, public manifestations of the "beautiful scenes" lately advocated as substitute imagery by psychologists and psychiatrists trying to reduce stress in individuals from other, more strident aspects of the culture. Frederick Law Olmsted long considered the making of landscapes in that light as a public service for private tensions and anxieties.

My interest in these "images of relief" was aroused in the 1960s in reaction to the expressway that was about to be run through Frederick Law Olmsted's Fens park in Boston. I learned how Olmsted's hydraulic system had conquered an unruly mud flat there, and how, surmounting that exquisite hydraulic scheme, a miniature model of the ancient coastal marsh or fen had been set forth. Feeling and technology of a superior kind were successfully joined by Olmsted in the Fens, just as those two ingredients were united in its proper companion piece (no longer identified in any scholar's mind with the Fens), Henry Hobson Richardson's Trinity Church. The conjunction of emotional and technical means in the Fens incited curiosity as to what other revealing instances of the association of architecture or engineering with major naturalistic sites may have existed. A survey turned up a number waiting to be investigated, of which those discussed here were the most distinguished and varied in their implications.

The last two generations of architectural historians and critics have made frequent references to "The Form Givers." Frank Lloyd Wright was certainly one; Mies van der Rohe, Walter Gropius, and Le Corbusier were others. The architects and landscape architects referred to here might better be called "Place Makers," among whom Wright would be assigned even more stature than as a Form Giver. Earlier Americans, like Andrew Jackson Downing and William Le Baron Jenney, could also function well in both realms. The novelty of the spaces that these artists set out to enrich arises from the fact that under their guidance the precincts became omnium-gatherums, or outdoor rooms of a special kind. Some could even be lived in as communal art works, giving body to a larger outlook, like the Hudson or Yosemite valleys—or rested in eternally, like landscaped cemeteries. These spaces gained authenticity from their contrast with the too hectic settlement of the continent, and the mushrooming of the cities, becoming spatial implosions rather than explosions—of which Graceland Cemetery or the Riverside Suburb would be two of the more isolated and resolute entities.

Urban patterns were more apt to result from historic accident. Chicago, the city

3

with the biggest hinterland, was an accidental mounding up from the convergence of railroads, great rivers, wide lakes, and fertile farmlands than from any enlightened program. Out of this loose aggregation sprang the skyscraper, which Wright attributed (against all historical evidence but with a certain soundness of topographical instinct) to the inspiration of the grain elevator and silo from the broad expanse of midwestern farmland.

Some environmental innovations, because of the unslaked American thirst for monumentality which the skyscraper only partly satisfied, may have gone too long underappreciated—the "rural" or landscaped cemetery; the public parks we take for granted today; the heavily treed suburbs, no longer in vogue; and the national parks and forests, designated only after considerable outlay of effort and concern. If the impulse arises to apologize for the inconsequence of these inventions in comparison to the achievement and drama of the skyscraper, airport, bridge, dam, superhighway, great auditorium, or factory, it should be acknowledged, from the examples of the University of Virginia and Monticello, the Hudson Valley, Mt. Hood, Graceland Cemetery, Riverside, and the Taliesin Valley, that much of the most original and handsome architecture this country has been able to produce accumulated within these kinds of finite spaces. Thickening urbanism encouraged the disregard of surrounding space by architects, together with a reluctance to consider more than a single building at a time on the part of the architectural historian. This investigation doubts that all can be known from the study of a single landscape, or a single building, but has great confidence that the combination of the two media will yield much more than is presently known. That the environmental innovations referred to here imparted more than regional and even national significance,

is suggested by the fact that the Fens was the seed of the Boston Metropolitan Park System (the first in the world) and the Massachusetts Public Reservations, and that the latter provided inspiration for the British National Trust for the preservation of landscapes and buildings; and by the fact that Riverside Suburb of the early 1870s had a strong influence on the genesis of the English Garden City of the late 1890s, which led to the New Town concept utilized in Britain and on the European continent after World War II. We may be contemplating sylvan halls here, but that does not mean they were philosophical backwaters or devoid of international importance in the historical perspective. From the time of Marie Antoinette's Hamlet at Versailles of 1783, there was an international romantic instinct to carve out precincts amidst the trees to reduce social friction and disjunction. The difference in America was that private concerns soon went public in the democratic expansiveness of the new scene, and that public manifestations, like parks and cemeteries, were supposed to ease the disorientation of ordinary individual lives.

This study is intended to complement the valuable writings of authors such as Perry Miller, Roderick Nash, Henry Nash Smith, Leo Marx, and the inimitable J. B. Jackson, while yet allowing the reader to relate more directly to actual settings and their attendant artifacts. It illustrates works of architecture with their sites an integral part of the pictorialization. The failure to recognize such previous landscape and building combinations in concert may be an unintended outcome of the lack of conviction that the American scene *can* develop further if sufficient attention is paid to it over periods of time.

In his eloquent *Machine in the Garden: Technology and the Pastoral Ideal in America* (which illustrated only three scenes by photo-

graphs—an Oklahoma railroad roundhouse; the famous painting of the Lackawanna Valley of 1855 by Inness, with another roundhouse; and the 1930 *American Landscape* by Charles Sheeler of Ford's River Rouge plant, all machine-haunted), Marx scanned the landscape through the eyes of literary giants such as Thoreau, Melville, Clemens, Henry Adams, and Fitzgerald. It is only in the description of Thoreau's Walden Pond, however, that Marx describes a setting that ever actually existed for his literary figures. Even then, he treats Walden as being only slightly real, because it is a "middle" landscape, neither here nor there, by dint of the flux of literary association. Huckleberry Finn and the Great Gatsby, according to Marx, ended up wrung out and disillusioned from their efforts to find an ultimate communal meaning, a rallying spot, because the "inspiriting vision of a more humane community" had "been reduced to a token of individual survival," to a "Garden of Ashes." A *modus vivendi* between the eternal American individualist and the constantly changing environment had failed to materialize. Like the first Puritan, successive figures felt strange and unwelcome in the environment, experienced a growing hostility toward it. There was no further fresh place to go. The pastoral landscapes were fading and becoming "obsolete" under the influence of the chattering, polluting, "progressive" machine.

While not questioning the validity of Marx's evidence, nor the basic conclusions about his literary sites, this approach postulates a more effective contact between artist-intellectuals and their settings. However eroded this process may appear by today, much of it is still discernible through a phenomenological interpretation. We look upon the artist-intellectual as leaving a mark upon nature with that intensity of observation that eventually became characteristic of all Amer-

ican intervention in the environment in the absence of a longer tradition. Thus the two Eliots of Boston were fully cognizant of the grim urbanism and industrialism springing up in eastern Massachusetts faster than elsewhere, but sought with fervor to retain the rugged geological heritage, the underlying bone structure, of Puritan Boston by instituting a metropolitan park system and public reservations in particular, and by advocating a wider use of the art and science of landscaping in general. The expansion was to result in a "third" type of American landscape, after that of the real and the literary. Nature was a reserve for the Eliots, to be held for the physical and spiritual redemption of a whole region, beginning to coarsen and rot out. The Fens was the talisman of that intention. This purpose would outflank the increasing individualism then being fostered in Boston by its social, commercial, and educational institutions, and shake off the intelligentsia's slowness in moving to make a substantive contribution to the public welfare. Nature would pave the way for mending and reinforcing the whole scholarly apparatus, so as "to repair the errors of a scholastic and traditional education, and bring us into just relation with men and things," as Emerson had put it. It would give intellectualization more room in which to exercise its new-found skills of observation beyond books.

Lately two studies have similarly enlarged our knowledge of the landscape heritage: *The Interpretation of Ordinary Landscapes* (ed. Donald Meinig, 1979) and *Common Landscapes of America: 1580 to 1845* (John R. Stilgoe, 1982). This study does not seek to uncover any "ordinary" or "common" heritage, as they did. The few examples would preclude that possibility. It is meant to be a cross-slice of historic manifestations rather than a detailed revelation, more of an exposition than a categorization. It has no hidden agenda and no new design system is concealed just

5

beneath its surface. Although it might, at times, resemble an archeological report or a chronological text, it is more often occupied with unearthing the unusual and mysterious appearances of settlement as they occurred. Each chapter attempts to present for consideration one rounded spatial and temporal experience. The study wants to understand what is possible from Americans at their broadest and best. There is a need to know how lucid these people were when they first looked at the land, and whether there was any continuity to their thought and action in regard to it thereafter. Hence the typologies of democracy are not treated at length, although the enormous importance of the philosophical experiment of democracy in the landscape is certainly discussed—in the Boston milieu, the Hudson Valley, Chicago and its environs, San Francisco, and in the national parks and forests. More careful is the tracking of the unusual mind and imagination, often coinciding, as they moved across the topography of the continent, while adjusting to new and difficult responsibilities. Should democracy be recognized for the spacious and noble, as well as for the small-sized and endlessly repeated units it has brought into being out of the raw materials

of building construction and present land? Is novelty of conception as typical of democracy as standardization? Does democracy necessarily and always imply immediate superficiality and eventual tragedy?

After the Revolution, the republic was at liberty to extend its curiosity into nature's remotest corners in seeking out the third landscape, whether right within cities, as with the Fens imitating the increasingly forgotten colonial marsh, with the landscaped cemetery transfixing time in another way, or in the Far West, where Yosemite National Park and Mt. Hood National Forest fulfilled the smoldering desire to be reassured by a major spatial or volumetric presence seen as timeless, a genuine rather than an artificial monumentality. Americans have always needed "another" place to go, whether large or small. They have been thought to have been in too much of a hurry to reach "The" place, too caught up in the new technology, to pay attention to the lasting esthetic significance of their immediate surroundings, but those in this chronicle evidently did pause early and often to take a longer look around at nature and to formulate a superior architecture for it.

Part I

GREAT GIVEN SPACES,
*Almost too Large
To Comprehend or Handle*

Jefferson's Charlottesville

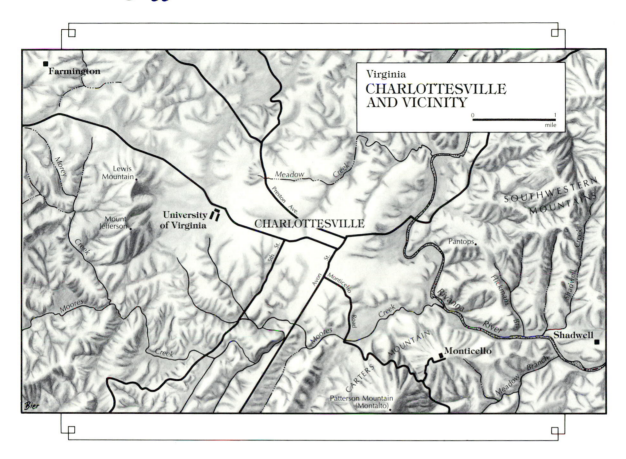

Virginia
CHARLOTTESVILLE
AND VICINITY

0 1
mile

EVERYONE recognizes that Jefferson was true to his time, but what time was it? He was forever trying to bridge the gap between the eighteenth and nineteenth centuries, East and West, the frontier and tidewater, Europe and America, rationalism and romanticism, authority and liberty, science and art, domestic space and monumentality, and between the ridges upon which his architecture rested and the valleys just below it (see map). He made the best of many disturbing transitions.

His desire to create a national building model for the environment owed little to the Virginia vernacular. He wanted the farmer present, but he did not want the agrarian log cabin or flimsy wooden shack. He said that the best minds from England would not be attracted to the University of Virginia if it were composed of log cabins, and he hoped to make up the shortfall as rapidly as possible. He reacted against vernacular buildings because they stood for localized indolence and lack of will. While

he held no brief for the political or social prejudices of the French or English, he recognized that their esthetic pursuits had progressed a great distance, and he quite impartially strove to take advantage of that for America's benefit, emphasizing better hygiene and morality at the same time. Most encouraging was his supposition that architecture and landscaping could be visually positive; that although struggle with the environment was inevitable, it should not be pessimistically faced, as it had been with the Puritans; and that the present place, as well as the vista of the future, should be carefully explored and developed. Mental keenness and daring he heartily endorsed, mere restlessness, never. His most revolutionary thought was that America could become a self-disciplined nation. His architecture and landscaping were the markers of that wager.

THERE scarcely could have been a more American intellectual than Thomas Jefferson when he expressed the hope that his fellow citizens would soon be pulling themselves up by their bootstraps, culturally speaking. To reach this end, he was prepared to converse in several tongues, not the least of which was architecture. He declared in *Notes on the State of Virginia* of 1781 that the "first principles of the art are unknown and there is scarcely a model among us sufficiently chaste to give an idea of them."[1] Jefferson's attempt to provide those architectural models appears extended and cosmopolitan yet somehow parochial when seen in the buildings themselves assembled by parts. This "bits and pieces" approach is especially noticeable in the add-on classical porticoes Jefferson used to dress up older houses (which he otherwise deplored as a type), like that at Montpelier for James Madison, or for Farmington on the edge of Charlottesville for his old friend George Divers (Fig. 1). In the latter he attained semimonumental scale in a most unconventional way by depositing a bayed room of two stories at one side—which became, eventually, a new front. The original house of 1760 was then left as a back wing, in southern fashion. He set out to replace the usual with the newly meaningful, carefully articulated, and permanently mon-

umental. The bays of the octagon with their white-rimmed oculus windows project beyond the central portico to subordinate the conventional house, now much withdrawn in prominence. Similarly, with the central dining hall of the West Range at the University of Virginia (Fig. 2) a massive entablature is set down on what is otherwise a low and modest body. The effect is that of a visor pulled over the eyes, or fingers placed to drum restlessly on the roof, only to have them impulsively push the main body of the building halfway underground. Jefferson had read about the Lilliputians. He seemed in this instance to confer on the students, the "little people" of the university, their own ingenuous scale.

Unorthodox and mildly shocking as the relative proportions of his components can be, Jefferson's buildings take on more convincing unity when understood as parts of larger ensembles within an uncommitted landscape. As a new architectural language was set up, broader and vaguer landscape implications were absorbed into the buildings as definitive bays, porticoes, terraces, and lawns. This larger coordination offered the challenge of the unknown, but also the reassuring return to the visible and known.

What was the landscape that caused such an architectural interaction actually like? There were three characteristics. The first was the sense of an utterly new settlement around Charlottesville, blowing in from the sea and the dignity of the older Tidewater district around Williamsburg. Awareness of that coastal area is reflected in all of Jefferson's iconography, including his "Sea View"

[1] Thomas Jefferson, *Notes on the State of Virginia*, ed. William Peden (Chapel Hill: University of North Carolina, 1955), p. 153. Since a number of the quotations are easily accessible in the several published collections of Jefferson's writings, footnotes for them will usually be omitted hereafter.

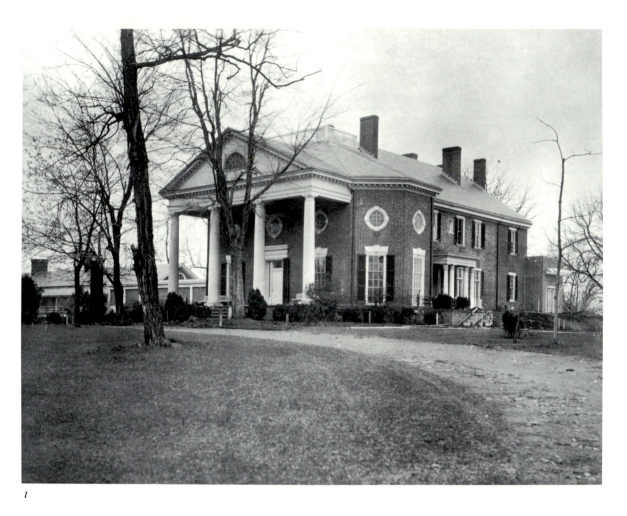

1

1. *Farmington, Charlottesville, Virginia, original house, 1760. Jefferson addition, 1802 (University of Virginia Library).*

2. *Central Dining Hall, West Range, University of Virginia, Thomas Jefferson, ca. 1820 (University of Virginia Library).*

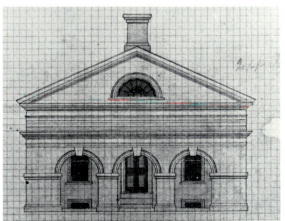

2

of the southern vista from Monticello, and his habit of regarding progress as a series of waves. The two rivers of Albermarle County, the Hardware and Rivanna—the latter running by Shadwell, his father's house—emptied into the James, which passed Richmond eighty miles down, and then moved to the ocean after touching at Williamsburg and Jamestown. The village of Charlottesville was not founded until 1762, only a year before Jefferson began work on his estate of Monticello; hence everything architectural in the vicinity had the gleam of newness, and not just Jefferson's own designs.

The second characteristic derived from the split, channeled, and tufted quality of the place, caused by the frequency and proximity of its hills. Elevations of 500 to 600 feet created a fluctuating panorama of maximum dropoffs. "At a point a little more than halfway up to the saddle of the ridge which is terminated by Monticello is one spot which I conceive was sought out by Jefferson with much woods tramping and tree-climbing to establish viewpoints. Here the steep forested hillside towers uphill above you, and grassy fields fall steeply downhill away from you. . . . All this is the frame, the foreground, the middle distance with the range of mountains against the sky. These mountains are made to appear very high by this view over the deep valley and its steep slopes . . . whereas over flat land from the same elevation they would have been rather unimpressive high hills."[2] The continual contrast in height and depth, the northeast to southwest ridge and furrow rhythm, enhanced the expectations of the space. Jefferson explored these relationships of the valleys with his imagination even more than with his legs.

Imaginary leaps over voids allowed no stable ground for a middle distance, although there was a slope of four miles up from the foot of Monticello through the town, and on to the university hill. Once the university was reached, however, the ridge and furrow rhythm began again: "In locating the group of buildings, Mr. Jefferson so fixed the main axis line of his quadrangle that the southerly view to the court was over a rather precipitous narrow valley running across the axis line with a narrow ridge beyond. . . . The rotunda also was placed at the head of a valley, running with the axis line, and through which a most effective view of this structure was to be obtained from uplands a third of a mile to the north."[3]

This exaggeration of height and depth led to a third characteristic. On the north-south axis the major valley was to become a prototypical panorama of the approach westward to the rest of the United States: "In the southeastern sections are the first 'peaks' the settlers encountered as they traveled inland from the sea. Named by them the Southwest Mountains, this range runs parallel to the more lofty Blue Ridge twenty-five miles to the west and . . . perhaps should be called merely 'hills.' "[4] As Jefferson showed, through his descriptions of the views from Monticello, the Natural Bridge, Harper's Ferry, and elsewhere, he was likely to discern the whole well, but also to play up individual features. Thus the Southwest Mountains became similes for the main spine of the Appalachians, when they were only 1,100 to 1,300 feet high and eighteen miles long. They were model "mountains" upon which to put model buildings. On a south

[2] William Alexander Lambeth and Warren H. Manning, *Thomas Jefferson as an Architect and a Designer of Landscapes* (Boston: Houghton Mifflin Co., 1913), pp. 104-105.

[3] Ibid., pp. 116-117. For a more recent estimate of the difficulty with intermediate space in the Jeffersonian landscape, see the beautifully illustrated William Howard Adams, *Jefferson's Monticello* (New York: Abbeville Press, 1983), p. 170.

[4] John Hammond Moore, *Albermarle: Jefferson's County, 1727-1976* (Charlottesville: University Press of Virginia, 1976), pp. 9-10.

crest of one of them at the Gap of the Ri-vanna stood Monticello, at 867 feet. Far to the west, beyond the Blue Ridge, was the intimation of the Rockies. Looking west to-ward mountains forming barriers occupied increasing numbers of the population during the 1830s and 1840s, shortly after Jefferson's death. But Jefferson had first taken the trou-ble to look out at them and back as well.

He maintained that enough architecture as sustenance had not accumulated in the en-vironment to feed the eye or nourish the spirit. What had accumulated was almost a careless afterthought. During his lifetime he held to the Palladian, Morris, and Gibbs styles, with Roman motifs added later. The landscape he regarded as a bounteous store-house needing no stylizing and already in place. In this frame of mind, he emerged from the cool and orderly rationalism of the Enlightenment into the fluctuating light, open expectations, and empiricism of the ro-mantic movement. One of Jefferson's es-thetic mentors, the Scot Lord Kames, antic-ipated his attitude. Both architecture and "gardening" (by which Kames meant land-scape architecture) could arouse "agreeable emotions or feelings." However, "In archi-tecture, the beauties of regularity, order, and proportion, are still more conspicuous than in gardening; but as to the beauty of color, architecture is far inferior." Archi-tecture was to draw vitality from the color of the landscape scene. Hence it became essential as a complement that Jefferson's porticoes—white perfections with redolent gleams—be seen against the kaleidoscope of blues, greens, and browns of nature, which, according to Kames, "can raise emotions of grandeur, of sweetness, of gayety, of mel-ancholy, of wildness, and even of surprise or wonder."[5]

When Jefferson's colorful views of the dis-tance are seen from within, such as from a portico or through the white-muntined win-dows of Monticello (Fig. 3, Pl. 1), the con-tinuity of the mountains is regarded as if through the specially gridded French graph paper on which Jefferson prepared his archi-tectural drawings.[6] The blue of the moun-tain range is fixed by the white of the archi-tecture. Side views are kept within orderly bounds by the meticulous linearism, cut into cubes or tesserae. Jefferson sought neither to overexpand nor to overreach, unlike later frontier Americans. To tap the untouched scenic reservoir, he wished to induce in-creasingly creative acts, proposing that "young as we are, and with such a country before us to fill with people and happiness, we should point in that direction the whole generative force of nature, wasting none of it in efforts of mutual destruction."[7] Guide-posts to a constructive peace ought to be fur-nished and milestones set up. The weakness of "learned" men was in not recognizing early enough the need for environmental prototypes. He wrote half-seriously to Mrs. Angelica Church from Paris in 1788, "In-deed, madam, I know nothing so charming as our own country. The learned say it is a new creation: and I believe them; not for their reasons, but because it is made on an improved plan. Europe is a first idea, a crude production before the maker knew his trade, or had made up his mind as to what he wanted." Europe, not America; architecture, not landscape, were the cruder innovations. The Deity had improved upon his previous experience in creating the landscape of America, as Jefferson hoped to do by put-ting up suitable buildings within it. There

[5] Lord Kames, *Elements of Criticism* (New York: Ma-son Brothers, 1860), p. 442.

[6] See Peter Collins, "The Origins of Graph Paper as an Influence on Architectural Design," *Journal of the Society of Architectural Historians*, XXI, 4, December 1962, pp. 159-162.

[7] Jefferson, *Notes on Virginia*, p. 174.

3. View north from West Portico, Monticello (Ralph Thompson).

was some catching up to be done, but no inherent pessimism. Consequently, pristine temples, play pavilions, and conspicuous pagodas might be distributed with taste and discrimination in the new wilderness.

JEFFERSON'S SITING, PROPORTIONING, AND DETAILING

Where did the layout for Jefferson's largest templed composition, the University of Virginia, stem from? Fiske Kimball and Frederick Nichols have cited the château of Louis XIV of 1695 at Marly, France, as the first

source, and Jefferson did go to see it with his friend Maria Cosway in the summer of 1786.[8] It had a main pavilion with a rotunda room at the end of a three-sided court and two parallel rows of six smaller pavilions on each side. Nevertheless, the derivation may not have been direct. Jefferson possessed a rare capacity for esthetic choice, but he was also preoccupied with societal and political ramifications. In those terms a republican

[8] A recent summary of their positions on Marly is in Howard C. Rice, Jr., *Thomas Jefferson's Paris* (Princeton: Princeton University Press, 1976), p. 109. See also Fiske Kimball, "The Genesis of Jefferson's Plan

campus might not follow so immediately and easily on an absolutist palace. Another building type was needed as an intermediate motif, and the most convincing precedent for that purpose would be the hospital.

Jefferson's overall social intent is as revealing as a study of his particular architectural motifs. A major interest lay with health. Thus he reported when he was getting ready to plan his university, "Much observation and reflection on these institutions have long convinced me that the large and crowded buildings in which youth are pent up are equally unfriendly to health, to study, to manners, morals, and order." Similarly, in the search for an appropriate site he noted: "What we are seeking is an eligible site for the College, high, dry, open, furnished with good water, and nothing in its vicinity which would threaten the health of the students." This seems to be a reaction against the College of William and Mary at Williamsburg as well, where, he recalled from student days, the "eccentric" position of the lower country encouraged "bilious diseases."[9] The Lawn of the University of Virginia is hence to furnish a form of environmental conditioning through the careful selection of a site, and through the European formal, rather than the American casual,

way of arranging separate buildings, since a multipurpose megastructure was out of the question.

That good health should fuel positive appearances seems to be at the heart of Jefferson's scheme for the campus layout. A premonition of this lay in the hospital plans drawn up in France in a flurry of reform just before the revolution of 1789. A key proposal was to replace after a fire of 1772 the sprawling old hospital of the Hôtel Dieu, in the center of Paris next to Notre Dame Cathedral on the Seine. Jefferson mentioned this proposed changeover, along with the new gatehouses and wall around Paris by Ledoux, in a letter from Paris to Col. David Humphreys on August 14, 1787. Of a pre-Académie des Sciences Commission plan for the new hosptial, the so-called Le Roy and Viel plan, architect Julien Le Roy revealed that with it he hoped to create an effect "like the pavilions of the Garden of Marly."[10] The advantage of the new plans over the random pile added to since the Middle Ages was to be the fresh air and sunshine flowing in from all sides onto the open site, and the reduction of contagion by the separation of the pavilion units. Robert Bruegmann also speaks of the final, Bernard Poyet (or Commission), layout (Fig. 4) as "part of a much larger reform movement,"[11] which pointed toward better environmental hygiene. He cited the paving of streets and the general sanitizing of Paris as additional proof of this laudable intention on the part of the Commissioners, who issued their third and last report with

for the University of Virginia," *Architecture*, XLVIII, 6, December 1923, pp. 397-399. Besides Marly, Kimball brings up and discards a design by Guénnepin for the Grand Prix of 1805, a possibility others would introduce later. Professor Nichols writes, "Probably the general scheme was inspired by viewing Louis XVI's favorite chateau at Marly." *Thomas Jefferson's Architectural Drawings* (Boston: Massachusetts Historical Society, 1961), p. 8. For a lively speculation on the "meaning" of the Lawn, which also goes back to Marly, see William Hubbard, *Complicity and Conviction* (Cambridge, Mass.: MIT Press, 1980), pp. 160-201. Another such essay which gives thoughtful emphasis to ambiguity, is David Bell, "Knowledge and The Middle Landscape: Thomas Jefferson's University of Virginia," *Journal of Architectural Education* 37/2, Winter 1983, pp. 18-26.

[9] A Lipscomb and A. Bergh, eds., *The Writings of Thomas Jefferson* (Washington: Thomas Jefferson Memorial Association, 1903), X, p. 140.

[10] John D. Thompson and Grace Goldin, *The Hospital: A Social and Architectural History* (New Haven: Yale University Press, 1975), p. 130. Hence Kimball and Nichols' supposition as to Marly being the inspiration would remain substantially, although more indirectly, correct.

[11] Robert Bruegmann, "Architecture of the Hospital, 1770-1870: Design and Technology," Ph.D. thesis, University of Pennsylvania, 1976, p. 47. It was in a lecture that Professor Bruegmann gave on "French Hospitals of the Eighteenth Century" before the Midwest Art History meeting at the University of Illinois

the last Poyet plan in it on March 12, 1788, on the eve of revolution.[12]

If a hospital type can be legitimately inserted between the Château of Marly and the University of Virginia, there is also room for the subtype of prisons. In connection with his research for a Virginia prison at Richmond in 1785, Jefferson mentioned in his *Autobiography* a precedent in Lyons, France, of 1761 by P. G. Bugniet. In his text about the prison, Bugniet employed the motto "Safety and Health," remarking that "too often the second has been neglected." In the same passage of the *Autobiography*, Jefferson alluded to the fact that he had also "heard of a benevolent society, in England, which had been indulged by the government, in an experiment of the effect of labor, in *solitary confinement*, on some of their criminals: which experiment had succeeded beyond expectation."[13] The purpose was, as with the later University of Virginia design, to condition the lives of the inmates for the better through architectural arrangement. The principle of solitary confinement mentioned by Jefferson was surely that of the English prison and hospital reformer John Howard, who had visited what he consid-

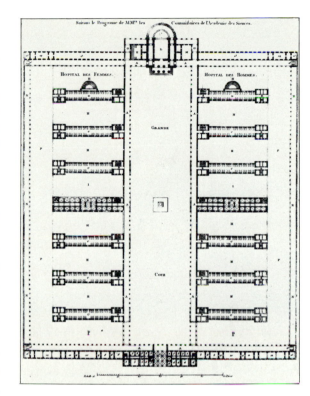

4. Final Poyet project for an Ideal Hospital for Paris, 1788 (Robert Bruegmann).

ered a highly praiseworthy medical facility for seamen, the Royal Naval Hospital at Stonehouse, near Plymouth, England, completed in 1762. It was, Howard said, "different from other royal foundations of this kind, as it consists of several detached buildings."[14] Howard provided two illustrations

in the spring of 1978 that it first dawned on me that Jefferson must have looked to these hospitals for the inspiration of his campus plan. Dr. Bruegmann was then very generous in helping me to follow up this intuition. See also Allan Braham, *The Architecture of the French Enlightenment* (Berkeley: University of California Press, 1980), p. 242.

[12] This brand of thinking of using civic geometry for public health purposes was also shown in Jefferson's plan for Jeffersonville, Indiana, of 1802, where open green squares in checkerboard patterns were intended to keep yellow fever down. John W. Reps., "Thomas Jefferson's Checkerboard Towns," *Journal of the Society of Architectural Historians*, XX, 3, October 1961, pp. 108-114; and *Town Planning in Frontier America* (Princeton: Princeton University Press, 1969), p. 280.

[13] Paul Leicester Ford, ed., *Autobiography of Thomas Jefferson, 1743-1790* (New York: G. P. Putnam's Sons, 1914), pp. 73-74. See also Howard C. Rice, Jr., "A French Source of Jefferson's Plan for the Prison at Richmond," *Journal of the Society of Architectural Historians*, XII, 4, December 1953, p. 29.

[14] John Howard, *The State of Prisons in England and Wales* (Warrington: William Eyres, 1777), with *Appendix to the State of the Prisons in England and Wales & C., Containing a Further Account of Foreign Prisons and Hospitals*, 1784), p. 240n. See also Nikolaus Pevsner, *A History of Building Types*, Bollingen Series, XXXV, 19 (Princeton, N.J.: Princeton University Press, 1976), pp. 150-154, 164; and Adrian Forty, "The Modern Hospital in England and France," *Buildings and Society*, ed. Anthony D. King (London: Routledge & Kegan Paul, 1980), pp. 66, 75, and 78. Forty makes the point that beyond Stonehouse the idea was not carried out again until the 1820s in France and the 1850s in England; thus Jefferson saw a unique object and adopted the idea early.

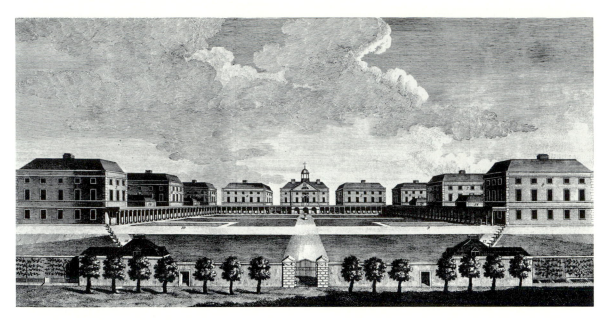

5. Royal Naval Hospital, Stonehouse, near Plymouth, England, 1762 (John Howard, The State of Prisons in England and Wales, 1784).

of it (Figs. 5-6) in his book on the prisons and hospitals of England and Wales which offer the most likely direct inspiration, aside from Marly, for Jefferson. This book was listed in both the "great" library Jefferson sold to Congress in 1815,[15] and in the 1828 catalog of the University, which he had been instrumental in preparing just before his death on July 4, 1826.[16]

Hereafter one descends even further into conjecture over widely held assumptions about the origins of the University plan, which the European hospitals shed some light upon. One has been that in his dual letters asking for suggestions for the plan to Dr. William Thornton and Benjamin Latrobe in 1817, Jefferson was setting forth by means of a crude sketch (Fig. 7) his com-

pletely original notion of what the layout ought to be. But if one compares the sketch in either letter to the plan of the Stonehouse Naval Hospital (Fig. 6), one sees that they are very similar—squarish, with a regular distribution of pavilions connected by porticoes represented by dots. Returning to the Stonehouse perspective (Fig. 5), a further possibility arises. Curiously, the engraver omits the two front pavilions in the perspective in order "to shew the Wards distinctly," according to the caption. The deletion was made because Howard did not approve of their placement.[17] Could this omission have supplied the further suggestion for Jefferson

[15] E. Millicent Sowerby, *Catalogue of the Library of Thomas Jefferson* (Washington: Library of Congress, 1953), iii, p. 27.

[16] *1828 Catalogue of the Library of the University of Virginia* (Charlottesville: Alderman Library, University of Virginia, 1945), p. 96.

[17] Thompson and Goldin, *The Hospital*, p. 142. Jefferson visited Greenwich Hospital for pensioners by Wren on his way from London to Paris in April 1786. It also had a colonnade and central feature with a dome. Edward Dumbauld, *Thomas Jefferson: American Tourist* (Norman, Oklahoma: University of Oklahoma Press, 1976), p. 81. Wren did a project plan for Greenwich Hospital between 1696 and 1702 which included the third ingredient of pavilions.

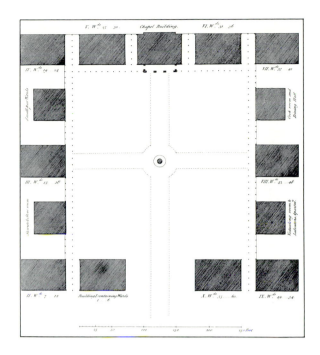

6. *Plan of the Naval Hospital, Stonehouse, near Plymouth, England (John Howard,* The State of Prisons in England and Wales, *1784).*

7. *Jefferson's sketch for a campus plan in a letter to Benjamin Latrobe of June 1817 (University of Virginia Library).*

who, in his two sketches for the letters, and subsequent studies, preferred the open-ended over the closed plan for the Lawn?

A second usual assumption is that Latrobe's reply and sketch of July 24, 1817, actually brought about the introduction of the Rotunda. If Jefferson had looked at the Howard perspective he would have known that, contrasted to his and Howard's plans, in elevation such a focal feature would be advisable. Jefferson's written gratitude to Latrobe for this suggestion may be merely his customary politeness. A third assumption often employed to explain the Lawn is that Jefferson tardily noted the narrowness of his actual site and then had to replace the square plan with a rectangle, thereby subtracting the two pavilions flanking the future Rotunda on his ink sketches: two pavilions which also appeared on the Stonehouse plan (Fig. 6). It is equally possible that he readapted the longer Poyet plan (Fig. 4) of the Académie Commission. It was also rectangular, had a central feature, and omitted the pavilions immediately flanking it, although its U was not open.

Two members of the French Commission, Tenon and Coulomb, who took an inspection tour of hospitals in England and Holland in 1787, had already determined on a scheme of parallel lines and pavilions before they left France, but it was with increased conviction that they discovered that the Plymouth Hospital had been erected on this scheme and had been functioning with great success for over two decades. The report of the trip was contained in the *Oeuvres* of Commission member Antoine Lavoisier,[18] with whom Jefferson was acquainted, because he was in a club, the Société de 1789, with the famous chemist and had commented on his works. Jefferson was in Paris as American

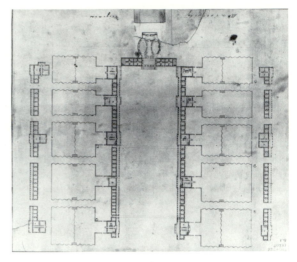

8. *Maverick Plan, University of Virginia, 1822 (University of Virginia Library).*

minister between 1784 and 1789, just when the discussion over the proposed new hospital was going on, and he would also have known another member of the Commission, Daubenton, the collaborator of the naturalist Buffon (whom he also knew). Furthermore, the Académie des Sciences final plan for the hospital and the Howard plan were reproduced in Plate 29 of J.N.L. Durand's *Recueil et Parallèle des Édifices de Tout Genre, Anciens et Modernes, 1799-1800*. Jefferson put that book on his want list for the University to William Hilliard, the Boston bookseller, in June 1825, which then appeared after his death in the catalog of 1828 as acquired.[19]

This brings us to a comparison of the Howard and Poyet plans with the earliest duplicated, Maverick Plan of the Lawn (Fig. 8), commissioned by Jefferson and used as an attraction for the first students. William B. O'Neal, the authority on the architectural books of Jefferson, has instead compared the Maverick engraving of 1822 with the outline

[18] *Oeuvres de Lavoisier* (New York: Johnson Reprint Corporation, 1965), III, p. 682.

[19] *1828 Catalogue of the Library of the University of Virginia*, p. 89. Professor Bruegmann also indicated this double presence to me in a letter of October 26, 1978.

of the famous Hôtel de Salm in Paris,[20] which Jefferson admired. O'Neal's suggestion supports the final conclusion that Jefferson's projects saluted a brilliant body of French and English architecture of the second half of the eighteenth century, and not one precedent alone.[21] French politics may have been decadent, as Jefferson realized when he came face to face with the court and king, but French architecture was superb, and that appealed to *another* of his many sides. Once home, his emphasis on hygiene and wholesome outlooks might be thought to give emotional absolution for continental corruption.[22] Jefferson was looking for an overall mood or atmosphere to be acquired from unlikely and contrasting sources.

[20] William B. O'Neal, *Jefferson's Fine Arts Library* (Charlottesville: University Press of Virginia, 1976), Plates LXII, LXIII. O'Neal observed, "The colonnade surrounding the court of the Hôtel de Salm, with a dominant portico at the end and a pavilionlike arched entrance on either side into service courts, may very well have been a remembered prototype for the Lawn" pp. 178-179.

[21] The way Jefferson dealt with new ideas seemed to be through recurrent synthesis, until he got what he wanted. O'Neal emphasized this process: "It is far more probable that the ground plan of the University evolved from the genius of Mr. Jefferson's intellect, his study of the problems involved in housing an institution of learning and from the demands of the actual site purchased for the University." "Origins of the University Ground Plans," *University of Virginia Alumni News*, L, 9, November 1962, p. 6. Another instance of the search for *the* source of the Lawn is represented by Bryan Little's "Cambridge and the Campus: An English Antecedent for the Lawn of the University of Virginia," *The Virginia Magazine of History and Biography*, 79, 2, April 1971, pp. 190-201. He likened the composition by Jefferson to Downing College at Cambridge, England, of 1805-1807. He also cited two drawings by John Soane of 1808 for a Royal Academical Institution in Belfast which had pavilions and an arcade, and was probably also inspired by Marly. Little again brought up the plan by Guénnepin, first noticed by Kimball, but decided that it did not apply, since it was published four years after Jefferson had crystallized his own plan. Little therefore also fell back on Marly.

[22] Nevertheless, Jefferson took childish delight in borrowing minor motifs from France, such as the half-

Jefferson's objection to the customary brick pile as the shelter for a university arose from his desire to furnish quantities of sunshine and fresh air. This motivation also played a part in the addition of gardens behind the pavilions. These found their premonition again in the writings of the Scottish esthetician Lord Kames. Kames stated unequivocally, "It is in early youth that lasting impressions are made; and it is a sad truth, that by the dirtiness and disorder of many colleges, pent within narrow bounds in populous cities, the youth who reside there are familiarized to such deformities, and rendered in some degree insensible to the elegant beauties of art and nature. . . . It seems to me far from an exaggeration, that good professors are not more essential to a college, than a spacious garden, sweetly ornamented, but without any thing glaring or bizarre, so as upon the whole to inspire our youth with a taste not more for elegance than for simplicity."[23] Like the French reaction against the ancient hospital near Notre Dame, the feeling seems to be as antimedieval as it is antiurban, because the big cities of the Industrial Revolution had not yet appeared.

It is ironic that Jefferson employed a Classical mode, since he tended to stretch its implications to the absolute limit, while advocating great accuracy in details. This has misled some into thinking that he wished to render everything in the most correct and convincing way, but somehow could not quite achieve it. One of his most un-Classi-

dome entrance of Pavilion IX, which obviously came from the entrance of the Hôtel Guimard in Paris of 1770, or the Barrier de Passy, both by Ledoux; or the three oval rooms of the Rotunda, now so beautifully restored, from the oval rooms he admired in the columnar pavilion of M. de Monville at Retz, near Marly, which he saw on his visit in the summer of 1786 with Maria Cosway.

[23] Lord Kames, *Elements of Criticism* (Edinburgh: A. Kincaid, J. Bell, 1765), II, p. 447.

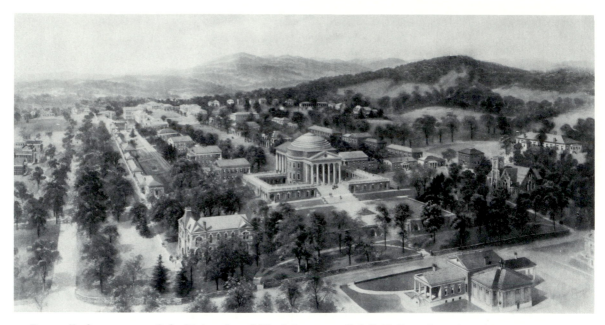

9. *Rummell photogravure of the University of Virginia, 1903. Cabell Hall at the end of the Lawn has just been put in place across the view, but the vista can still be seen from this height (University of Virginia Library).*

cal gestures was to open the southwest end of the Lawn so that it might "be extended indefinitely." Later figures would want to close it off "Classically." The view of the passing range of hills undoubtedly stretched the spatial credibility of the Lawn, but never disrupted its integrity (Fig. 9). Bernhard, Duke of Saxe-Weimar, son of the patron of the German counterpart to Thomas Jefferson, Johann Wolfgang von Goethe, noted only phlegmatically during his visit in 1825, while Jefferson was still alive, that from the end of the Lawn there was "a very fine view of the Blue Ridge,"[24] which was not actually of the Blue Ridge but rather a set of lower hills 500-600 feet high toward Oak Hill, since the Lawn did not face due west. The student imagination was to be engaged by this outlook, catapulted forth over the valley ninety feet below, tall as a nine-story building. The concentration demanded by the stiff discipline of learning could be offset by

[24] *Travels through North America during 1825 and 1826* (Philadelphia: Carey, Lea & Carey, 1828), I, p. 197.

the release to the distant view, as to the gardens at the back of the pavilions on the smaller scale.

Jefferson's ultimate wish was for a botanical garden at the bottom of the Lawn. This was carried out on six acres until it was replaced by Stanford White's Cabell Hall (Fig. 10) in the building campaign of 1896-1898.[25] White extended its arms out in two bays, together with one-story wings, as if to forestall any further thought of escape from serious academic business. The portico of Ca-

[25] George Humphrey Yetter in "Stanford White at the University of Virginia: Some New Light on an Old Question," *Journal of the Society of Architectural Historians*, XI, 4, December 1981, pp. 320-322, states that it was the Rector of the University of Virginia, W.C.N. Randolph, who decided where Cabell Hall should go, and not White, but Professor Nichols advised the author in a phone conversation of August 15, 1983, that his latest researches indicate that the responsibility was divided between Randolph and White. See also Frederick D. Nichols and Ralph E. Griswold, *Thomas Jefferson: Landscape Architect* (Charlottesville: University Press of Virginia, 1978), pp. 167-169.

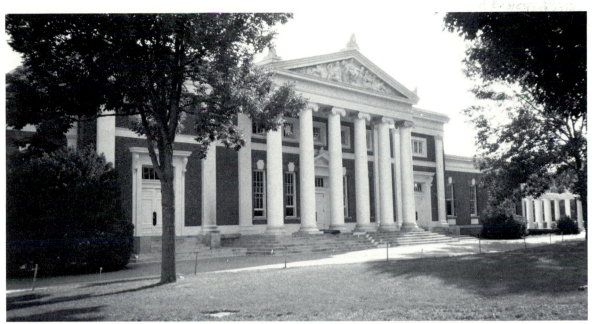

10

bell Hall becomes very shallow under the spatial impact of the Lawn. The mutation in Jefferson's work is always from the meticulous, although never fussy, drawing to the full-bodied, robust, and airy portico. His porches and loggias come to life in three dimensions somewhere between light and shade. This mutation can be more easily understood by comparing Jefferson's drawing for the first pavilion built, Number VII (Fig. 11), to a submission for the same pavilion at Jefferson's request by Dr. William Thornton. Thornton's black and white drawing (Fig. 12) is a generalized schema with deep, dark shadows, while Jefferson's is flat, highly animated, and without shadows. It includes his ever-present window muntins, key blocks in the arches, triglyphs in the entablature, a fanlight in the pediment, and the necessary chimney topping it all. The scale is childlike, again deriving from eighteenth-century garden pavilion dimensions, like those of the tiny dining hall at the center of the West Range (Fig. 2). The true key to the carry-over from the drawing to the actual pavilion (Fig. 13) from Thorn-

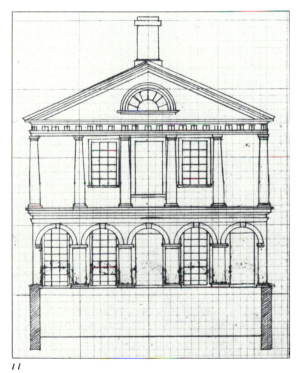

11

10. *Cabell Hall, University of Virginia, Stanford White, 1898-1902 (J. Murray Howard).*

11. *Drawing, Pavilion VII, University of Virginia, Thomas Jefferson (University of Virginia).*

23

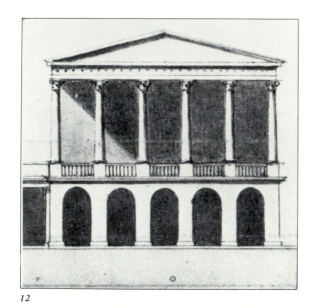

12

12. Pavilion VII as suggested by Dr. William Thorn-ton, 1817 (University of Virginia Library).

13. Pavilion VII, University of Virginia, Thomas Jefferson. The first pavilion built (R. Thompson).

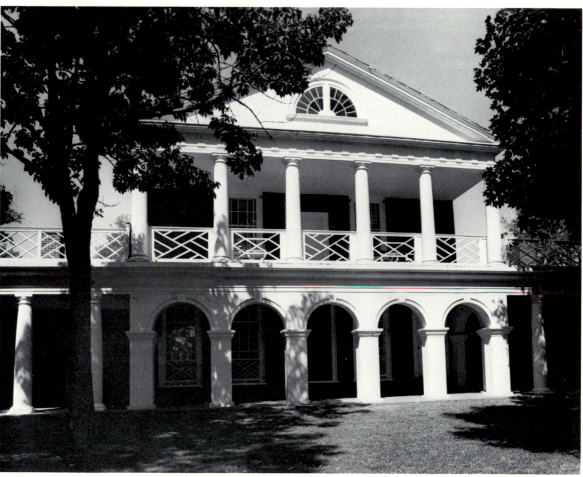

13

ton's suggested design lies, however, in his personal way of addressing the third dimension. In looking at his porches, one must remember that they did not regularly exist in the previous Georgian and Federal styles. Jefferson never overcame his delight in that simple fact. He pulled the porch bravely forward, while the pavilion proper remained reticent in the background, in a Georgian-Federal manner. Jefferson built temples over and around hypothetical Georgian courthouses, thus making the most of a customary form so that no lasting cultural shock ensued. Behind the sequencing, nevertheless, still rests the pleasure in the fragmented drawing, in potential disassembly or decoding, so it comes as no surprise to learn that Jefferson was intrigued all his life by literary codes and ciphers, and liked to use such master words in them as "artichokes" and "antipodes."[26] With the little awkwardnesses and peculiar joinings between units, the grounds became all together an evocative puzzle arising from a great variety of positionings. This ambivalence is one reason why some have interpreted the Lawn as a mall, while others have seen it as an academic quadrangle, a sacred cloister, a public square, or an unusually wide avenue. Its juxtaposing and ambivalent features and meanings, make it very American. Every facet has to be represented.

On Pavilion X (Fig. 14), the concluding unit of the East Range, two appendages of four columns each stand daintily and tentatively, almost French in their slender grace. The parapet of the attic roof, now removed, would have made the contrast in scale between large and small porches even more noticeable. When students are observed under these appendages, they fade like diurnal ghosts into the shadows and become the least features of the descending hierarchy.

The impression of the Lawn is of a great, open, interactive space, on the margins of which are elegant and animated facades. Except for the grass and trees, it is not unlike the Place de la Concorde of Paris, with Gabriel's Hôtel du Garde-Meuble and its companion pavilion hovering in the background as masterful scene painting. This association is not as far-fetched as first appears. The equestrian statue of Louis XV by Bouchardon could be reached in 820 steps from Jefferson's residence at the Hôtel de Langeac on the Champs-Elysées, according to his pedometer.[27] This was the most important Parisian public space for him. It is an ironic accident of history that this supremely refined square of the last half of the eighteenth century would be the setting not only for the wedding celebration of Marie Antoinette and the future Louis XVI in 1770—at which 132 spectators were crushed to death by the mob—but also of their execution at the guillotine. Jefferson himself passed through the square in his carriage only moments before stones were hurled by a mob at the king's German Cavalry in June 1789.[28] His preoccupation with what he called the "pure" and "chaste" in architecture appears to be in a measure a shriving from such disturbing memories from Europe. The difference between the Lawn and the Place de la Concorde lies in the careful articulation of the white porches and rosy pavilions in the projections of the third dimension, compared with Gabriel's delicately drawn details on the ghostly gray facade of the Garde-Meuble. European ruins and sophisticated city palaces were of unending interest to Jefferson, but he also had an irresistible urge to rejuvenate them.

[26] Donald Jackson, ed., *Letters of the Lewis and Clark Expedition* (Urbana: University of Illinois Press, 1962), pp. 9-10; Donald Jackson, *Thomas Jefferson and the Stony Mountains: Exploring the West from Monticello* (Urbana: University of Illinois Press, 1981), p. 134.

[27] Rice, *Jefferson's Paris*, p. 26.
[28] *Autobiography*, pp. 143-144.

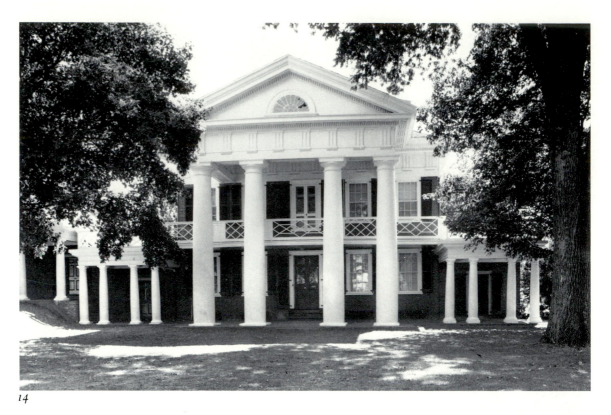

14

14. *Pavilion X, end of East Range, University of Virginia (R. Thompson).*

15. *Families of columns, East Lawn, University of Virginia (T. A. Heinz).*

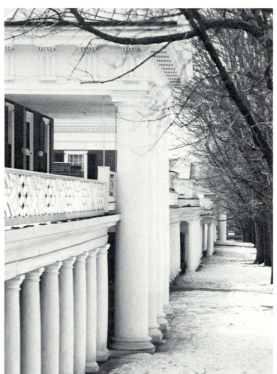

15

16. Sentry column, West Lawn, University of Virginia (R. Thompson).

Despite Jefferson's concern for rights and liberties, a paternalistic rectitude is present also. This "governing" power is nowhere explicitly stated, but it is highly detectable nonetheless.[29] Columns stand free, but remain sedate within constituted authority. Porticoes are organized into preceptorial groups (Fig. 15) of two main sizes, receding and projecting anthropomorphically like Jefferson's own extended southern family.

Here the columns contribute much more three-dimensionally than a belated French backdrop. A smaller event occurs with the sentry columns in the middle of each entrance coming up from the lateral drives to the Lawn (Fig. 16). They keep the space from lending distraction, bleeding out through doors at the sides.[30] Diminutive as these Tuscan columns are, they nevertheless carry great authority.

It is Jefferson's exceptions to his closely held Classicism that provide most of the extraordinary vibrancy. The Rotunda (Pl. 2) is only half the size of its model, the Pantheon

[29] William H. Pierson, Jr., has said in this connection, "In the architectural complex of the university the dignity of the individual is symbolically sustained and protected by the unity and power of the government." *American Buildings and Their Architects; The Colonial and Neo-Classical Styles* (New York: Anchor Books, 1976), p. 332.

[30] The special position of these was pointed out to me by Professor Nichols.

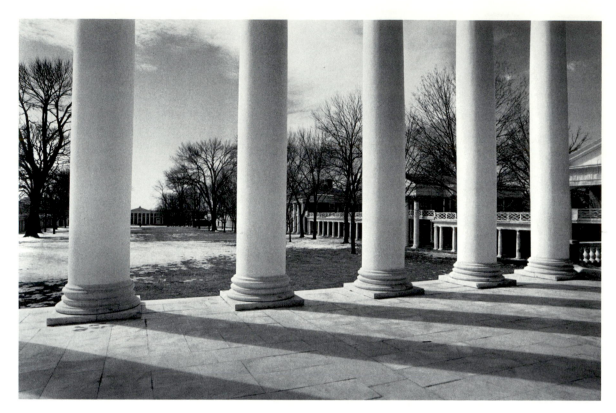

17. Lawn from Rotunda (T. A. Heinz).

in Rome, and so remains on domestic terms with the adjoining pavilions, far enough away from it so that they preserve their own identity. The relation is less imperial, more republican, but nevertheless reserves an authority. That the Rotunda was intended as the major point from which to view the Lawn is evidenced through the reciprocal relation of the colonnade to the adjusted perspective (Fig. 17).[31] Jefferson's white columns taking their places forward and early in repetition make it possible for this vista to be seen in increments. The pavilions appear to maintain a uniform distance even as they

recede from the spectator on the porch of the Rotunda. But the first four, closest to the Rotunda are 53 feet apart on the west, and 64 feet on the east. The next are 89 feet apart on the west, and 93 feet on the east. The next are 104 feet apart on both sides, while the last two pavilions stand 122 feet on each side from them.[32] The gardens likewise widen by 50 feet from north to south, the railings rise, and the terraces drop in expectation of the formerly open view to the southwest at the rate of 3 feet 6 inches each. Concerned as Jefferson often was with measurement, he was also sensibly occupied with

[31] Nichols and Griswold, *Jefferson: Landscape Architect*, p. 162. See also Frederick D. Nichols, "Restoring Jefferson's University," *Building Early America*, ed. Charles E. Peterson (Radnor, Pennsylvania: Chilton Book Co., 1976), pp. 319-320.

[32] Lambeth and Manning, *Jefferson: Architect and Designer of Landscapes*, p. 62, mention these refinements, but their measurements were incorrect. For greater accuracy I am indebted to Dr. J. Murray Howard of the Design Services and Support Staff of the University of Virginia.

the appearance of measurement, as these re-
finements, which he never seems to have
mentioned, demonstrate. Thus, he noticed,
"Buildings are often erected, by individuals,
of considerable expence. To give these sym-
metry and taste would not increase their
cost. It would only change the arrangement
of the materials, the form and combination
of the members."[33]

The walk to the end of the Lawn and the
view back produces a diametric impression,
for everything then appears that much far-
ther away, due to the optical correction now
operating in reverse. With the terraces chest-
high in front of the person looking back, one
submits to detachment—the distance sum-
marily increased by the half-size of the cen-
tral feature, the Rotunda. If an architect
could articulate and control the foreground,
so that the spectator actually felt its concrete
existence, as happens through the presence
of columns, then the distances would pur-
port even more. As Daniel Boorstin cleverly
explained it: "The Jeffersonian's need to el-
evate craftsmanship into Godhead was at
least partly explained by his own objective
environment—by the challenge of an unex-
plored and beckoning wilderness."[34]

MONTICELLO: JEFFERSON'S OBLIQUE APPROACH

Jefferson's penchant for psychological loose-
ness in the force field, only held together by
the abstractly geometric, is also evident at
Monticello, where one receives a cumulative
impression of disparate units and fenestra-
tions rapidly succeeding each other (Fig. 18).
Monticello is authentically Classic, but Jef-
ferson characteristically drew no overall or
unifying conclusion from that fact. The vis-
ual irregularity is resolved only by looking at

[33] Jefferson, *Notes on Virginia*, p. 153.
[34] Daniel Boorstin, *The Lost World of Thomas Jefferson*
(New York: Henry Holt & Co., 1948), p. 55.

the house and dome straight on. However,
at that moment the octagonal drum of the
dome begins to sink with its oculus windows
beneath the apex of the west pediment, be-
cause the favored motif of the portico comes
forward so far. One has to move to an angle
to recover from the lost dome effect (Fig.
19). But now a porch column cuts off the
window at the angle of the bay where the
view out is indicated. The Renaissance rail-
ing above the entablature, which hides the
irregularities of the roof and Jefferson's spe-
cial skylights, also reduces the significance of
the drum of the dome and reduces itself to
flat balusters when it touches the dome. The
architectural language may be archeological
and erudite, but the handling of it is totally
amateurish and experimental. Conventional
stylistic terms such as Palladian, Classic,
Functional, or Organic would go only a cer-
tain distance in explaining Jefferson's rendi-
tions. The out-of-phase awkwardness, ex-
pressed here by uncaring absence of
strictness over Baroque hierarchies, reveals
how hard he tried. He believed that inno-
vation outside the rules must occasionally
take place in order to relieve the *horror va-
cuui*, which in his time stretched to the very
horizon and was without prototypes. At the
Monticello elevation, the singular innova-
tions reverberated in the vast space (Fig. 19).
At the back of the nickel or on the postage
stamp, where Monticello is also presented,
those same experiments are more grating
than stimulating, because the house is shown
symmetrically, and within a confining sur-
face area. It then has so little air and land-
scape color around it. But at the very mo-
ment when Jefferson's restless and angular
architecture was supposed to be refreshing
the republic, it often appeared to be quietly
withdrawing. On Monticello hill the di-
lemma of the highly gifted and sensitive in-
dividual, when attempting to comprehend
the intractable American environment, was
first postulated.

Jefferson's first earth project was leveling the Monticello hill, a plateau 250 by 500 feet, largely executed in 1768. Later he spoke of wanting to do the same for his nearby Pantops Farm. He was ahead of his time in employing the berm as a concealing element. At Poplar Forest he had two mounds shield the privies from the octagonal house as early as 1811. One could enter the house from either of two earth levels.[35] The roof decks of the service wings at Monticello called attention to the southwestern lawn, upon which he and his guests could look internally while seated on the garden chairs and benches at the northwest corner of the decks, taking advantage of the prevailing summer breeze.[36] The four roundabout drives were likewise forms of earth artifice, as were the three terraced utility gardens on the southern slope, which he called his "platforms."[37] In-ground benches consisted of

rock and turf. Warren Manning, the landscape architect out of the Olmsted office, praised Jefferson's subtlety as a designer in terms of privacy and seclusion in 1913: "On the west of this entrance road as it passed the house, the terrace at the servants' quarter level was high enough up above the road so that activities thereon could be screened from visitors on foot or in vehicle by a low hedge."[38] This southwest lawn was indeed a protected pool of space. Dumas Malone stressed in "Mr. Jefferson's Private Life" the need for privacy against his public side: "He sometimes encouraged supporters to defend his public conduct, but he guarded his personal privacy with a jealousy bordering on obsession."[39] His landscape architecture and architecture were not immune to his feelings, however Classical their appearance.

It was a European Baroque convention to have one tall side of a country house, up to three or four stories, appear as a monumental facade looking down upon a paved front court, with a similar lofty slab at the rear turned toward a long, horizontal green *allée* and a final focal point at the end. Jefferson adopted this custom at Monticello, but with emendations.[40] The effect is no longer so European because there is no vertical slab present at either facade—instead there are two projecting columned temples. In many re-

[35] Nichols and Griswold, *Jefferson: Landscape Architect*, p. 124.

[36] William Beiswanger of the Thomas Jefferson Memorial Foundation has put forth the intriguing idea about these decks that "Jefferson may have had in mind Lord Kames' suggestion for an artificial walk elevated high above the plain—an airy walk which would extend and vary the prospect and elevate the mind—when he designed the L-shaped terraces which extend from the wings of Monticello." "Jefferson's Designs for Garden Structures at Monticello," *Journal of the Society of Architectural Historians*, XXXV, 4, December 1976, p. 310. Amidst the permanent garden chairs and benches on the north terrace Jefferson also placed a pedestal, topped by a replica of the maize capital from the Washington Capitol by Latrobe. John E. Semmes, *John H. B. Latrobe and His Times, 1803-1891* (Baltimore: The Norman Remington Co., 1917), pp. 249-251. Part of the aim of Kames and Jefferson was to avoid ennui. The passage which Beiswanger referred to in Kames shows that motivation clearly: "Artificial mounts in that view [on an "insipid," boring plain] are common: but no person has thought of an artificial walk elevated high above the plain. Such a walk is airy, and tends to elevate the mind: it extends and varies the prospect; and it makes the plain, seen from a height, appear more agreeable." *Elements of Criticism* (New York: Mason Brothers, 1860), p. 448.

[37] Frederick D. Nichols and James A. Bear, Jr., *Monticello* (Charlottesville: Thomas Jefferson Memorial

Foundation, 1967), p. 61. See also Nichols, *Jefferson's Architectural Drawings*, p. 7.

[38] Lambeth and Manning, *Jefferson: Architect and Designer of Landscapes*, p. 109.

[39] *Proceedings of the American Antiquarian Society*, 84, 1, April 1974, p. 66.

[40] Three prominent architectural historians have newly commented on the inside-out, inverted quality of the house plan and grounds. Buford L. Pickens, "Mr. Jefferson as Revolutionary Architect," *Journal of the Society of Architectural Historians*, XXXIV, 4, December 1975, p. 263; Pierson, *American Buildings and Their Architects*, p. 307; Walter Whitehill, "The Many Faces of Monticello," *Address at Monticello* (Charlottesville: Thomas Jefferson Memorial Foundation, 1965), p. 10.

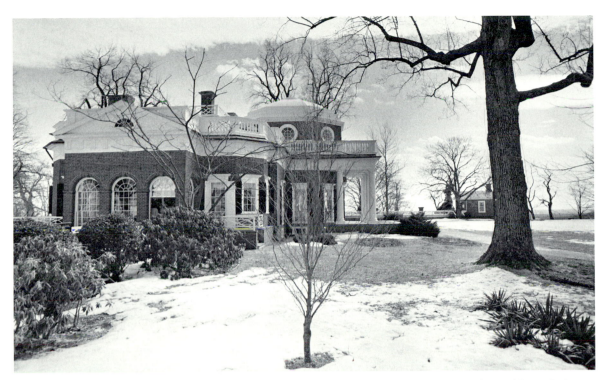

18. Monticello, *view of house from North Terrace. From the side one hardly sees it as one house* (T. A. Heinz).

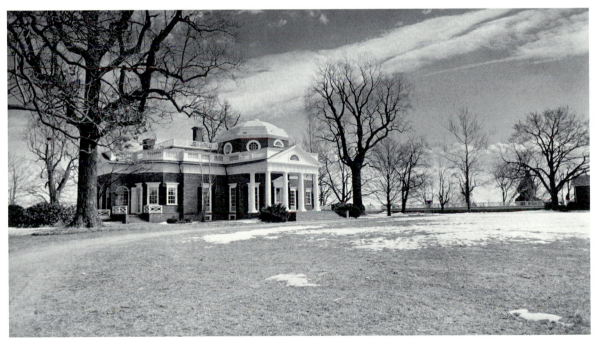

19. *Oblique view of Monticello from the West Lawn. This is the angle the house is supposed to be seen from. It shows lonely and private against the sky, as he sometimes felt* (T. A. Heinz).

spects Monticello is a private, informal, free, eighteenth-century cluster of apartments—not a mansion—within a public, nineteenth-century Neoclassic temple form, the whole prevented at the last moment from splitting apart by a substantial entablature.

The west temple thrust of the portico is a positive accent that emphasizes the garden side, but there is really nowhere to go on the west or southwest because of Carter's Mountain (Jefferson called the peak Montalto) rising twenty degrees off axis and 250-300 feet higher to the southwest and blocking the view. Originally, a considerable woods also obscured this outlook. William Buffum in lectures of 1973 and 1976, noticed this contradiction in the spatial feedback of the west lawn and the bafflement it produced: "Jefferson never fully completed a 'front and garden sided' concept, because the directional feeling of the South West lawn remains toward the house rather than out from it. Looking out across the oval lawn surrounded with trees, there is little to lure one out unless he has been told or can imagine how rewarding it will be to walk back. The tourist today often looks as if he is fighting a duel as he paces away a certain distance, depending on what lens is on his camera, then turns to photograph the house."[41] Buffum believed the explanation for this inversion was in a sketch by Jefferson of his grounds contained in a letter to John H. Freeman, his overseer, in 1806 (Fig. 20). It shows three roundabout paths coming up through the western woods and converging on Mulberry Row, the service road which has the ridge of Carter's Mountain as a backdrop. Emerging from the long and circuitous path in the woods, one could then look up to the house as a revealed artifact, with the greater space of the northeast behind it. Buffum concluded that Jefferson "apparently could never abandon the idea of winding around the mountain, breaking out of the woods onto the summit, and seeing his house with views beyond in every direction."[42]

Buffum felt that this moment of sudden revelation from a particular point was suggested to Jefferson by his reading of the British landscape theoreticians Thomas Whately and William Shenstone, both of whom contended that buildings should be approached obliquely, even across a field, and not head on. In such a context, the house and dome had no need to constitute a great, static, axial pile with a flat facade, to be seen from the end of an *allée*. They stood instead for a low crowned feature to be reached by a gradual uphill aspiration. Buffum believed this English influence persuaded Jefferson that "a house should be merely a supporting part in a larger landscape concept."[43]

[41] William P. Buffum, Jr., "Monticello's South West Approach," paper given on March 14, 1973, in Providence, R.I., pp. 6-7. Mr. Buffum was kind enough to send his unpublished papers and allow me to quote from them.

[42] Ibid., p. 7.

[43] William P. Buffum, Jr., "The English Landscape Design Influence on the Architecture of Monticello," paper given in October 1976 in Providence, R.I., p. 1. Samuel A. Roberson in his Yale Ph.D. thesis of 1974, entitled "Thomas Jefferson and the Eighteenth Century Landscape Garden Movement in England," notes that by 1770 (p. 2) or 1771 (p. 22) Jefferson had read not only the essays of Shenstone and Whately, but also Lord Kames. The essential influence appears to have been from a "school" of landscape thinkers of the 1760s, for Kames, in addition to Shenstone and Whately, observed, "In a direct approach, the first appearance continues the same to the end: we see a house at a distance, and we see it all along in the same spot without any variety. In an oblique approach, the interposed objects put the house seemingly in motion: it moves with the passenger, and appears to direct its course so as hospitably to intercept him. An oblique approach contributes also to variety: the house, being seen successively in different directions, takes on at every step a new figure." *Elements of Criticism* (Edinburgh: A. Millar, 1765), II, pp. 440-444. The purpose was again (see n. 36) to avoid ennui and create excitement, as on Jefferson's terraces at Monticello and from the open Lawn on the southwest at the University.

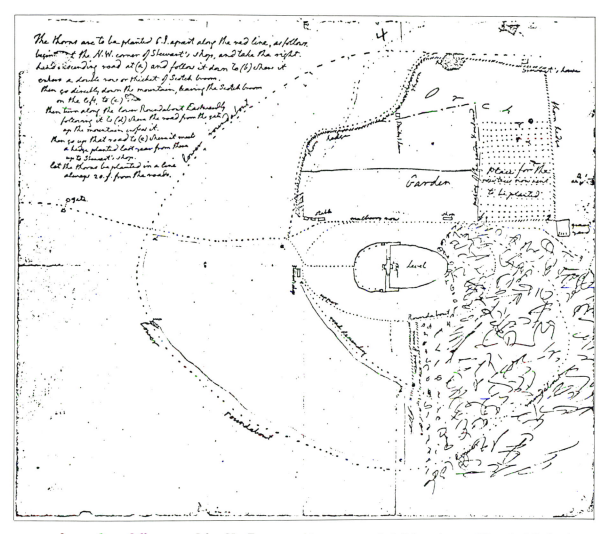

20. *Letter from Jefferson to John H. Freeman, his overseer, 1806 (Massachusetts Historical Society).*

JEFFERSON'S ARCHITECTURE IN RELATION TO CLIMATE

In his pioneering *The South in Architecture* of 1941, Lewis Mumford spoke of the Classical Revival temple as having "a bleakness and gawkiness in the American landscape."[44] He was thinking of the New-Greek temples of New England, upper New York state, and upper Ohio, which their owners painted all white in a cold climate. Jefferson's architecture may have also been international and ancient in inspiration, and certainly nationalistic in intent, as theirs was, but his was more deliberately regionalist in reference. He was ready to postulate a direct connection between the warmer climate of Virginia and the physical and mental health of its inhabitants, with a little exaggeration to help matters toward the preferred conclusion. Writing to his daughter, Martha, in 1791 from northern New York, where he was sight-seeing on Lake Champlain and Lake George, he reported, "Here they are locked up in snow and ice for six months. Spring and autumn, which make a paradise in our country, are rigorous winter with them; and a tropical summer breaks on them all at once. When we consider how much climate contributes to the happiness of our condition, by the fine sensations it excites, and the productions it is parent of, we have reason to value highly the accident of birth in such a one as that of Virginia."[45]

The French custom of cutting off the lower boughs of trees to a uniform height in the Champs-Elysées and Tuileries Gardens, where Jefferson took his leisure when in Paris, must have encouraged him to look upon trees as an umbrella from the sky. He liked to bring out his chair and papers at Monticello and work under the trees. His ambition to acclimatize also comes out in the well-known letter of 1806 to William Hamilton of Woodlands, near Philadelphia: "But under the beaming, constant and almost vertical sun of Virginia, shade is our Elysium. In the absence of this no beauty of the eye can be enjoyed. . . . The only substitute I have been able to imagine is this. Let your ground be covered with trees of the loftiest stature. Trim up their bodies as high as the constitution & form of the tree will bear, but so that their tops shall still unite & yield dense shade. A wood, so open below, will have nearly the appearance of open grounds." As the Place de la Concorde turned into the Lawn of the University of Virginia, so the adjoining Champs Elysées became Jefferson's back lawn at Monticello.

THE "DISTANT" IN RELATION TO THE "NEAR"

Jefferson rarely considered anything at a distance or in the future without some reference to matters close at hand or in the past. He played up one element, such as a window, a porch, or a terrace, so as to explain many others, such as the distant hills; or the detail of a column, capital, entablature, or dome so that the future would seem more secure in the endorsement of the past. When one looks out from Monticello hill, it seems less disconcerting that Jefferson never established a stricter architectural axis. The surrounding views are handled in rotation, as if along the spokes of a wheel, as one might anticipate from his habit of encircling his house perceptually in order to initiate its porches, bays, terraces, and dependencies. Jefferson described the approach in the Hamilton letter: "Of prospect I have a rich profusion and offering itself at every point of the compass [not strictly true, with the ridge

[44] (New York: Harcourt, Brace & Co.), p. 72.

[45] As quoted in Sarah N. Randolph, *The Domestic Life of Thomas Jefferson* (Charlottesville: The Thomas Jefferson Memorial Foundation, 1967), p. 167.

34

of Carter Mountain blocking the southwest] To prevent a satiety of this is the principal difficulty. It may be successively offered, and in different portions through vistas, or which will be better, between thickets so disposed as to serve as vistas, with the advantage of shifting the scenes as you advance on your way."

The Duc de la Rochefoucauld, who visited Monticello in 1796, also noticed this broader prospect as being "perhaps already too vast." He spoke of the brief visual relief offered by the interruption of Carter's Mountain, concluding, "The aid of fancy is, however, required to complete the enjoyment of this magnificent view. . . . The disproportion existing between the cultivated lands and those which are still covered with forests as ancient as the globe, is at present much too great."[46]

The competition between the by-then contained and the eventually-to-be extended becomes clearer if Monticello is compared with Palladio's sixteenth-century Villa Rotonda near Vicenza in Italy, the ultimate European source of several of Jefferson's architectural images. As James Ackerman said of the Villa Rotonda, "The one thing it has in common with the other Palladian villas is that the viewer was not regaled by the moods of rugged nature but by the orderly patterns of husbandry. The Renaissance Italian looked on nature with suspicion unless it had been tamed by man."[47] Palladio's was a conquest enjoyed, while Jefferson's was a victory in the offing. Camillo Semenzato explained, "Palladio reduced the projections of his volume to a minimum, not only because he sought a purity of form, but also because he wanted to achieve the maximum effects of brightness and luminosity from light reflections. It is necessary to remember

that his buildings were intended as 'ideal' structures, by nature evocative despite their concrete functions."[48] Much of this might be said also about Monticello, except that its projections are at a maximum, and the luminosity becomes even more conspicuous with the white wood trim, overriding the effect of the southern soft and warm-colored brick. The Marquis de Chastellux, for instance, on approaching Monticello in 1782, remarked, "We had no difficulty in recognizing on one of the summits the house of Mr. Jefferson, for it may be said that 'it shines alone in this secluded spot.' "[49] Both houses were in and on nature, rather than of it, which made it possible for both to stand as archetypes. However, the Italian villa, already ancient by virtue of its association with an older and more settled landscape, is a square-cut jewel set tightly in a mellow antique setting, whereas Jefferson's pavilion is more of a multifaceted diamond, an improvisation of planes, sparkling forth from every surface in expectation of a new day and a new country.

As personal as Jefferson's interpretation of nature might appear to be, it was also encouraged by a growing national sensitivity to landscape scenery between 1780 and 1785, after the Revolution.[50] Larger natural areas came to be seen as running pictorial panels or intaglio reliefs. While views to the north and east from Monticello are remarkable in the repetition of the low, rolling hills and mountains, it is from the southern "panel" that one learns the most. That vista exhibits none of Palladio's "gentle approaches" and

[46] As quoted in ibid., pp. 198-199.

[47] *Palladio: The Architect and Society* (Harmondsworth, England: Penguin Books Ltd., 1966), p. 73.

[48] *The Rotonda of Andrea Palladio*, Ann Percy, trans. (University Park: Pennsylvania State University Press, 1968), I, pp. 27-28.

[49] *Travels in North America in the Years 1780, 1781 and 1782*, ed. Howard C. Rice, Jr. (Chapel Hill: The University of North Carolina Press, 1963), 2, p. 390.

[50] Mary E. Woolley, "The Development of the Love of Romantic Scenery in America," *American Historical Review*, III, 1, October 1897, p. 61.

"charming hills," which were long ago "all cultivated." It is flatter, largely uncultivated, even today, and of tremendous extent. Jefferson compensated for the apparent monotony by making the scene into an imaginary "Sea View," where certain visual phenomena would heighten its significance. The snow-capped mountains to be eventually discovered and mapped to the west are invisible from here, so Jefferson turned for drama eastward toward the ocean, also unseen, but known to him and registered in his memory. "Having had occasion to mention the particular situation of Monticello for other purposes, I will just take notice that its elevation affords an opportunity of seeing a phaenomenon which is rare at land, though frequent at sea. The seamen call it *looming*. . . . Its principal effect is to make distant objects appear larger, in opposition to the general law of vision, by which they are diminished. . . . There is a solitary mountain about forty miles off [Willis Mountain, which Jefferson likened to the pyramid of Cheops], in the south, whose natural shape . . . is a regular one; but, by the effect of looming, it sometimes subsides almost totally into the horizon; sometimes it is hemispherical; and sometimes its sides are perpendicular, its top flat, and as broad as its base. In short it assumes at times the most whimsical shapes, and all these perhaps successively in the morning." For a matching prospect from the terrace deck on the other, north, side (Pl. 1), Jefferson wrote that the "Blue Ridge of mountains comes into view, in the North East, at about 100 miles distance, and, approaching in a direct line, passes by within 20 miles, and goes off to the South-west. This phaenomenon begins to shew itself on these mountains, at about 50 miles distance, and continues beyond that as far as they are seen. . . . Refraction will not account for this metamorphosis [actually, the phenomenon appears to be that of the Fata Morgana mirage, so refraction does count]. That only

changes the proportion of length and breadth, base and altitude, preserving the general outlines. Thus it may make a circle appear elliptical, raise or depress a cone, or a cone a sphere."[51] By searching for a solid geometry through the ever-present blue haze, Jefferson appears the romantic in search of a scientific encounter. He wanted to perceive this elusive nature as an integrated system discovered through a vast new experimental laboratory.[52] The abundant natural material exhilarated Jefferson, but the shortage of means to reach, classify, and interpret it frustrated him. The result of his rationalizing over this unwieldly landscape to the south was still larger voids created between what he called "near" and what he termed "distant," which ultimately appeared unbridgeable. The arrival of a compatible middle distance had to wait for the Hudson Valley scene in the cultural experience of the nation.

The sheer size of America finally overwhelmed Jefferson's logic. In the American narrative, feeling came after logic as a means of treating with the landscape. William Cullen Bryant, less than five years after Jefferson's death, accentuated the mysteries of nature in order to cope with the growing awareness of the vast size of the country. "Foreigners who have visited our country, particularly the mountainous parts, have spoken of a far-spread wilderness." It "suggested the idea of unity and immensity, and abstracting the mind from the associations of human agency, carried it up to the idea of a mightier power, and to the great mystery of

[51] Jefferson, *Notes on Virginia*, pp. 80-81. Henry Randolph in his *Life* reported that Jefferson likened Willis Mountain to the pyramid of Cheops in Egypt as an exemplar of the geometric. He also reported in 1851 that Willis Mountain "loomed" in the way described by Jefferson (III, pp. 338-339), as did Professor George Tucker in his *Life* of 1837 (I, pp. 530-531).

[52] This is the metaphor provided by William Peden in his Introduction, p. xiii, to Jefferson's *Notes on Virginia*.

the origin of things."[53] It was this larger setting, rising above "the associations of human agency," that drew the American attention away from Charlottesville and similar orbits by virtue of the increasing attractions of romantic size and mystery. This would put individual observation and rational comprehension under an even greater strain, and place architecture with its finite human dimension and "associations" at a further disadvantage. Under these auspices, Jefferson's "mountainous" world of hills and vales around Charlottesville would become conceptually too small, and only a great national park, with no permanent residents and as few buildings as possible, would be one day big enough.

JEFFERSON'S PRECOCITY WITH THE LANDSCAPE

European observers, like the comte de Buffon, the abbé Raynal, and even la Rochefoucauld, wanted to postpone acknowledgment of the fledgling republic on its physical side. Buffon believed that "some centuries hence, when the lands are cultivated, the forests cut down, the course of the rivers properly directed, and the marshes drained, this same country will become the most fertile, the most wholesome and the richest in the whole world, as it is already in all parts which have experienced the industry and skill of man."[54] Jefferson was certainly aware of the French attitude, but did not want to wait so long to see the continent fructify. He exhibited no anxiety over the western prospect, only the anticipation of an orderly progress: "Let the philosophic observer commence a journey from the savages of the Rocky Mountains,

eastwardly towards our seacoast. . . . He would next find those on our frontiers, in the pastoral state, raising domestic animals to supply the defects of hunting. Then succeed our own semi-barbarous citizens the pioneers of the advance of civilization, and so in his progress he would meet the gradual shades of improving man until he would reach his, as yet, most improved state in our seaport towns. . . . I have observed this march of civilization advancing from the seacoast, passing over us like a cloud of light, increasing our knowledge and improving our condition, insomuch as that we were at this time more advanced here than the seaports were when I was a boy. And where this progress will stop, no one can say."[55] Jefferson could visualize vast quantities of land which he could not see and never would visit, as he showed with his policy toward the Northwest Ordinance of 1785, the Louisiana Purchase of 1803, and the Lewis and Clark Expedition to the Northwest in 1803-1806.

Civilization passed over the land "like a cloud of light." It was carried easily along, touching a golden green landscape, instead of over a rocky and uneven ground by a painful pilgrim's progress. The continental venture was kept in check, however, by a conceptual geometry found only within a rational sphere—as within a room or suite of rooms, the best analogy being of a great domed room. It held implications of limits and containment, as later, more romantic, visions of the landscape did not. Jefferson admired the first Halle aux Bleds in Paris of 1783, with its light wooden dome. He sought to impose this precedent two decades later on the recalcitrant Latrobe (who thought Jefferson old-fashioned in his respect for things bookish and French) as a model for the Representatives' chamber in Washington.[56] That semicircular Capitol

[53] William Cullen Bryant, *The American Landscape,* *No. 1* (New York: Elam Bliss, 1830), p. 6.

[54] As quoted in Gilbert Chinard, "Eighteenth Century Theories on America as a Human Habitat," *Proceedings of the American Philosophical Society,* 91, 1, February 25, 1947, p. 32.

[55] As quoted in ibid., p. 54.

[56] See Paul Norton, "Latrobe's Ceiling for the Hall

room was later depicted by Samuel F. B. Morse in a painting at the moment when the great chandelier was being lowered and lit at dusk, so that a shadowy eloquence reverberated all around. Jefferson made an arrangement more finite and comprehensible, and captured the philosophic impulses of the age, by creating a centralized position (Monticello or the University of Virginia), while hoping to join it with an increased recognition of what lay beyond at the periphery (the Blue Ridge Mountains). There was a constant awareness fed back to the central core from the surroundings because of the consciousness of the several illuminations—shining culture in the middle with the dark and glossy woodlands beyond being a major contrast. The proportioning by chambers was an elaborated version of other contemporary thought. William Bartram, his botanist neighbor in Philadelphia, wrote in *Travels through North and South Carolina, Georgia, East and West Florida*: "This world, as a glorious apartment of the boundless palace of the sovereign Creator, is furnished with an infinite variety of animated scenes, inexpressibly beautiful and pleasing, equally free to the inspection and enjoyment of all his creatures."[57] Nature was a great palace, now opened through republicanism to "all his creatures," yet to be seen unwrecked by revolution with its backdrop of gilt mirrors, mellow pictures, bibelots, books, brass sconces and key plates, crinkling fabrics and more profound panels, intact, and bathed in an ambiance of the warmest and most receptive kind.

of Representatives," *Journal of the Society of Architectural Historians*, X, 2, May 1951, pp. 5-10, and "Thomas Jefferson and the Planning of the National Capital," *Jefferson and the Arts: An Extended View*, ed. William Howard Adams (Washington, D.C.: National Gallery of Art, 1976), pp. 211-224. See also William Howard Adams, ed., *The Eye of Thomas Jefferson* (Washington, D.C.: National Gallery of Art, 1976), p. 341.

[57] (London: J. Johnson, 1792), Introduction, p. viii.

JEFFERSON AND THE PURITAN VIEW

There was a gratification for Jefferson in extending the Monticello grounds, whose style ultimately stemmed from an English or French estate, outward to blend with the public domain, a previously unheard-of fusion. Jefferson's forward-looking view embodied an eighteenth-century optimistic assumption of altruism and good will. But an equally meaningful lesson lay in the contrast of this attitude to the pessimism and inhibition of the seventeenth century.[58] The spirit of romanticism, with its later leanings through literature to landscape, was previously spent by Jefferson on the informative literature of agriculture, natural history and botany, gardening and architecture, and a score of other burgeoning studies in the hope of covering the increasing territorial responsibility.

The misfortune occurred when his enthusiasm for observation and ability to share an image were submerged by the Civil War and the consequent lack of discipline and control of industrial, commercial, and urban energy. The pragmatism he subscribed to did continue. The intellectuality, sense of public responsibility, and promotion of artistic refinement were to be cut off. Popular association after the Civil War was to be more with his sectional than his national image. Northern identification of the columned porch as a symbol of antebellum repression, even decadence, precluded the chance of its standing free again as a swelling, well-aired, open ideologue of national dignity and security when facing the landscape. Many were to

[58] Daniel Boorstin has silhouetted this critical contrast: "Where the Puritan (in resignation to his environment) had found a proof of his election in the adversity which he suffered, the Jeffersonian boasted the unhampered prosperity of his enterprises." *Lost World of Thomas Jefferson*, p. 227.

hold it a black mark that he had not envisioned an open enough marketplace for democracy, whereas it was obvious that his mission had been to erect a theater in which the meritocracy of a republic could act out its drama in the dignity it required. The general suspicion of universities and intellectuals in public affairs also worked to his detriment.

Jefferson's outlook was sanguine, his mind brilliant, but an environmentally bleak picture preceded his vision, and a fragmented, disconnected, and physically uglier situation followed it. Hence, the cultural legacy he represented became more tightly bracketed by time, instead of providing a precedent for spiritual and artistic growth. Bankruptcy at the end of his life oddly anticipated the tragedy of the War Between the States. The two became linked. His descendants would have to start a school at nearby Edgehill (for which he also provided drawings) to keep body and soul together: "Through the school the sisters greatly aided their father, Colonel Randolph, whose fortune suffered both through the Civil War and earlier, through the many responsibilities which came to him after Mr. Jefferson's death. There were these debts to be met which came about through no fault of Mr. Jefferson's, but because of his many and long absences from home, in the service of his country."[59] His house came to be used as a carriage and grain barn. Yet it was to survive as an ineluctable presence into the twentieth century to capture the attention of some of its most sensitive and able architects, such as Moore, Lyndon, and Allen, who noted in their book on "places" that "if a building in an open rural landscape is also on top of a hill, its power to claim the land all around and below is increased. . . . it is a pervasive power, possessed as well by totally domestic buildings like Monticello,

which from the top of its little mountain manages to command considerable horizons even though parts of that landscape today are cluttered with other buildings."[60]

Perhaps the fault of the nation lay in a too firm foundation in pessimism and rigor, followed by an overflowing confidence in rationalism in the eighteenth century, and then another great wave of enthusiasm from romanticism in the early nineteenth century. The different moods and rapid sequence could alone have created incompatible expressions. However, Jefferson's approach gives a glimpse of a continuity up to his time, and an incipient tradition. The common outlook—Puritan or Jeffersonian—was based on a particular program for the land, rather than on any specialized effort at acculturation that would ignore the land as much as possible. Whatever functions might be later assigned to pragmaticism, empiricism, materialism, or individualism, they would still be bound under the Puritans or Jefferson to have a communal tie with the land and earth forms.[61]

In his desire to extract meaning from the presence of a hill, Jefferson indeed shared a common symbolism with the Puritans. John Winthrop, while aboard the Arbella in 1630, associated the Covenant with a hill: "Now if the Lord shall please to hear us and bring us in peace to the place we desire, then hath He ratified this covenant and sealed our Commission, and will expect a strict performance

[59] Randolph, *Domestic Life of Jefferson*, Foreword to the third edition, pp. v-vi.

[60] Charles Moore, Gerald Allen, Donlyn Lyndon, *The Place of Houses* (New York: Holt, Rinehart and Winston, 1974), p. 192.

[61] To sample how Jefferson is regarded in relation to later post-Puritan thinkers, see J. B. Jackson, "Jefferson, Thoreau & After," *Landscapes: Selected Writings of J. B. Jackson*, ed. Ervin H. Zube (Amherst: The University of Massachusetts Press, 1970), pp. 1-9, and Merrill D. Peterson, "The American Scholar: Emerson and Jefferson," *Thomas Jefferson and the World of Books*, Symposium at the Library of Congress, September 21, 1976 (Washington, D.C.: Library of Congress, 1977), pp. 23-33.

of the articles contained in it. . . . For we must consider that we shall be as a city upon a hill, the eyes of all people are upon us."[62] The University of Virginia was an ideologue of a secular city upon a hill, too, with all eyes to be drawn toward it as a focal point for the civic conscience. There were also to be practicing neophytes within it.

Yet the first years in New England caused these inhabitants to doubt the worth of their loyalty. A mood of dissatisfaction would hang on to haunt the country, even two decades after World War II, for as eminent geographer David Lowenthal said: "The nature of America, like its scale, leaves the spectator alone in an alien world—alien both in what it contains and what it lacks. America is still full of unfamiliar, undomesticated, unclassifiable things, 'a waste and a howling wilderness,' as Michael Wigglesworth described it in the seventeenth century."[63] The New England winters were harsh. Its rocky and infertile soil lacked the benign overlay of Virginia's climate, although Virginia's soil was to grow thin after a while. The Puritan's inclination was to pull up stakes and seek opportunities farther west. Under such stresses the symbolic mountain was turned into something else—a lofty peak from which to scan the far horizon. Governor Bradford fabricated a lookout from the biblical Mt. Pisgah in his history of the Plymouth Plantation: "Besides what could they see but a hideous and desolate wilderness, full of wild beasts and wild men—and what multitudes there might be of them they knew not. Neither could they, as it were, go up to the top of Pisgah the mountain to view from this wilderness a more goodly country [which would be Canaan] to feed their hopes; for

which way soever they turned their eyes (save upward to the heavens) they could have little solace or content in respect of any outward objects."[64] Jefferson, on the other hand, was able to find his mountain and to capture hope of "a more goodly country" beyond it. Among the Puritans there was a yearning for the past across a distant sea and an anxiety over the future of the continent to the west that were to blur the American intuition and inhibit its esthetic capacity for some while to come. Although the Puritans left their homeland for political and religious reasons, they did not necessarily wish to come to the American continent for environmental ones. They therefore drew in upon themselves, in medieval, theocratic fashion, in their villages and homes. Jefferson, on the other hand, immediately set out to create and assemble those "outward objects" mentioned by Bradford as indispensable for daily environmental happiness.

The spectacular beauty of the Jeffersonian vision of architecture, contrasting with the ridges above, the hills beyond, and the deeper valleys below, arose from its capacity for all-inclusiveness as it postulated better

[62] As quoted in Perry Miller, ed., *The American Puritans: Their Prose and Poetry* (Garden City, New York: Doubleday and Co., 1956), pp. 82-83.

[63] David Lowenthal, *The Geographical Review*, 58, 1, January 1968, p. 66.

[64] William Bradford, *Of Plymouth Plantation: 1620-1647*, ed. Samuel Eliot Morison (New York: Alfred A. Knopf, 1952), p. 62. For a general discussion of how the Puritans took hold of the land, see Alan Heimert, "Puritanism, the Wilderness, and the Frontier," *New England Quarterly*, XXVI, September 1953, pp. 361-382, and Chester E. Eisinger, "The Puritan's Justification for Taking the Land," *Essex Institute Historical Collections*, LXXXIV, 2, 1948, pp. 131-143. In the latter the Puritan vs. Jefferson issue is also raised in terms of the land itself: "In the span of years between the Puritan ascendancy and the American Revolution, the theory of natural law and natural rights shifted its basis from God to the human reason, undergoing more and more secular mutations until it came to full stature in documents like the Declaration of Independence. Then, in contrast to Puritan practice, natural rights doctrine alone was used to enforce claims to the land" (pp. 134-135). See also Peter N. Carroll, *Puritanism and the Wilderness: The Intellectual Significance of the New England Frontier 1629-1700* (New York: Columbia University Press, 1969).

intervals among farms, towns, water, trees, people, and hilltops. He reviewed those relationships from the best vantage points and platforms he could gain. Jefferson obtained a direct satisfaction from his involvement with his environs, as the Puritans could not from theirs because they did not accept the world as physically believable and attractive in the way he did. Hence, in the seventeenth century they could not compose a new architectural language appropriate enough to the new setting. Their Connecticut Valley of the eighteenth century would be their own reaction after the Revolution against such spiritual penury, which Jefferson's granddaughter observed with approval to him in 1825, as he was fading toward death. Their leaders nourished a definite foreboding over the possible disintegration of society through territorial expansion, as he never would. Thus Governor Bradford reported from Plymouth in 1632, almost at once after settlement, "Also the people of the Plantation began to grow in their outward estates. . . . By which means they were scattered all over the Bay quickly and the town in which they lived compactly till now was left very thin and in a short time almost desolate. . . . And others still, as they conceived themselves straitened or to want accomodation [*sic*], broke away under one pretence or other, thinking their own conceived necessity and the example of others a warrant sufficient for them. And this I fear will be the ruin of New England [and he might well have said of the whole nation, if it were in existence then], at least of the churches of God there, and will provoke the Lord's displeasure against them."[65] There was too much land and opportunity elsewhere available on the continent. The land became manifest as a sin and temptation.

Jefferson wished to return to his own hill away from political missions overseas and in Philadelphia and Washington. He ascended to it in order to contemplate his more authentic and convincing childhood scene, not another Canaan.[66] Americans, without a longer tradition, tended to seek resonance in childhood memories. The Puritans and Pilgrims wanted to flee from their self-righteousness and daring, which had brought them so far, while he created an anchor through the agency of architecture. His world had domestic monumentality; theirs did not. Jefferson's vision was as phantasmagoric as theirs, but it found embodiment in abstract geometry, and glowed with color, light, texture, and bright optimism, at least as far into the visible world as theirs was removed from it

From his "sky room" in the dome of Monticello he could search the horizon, especially to the north or south, but his view would never be calculated to rupture it, as the Puritans' had been, and as was certain to happen in other places, particularly along the Hudson Valley with the increased restlessness of the full-fledged romantics. The Puritans saw only bleakness, but kept moving impetuously into it. He saw only promise, opportunity, and allure, but did not step forth into them. He would rather first understand the local landscape, architecture, and natural history of Virginia immediately around him, so as to successfully record and reorder them. He ennobled the art and science of architecture with his ardor, but used it strictly *in situ*.

In his study of the "Romantic Aspects in the Works of Thomas Jefferson,"[67] Donald Shontung observed that the criteria of romanticism emerged from the late eighteenth-century aesthetic and could be measured by

[65] *Of Plymouth Plantation*, pp. 253-254.

[66] See A. Whitney Griswold, *Farming and Democracy* (New York: Harcourt, Brace & Co., 1948), pp. 22-25.
[67] Ph.D. thesis, 1977, Ohio University (Ann Arbor, Michigan: University Microfilms International, 1981).

the response to "the affirmation of the individual and his inherent rights, the desire to explore and learn from nature and the supernatural in all its diversity, and finally the desire to create a new society different from the pre-existing one."[68] Shontung concluded that Jefferson was a transitional figure, utilizing both the empiricist's romantic and the rationalist's neoclassic approaches. Rationalism was more reflected in his architecture, empiricism in his landscape. The freshness in his buildings derived, however, not so much from the fact that they were in transition as from the circumstance that romanticism followed so quickly on rationalism.

Wherever he asked his family or the students to come to rest, he made sure to offer

them dignity in order to compensate for the temptations of geographic aimlessness and expansionism. The orderly orientation toward the distant, wild, open view to the southwest from the Lawn at the University of Virginia indicates this, as does his emphasis on white porches and ruddy bays at Monticello, stretching out toward the landscape but drawing halfway back on the west front. Art was visible proof that ethical, hygienic, and intellectual needs were being early addressed in a particular place. Architecture was a sustaining factor, its domesticated monumentality a visible pledge against brutal revolutions, or imperialistic adventures following, such as had happened in France; in what Jefferson hoped would turn out to be a truly innocent, decent, and "pure" country at the last.

[68] Ibid., pp. 28-29.

The Hudson Valley

THE Hudson Valley was more fully formed than the district around Charlottesville, having a beginning—at New York City—and an end—essentially at Albany (see map). Thus, it offered a natural container for esthetic, as well as political, economic, and social thoughts. The progression up the Hudson can be traced through a stylistic series of estates which take their ascendancy from a particular geologic formation—the terrace. Several of these terrace estates were built by artists and writers for themselves. As around Jefferson's Charlottesville, there was an impulse among such individuals to second, and even top, the extraordinarily harmonious scenery with inventive architecture.

Opposing the desire for blending architecture with the set sides and fixed limits of the wooded valley was the wish to feature the unusual object or person and the infinite distance. This spirit of proclamation culminated in Olana, the great estate of the landscape painter Church, where the house was fully and visibly exotic and the setting no longer big enough for it. In the same vein, the communal or suburban visions for the Valley, as developed by N. P. Willis and A. J. Downing, could not find total fulfillment there. The only authentic Hud-

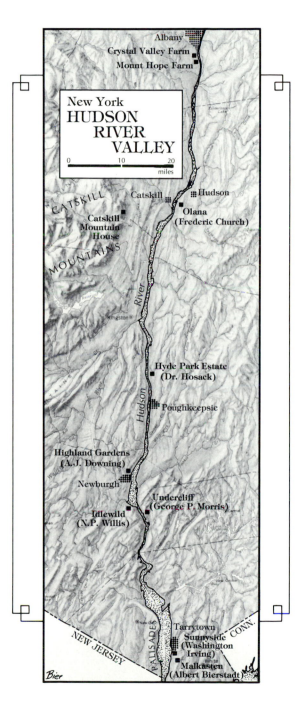

New York
HUDSON
RIVER
VALLEY

0 10 20
miles

son Valley suburb was to be out of it at Lewellyn Park in West Orange, New Jersey. Furthermore, the artist or writer could not keep the Valley protected from the importunities of the extraction of natural cement; of clay for bricks; of iron for bridges, tall buildings, and ships; of lumber torn from the shores. The ground could not be held against New York City; but for a short and remarkable time, largely between 1830 and 1880, a garden paradise for actual residence and recreation was nearly achieved by the artists and authors, stimulated by the proximity of New York City. From the Hudson Valley this higher idealism, to which almost everyone had an allegiance and was endeavoring to adjust, was transferred directly to the Far West.

JEFFERSON'S mountains were twenty to thirty miles away from Charlottesville. In the Hudson Valley they push to the shore, especially on the west. Halfway up the river they are furrowed by secluded glens and coves, intimate recesses, such as found their way into the folk tales and legends of Washington Irving and the paintings of John Quidor.[1] The feature that the Duc de la Rouchefoucauld (and Jefferson) had judged missing in the view from Monticello now took precedence from vantage points all along the Hudson, in the former's terms "a broad river, a great mass of water,"[2] enhancing the contrast of foreground and distance, furnishing a middle ground, and making a ready pocket into which to fit the lambent atmosphere.

Relationships between man and nature in the Hudson Valley were to be expressed through painting and literature rather than science and politics. Although there was a continuing concern for environmental health,[3] as with Jefferson, Scientism as a neat formula for solving environmental problems was over. Jefferson the lone aristocrat became poor, while the groups of satraps of the Hudson Valley, lower-middle-class people, suddenly became rich. The Valley was to be a populated landscape, with well-nurtured talents occupying it in large numbers because of its proximity to New York City. Nathan P. Willis, the most vocal observer of the Hudson pageant, declared "The figures in a landscape are half its beauty. 'Grounds' are embellished by groups, and by waving dresses and moving forms to a degree a painter well understands."[4] This colorful surface animation became habitual. So, says Thomas Cole, the doyen painter of the Hudson River School, "We want human incident, interest, and action, to render the effect of landscape complete."[5] Human figures, rocks, mountains, and trees were utilized in lieu of Old World ruins.

[1] Paul Shepard, "The Cross Valley Syndrome," *Landscape*, 10:3, Spring 1961, p. 5, speaks of geology affecting esthetics in the Hudson Valley, especially in the stories set in coves by Irving, and in the Connecticut Valley. James T. Callow, *Kindred Spirits: Knickerbocker Writers and American Artists, 1807-1855* (Chapel Hill: University of North Carolina Press, 1967), pp. 185-188, discusses the connection between the settings of Irving's stories and Quidor's pictures.

[2] De la Rochefoucauld as quoted in Sarah N. Randolph, *The Domestic Life of Thomas Jefferson* (Charlottesville: Thomas Jefferson Memorial Foundation, 1947), p. 199. According to Henry S. Randall, "Mr. Jefferson used to say if the county of Fluvanna (lying directly east of Albermarle) was a lake, and Willis's Mountain a volcano, his scenery would be perfect." *The Life of Thomas Jefferson* (Philadelphia: J. B. Lippincott & Co., 1871), III, p. 339. This need for more spectacular scenery was one of the reasons intellectuals turned their attention westward. See also John Dos Passos, *The Ground We Stand On* (New York: Harcourt, Brace and Co., 1941), p. 232.

[3] Raymond J. O'Brien, *American Sublime: Landscape and Scenery of the Lower Hudson Valley* (New York: Columbia University Press, 1981), pp. 228-229 goes into "The River's Therapeutic Image." The diseases found most were malaria and cholera. The antidotes were higher elevations and purer air.

[4] Nathan P. Willis, *Outdoors at Idlewild* (New York: Charles Scribner, 1855), p. 156.

[5] As quoted in Walter Mann, "Some European Romantic Influences on Thomas Cole," M. A. thesis, Columbia University, 1951, p. 49. Callow in *Kindred Spirits*, pp. 153-157, elaborates on four ways the human figure was used in Hudson River School pictures.

With the possible exception of the Rhine Valley, which James Fenimore Cooper thought inferior,[6] there was no comparable river scenery anywhere on the European continent, certainly not in England, the literary source of romanticism. Until 1807 and the advent of Fulton's steamboat, movement up the Hudson had been accomplished by solid-bottomed Hudson River sloops tacking endlessly, affording innumerable sight lines. The Irish actor Tyrone Power reported that his consciousness "was absorbed, filled, bewildered, in the admiration which each rapidly-opening point awakened, for never before this fair morning had such a succession of matchless river views passed before my delighted eyes."[7] His entire physical and mental being was swept up by the "glorious magic." It was an individualized, romantic experience, yet it held the same potential as Jefferson's outlook on Charlottesville, of becoming public and patriotic. Thus a French traveler in the 1820s mentioned that his American fellow passengers dropped their cards and rushed on deck at vital locations because they believed it their duty to revere the views coming up around them, "as each traveler finds in them new reasons why he should love his country."[8]

The Hudson Valley offered constantly renewed enchantment within relatively short distances. English suburbs had this same rhythm of sudden turns to reveal novel scenes.[9] Willis first used the term "suburb" in connection with the Hudson Valley in the 1840s. The instrument which made such a new terminology possible was, of course, the commuter steamboat. "No place can be rural, in all the *virtues* of the phrase, where a steamer will take the villager to the city between noon and night, and bring him back between midnight and morning. There is a suburban look and character about all the villages on the Hudson which seems out of place among such scenery; they are suburbs; in fact [the steamboat] has destroyed the distance between them and the city."[10] The proximity to New York City contributed the dynamism and made the villages "suburbs." Willis' village of Cornwall, or the town of Newburgh, both at the Highland Gate, were the farthest commuting points—fifty miles. By the 1850s the railroads had begun to supplant the river steamer. Then indeed New York City appeared a place to escape from, rather than a shopping, cultural, or financial center to resort to, as it had been in the 1840s and earlier. Right after the Civil War the Woodwards' builders' books were predicting that "As far as New York city is concerned, it is simply a question of time how soon our middle-class citizens, who desire to live comfortably, with due regard to economical conditions, will be obliged to choose the country for their homes."[11]

[6] James Fenimore Cooper, "American and European Scenery," *The Home Book of the Picturesque* (New York: George P. Putnam, 1852), pp. 62-63. John Zukowsky has dealt with the Rhine Valley association in "Castles on the Hudson," *Winterthur Portfolio*, 14, 1, 1979, pp. 73-92. He has also brought up the important issue of the difference between the picturesque and the utopian in "The Picturesque and Utopian: A Contrast in Spaces," *Nineteenth Century*, 2, 3-4, 1976, pp. 17-21.

[7] Tyrone Power, *Impressions of America During the Years 1833, 1834 and 1835* (London: Richard Bentley, 1836), I, p. 342.

[8] J. Milbert, *Picturesque Itinerary of the Hudson River and the Peripheral Parts of North America*, 1826, trans. by Constance D. Sherman (Ridgewood, N. J.: Gregg Press, 1968), p. 41.

[9] Walter L. Creese, "Imagination in the Suburb," *Nature and the Victorian Imagination*, U. C. Knoepflmacher and G. B. Tennyson, eds. (Berkeley: University of California Press, 1977), pp. 58-59.

[10] Nathan P. Willis, *American Scenery Illustrated* (London: George Virtue, 1840), p. 106.

[11] George E. and F. W. Woodward, *Woodward's Country Homes* (New York: George E. and F. W. Woodward, 1866), p. 11.

THE HUDSON VALLEY VS.
THE CONNECTICUT VALLEY

Besides being a suburban adjunct to New York City, the Hudson Valley can be seen in parallel to its sister to the east, the Connecticut Valley. The one hundred and fifty miles from New York to Albany had been endowed not only with unequaled scenic values, but also with agriculture, timber in good supply, fishing, and a lively commerce between the two original Dutch cities. To the Connecticut Yankees it was one of the "three interior Canaans" (Fig. 1). The biblical Canaan was seen from Mt. Pisgah by Moses as "the land promised to the ancient fathers." Indeed, there is a Mt. Pisgah, 1,264 feet high, twenty miles east of Springfield, Massachusetts, looking on the Connecticut Valley. Several prominent architects, including Philip Johnson, have their homes in New Caanan, Connecticut. The Puritans even illegally adopted the Hudson Valley: "If you would know the garden of New England, then you must glance your eye upon the Hudson's river."[12] However, they were hesitant about the Hudson Valley habits of life, in contrast to its obvious natural attractions. This is reflected in the comments of Timothy Dwight, Congregational minister, Revolutionary chaplain, and president of Yale, who traveled through this district between 1796 and 1815. Dwight clung to the conviction of the Massachusetts governors Winthrop and Bradford that if the inhabitants of a given locale did not lead upstanding lives, they would be found unworthy by God of the location into which they had set themselves. Contrasting the second Canaan, the Connecticut Valley, with the third, the Hudson Valley, Dwight rein-

1. The Three Parallel Canaans of the Puritans: East Coast of Massachusetts, Connecticut Valley, and Hudson Valley (Burt's Illustrated Guide of the Connecticut Valley).

voked the medieval "goodly towne," which had a long provenance in Europe as well as America for the Puritans. According to Dwight, the villages of the Hudson were too devoted to commerce and too rudely arranged. Their appearance did not begin to suggest a social convenant. This deficiency could only be rectified through the external application of eighteenth-century rules of discipline and good taste (to become "rural

[12] As quoted in Alan Heimert, "Puritanism, the Wilderness, and the Frontier," *The New England Quarterly*, XXVI, 3, September 1953, p. 365.

taste" in Downing's Hudson Valley vocabulary). The model for reform, Dwight believed, lay in the Connecticut Valley. "The towns in [the Connecticut] valley are not, like those along the Hudson, mere collections of houses and stores clustered around a landing, where nothing but mercantile and mechanical business is done; where the inhabitants appear to form no connection or habits besides those which naturally grow out of bargains and sales; where the position of the stores determines that of the house, and that of the wharf commands both; where beauty of situation is disregarded, and every convenience except that of trade is forgotten."[13]

The Connecticut Valley had achieved comeliness by cultivating the concept of the "goodly towne." Another person steeped in the same Revolutionary ideals as Dwight, Ellen Randolph Coolidge, traveling through in the summer of 1825 from Virginia to her new husband's home in Boston, noticed that the scene could "almost challenge *Old* England in beauty of landscape." She wrote thus to her grandfather, Thomas Jefferson, along with her observations from Mount Holyoke, that the countryside "resembles one vast garden divided into its parterns. There are upwards of twenty villages in sight at once, and the windings of the Connecticut are every where marked, not only by its own clear and bright waters, but by the richness and beauty of the fields and meadows, and the density of population on its banks. The villages themselves have an air of neatness and comfort that is delightful. The houses have no architectural pretensions, but they are pleasing to look at, for they are almost all painted white. . . . The school houses are comfortable-looking buildings, and the Churches with their white steeples, add not a little to the beauty of the landscape. It is common also to find the larger of these country towns, the seats of colleges which are numerous throughout the country."[14] The concept of an educated and informed populace bringing order, dignity, and grace to the landscape, and so enhancing and purifying it, had, of course, originally been Jefferson's. He replied to his granddaughter that he remembered traveling through the Valley in 1791, and that her description of increased settlement and a greater prosperity only affirmed what people could do for themselves, once possessed of a good enough government without tyranny.[15]

The good life following on the Revolution was essentially inscribed on a scenic rotulus: "The broad open lands, or *intervals* . . . which border upon the Connecticut, contain some of the most sunny and fertile pictures of the cultivation to be found on our continent. From the mouth of the river up to its rise beyond the White Mountains, it is gemmed with beautiful rural towns, many of them among the first in our country for prosperity, neatness, and cultivated society."[16] This unique civic association in a natural setting was grounds for the odious comparison: "No wonder then, that, like many other portions of the Eastern States, [the Connecticut Valley] contrasts so vividly with newer and rougher parts of the Union."[17]

Again came the invidious comparison from Dwight, but this time with European villages instead of with those of the Hudson Valley or the rest of the United States. "The villages on the other side of the Atlantic are exhibited as being generally clusters of

[13] Timothy Dwight, *Travels in New England and New York*, ed. Barbara Miller Solomon (Cambridge, Mass.: Belknap Press, 1969), II, p. 230.

[14] *The Family Letters of Thomas Jefferson*, ed. Edwin M. Betts and James A. Bear, Jr. (Columbia, Missouri: University of Missouri Press, 1966), p. 455.

[15] Letter of August 27, 1825 (Massachusetts Historical Society).

[16] Willis, *American Scenery Illustrated*, p. 170.

[17] T. Addison Richards, *American Scenery* (New York: Leavitt & Allen, 1854), p. 298.

2. *Charles Parsons Farm, Conway, Mass. The house and barn could be an integral part of the rest of the settlement in the Connecticut Valley. White buildings scattered about the landscape were very typical of its arrangement* (History of the Connecticut Valley in Massachusetts).

houses standing contiguously on the street; built commonly of rough stone, clay, or earth, and roofed with thatch; without courtyards or enclosures; and of course incapable of admitting around each house the beautiful appendages of shrubs, trees, gardens, and meadows."[18] European crowding was not a necessity in America, so nature could be brought back into the town, and bushes and trees planted close to the house, the premise of the suburban layout ever since. Home lots in the Connecticut Valley varied from two to ten acres. Each lot, despite the house and outbuildings upon it,

would look like "a meadow, richly cultivated, covered during the pleasant season with verdure, and containing generally a thrifty orchard."[19] These in-town citizen farmers (Fig. 2), dwelling on their individual home plots, had civil manners, expressed through communal meetings and personal exchanges, many of them being "liberally and politely educated," which is why Dwight's Yale and the other colleges would be needed, for civility in deportment, as well as virtue and enlightenment. These proprietorships would be accompanied by out-of-town meadows, but no part of either portion

[18] Dwight, *Travels*, II, p. 231.

[19] Ibid.

49

would ever be called an estate. Ownership in New England could not be justified by personal make-believe or fantasy, as in the later Hudson Valley, only through community approval.

The single house color and simple materials were given serious consideration. Dwight, like Mrs. Coolidge, was taken by the universal whiteness of the dwellings of the Connecticut Valley. Because they were of wood, they could be "neater, lighter, and pleasanter dwellings than those of brick or stone. As they stand at a distance from each other [on the single lots], they are little exposed to fire except from within, and accordingly are very rarely consumed. Both they and the public buildings [including the churches] are usually painted white. No single fact except the universal verdure and the interspersion of streams contributes equally to the sprightly, cheerful appearance of any country."[20] The attributes "sprightly" and "cheerful" suggest again eighteenth-century optimism, reinforced by the success of the Revolution, following on the previous Puritan need for conformity. The importance of intelligence and propriety must be made apparent by the ubiquitous white paint, the street arches of elms, maples, and chestnuts, and the multiplicity of academies and colleges.

Hudson Valley houses would not be as conspicuous. Their walls were to be muted into softer fawn, dun, gray, or chocolate hues; a range of colors blending with nature. The house silhouette would likewise depend more on conscious irregularity of outline and asymmetry, to accord with nature. All the arts were to be more superficially decorative, but were also intended to contribute to the appearance of greater visual harmony in nature. Downing reports in "The Colour of Country Houses" that "landscape painters

always studiously avoid the introduction of white in their buildings, and give them instead some neutral tint—a tint which unites or contrasts agreeably with the colour of trees and grass, and which seems to blend into other parts of natural landscape, instead of being a discordant note in the general harmony."[21]

Downing, for his part, did not regard the basic white house of the Connecticut Valley with admiration, because it was so "simple and unpretending—often, indeed, meagre and unworthy of notice."[22] But the tunnel-like spatial flow of the street arches of elms, chestnuts, and maples bid fair to overcome him. He maintained that trees "can teach us lessons of antiquity, not less instructive and poetical than the ruins of a past age."[23] Careful arrangements of trees, people, and buildings were also needed in the Hudson Valley, he felt. Most significant of all, Downing believed that the Connecticut Valley offered irrefutable evidence that intelligence and education led directly to the improvement of the environment, since where "nearly the whole of the population enjoy the advantage of education, as in New England," cooperative public expressions did result, and "we are almost forced to believe that the famous common schools of New England teach the aesthetics of art, and that the beauty of shade trees is the care of special professorships."[24] In an essay on "The Moral Influence of Good Houses," he referred to the priority of Timothy Dwight.[25] Downing

[20] Ibid., pp. 231-232.

[21] The Horticulturist, I, 2, May 1847, p. 490. James Early in Romanticism and American Architecture (New York: A. S. Barnes and Co., 1965), p. 66, suggested that these picturesque color theories of Downing echoed those of Reynolds, Price, and Wordsworth.
[22] "On Planting Shade Trees," The Horticulturist, II, 5, November 1847, pp. 201-202.
[23] "How to Choose a Site for a Country Seat," The Horticulturist, II, 6, December 1847, p. 252.
[24] Downing, "On Planting Shade Trees," p. 201.
[25] The Horticulturist, III, 2, February 1848, p. 346. Downing backs up, years later, Dwight's conclusion

wanted to strengthen the domestic bond by reinforcing it with both ethical and esthetic content. James Fenimore Cooper even became agitated over the use of French green on blinds and shutters, instead of the more usual dark green.[26] He, like Downing, deplored the contrast of white and green in the landscape at large.

THE HARMONY OF THE HUDSON VALLEY

For Thomas Hamilton, a Scottish novelist traveling along the Hudson in the 1830s, the impact of the first uplifting glimpses of its shores depended upon the organic integration of their parts within a small compass. "What struck me as chiefly admirable, was the proportion of the different features of the landscape. Taken separately, they were not much. Every one has seen finer rocks and loftier mountains, and greater magnificence of forest scenery, but the charm lay in the combination, in that exquisite harmony of detail which produces—if I may so write—a synthetic beauty of the highest order.

> 'Tis not a lip or cheek, we beauty call,
> But the joint force, and full result of
> all.'

about the Hudson River villages in "Our Country Villages": "You feel little or nothing of that sense, of 'how pleasant it must be to live here,' which the traveller through Berkshire or the Connecticut valley or the pretty villages around Boston, feels, moving his heart within him." *The Horticulturist*, IV, 12, p. 538. The New Yorkers should plant trees, build better houses, and keep the pigs and geese out of the streets, he says, all of which Newburgh was eventually to do. To save the reader "research and investigation" as to why the difference between Massachusetts and New York in this respect, Downing will tell us—the former has more educated citizens. He mentions Brookline and Northampton as especially beautiful and tasteful towns, "but they are in Massachusetts." (n., p. 539.)

[26] Cooper, "American and European Scenery," pp. 59-60.

"Add elevation to the mountains, and the consequence of the river would be diminished. Increase the expanse of the river, and you impair the grandeur of the mountains. As it is there is perfect subordination of parts, and the result is something on which the age loves to gaze, and the heart to meditate, which tinges our dreams with beauty, and often in distant lands will recur, unbidden to the imagination."[27] After such a compaction, gaining the power for unification of the landscape from each of the details, it seems less remarkable that this valley was to be the cradle of the first school of American landscape painting, lasting until 1875. The novelty was in the recognition that the American scene could be looked upon as an entity or ensemble—a total picture. This was the relief which the prospect of the Hudson initially promised—a remission of the political and religious enthusiasm for the Connecticut Valley forms in favor of the even more vivid and sensuous enjoyments of Hudson River landscape beauty.

There were vantage points along the valley from which to observe these ingratiating effects, in addition to the boat decks. Instead of on an alluvial plain, upon which the homesteads of the Connecticut were placed, the prime sites on the Hudson were upon the more elevated shelves, tables, plateaus, and terraces (as they were variously called). This geological circumstance would greatly affect how the artists looked upon the Valley. There were four groups of these terrace sites—at Tarrytown, Newburgh, Hyde Park, and on up to the towns of Catskill and Hudson, across the river from each other.

Much of what remained in virgin forest to make up earlier appearing, naturalistic views was a result of the conservative land policy of the Dutch. Their patrons had been reluctant to open up their holdings along the

[27] Thomas Hamilton, *Men and Manners in America* (London: T. Cadell, 1833), p. 287.

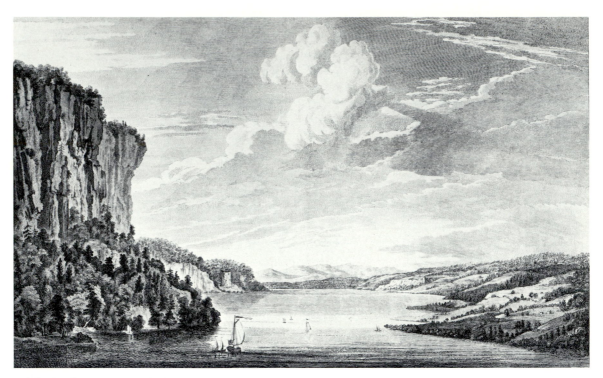

3. The Hudson River at the Tappan Zee, 1768. Note the extreme contrast between the scale of the tiny cottages on the right and the towering Palisades on the left (New York Public Library).

river.[28] This was a second kind of relief which the Hudson Valley put forth, the presence of an unspoiled nature so close to a great city. A print from the third quarter of the eighteenth century (Fig. 3), supposedly by the British governor "Pownal,"[29] exaggerated the towering aspect of the forty-mile-long Palisades above New York City, as contrasted to the smaller-scale slopes on the eastern shore. The exaggerated difference nevertheless conveyed a germ of truth for the entire valley. Many noticed this contrast of wild with domestic, of big with little—including Peter Kalm and Timothy Dwight.[30] In 1907 a book was even published dealing only with the legends of the more heavily forested western bank—a whole book for half a river.[31] This meant

[28] Maud Wilder Goodwin, *Dutch and English on the Hudson* (New Haven: Yale University Press, 1921), p. 34. The Charter of Privileges and Exemptions for Dutch estates, sixteen miles long, or eight if on both shores, running back "so far into the country as the situation of the Occupyers will permit," dates from 1629. Paul Wilstach, *Hudson River Landings* (Indianapolis: Bobbs-Merrill Co., 1933), p. 50. O'Brien, *American Sublime*, pp. 66-75, reinterprets some of the Goodwin, Wilstach, and Carmer views on the Dutch, particularly in regard to "Topophobia," their alleged fear of the land.

[29] Probably Thomas Pownall (1722-1805), *secretary* to the governor of New York from 1753 to 1756. Pownall was, however, later to be governor of Massachusetts (1757) and South Carolina (1760). O'Brien, *American Sublime*, p. 59, mentions the view, and goes on speaking of the artist as "Governor" Pownall.

[30] Dwight, for instance, says, "On the western side, it is forested to a much greater extent that I had been prepared to expect: a fact owing, I was told, to the reluctance with which the Dutch farmers consent to any alteration in the state of their possessions." *Travels*, IV, p. 12.

[31] Charles Gilbert Hine, *The West Bank of the Hudson River: Albany to Tappan: Notes on Its History and Legends, Its Ghost Stories and Romances* (Newark, N.J.: C. G. Hine, 1907).

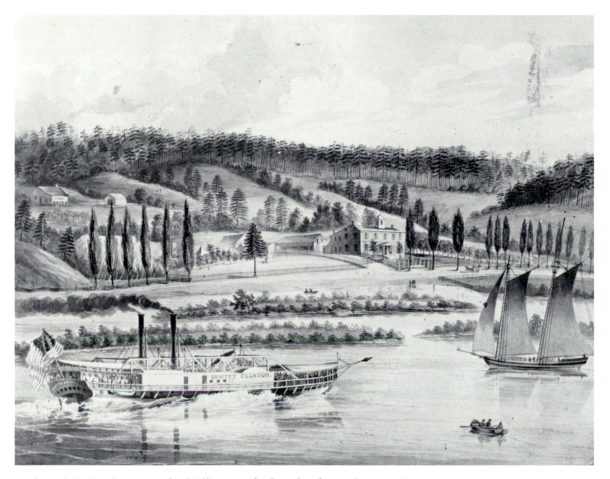

4. *Crystal Valley Farm, south of Albany at the Overslaugh, as of 1834 (Albany Institute of History and Art).*

that the artists and owners (often the same person) would always have a place to look from—the terraces of the eastern shore—and something to look at—the wooded western hills.

ESTATE TYPES OF THE HUDSON VALLEY

On the eastern terraces of this east-west juxtaposition a number of estates were built that developed in time from those having relatively little to do esthetically with nature to those that were more closely and carefully

adjusted to it. A stylistic sequence ensued. The type gradually took up desirable viewing positions.

NEO-CLASSIC ESTATES

Crystal Valley Farm, Overslaugh, south of Albany, as of 1834. The summer residence of C. R. Benthuysen and John Taylor (Fig. 4), Crystal Valley Farm, a few miles south of Albany, is characteristic of the river farm before the elevation in type and siting caused by the more demanding romanticism. In the foreground is a well-known "overslaugh," the Dutch term for sandbar. Of note is the

direct engagement of the farm with the road and shore, which run right by the formal front of the old style Federal house, with its centralizing cupola and leanto. The farm was on low ground as close to the shore as possible so that the stock could be well watered. Only later were villas built high on bluffs, removed and aloof. The main road would then run behind the house, with "the barn and outbuildings out of sight." Crystal Valley Farm displayed none of that later informal self-consciousness, but rather a formal unself-consciousness. It was frankly a working farm, despite the formality of the house. There is a complacency about this scene such as seldom appeared again along the river.

Mount Hope Farm, south of Albany, the Ezra Prentice House, 1834-1840. The Prentice Farm (Fig. 5), a little over a mile south of Albany, represents the next stage in the evolution of the Hudson Valley estate. This house, more solidly foursquare and classical, was of the pre-Downing type, well described by the Woodwards: "The prevailing taste in country dwellings, before Mr. Downing's time, was defective enough. A large, square, wooden house, painted intensely white . . . was the very beau ideal of a gentleman's country dwelling."[32] The road still ran by the edge of the river, and the main barns were left anachronistically down by it, at the southeast corner. Otherwise the house had begun to withdraw. The facade was more self-consciously Classical than at Crystal Valley, yet more of it was hidden by trees. But from the new-found terrace it was also possible to enjoy distant prospects. "The view from the house is of uncommon beauty, and embraces the city on the left, and the Hudson for many miles below, until lost among the blue hills."[33] There were also

service buildings on the bluff, and "a hundred feet north and south of the main house was a 'wing' of brick, and between each wing and the main house a continuous row of outhouses, sheds and store-rooms of wood, all painted white."[34]

A number of personal features around the square white house indicated that this was a prototypical estate of the new era, although these were as yet loosely organized. "In front, and about thirty rods below the house, is a fine elliptical sheet of water, 150 feet long by 100 wide, bordered by trees, and surrounded by a neat fence, and in the centre of which a perpetual fountain, in the form of a fine delicate silver jet, shoots upward fifteen feet or more in height."[35] Next to the fountain were Prentice's imported South Down and Cotswold sheep. There were three marble statues (barely visible in the illustration) and two very large marble vases in front of the house. Inside, in niches in the salon, were six Neoclassical statues by Henry Kirke Brown.[36] Four were of the seasons, a fifth the Discobolos. Behind the house were extensive gardens, with another fountain and greenhouses. Behind these were orchards and fields.

Hyde Park Estate, Dr. David Hosack House, Martin Thompson, Architect; André Parmentier, Landscape Gardener, 1828-1835. For many, the Hyde Park Estate was the most remarkable on the river. The view from it (Pl. 3) was to become the subject of numerous prints and essays. The terrace which made the view possible ran along the east bank for almost a mile, at 175 feet above the water. Below, sailboats tacked across what at first appeared to be an inland lake. From the ci-

[32] *Woodward's Country Homes*, pp. 17-18.
[33] *Munsell's Collections of the History of Albany* (Albany: J. Munsell, 1867), II, p. 475.

[34] William Kelly Prentice, *Eight Generations* (Princeton, N.J.: privately printed, 1947), p. 90.
[35] *Munsell's Collections*, II, p. 475.
[36] Henry T. Tuckerman, *Book of the Artists* (New York: G. P. Putnam & Son, 1867), p. 576, mentions Prentice as the early patron of Brown. Prentice was twice abroad, in 1837 and 1841.

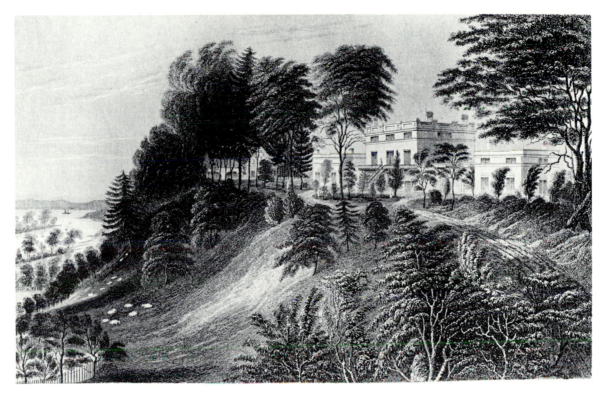

5. *Mount Hope Farm, Ezra P. Prentice House, south of Albany, 1834-1840 (Albany Institute of History and Art).*

vility of the shady lawn, where the owner presided at tea with his family, the terrace faced the wilder western shore, almost as if toward a shallow stage seen through a proscenium, creating a unity in the backdrop such as that observed by Thomas Hamilton near West Point, "a synthetic beauty of the highest order." Additional drama and dimension were provided by the broad outlook up the river northwest toward the Highlands. The private precinct of the Hudson River squire was extended toward a public pictorial concern in the distance. This was the third type of mental relief to be had from the Hudson Valley, after the reduction of the political and religious strictures of the Connecticut Valley; and after the relaxing effect from nature so close at hand to a large city; an echoing form of containment, an unthreatening, well-proportioned, and well-

placed feedback for visual curiosity about the new country.

In July 1832, four years after Dr. David Hosack bought the property from William Bard, the son of his former partner, Dr. Samuel Bard, the eighteen-year-old English artist Thomas Wharton came to visit the doctor to escape the cholera in New York City. (Hosack and the Bards were physicians in the city.) Wharton could actually see as far as the first hostelry in the mountains, the renowned Catskill Mountain House. "The mountain house and its piazza is perfectly distinct thro' an excellent Telescope that stands in the Hall—it is 30 miles off and to the naked eye appears like a white spot near the summit of the most easterly mountain."[37]

[37] Thomas K. Wharton, "Private Journal," May 1830—October 1834, I, Manuscript Room, New York Public Library, n.p.

55

6. *Catskill Mountain House from Hyde Park Estate Beach, with Esopus Island and the tempietto on Bard Rock to the right. The careful balance of features in a basin shows it to be an early Hudson Valley view (New York Public Library).*

Looking upriver from Crystal Cove at the southern foot of the estate, Wharton showed the "white spot" in a sketch as a tiny rectangle (Fig. 6) just above the smoke of a steamboat lashed between barges. Above the heads of the three spectators was Esopus Island, and to the north on the nether shore the tempietto on the flat surface of Bard Rock indicated the upper end of the Hosack estate. The view was an exercise in setting out and tying together landscape features from a beach to make a composition, just as was done from the plateau above.

It is not the synthesis of prints and drawings, however, but today's contour maps that reveal that this terrace is not only handsomely elevated, but also considerably back from the river. Behind it is another, more gradual, drop into the secondary valley of Crum Elbow Creek, with its artificial waterfalls. Striving to take dramatic advantage of this configuration at the rear, Hosack moved the entrance avenue of his house to the left, or south, of the previously symmetrical axis so that carriages could dip down the hill from the Albany Post Road and curve rapidly up again after crossing a bridge over the creek, as still happens today. The barns and farm proper were kept back across the Post Road, inland to the east. This exclusion of the support buildings from the plateau left the latter more uninterrupted as a "pleasure ground."

Harriet Martineau, the English author, re-

garded the plateau as a "natural terrace, overhanging one of the sweetest reaches of the river; and, though broad and straight at the top, not square and formal, like an artificial embankment, but undulating, sloping, and sweeping between the ridge and the river."[38] She saw that because the wide slope down to the river had mounds and was carpeted with turf, it tempted grown people, "who happen to have the spirits of children, to run up and down the slopes, and play hide-and-seek in the hollows. Whatever we might be talking of as we paced the terrace, I felt a perpetual inclination to start off for play."[39] But superimposed on these all-absorbing indulgences in elemental earth forms was a supposedly sophisticated type of landscape gardening, and that too fascinated many people, among them A. J. Downing. In the first edition of his *Treatise on the Theory and Practise of Landscape Gardening*, he cited Hyde Park as "one of the finest specimens of the modern style of Landscape Gardening in America. . . . The plans for laying out the grounds were furnished by Parmentier, and architects from New York were employed in designing and erecting the buildings. For a long time, this was the finest seat in America."[40]

André Parmentier is said to have worked on the grounds between 1827 and 1828, and to have been the founder of the "natural" or "modern" style of landscape gardening in the United States.[41] A Belgian-educated descendant of a long line of gardeners who served the French king and nobility,[42] Parmentier's informal, asymmetrical, and picturesque style appeared almost as a sympathetic reaction to the French Revolution, insofar as he referred to the "rights" of nature. He declared that the old system, the ancient landscape regime, was "ridiculous" and "ruinous," presumably the language one would apply to the French aristocracy. His more roving and rule-free way of planting, of which no trace now exists, was to take advantage of the spread of the large plateau. His frequent allusion to freedom brought him close to the prejudices of the American Revolution, also. His claim that he was a tireless seeker of improvement and change, along with his use of the term "modern style," undoubtedly enlisted the intellectual support of New Yorkers at the time. "The modern style presents to you a constant change of scene, perfectly in accordance with the desires of a man who loves, as he continues his walk, to have new objects laid

[38] Harriet Martineau, *Retrospect of Western Travel* (London: Saunders and Otley, 1838), I, pp. 74-80, and *Society in America* (New York: Harper & Brothers, 1838), p. 309. See also Roland Van Zandt, *Chronicles of the Hudson* (New Brunswick, N.J.: Rutgers University Press, 1971), pp. 194-220, for the travels of Fanny Kemble, Martineau, and others.

[39] Martineau, *Retrospect*, I, pp. 54, 74-75.

[40] A. J. Downing (New York: George P. Putnam, 1841), p. 22.

[41] The earliest recognition of Parmentier in recent times is in Joel E. Spingarn, "Henry Winthrop Sargent and the Early History of Landscape Gardening

and Ornamental Horticulture in Dutchess County, New York," *Year Book of the Dutchess County Historical Society*, 1937, 22, pp. 38-42, although Helen Wilkinson Reynolds in "The Story of Hyde Park: Its Connection with the Medical Profession and the Science of Horticulture," *Year Book of the Dutchess County Historical Society*, 1928, 13, p. 28, mentions him. Some caution is advisable in ascribing the entire character of the estate to Parmentier. A visitor of 1831 speaks of a Mr. Hobbs, an English gardener, as being in charge of the grounds the year after Parmentier is supposed to have completed his work. A. Gordon, "Notices of Some of the Principal Nurseries and Private Gardens in the United States of America," *The Gardener's Magazine and Register of Rural and Domestic Improvement*, E. C. Loudon ed., June 1832, p. 282. Samuel Bard, Jr., also wrote his father, the earlier owner, in April and June of 1764 from Edinburgh, where he was studying medicine, about the new book of the Scot, Lord Kames (who so influenced Jefferson), and the need for modesty and informality in the design of grounds. Charles W. Snell, "History of Hyde Park Estate: 1705-1894," *The Hyde Park Historian*, chap. One, no. 25, January 1956, n.p.

[42] C. Stuart Gager, "André Parmentier," *Brooklyn Botanic Garden Record*, 15, January 1926, pp. 12-13.

open to his view," Parmentier wrote as he was about to undertake Hyde Park, adding, "Gardens are now treated like landscapes, the charms of which are not to be improved by any rules of art."[43] This loosening, expanding attitude was prophetic of the eventual artistic fate of the whole Hudson Valley.

However, the situation left something to be desired architectonically. The dwelling was too exposed and wanting in picturesque qualities. Fanny Kemble, the English actress, noticed on her travels of 1832-1833 that "the situation of the house, on the edge of the ridge, appeared to me, from the river, rather too much exposed."[44] Martineau felt in 1835 that the house was nondescript, but the topography fascinating.[45]

Dr. Samuel Bard had originally built, upon the present site of the Vanderbilt Mansion, a Federal house with a gable roof and a prominent central pavilion. There was a Palladian window over the front door and a fanlight in the pediment of the pavilion, with porches at the sides of the house.[46] These features, together with the more generous proportions, identified the late, 1795, date. In 1829 Hosack commissioned Martin E. Thompson of New York City to rework and enlarge the former Bard home,[47] resulting in the house which Kemble and Marti-

neau saw. But it was to be even more impersonal than the Federal house it overlaid. In 1845 it burned.

The restraint and conventionality of this architectural design was compensated for by the pristine beauty of the plateau and the increased desire for growing things in a free way upon it. Hosack shared an interest in the New York State agricultural movement, along with Downing.[48] He had sent in 1806 a catalog of his plants to Jefferson, and corresponded intermittently with the president until the latter's death. Parmentier founded his own botanical garden in Brooklyn in 1825. That he was more than the faded ghost he has become since is indicated by Downing's statements that "We consider M. Parmentier's labours and example as having effected, directly, far more landscape gardening in America, than those of any other individual whatever."[49] Hosack urged Parmentier to take the superintendency of the Elgin Botanic Garden (on the present site of Rockefeller Center), which Hosack had founded in 1801. Hosack, besides being a doctor, had been a professor of botany, beginning in 1797, at Columbia College. Landscape gardening at this moment was largely the result of esthetic motivation in the cause of a new country, but it also depended heav-

[43] A. Parmentier, "Landscape and Picturesque Gardens," *The New American Gardener*, Thomas G. Fessenden ed. (Boston: J. B. Russell, 1828), pp. 184-185.

[44] *Journal* (London: John Murray, 1835), II, p. 233.

[45] Martineau, *Retrospect*, I, p. 74. Another good description of the estate from the river is in *New York State Tourist: Descriptive of the Scenery of the Hudson, Mohawk, & St. Lawrence Rivers* (New York: A. T. Goodrich, 1842), pp. 33-34.

[46] Illustrated in J. Brett Langstaff, *Dr. Bard of Hyde Park* (New York: E. P. Dutton & Co., 1942), opp. p. 198. The original drawing is in the New York Public Library.

[47] Claire Klein Feins, "Dr. David Hosack at Hyde Park: A Report for the Vanderbilt Mansion National Historic Site, at Hyde Park," unpublished typescript,

Vanderbilt Mansion, Hyde Park, N.Y., 1951, p. 3. See also Talbot Hamlin, *Greek Revival Architecture in America* (New York: Dover Publications, 1944), p. 260. An elevation is in the Avery Library of Columbia University, signed by Alexander Davis, already in the office of Town and Thompson, to become Town and Davis.

[48] Hosack and Downing in the larger agricultural picture of the state are discussed in U. P. Hedrick, *A History of Agriculture in the State of New York* (Geneva, N.Y.: State Agricultural Society, 1933), pp. 380-404.

[49] Downing, *Treatise* (1841 ed.), p. 41. Downing expressed a similar estimate of Parmentier in "Notices on the State and Progress of Horticulture in the United States," *The Magazine of Horticulture, Botany, and All Useful Discoveries and Improvements in Rural Affairs*, C. M. Hovey ed., 3, January 1837, p. 4.

ily upon the rising sciences of horticulture, arborculture, and pomology. These skills were looked upon also as important parts of the future armament of the republic. Nevertheless, Hosack wanted to take advantage of his wealth, knowledge, and professionalism to draw him apart from political affairs. When asked to run for public office, he declined, replying, "If a party could be formed favourable to the interests of *education*, of *agriculture*, and the *commercial* character of our state; to the development of its natural resources and promotion of internal improvements; to such a party I could not hesitate to avow my allegiance and to devote the best exertions of which I am capable . . . but under existing dissensions, I must decline all connexion with our political institutions, and devote myself to the cultivation of the vine and fig-tree, as more conducive to my own happiness and that of my family."[50] In Hosack can be witnessed the wedge driven between the arena of political action and the withdrawing, private personality of wealth. Individualism and the isolation of the family were being fostered by the wealth in the Hudson Valley. However, another wealthy figure, later brought up in this little village, which took its name from the Hosack estate, was able to recombine an interest in arborculture, Hudson River scenery, architecture, the history of the valley and state, and national and international politics, however much he may have wanted at one time to remain a local squire, especially after a debilitating illness.[51] His name was Franklin Roosevelt.

[50] As quoted in Freeman Hunt, *Letters about the Hudson River and Its Vicinity, Written in 1835-37* (New York: Freeman Hunt & Co., 1837), p. 160.

[51] This important issue of the individual or family versus the public weal is dealt with in books like Jan Lewis, *The Pursuit of Happiness: Family and Values in Jefferson's Virginia* (Cambridge: Cambridge University Press, 1983), or Richard Sennett, *The Fall of Public Man* (New York: Knopf, 1977).

EARLY LITERARY ESTATES

Sunnyside, Tarrytown, Washington Irving House, George Harvey, 1835. Literary estates represent the next stylistic phase of the evolution, accompanied by an even greater emphasis upon the idiosyncrasies and ideals of each owner. They also illustrate the trend toward making the artist or writer into the model citizen. Washington Irving's Sunnyside holds a special position in this lineage because it reflects its owner's very strong personal preferences. Hosack's estate contained seven hundred acres; Sunnyside had only twenty-four at its maximum size, "and yet so varied is their surface, so richly wooded and flowered, and so full of elfish winding paths and grassy lanes, exploring hillsides and chasing merry brooks, that their numbers seem to be countless."[52] On this more concentrated spot was a stream running through a cloistered vale (Fig. 7), interrupted by an artificially dammed pond, which Irving called his "Little Mediterranean," from whence it continued down to the Hudson. The topographical sequence was, in effect, an inward-looking and minorsized version of the Hudson Valley itself.

The house faced south to the stream rather than west toward the Hudson River. It had been built in 1656 as part of the Philipsburg Manor, burned in the Revolution by the British, rebuilt after the war (Fig. 8), and finally remodeled by George Harvey, with assistance from Irving, after the latter had purchased the farmhouse in 1835 (Fig. 9). Like Jefferson at Monticello, or Wright at Taliesin, Irving had played in this vicinity as a child: "I thank God that I was born on the banks of the Hudson, for I fancy I can trace much that is good and pleasant in my

[52] T. Addison Richards, "Sunnyside—the Home of Washington Irving," *Harper's New Monthly Magazine*, XIV, LXXIX, December 1856, p. 9.

7. *"The Mediterranean Sea," Ornamental Pool of Washington Irving at Sunnyside, Tarrytown, New York* (*Benson J. Lossing*, The Hudson).

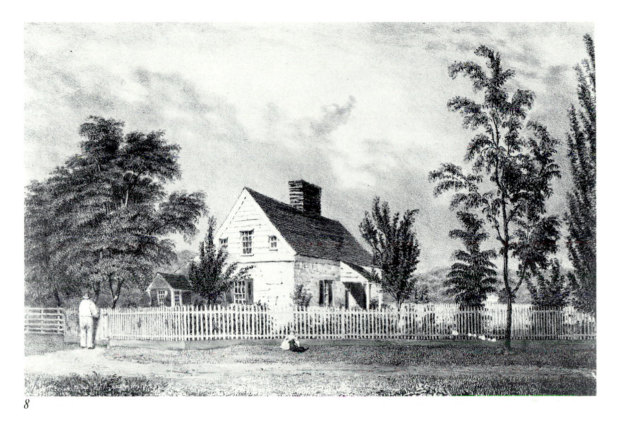

8

9

8. *Van Tassel Cottage, later Sunnyside, Tarrytown, New York (New York Public Library).*

9. *Van Tassel Cottage, Sunnyside, from a painting by George Harvey, the readapting architect, after the purchase by Washington Irving in 1835 (New York Public Library).*

heterogeneous compound to my early companionship with this glorious river."[53]

Franklin Roosevelt had noticed that "often these houses of the Hudson Valley [Dutch] are found in cosy places, back from the highway, down below a hill, far from a neighbor, snuggling as it were into a perfect landscape-setting and happy in their isolation."[54]

[53] As quoted in Wallace Bruce, *Along the Hudson with Washington Irving* (Poughkeepsie, N.Y.: A. V. Haight Co., 1913), p. 6. Joseph T. Butler says in *Washington Irving's Sunnyside* (Tarrytown, N.Y.: Sleepy Hollow Restorations, 1974), p. 32, that Irving, in trying to escape a yellow fever epidemic in New York City in 1798, first saw the property he was to buy as a guest of the Paulding family. Another literary estate of prominence would be Placentia, just above Hyde Park Estate, belonging to James K. Paulding, the author of *Dutchman's Fireside* and *Westward Ho!*, who was the particular friend Irving came to visit in Tarrytown in 1798.

[54] Helen Wilkinson Reynolds, *Dutch Houses in the Hudson Valley Before 1776* (New York: Payson and Clarke, Ltd., 1929), Introduction by Franklin Roosevelt, p. 2.

Harvey, too, recognized this tendency, saying that Irving's house was as "quiet and sheltered a nook as the heart of a man could require in which to take refuge from the cares and troubles of the world, and as such it had been chosen in old times."[55] Harvey was then working on his series of paintings *Atmospheric Landscapes of North America*, in which a similar innocence and quiet musing could be discerned. The new American mood of gentleness and whimsy was imposing itself, along with the need to escape into fantasy. By 1851, Harvey reported that the house was becoming so shut in by trees "as to prevent its being seen from the river."[56] By 1879, Martha Lamb remarked, "Sunnyside lies hidden with jealous foliage, its open sunlit lawn so affectionately embraced by protecting trees and shrubbery as to deny all vagrant observation."[57]

Seclusion and reticence at the site, yet the house itself appeared within it as a conceit, just the opposite of the relationship of the plainer, more eighteenth-century, house to the more picturesque outlook at Hyde Park. It was dedicated to uniquely personal details, "embellishments," Downing preferred to call them. The stucco of Harvey and Irving's transformation was applied over the rough masonry and weatherboarding of the old house like the application of fresh sheets of paper, readied for new literary inscriptions. The thin, crow-stepped gable on the southern entrance porch emulated that on the old Vanderheyden Palace in Albany. The wiry silhouettes of a trotting horse, a rooster, and a pennant on weather vanes, and the upright, cylindrical flues of the "tudor" chimneys, in rows of three on the narrow ridges, contrasted with the solid taciturnity of the original folk house beneath.

It seemed as if Irving wanted to hide himself within the past, as in nature among trees, but also to bring history alive again in his own way. His equivalent in such an enterprise was, of course, his friend Nathaniel Hawthorne. In *The House of Seven Gables*, Hawthorne described the Salem dwelling unauthentically: "Its whole visible exterior was ornamented with quaint figures, conceived in the grotesqueness of a Gothic fancy, and drawn or stamped in the glittering plaster, composed of lime, pebbles, and bits of glass, with which the woodwork of the walls was overspread."[58] Actually, the House of Seven Gables never had plaster or English pargetting on it but was always covered with dark, narrow weatherboards. The true vernacular features of the seventeenth century were simply inadequate to the quickened visions of these two authors. "Superior" modern knowledge brought the confidence to state everything more didactically and evocatively.

Idlewild, home of Nathan P. Willis, Calvert Vaux, 1852-1853. The Highlands, site of Willis' Idlewild, represent the most theatrical mountain scenery up to the Catskills, forty miles north. They are not high, 1,400 or 1,500 feet, but they drop directly to the river.[59] Having the necessary terraces to build upon, either within the mountains or immediately adjoining them, they allowed for an unusual conjunction of dramatic elements. A lithograph of the Highland Gate from Fort Putnam of 1859 (Fig. 10) and an

[55] George Harvey, *Illustrations of Our Country* (Boston: Dutton & Wentworth, 1851), p. 29. See also Donald A. Shelly, "George Harvey and His Atmospheric Landscapes of North America," *The New-York Historical Society Quarterly*, XXXIII, 2, April 1948, p. 104. Richards, "Sunnyside," pp. 1-21, has numerous pictures of the grounds by the author.

[56] Harvey, *Illustrations*, p. 29.

[57] Martha J. Lamb, *The Homes of America* (New York: D. Appleton & Co., 1879), p. 152.

[58] (Boston: Houghton Mifflin, 1941), p. 24.

[59] For the explanation of convergence of a number of natural features, including in the Hudson Valley, see Shepard, "The Cross Valley Syndrome," pp. 4-8.

10. The Highland Gate from Fort Putnam, B. G. Stone, 1859. Mt. Taurus of George Morris and Cold Spring are visible on the farther side. Nathan P. Willis lived behind the mountain to the left (New York Public Library).

aquatint of the same scene of only a half century earlier (Fig. 11) reveal what the surge of romanticism rapidly brought to the reinterpretation of hills in relation to valleys. The 1802 aquatint is set on a comparatively airless stage with a vanishing-point perspective and an even illumination into the distant view. Isolated, cardboardlike mountains are rolled in at intervals from each side, like eighteenth-century theatrical flats. By contrast, the Fort Putnam lithograph is filled with a binding atmosphere, a greater scale, and much more detail. The hills become molded sculptures in their own right. An eagle hovers in the foreground on the updraft. Cloud shadows race each other fitfully across the surface of forest and meadow, with a shower over Mt. Taurus on the eastern shore. This radically altered perception of the American scene amounted to an enlarging awareness of a more diverse occupation of space, following the constant turning of the river instead of vanishing-point perspective; to the closer identification of a variety of landscape features; and to an increasing sensitivity to light and shade as modulated by atmosphere, later to be called "luminism" in painting.

Just around the bend from Fort Putnam is Cornwall, where the consumptive Willis, a refugee from the east wind and salt air of Boston, had settled to recover his health. This enterprising Yankee, who was portrayed in *Washington Irving and His Literary*

63

11. The Highland Gate from Chamber's Creek, Francis Jukes, 1802 (New York Public Library).

Friends at Sunnyside, and who was to be buried at Mt. Auburn Cemetery in Cambridge, had found his health resort and Neo-Puritan New Canaan simultaneously. "I have passed a whole winter on this Highland Terrace, daily on horseback, and riding constantly over its ten-mile surface [up to Newburgh], without once feeling anything like the depressing and searching east wind so poisonously uncomfortable at Boston. This information may be of use to invalids."[60] Typical of the consumptive, Willis had a feverish appreciation of beauty, but he never became despairing or melancholy because of his in-

tense pleasure in the act of observation. He was determined in his writing to compensate for the American inability to conceive and bring forth an ideal visual beauty.[61] The site Willis picked for his house (Fig. 12) was on a terrace looking toward a bend in the river and Storm King Mountain from the front, and into a hemlock-shaded vale at the back. The promontory was part of the much larger tableland running up to Newburgh. He and his family spent the summer of 1850 in a nearby farmhouse, becoming so enchanted with the environs that they bought fifty acres near the entrance of Moodna Creek

[60] Willis, *Outdoors at Idlewild*, p. 52.

[61] As quoted in Lewis Beach, *Cornwall* (Newburgh, N.Y.: E. M. Ruttenber & Son, 1873), p. 88.

and built a villa which they moved into in the summer of 1853.[62] In this act of appropriation lies further evidence of the general cultural progression of the Hudson Valley from humble boarding farmhouse in the backland to prominent private villa on a terrace above the river.

Willis called his vale a "glen." In reality it was a wild ravine, two hundred feet deep, crossed on fallen trees above seasonal rapids and cascades. The site was developed by identifying its every feature, which Willis orchestrated like "a wise man's inner life illustrated and set to music." He wished to make of it "a close remoteness,"[63] to furnish outdoor improvements "as obvious as they are almost numberless—charming paths that might be cut, precipices and waterfalls that might terminate vistas, terraces that might be turned into glades and lawns, chasms that might be romantically bridged, and rapids that should be seen from eminences."[64]

Because he had been told that his land had no practical value, Willis named his estate "Idlewild."[65] His determination to exploit the esthetic diversity of his wasteland caused some discomfort for Calvert Vaux, Downing's architectural partner, following Davis. Willis asked Vaux, who lived in the vicinity, to furnish plans for the Neo-Gothic house (Fig. 13), but he was not allowed to follow up with working drawings, nor to superintend construction. Vaux therefore had understandably mixed reactions to the final result: "When the building had been entirely erected on paper, and before the foundations were laid, all the lines of the plan were set

12. *Idlewild, Home of Nathan P. Willis (now destroyed), 1852 (Lossing, The Hudson).*

13. *Idlewild, typically Downingesque. Willis liked evergreens close to his house, Vaux and Willis (Vaux, Villas and Cottages).*

[62] Henry A. Beers, *Nathaniel Parker Willis* (Boston: Houghton, Mifflin & Co., 1885), pp. 326-327.

[63] Lamb, *Homes of America*, p. 165.

[64] Beach, *Cornwall*, pp. 88-89.

[65] T. Addison Richards, "Idlewild, The Home of N. P. Willis," *Harper's New Monthly Magazine*, XVI, 92, January 1858, p. 146. Also E. M. Ruttenber and L. H. Clark, *History of Orange County*, New York (Philadelphia: Everts and Peck, 1881), p. 779.

out under the special direction of Mr. Willis, who seemed to take more interest in accommodating the house to the fancies of the genius of the place than in any other part of the arrangements."[66] The alacrity of Willis' response to the surrounds weakened the integrity of his house plan, according to Vaux. Nevertheless, Vaux recognized the tack taken by Willis as a sincere step toward a domestic architecture of environmental sensibility and worth. "High up among the trees, and apparently on the very edge of a precipitous ascent, it seems to peer over the topmost branches of the dark pines, and to command the whole valley below. . . . We sometimes hear a regret that the shores of the Hudson are deficient in interesting buildings, and that they lack the poetic associations that cling to the Rhine, with its thousand picturesque old ruins. This is perhaps true; but if so, it might easily be remedied, if the poetic spirit were encouraged to be active in the *life*, and not passively dependent on the *memory*, for picturesque and artistic beauty belong to whoever can realize them."[67] Vaux, an Englishman, was betting upon the supposed American capacity to improvise, once a suitable enough image, like that of the Rhine Valley, was put before it.

In some respects, as Vaux readily perceived, Idlewild was a major expression of a minor and amateur personality, but because of the extraordinary range of action and interest permitted by the era, Willis could hardly miss with the public, to whom he likewise represented a peculiarly American type—the action-oriented, homespun, *ad hoc* philosopher, interested in the immediate, but somehow giving the environment further meaning at the same moment. "Mr. Willis has ever been a greater reader of the world around him—its physical beauty, its feeling

and action—than of musty tomes. He prefers black eyes to black letter, and makes daily life his library and teacher."[68] (Downing's penetrating "black eyes" were also legendary in the valley.)

Undercliff, home of George P. Morris, 1833-1835. Across the Hudson at the Highlands, to the north of Cold Spring village, was the Undercliff estate—"The Gem of the Hudson River," according to Willis—whose owner, Gen. George P. Morris, was closely associated with him in publishing the *New Mirror* and the *Home Journal*. The house, built on a plateau by John C. Hamilton, son and biographer of Alexander Hamilton, was a white, foursquare Greek apparition like Ezra Prentice's Mount Hope estate near Albany of the same decade. But the grounds at Undercliff were conceived in a more unified, self-conscious, and sequential manner. Morris was even said to have had a plan on paper for the grounds.

On the north, Mt. Taurus, employed in Irving's story of Dolph Heyliger to roll back the thunder of the Highlands, protected the house from the wintry blasts. It appears as a dark backdrop in the illustration by Bartlett (Fig. 14) following Willis' description: "UNDERCLIFF" . . . is situated upon an elevated plateau, rising from the eastern shore of the river; and the selection of such a commanding and beautiful position at once decides the taste of its intellectual proprietor. . . . In front, a circle of greensward is refreshed by a fountain in the center, gushing from a Grecian vase, and encircled by ornamental shrubbery; from thence a gravelled walk winds down a gentle declivity to a second plateau, and again descends to the entrance of the carriage road, which leads upwards along the left slope of the hill, through a noble forest, the growth of many years, until

[66] Calvert Vaux, *Villas and Cottages* (New York: Harper & Brothers, 1857), p. 248.

[67] Ibid., p. 249.

[68] Richards, "Idlewild," p. 146.

14. Undercliff, near Cold Spring, the seat of General Morris, 1833-1835, drawn by William Bartlett, 1840 (Willis, American Scenery Illustrated).

suddenly emerging from its sombre shades, the visiter beholds the mansion before him in the bright blaze of day."[69] There were three apertures cut from the house through the forest, to be especially noticed when the waters sparkled in the sunlight, just as the house was suddenly seen in the sunshine when one emerged from the darker woods below it. One vista aimed southwest toward West Point, one immediately south toward Cold Spring, and the third (Fig. 15) toward

[69] Willis, *American Scenery Illustrated*, II, p. 19. For further information on Undercliff and Mt. Taurus, see T. Addison Richards, *Appleton's Illustrated Hand-Book of American Travel* (New York: D. Appleton & Co., 1857), p. 130; Beach, *Cornwall*, p. 85; and Wallace Bruce, *The Hudson* (New York: Bryant Union Co., 1913), p. 99.

15. Undercliff, with vista to the northwest toward Idlewild (Lossing, The Hudson).

the northwest and Cornwall, Willis' village, on the Newburgh basin.

Despite Willis' assertion that the "noble forest" of Undercliff was a "growth of many years" in order to obtain "ancient" status for it, its creation seems to have been rather accidental, and fairly recent. Morris had hired the former gardener of an English earl to tend it, but to his chagrin, the gardener's repertoire consisted mostly of the indiscriminate cutting of trees. Fortunately, the loss was largely of expendable cedars. Conceding this, Morris gave orders that they be replaced by more desirable varieties, such as oaks, chestnuts, and maples.[70] This broader choice of trees and shrubs, joined with the three vistas, gave a premonition of Downing's more sophisticated effects. Some believed that the traumatic experience with the erstwhile gardener resulted in Morris' song, "Woodman, Spare that Tree," which became a popular success and an influence on conservation efforts.

Willis was anxious to add dignity and respectability to the geological wonders of the Highlands, so he changed the pedestrian-sounding Butter Hill (Boter Berg in Dutch), a mile to the south of Idlewild and across from Undercliff, to the majestic Storm King.[71] Around it and Cro'-Nest, a little farther to the south, and Mt. Taurus (before Willis' intervention, Bull Hill) across the river, electrical storms reverberated as in no other spot on the river. The crash of these metaphorical cymbals, when joined with the flare of lightning, brought nature that much closer (Fig. 16): "And now we are within the gates of the Highlands themselves, in the presence of the Great Storm-King and the dark pile of the Cro'-Nest. . . . Under the frown of a low thunder-cloud they take on a grim majesty that makes their black masses strangely threatening and weird; one forgets to measure their height [for an American a serious omission], and their massive, strongly-marked features by any common standard of every-day measurement, and they seem to tower and overshadow all the scenes around them, like the very rulers and controllers of the coming storm. And when the sunlight comes back again, they seem to have brought it, and to look down with a bright benignity, like giant protectors of the valley that lies below."[72] Americans particularly appreciated mountains for their monumental sense of fixity, bulk, and strength, and the opportunity to get near them, as we shall see also in the case of Mt. Hood, all white instead of dark and brooding, as here. In both instances monoliths were located in the midst of premier settings, making the effect of the mountains maximal—equaling a fair dominance of surrounding harmony.

LATER PAINTERS' ESTATES

Malkasten or Hawksrest, Bierstadt House, Irvington-on-Hudson, J. Wrey Mould, 1866-1867, destroyed by fire, 1882. From the artist Bierstadt's house (Fig. 17), named Malkasten after the arts club he frequented as a student in Düsseldorf, Germany, it was possible to see Irving's Sunnyside, which Bierstadt painted in the now-lost *Home of Irving.*[73] "It was because of his conviction that the patient and faithful study of nature is the only adequate school of landscape art that Bierstadt, like Cole and Church, fixed his abode on the banks of the Hudson." At the same time Bierstadt's house was "within convenient access to New York, and in the midst

[70] Hunt, *Letters about the Hudson River,* pp. 107-108. Hunt knew Downing, as per the Preface. See also Marguerite W. Rogers and Nelson De Lanoy, *George Pope Morris 1802-1864* (Cold Spring, N.Y.: privately printed, 1964), pp. 4-5, and *Morris of Undercliff* (Cold Spring, N.Y.: David M. Reilly, 1964), p. 5.

[71] Willis, *Outdoors at Idlewild,* p. 188.

[72] William Cullen Bryant ed., *Picturesque America* (New York: D. Appleton & Co., 1873), I, 2, p. 7.

[73] Lamb, *Homes of America,* p. 151.

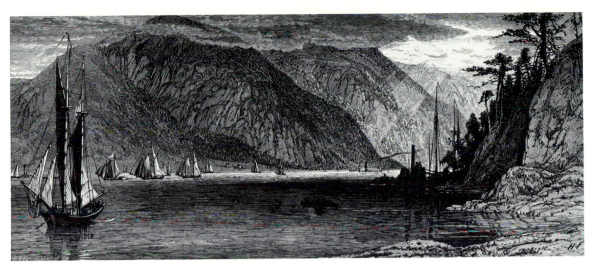

16. Cro'-Nest and Storm King under a Thunder Cloud, but with a Shaft of Light. Besides as unique objects, Americans liked mountains as signs of triumphant strength and stability, permanence and monumentality (William Cullen Bryant, Picturesque America).

of a genial and cultivated neighborhood."[74] However, the site was more withdrawn from the river, like the later estate of Olana belonging to Frederic Church, farther north and across from Catskill. A greater distance from the water was characteristic of this last category of estate.

Bierstadt organized the interior of his home much as Irving had arranged the exterior of his, by means of a series of asides that had less to do with the house as a home than with a new and larger esthetic territory. According to Bierstadt it was "erected to suit all the possible requirements of an artist."[75] These would include setting up canvases as large as forty feet wide and thirty-eight feet high, and viewing them from distances within the house. What had happened chronically in the Hudson Valley itself, the measured step back, now occurred inside a specially designed dwelling. Bierstadt wanted, as much as Willis had in the plan of Idlewild, to keep in intimate touch with na-

ture, and he was inordinately proud that the building stone had come from his own earth and that he had chosen the precise location of the house by walking slowly over his own ground. As a New Englander, Church knew of Boston's reputation as the moral and intellectual "Hub of the Universe"; he facetiously called Olana "The Center of the World." Nevertheless, the architectural styles for this centripetality became vaguer and more diffuse as time passed. Bierstadt declared that his house was "of no particular style of architecture,"[76] while Church reported that his was "Persian, adapted to the occident."[77] The actual tension was between the desire to interpret the valley landscape (and eventually the world beyond) and the strain of accomplishing that, when there was no tacit agreement as to what the Hudson landscape actually meant, especially as the awareness of its dimensions expanded. For

[74] Tuckerman, *Book of the Artists*, p. 396.
[75] *New York Sun*, November 11, 1882.

[76] Ibid.
[77] David C. Huntington, *The Landscapes of Frederic Edwin Church* (New York: George Braziller, 1966), p. 114.

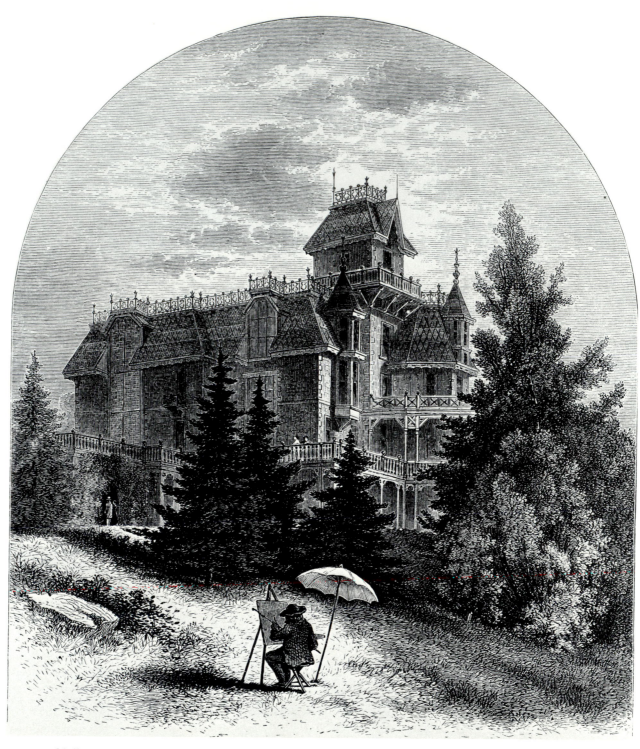

17. *Malkasten, residence of Albert Bierstadt, Irvington-on-Hudson, J. Wrey Mould, 1866-1867, destroyed by fire, 1882. The artificial terraces and big studio windows are especially noteworthy (Martha Lamb,* Art Journal, *1876).*

instance, in Bierstadt's San Francisco studio another specially constructed house threw off older canons of style entirely in order to gather in a newer and fuller horizon: "The studio wherein [pictures were] finished is a tall, slight frame house, especially built for him on the very top of Clay-street hill, and about 300 feet above sea level. This house, with its windows opening in every quarter, commands a magnificent view of the city below, and of the Bay, from the Golden Gate in the west to Mount Diablo in the east, including the whole sweep of its varied shore lines and studding islands. . . . The large window—as big as the side of the house—which gives him the north light painters always want, commands at one glance a view of the whole passage from the Pacific Ocean to the inner Bay, with the peninsular and Marin county shores including Mount Tamalpais, a distance of six or seven miles. . . . Turning from the large [window]—which we may call a perpendicular skylight—and from the beautiful nature-picture it reveals, the visitor to Mr. Bierstadt's unique atelier sees on a canvass the picture produced by his art."[78] The painting alone would be a final magic formula with which to gather in and encapsulate the surrounding landscape.

At Irvington-on-Hudson this same manipulative principle was used within a less awesome scenic spread, but with a more grandiose shaping of the house itself: "A noble room—this studio comprises three stories in height, starting from the second floor; on the same floor is a library, separated by doors twenty feet high, curtained with *portières* of striped Algerian stuff. One side of this room is composed entirely of glass. When thrown together, library and studio, a space seventy feet in length is gained. The studio is fitted with oiled pine-floors and woodwork; a large fireplace, surmounted by a picture, adds dig-

nity and cheerfulness to one side of the room while a gallery running across one end enables Mr. Bierstadt to gain distant views of his own pictures."[79] Artificial vantage points were sought by means of interior stairs, balconies, and specially constructed corner viewing closets, ten feet high.[80] Porches and terraces also echoed the natural terraces ubiquitous in the valley: "being built into a hill, one can step from every story on to *terra firma*; from a contemplation of celestial scenery in the second story, from a view which one observer described as being like that from a balloon."[81] The house was "at once picturesque, unusual, and sincere."

Olana, Estate of Frederic Church, opposite Catskill, Vaux, Withers, and Church, 1870-1874, Studio Wing added 1888-1891. Olana is on a hill, five hundred feet above, and, like Malkasten, three quarters of a mile from the river. Although the estate had become territorial, the central fact remained the house itself (Fig. 18). "Church may well have had at the back of his mind the image of *The Parthenon*, which he was painting while he was building his Hudson acropolis."[82] However, Church had journeyed to South America in 1853, and again in 1857. In 1868 he traveled in the Near East (passing quickly through Europe), from which came the inspiration for his "Persian" home. His solution to chronic American restiveness was found on these travels, for he reported, "I like *wood* for

[78] As quoted in George Hendricks, "The First Three Western Journeys of Albert Bierstadt," *The Art Bulletin*, XLVI, 3, September 1964, p. 351.

[79] Martha Lamb, *The Art Journal of 1876* (New York: D. Appleton & Co., 1876), pp. 45-46.

[80] Jennie Black Prince, whose family rented Malkasten for four years after 1869, mentioned that the studio had boxes in each corner, reached by stairs, "which were built to give a more correct view of the heroic sized canvases of the painter." Gordon Hendricks, "Bierstadt's The Domes of the Yosemite," *American Art Journal*, II, 2, 1971, pp. 24-25.

[81] Lamb, *Art Journal of 1876*, pp. 45-46.

[82] David Huntington, *Landscapes of Fredric Church*, p. 119. A reporter in 1890, however, likened it to a castle on the Rhine. Frank J. Bonnelle, "In Summer Time on Olana," *Boston Sunday Herald*, September 7, 1890.

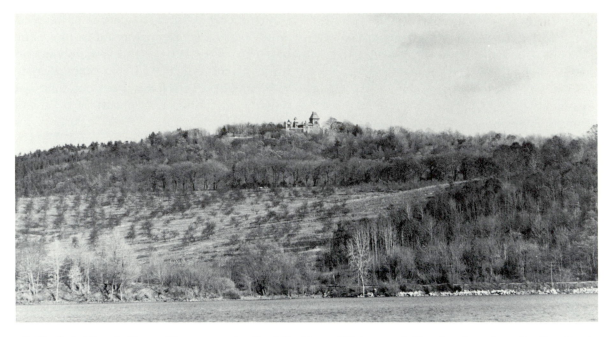

18. Frederic Church House, Olana, opposite Catskill, Vaux, Withers, and Church, 1870-1874. Studio wing by Church, 1888-1891 (W. Creese).

[architectural purposes] less and less as I grow older. The transition from solid walls and the tiled roofs of Mexico to the shingles, laths, clapboards, paint and paper of the States was painful to us. Wood is awfully convenient and cheap just now, but I suppose when our forests are swept away by axe and fire—we will use more stones—and tiles instead of shingles. The clapboard palaces will rapidly disappear."[83] For him, walls were a "first beauty."[84] At Olana they were two and a half feet thick, of bluestone and brown shale. This was as much a postwar as a personal sentiment. The Woodwards, publishing right after the Civil War, when a general need for stability was felt, made a simi-

lar plea for discarding wood in favor of more enduring stone walls.[85]

Church was to use the flat surfaces of these massive walls like canvas stretchers (Pl. 4) on which to "paint," or gently inlay, his stunning color code. This was not accomplished through picaresque details of local origin, as at Sunnyside some four decades earlier, but with an international, or at least a cosmopolitan, flavor. The underlying forms are heavily influenced by the pavilion tower and mansarded roof of the French Second Empire style, as at Malkasten, appropriate to the late 1860s and 1870s, but the color inlays produce the effect of two-dimensional abstract pictures, large and small, hung close together in a Victorian gallery. This is more readily apparent in the finished dwelling than in the proposed elevation by Calvert Vaux, which is broken into more three-dimensional pavilions. Vaux had no

[83] Letter from Church to Erastus Dow Palmer, June 5, 1884, Albany Institute of History and Art.

[84] Ibid., August 4, 1869, Albany Institute of History and Art. In a letter to W. H. Osborn from Berchtesgaden, Germany, July 29, 1868, before he had begun his house, Church wrote, "when you build, build of stone—never be tempted to build of wood." Olana Collection.

[85] Woodwards, *Country Homes*, pp. 17-18.

better luck with Church than he had had with Willis, for neither writer nor painter took many of his suggestions, and Church replied, when asked, "I made it out of my own head."[86] The upper part of the main tower is in panels of red, yellow, and painted black brick. Cornices were elaborately painted and stenciled in colors picked out with silver and gold. The roofs were covered with red, green, and black slates, "relieved by a few gilt slates."[87]

A restrained sensuality was introduced inside as well by Church, who was brought up in the Connecticut Valley, with north to south axes through the stairwell, "court" hall, and "ombra," the deeply shaded internal porch; and east to west through the vestibule, court hall, library, connecting gallery, studio, and its porch; with subaxes around the perimeter. The aiming of these rooms toward major views to the southwest and west recalls the opera glasses and tin tubes used as visual aids to examine Church's gigantic canvases when the gallery depth was too shallow in New York City. The furnishings are arranged as if in small shrines, scrupulously relating to each other, as do the panels on the outside wall. The fixity of objects is overcome by the sensitive color coding of the interiors, in which stenciling plays a large part. The court hall focuses the effect with almost all the colors in the other rooms echoed in it,[88] while the sitting room provides the most notable harmony of them. The fireplace in the sitting room is stenciled in silver and gold; the remaining colors repeat the hues of the painting over the mantelpiece, *El Khasne, Petra*, chiefly salmon (the carved stone front), brown, and gray. The fireplace front is correspondingly a salmon marble, with the window and door frames painted the same color. The walls are gray and the woodwork brown. The ceiling is a light green, opposite to salmon on the color wheel. The door and window surrounds are decorated with stencil bands containing Arabic calligraphy. The upholstery, draperies, and carpet are also related.[89]

Church faced his residence southwest, but his domain was entirely different from that of Irving's Sunnyside, which also faced south, but became miniaturized. Olana proclaims itself from the hilltop. Yet one becomes gradually aware from its terrace of the subsiding curve of the horizon, of the view slipping beyond recall. From this a fragility of prospect eventuated (Fig. 19). Certainly Church originally intended to control his vista as completely as any earlier estate owner. In 1884 he wrote to the sculptor Palmer, "I have made about 1 3/4 miles of road this season, opening entirely new and beautiful views—I can make more and better landscapes in this way than by tampering with canvas and paint in the studio."[90] In the

[86] Bonnelle, "In Summer Time on Olana," p. 17.
[87] Lamb, *Homes of America*, p. 151.
[88] Nancy Van Dolsen, "An Unending Process: Frederic E. Church and the Stencilling of Olana," July 1983, p. 3B, Olana Collection.
[89] Letter to author from James Ryan, August 22, 1983.
[90] Letter to Palmer, October 18, 1884, Albany Institute of History and Art. Peter L. Goss, "Olana— The Artist as Architect," *Antiques*, 110, 4, October 1976, p. 769, has interesting comments on the carryover of painting into landscape art, treated at greater length in his Ph.D. thesis at Ohio University of 1973, "An Investigation of Olana." See also Elizabeth Lindquist-Cocke, "Frederic Church's Stereographic Vision," *Art in America*, 61, 5, September-October 1973, pp. 70-75. Another artist who tried to create a similar balance between outside and in was Jasper Cropsey in his house at 49 Washington Avenue at Hastings-on-Hudson, still standing. It replaced in 1885 his twenty-nine-room, board-and-batten mansion, "Aladdin," near Greenwood Lake in Warwick, New York, which burned in 1909. The Hastings-on-Hudson site is high on a hill which falls away on the west and north into a ravine, with a brook running down to the Hudson. The cottage is of board and batten, three bays by one bay, the studio square and hip-roofed, with carved wooden trusses. Another studio house belonged to Jervis McEntee at Rondout, which was also designed by

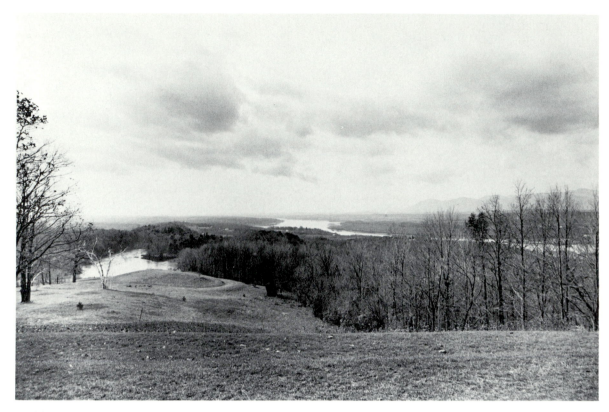

19. Meadow, artificial pond, Hudson River, and the Catskills from Olana. The ground down to the pond originally had many trees (W. Creese).

same manner, he planted trees with great enthusiasm from the start, telling a reporter in 1890, "I thought of hardly anything but planting trees, and had thousands and thousands of them set out on the southern and western slopes."[91] James Ryan has said, "Throughout the grounds maples, birches, hemlocks, chestnuts and oaks were planted singly and in clumps. In setting out these trees the color of the bark, the hue of the foliage and the shape of the tree were all considered in directing the gaze of the viewer through this 'living landscape.' The eye of the landscape painter and the landscape gardener were united at Olana."[92] Earlier photographs and literary accounts show that the trees were planted closer to the house and nearer to the roads than they appear today. Vision was indeed cut off until the last moment in the ascent.[93] The view down was through a cluster of birches and hemlocks on a knoll, which appears barren today (Fig. 19).

Had Church violated the Hudson River

Calvert Vaux, his brother-in-law. McEntee was a pupil and friend of Church. Thomas O'Sullivan, "Studios of Victorian Artists," *The Crayon*, XII, 2, Summer 1980, p. 6.

[91] Bonnelle, "In Summer Time on Olana," p. 17.

[92] James Ryan, "F. E. Church's Harmonious Work of Art: Landscape Design at Olana State Historical Site," February 1, 1982, p. 3.

[93] F. N. Zabriskie, "An Artist's Castle, and Our Ride Thereto," *The Christian Intelligencer*, September 10, 1884, p. 2, "The house is hardly seen till you are directly upon it." Caroline P. Atkinson, ed., *Letters of Susan Hale* (Boston: Marshall Jones Company, 1919), p. 251, tells in 1890 of "the dark, long drives, up our winding wood road."

rule that all scenic features must be congruent within a bowl of sufficiently limited dimensions? He was able to make only one telling gesture for pulling the distant Hudson River toward the house—by constructing a pond at the foot of the open meadow.[94] Although it covers a mere twelve acres, its location in the middle distance balances it against the mighty Hudson several miles in the background, which also looks like a two-mile lake from this location (Fig. 19). Both take maximum advantage of reflection from the sky to achieve prominence. Some of his epic canvases, such as *Cotopaxi*, *Rainy Season in the Tropics*, or *The Andes of Ecuador*, used water in the same way, as an accent to bring the untoward spaces together and the sky down, often with a minor body near a major one, in the shape of a waterfall, winding stream, or secondary pool. It was a form of landscape phrasing which, in combination with the mountains, dissolved the more rigid dimensions and suggested a fluid and transitory world.

Forewarning of difficulty with spatial management had been given in the paintings of Church's teacher Thomas Cole, who lived across the river from the site of Olana when Church studied with him. Both wanted to visualize at a larger scale. Cole's *Schroon Mountain* (Fig. 20) featured another type of compelling abstraction besides its tiny pool. For an American then, a mountain was even more primary. The peak looks taller and more apical than any Hudson Valley mountain, drawing off interest from the local to the national scene, because its reference is to the future and the West, which Cole could not yet see or understand. "Cole's mountain is more rugged than any he could have found in the East, but this admission of the 'nervous rocky West' serves the image of space and reflects, in an otherwise realistic picture, an awareness of the totality of this American experience."[95] But of course Cole cannot "know" that totality yet, so repose is fruitlessly interrupted in the old Hudson Valley bowl or cradle. The composition is founded on shifting earth planes and the implication of further adventure, with restless diagonals held in tenuous symmetry by only four blasted trees. The image stretches apart. The structuring is familiar, but the total impression is strangely different. We have only to recompare the aquatint of Chambers Creek of 1802 (Fig. 11) to realize how markedly perceptions had changed in a little over three decades. The solid, horizontal stage dissolved underfoot, and the desire to sculpt the mountain led to a manneristic manipulation. Human figures were removed to make for a total wilderness.

THE NEWBURGH BASIN AND DOWNING'S HOME

The spectacle of abundance in Nicholas Biddle's certificate of membership in the Horticultural Association of the Hudson Valley of 1839 (Fig. 21) revealed another, more intact, Hudson Valley bowl. This honorary mem-

[94] There is a tradition that Olmsted designed the grounds of Olana. Olmsted and Church were fourth cousins and both came from Hartford. Olmsted and Vaux saw to it that Church was named a commissioner of Central Park in 1871. Both planted trees in great numbers. In an addendum to his "F. E. Church's Harmonious Work of Art," Ryan has shown that the tradition probably derived from a check of January 7, 1873, to Olmsted, Vaux & Company from Church for $235.72. Ryan believes this is a final payment for Vaux's architectural work on the house, rather than any landscape work by Olmsted, since it is endorsed by Vaux. Ryan puts more emphasis on the Englishman Charles Smith's book *Landscape Gardening* (New York: C. M. Saxton and Company, 1853) as a source for Church's landscape schemes, since it was in the latter's library, and takes up all the problems which had to be handled, such as making an artificial pond, winding roads, planting trees, and the siting of a house.

[95] John W. McCoubrey, *American Tradition in Painting* (New York: George Braziller, 1963), p. 27.

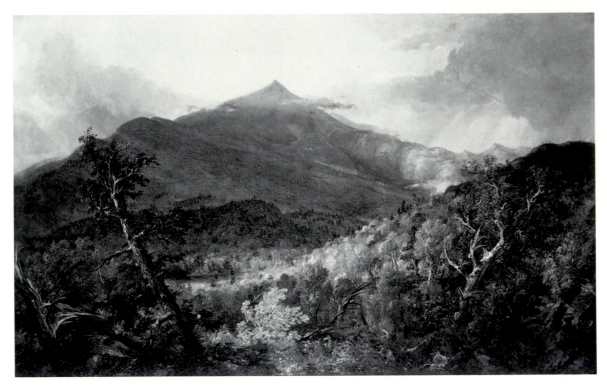

20. Schroon Mountain, Adirondacks, Thomas Cole, 1838. The Hudson Valley bowl is still present, but pulled to the right and left. A cloud floats at the peak, to make it seem worthy of the West (The Cleveland Museum of Art, Hinman B. Hurlbut Collection).

bership (besides being a banker, Biddle was an amateur horticulturist) was undoubtedly masterminded by A. J. Downing, who signed the lithograph at the lower left as corresponding secretary. The terrace outlook, although obviously imaginary, could almost be from Downing's own home on the Newburgh Basin. On the ground between the two trees are the tools for management of horticulture and pomology, along with baskets of fruits and vegetables. Peace and contentment, rather than dissatisfaction, permeate the picture, which is in Franklin Roosevelt's collection of prints and drawings of the Hudson. One is not surprised to learn that Downing was then attempting to become a more refined person—president of the Newburgh Library Association and a charter member of the Newburgh Ly-

ceum.[96] His father, Samuel, began advertising trees for sale in 1810, and it was said of him in 1846: "This inclination of Mr. Downing to improve the fruit of the country was gradually infused into his children as they grew up, determined the nature of their occupations, and was the means of changing and renewing the whole system not only in this part of the country, but in many parts of the Union . . . and our opinion is that the products of which we speak, whether fruit or flowers, are admirably calculated to subdue the appetites, feelings and affections, improve the social condition of men, and win them from the rude and grosser habits, to those of simplicity, elegance and virtue."[97]

[96] E. M. Ruttenber, *History of Newburgh* (Newburgh, N.Y.: E. M. Ruttenber & Co., 1859), pp. 252, 257.
[97] Samuel W. Eager, *An Outline History of Orange*

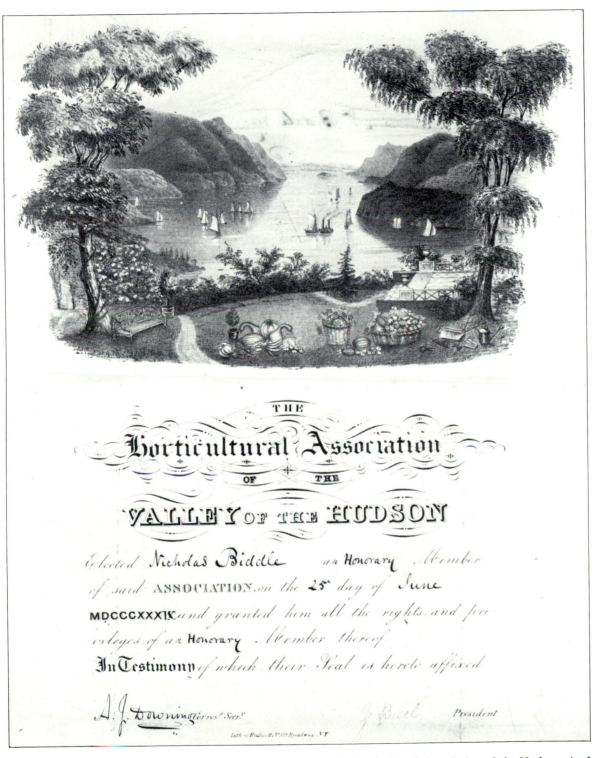

21. *Nicholas Biddle's Certificate of Honorary Membership in the Horticultural Association of the Hudson, A. J. Downing, June 1839 (Franklin D. Roosevelt Library).*

Horticulture would have a constructive effect upon democratic society. As with many American intellectuals and artists concerned with landscape and buildings, there was an urge to disseminate gentleness and tranquility in an otherwise uncouth environment— as much of an aim toward suffusion as uplift. A. J. Downing himself came close to subordinating the ornamental aspects of horticulture, which meant almost everything to him, to its supposed influence for social betterment: "Granting all the foregoing [using horticultural pleasures as a reward of new-found wealth], we are inclined to claim also, for horticultural pursuits, a political and moral influence vastly more significant and important than the mere gratification of the senses. We think, then, in a few words, that Horticulture and its kindred arts, tend strongly to fix the habits, and elevate the character of our whole rural population."[98] Sensuality was for giving purpose and conviction in the Hudson Valley, as contrasted to the Connecticut Valley, where cool, rational order was paramount.

Attachment to the land was needed to overcome what was described after Downing's death in his magazine *The Horticulturist* as "the restless roving tendency of the times."[99] As David Schuyler has observed, "Downing's advocacy of agricultural education was an attempt to reinforce Jefferson's ideal of the independent yeoman farmer, which was threatened by the restless mobility of the rural population."[100] Downing may

have been unusually aware of this mobility because his father was originally a coach maker and wheelwright from New England, and many New Englanders crossed the Hudson at Newburgh on their way west in wagons. Downing assumed leadership not by right of superior eloquence alone, as some commentators have claimed, but rather, as with Jefferson, through his precocity and intense desire to provide an ethos. The ease with which he dispensed advice on every branch of building and gardening was deceptive in relation to the depth of his conviction. His inspiration told him exactly what Jefferson's had: "the development of the finer and more intellectual traits of character are slower in a nation than they are in a man."[101] The man—Downing—would speak for the multitude.

North from Willis' stormy narrows at the Highland Gate (the pass about as wide as the hills are high), Newburgh harbor opened into another great placid lake, as seen in the views in the Biddle certificate and from the Ruggles House in Newburgh (Fig. 22). We learn from Willis that "Newburgh stands upon a pretty acclivity, rising with a sharp ascent from the west bank of the Hudson; and, in point of trade and consequence, it is one of the first towns on the river. In point of scenery, Newburgh is as felicitously placed perhaps, as any other spot in the world, having in its immediate neighbourhood every element of natural loveliness; and, just below, the sublime and promising Pass of the Highlands."[102] What in other contexts had been a private seat upon a ter-

County (Newburgh, N.Y.: S. T. Callahan, 1846), p. 175.

[98] "The Influence of Horticulture," *The Horticulturist*, II, 1, July 1847, p. 9.

[99] "The Publisher's Farewell," XII, December 1852, p. 538.

[100] David Schuyler, "Rural Values and Urban America: The Social Thought of Andrew Jackson Downing," M.A. thesis, University of North Carolina, 1975, p. 23. He goes further with this conclusion in "Public Landscapes and American Urban Culture, 1800-1870: Rural Cemeteries, City Parks, and Sub-

urbs," Ph.D. thesis, Columbia University, 1979, pp. 204-207.

[101] A. J. Downing, "A Few Words on our Progress in Building," *The Horticulturist*, VI, June 1851, pp. 250-251.

[102] *American Scenery Illustrated*, I, p. 51. See also A. Elwood Corning, "The Ruggles House," *Newburgh Bay and Highlands*, XXVIII, 1942, pp. 5-10; and Helen Ver Nooy Gearn, "Who Owned the Famous Ruggles House?" *Newburgh News*, July 27, 1966.

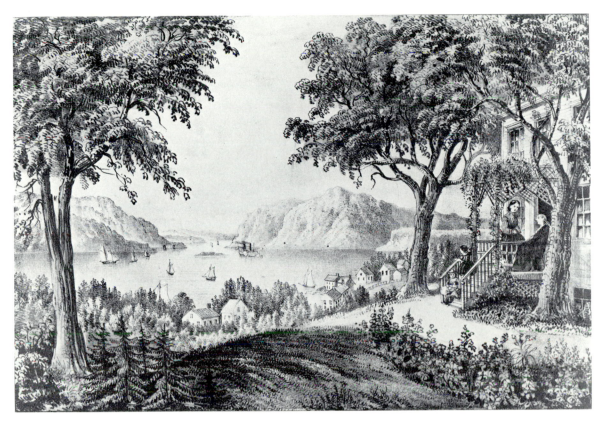

22. Newburgh Basin from the Ruggles House, 1846. This is the Hudson lake or bowl which inspired Downing's Dans Kamer reverie from lower down (Currier & Ives).

race from which to view the river now appeared as a terraced and bustling town with the prized outlook in its very midst. Evidently the squalor, noise, and haste brought on by the commercial opportunities of the Hudson landing (so deplored by Timothy Dwight in his comparison of the Connecticut and Hudson valleys) need not prevail everywhere.

As the view from the Ruggles House exemplified the private terrace in a public setting, so the first popular article by Downing, written when he was no more than twenty, sought to describe the all-embracing and calmer outlook suggested by the same bay. "The Dans Kamer: A Revery in the Highlands" appeared in *The New York Mirror*, a newspaper "Devoted to Literature and the Fine Arts," and edited by Morris, the owner

of nearby Undercliff, and his friend Willis, the proprietor of Idlewild at Cornwall. Downing gazed through the haze at an Indian summer, with a great sheet of water lying open and serene before him. "Indian summer! mild and balmy season, we love thee, for thou art to us as the poetry of the year." His vantage was from a huge flat rock, "a romantic point that juts out into the blue waters of the Hudson, and forms the northern boundary of the noble bay of the Highlands."[103] This rock is known as the Dans Kamer, another naturalistic terrace, but much closer to the surface of the water than the porch of the Ruggles House. From

[103] XIII, 15, October 10, 1835, p. 117. See also A. J. Downing, "Beacon Hill: American Highland Scenery," *The New York Mirror*, XII, 37, March 14, 1835, pp. 293-294.

that low down, he says, the bay is "lake-like in its extent (it would be a *leman* in any other country), fringed as you have seen dark lashes fringe some liquid eye with a soft and dim reflection of bright villas deep-set in verdure, rich tracts of cultivated land, cheerful villages, and above all, those aged guardians of the panorama, the deep blue mountains, their shadows reaching far down upon the clear bosom of the waters where their teints mingle with its cerulean hue, even as they melt away in the celestial sky above them; the white-sailed barks moving on in swan-like beauty, the only things meanwhile to convince you that the same water is not another and a liquid firmament."[104]

The rock upon which Downing reclined to enjoy the placid surface of the water denied him any permanent respite, however, because it was once the "Devil's Dance Chamber." There, as Washington Irving remembered,[105] the Indians carried out their wildest dances, horrible in firelight and visible from the river. Downing wondered whether the Indians had been wronged in having been driven too early from this setting, and whether the white man had subsequently abused and neglected it. In spite of the lack of organizing abilities that would have enabled the Indians to stand up to the white invaders, and other flaws in their character, such as their cruelty to each other, one could not help but feel, in this setting in the quieter Indian summer, a compassion "that prompts us to pause and reflect tenderly and forgivingly, now that they are mingled with the dust of their native hills, and their dancing grounds are silent for ever."[106] Somehow, Downing believed, a reunifying harmony might be found in the landscape of the future.

We have become accustomed to regarding the Neo-Gothic and Tuscan villas of Downing, Davis, Vaux, and Withers as the only architectural expressions of the Hudson Valley pastoral. However, the pencil sketches of Edwin Whitefield for a manuscript (now in the Winterthur Museum), "Houses along the Hudson,"[107] and the *Hudson Panorama* of Wade and Croome (1847), illustrate an eclecticism of greater range in domestic architecture—Federal, Greek Revival, Italianate, and, of course, an abundance of Gothic Revival. While Whitefield might play down foliage to sell his book to owner/subscribers, and Wade and Croome might do the same in order to help their customers spot architectural gems from the middle of the river, a rudimentary instinct toward display and conspicuousness is also obvious, despite efforts to assure that the siting should absorb the houses easily and comfortably into nature—with the "bright villas deep-set in verdure," as Downing put it. Downing's reform of Gothic villas was aimed simultaneously at the already templed hills and the crude cutting of trees. Esthetic and commercial enterprise competed with the ever-present desire for peace and tranquility in the landscape after the pioneer onslaught. This brisk competition between the new affirmation of house styles, as seen from Sunnyside to Olana, and the soothing, healing, and concealing effect of nature wanted from the older Dutch landscape, as indicated in Downing's reverie, would likewise be seen in the invention of the rural, garden, or landscaped cemetery, where the larger and more luminous monuments did not always subside into the restrained landscaping either.

Whitefield's view of Newburgh harbor in 1846 (Fig. 23) shows the Downing house,

[104] Ibid.

[105] Washington Irving, *Knickerbocker History of New York* (New York: Dodd, Mead & Co., 1915), p. 217.

[106] Downing, "The Dans Kamer," p. 118.

[107] John Zukowsky has now published the Whitefield drawings in *Hudson River Houses* (Cold Spring, N.Y.: North River Press, Inc., 1981). For an excellent study of the cottage trend, see David Schuyler, "English and American Cottages, 1795-1855," M. A. thesis, University of Delaware, 1976, p. 35.

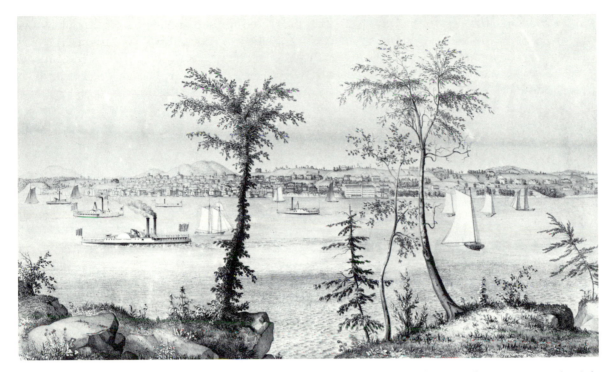

23. Newburgh, New York, Edwin Whitefield, 1846. Downing's house is seen between the two trees at the right (New York Historical Society).

Highland Gardens, to the right between two saplings on the near shore. To the left, at the other end of town, would be the Ruggles House and beyond, Idlewild. Below are the docks, factories, and mills of the shoreline. "Nearly all the business is crowded into one street, running parallel with the river."[108] Downing thought the poor taste in his day came more from hyperactivity than from the typological indifference deplored by Jefferson in Virginia. Thus, Downing concluded, "There are many persons who are as discontented with this new hot-bed growth of architectural beauty, as JEFFERSON was with the earlier and ranker growth of his day."[109] Downing had evidently read Jefferson's *Notes on the State of Virginia*, as Olmsted was to do after him.

Downing's Highland Gardens was above the confusion of lower waterfront Newburgh. The precise location of the house was due to the fact that the family nursery had been founded on the site, but Downing was also committed to upgrading everything around him, and this implied an involvement with the town. The English suburban aim, according to a New York newspaper, was to draw in "those charms which in other countries she lavishes in wild solitudes," and assemble them "around the haunts of domestic life."[110] So Downing set out to accomplish with one clever stroke the extension of nature into the public realm. He spoke of grafting art upon nature and at the same time obtaining from the latter "a borrowed charm."[111] According to a local newspaper of 1837, "heretofore 'the spirit of money getting' has absorbed the attention of our entire

[108] Hunt, *Letters about the Hudson River*, p. 191.
[109] Downing, "A Few Words on our Progress in Building," p. 249.

[110] "The Architects and Architecture of New York," *Brother Jonathan*, V, 8, June 24, 1843.
[111] Downing, *Treatise* (1850), p. 371.

population, and they have had neither time nor inclination to promote the high intellectual culture of our society. Recently, however, there is a manifest change. . . . Let our population do as much for the cause of learning during the coming as they have during the past year, and the scholar and the man of leisure will say with pride of feeling as our merchants now say, 'I am a citizen of Newburgh.' "[112] The need to take cultural inventory was becoming strong, and Downing was one of the chief agents of its renaissance: "More creditable to the city are those [homes] of the later period, from the fact that they are a perpetual tribute to the memory of Andrew J. Downing, who, born amid the scenes which have been so briefly sketched, grafted his pure and artistic perceptions not only upon the community in which he lived, but upon the nation."[113] In 1846 a local newspaper reported a campaign for planting street trees in Newburgh. Three years later Downing was writing in *The Horticulturist* about upgrading the whole Hudson Valley through the improvement of domestic architecture and street trees, working together.[114]

The possibility of totally transforming the town through rules first made up for the private estate was snuffed out, however, with Downing's death by drowning when the steamer on which he was sailing down river caught fire on July 28, 1852. Marshall Wilder's eulogy of November 1852 at the Pomological Congress in Philadelphia has that combination, witnessed all through the examination of American landscapes, of the preternatural intensity of gaze with the lack of the cumulative weight of knowledge or tradition in the modeling of the land. The gaze is very direct. The passengers, all unknowing, crowd the deck of the Henry Clay to view the approaching Newburgh shore (Fig. 23), "near a city, which rises in beauty and grace from its western bank back to the brow of the distant hill. There is a

Cottage, half embowered
With modest jessamine, and there a
 spot
Of garden ground, where, ranged in
 neat array,
Grow countless sweets.

"Its architecture is in the most approved Elizabethan style. Its grounds are tastefully laid out and adorned, and he who named it 'Highland Gardens' accurately translated the natural language of the place. It overlooks the city and river, and commands a view of one of the most extensive and beautiful landscapes of the world. The very site seems designed by nature for the birth place of genius, and for the abode of comfort, taste and learning."[115]

On the contemporary maps of Newburgh, Downing's block, surrounded by Liberty, Grand, and Broad streets, could hardly appear more commonplace in its rectilinear form.[116] Yet the interior of the plot was a novel lesson in invention and dexterity (Fig. 24). The layout had the fertile character of a farm within a town, with an orchard, a vineyard, and a kitchen garden surrounding a peninsula of residential land. The latter was in turn divided into two tongues by a drive-

[112] *The Newburgh Telegraph*, as quoted in Arthur Channing Downs, "Downing's Newburgh," *Newburgh Revealed* (Newburgh, N.Y.: Newburgh Arts Council, 1975), p. 7.

[113] E. M. Ruttenber and I. H. Clark, *History of Orange County, New York* (Philadelphia: Everts & Peck, 1881), p. 278.

[114] *Newburgh Gazette*, February 25, 1846, and June 6, 1849. See also "On the Improvement of Country Villages," *The Horticulturist*, III, 12, June 1849, pp. 545-549, for Downing's thought on street trees.

[115] "Col. Wilder's Eulogy on Mr. Downing," *The Horticulturist*, XI, November 1852, p. 491.

[116] Phyllis Odiseas, "Buildings and Building Technology in Newburgh, N.Y., 1840-1850," *Paper for the Class of Charles E. Peterson on the Technology of Early American Buildings*, Columbia University, December 1970, contains a thorough study of the vanished house with maps. She reports that it was of sepia-colored sandstone, and not brick, as the 1846 Parmenter map suggests. The other indispensable article on Highland Gardens is Arthur Channing Downs, Jr., "Downing's

way around the house and a long walk in the park beyond it, where every advantage was taken for observing the specimen trees and bushes. "So skilfully were the trees arranged, that all suspicion of town or road was removed. . . . You fancied the estate extended to the river as an ornament, and included the mountains beyond. At least, you felt that here was a man who knew that the best part of the landscape could not be owned, but belonged to every one who could appropriate it."[117] The older American dilemma, of not knowing for certain where the private domain left off, and the public one began, was again in evidence.

Choices in arrangement were tastefully made, and a certain exclusiveness resulted within the property itself (Fig. 25). Perhaps because she was Swedish and not American, Frederika Bremer immediately recognized the conscious invention: "Every thing has been done with design—nothing by guess, nothing with formality. . . . Within the house there prevails a certain darkness of tone; all the wood-work of the furniture is brown; the daylight even is dusk, yet nevertheless clear, or, more properly, full of light—a sort of imprisoned sunshine, something warm and deep; it seemed to me like a reflection of the man's own brown eyes (Fig. 26). In the forms, the furniture, and the arrangement prevails the finest taste; every thing is noble and quiet, and every thing equally comfortable as it is tasteful. The only things which are brilliant in the rooms are the beautiful flowers in lovely vases and

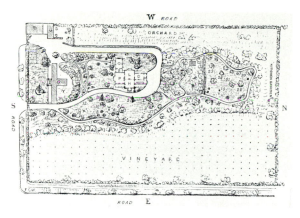

24. *Downing's Block, Newburgh. The outline is rectangular because it is within the limits of a town* (Downing, Rural Essays).

25. *Highland Gardens of Downing, now destroyed, Frederick Withers drawing. The house as it appeared in the year of Downing's death, 1852. It represented a high style, Elizabethan, dwelling in a private grove* (Downing, Rural Essays).

Newburgh Villa," *Association for Preservation Technology Journal*, IV, 3-4, 1972, pp. 1-113. Additional works on Downing's more general efforts (both unpublished) are Edith Norton July's pioneering master's thesis at New York University of 1945, "Andrew Jackson Downing: A Guide to American Architectural Taste," and George Bishop Tatum's invaluable Ph.D. thesis at Princeton University of 1950, "Andrew Jackson Downing: Arbiter of American Taste, 1815-1852."

[117] George Curtis, "Memoir," in A. J. Downing's *Rural Essays* (New York: George P. Putnam & Co., 1853), pp. xxxii-xxxiii.

26. Downing of the Dark Eyes. As with Irving or Willis, there was confidence that Downing could discern what the culture needed on an empirical (romantic) basis (Downing, A Treatise on the Theory and Practice of Landscape Gardening).

baskets."[118] As Jefferson had at Monticello, Downing withdrew into his house at the same time that he advanced into his landscape surroundings.

It is evident that Downing wanted to manufacture integrated environments that held warmth, intimacy, and amenity. Willis observed in 1840, "It is in *river scenery*, however, that America excels all other lands: and here the artist's labour is not, as in Europe, to embellish and idealise the reality; he finds it difficult to come up to it."[119] Willis too believed that out of a better setting, better understood and utilized, a more complete and satisfying style of life would eventuate, but he reverted for clarity and unity to the

eighteenth-century concept of a great outdoor room for the purpose, in which an elevating drama might be enacted. "To what degree sunsets and sunrises, clouds, moonlight, and storms, are aggrandized and embellished by this peculiar formation of country, any student and lover of nature will at once understand. Life may be, outwardly, as much more beautiful, amid such scenery, as action amid the scenery of a stage is more dramatic than in an unfinished room."[120] Calvert Vaux too wanted an architecture which would "thrive in the open air, in all weathers, for the benefit of all," not a removed, private, hothouse art, since in America "there is plenty of prosperity and opportunity; plenty of money and industry; plenty of every thing but education and the diffusion of knowledge."[121] The intellectual-artist had that special mission of educating the public. The landscape might be brought under control, but it was only through the addition of an educated architecture that a final triumph would be achieved. "Let such a taste [as that of A. J. Davis] spread generally, and our towns would soon present continuous elevations of architectural beauty, and our country estates become as celebrated for their fine structures, as they now are for their landscape scenery."[122] The gift of the Hudson Valley scenery urged them toward a more crowning and comprehensive ideal of architectural achievement, which was supposed to spread from estates to towns, before Downing's death.

This synthesis of architecture and landscape would triumph only if a model site for a united lifestyle could be found. In 1851

[118] Frederika Bremer, *Homes of the New World* (New York: Harper & Brothers, 1853), I, pp. 19-20. Could Downing have been influenced by Walter Scott's Abbotsford, which had a similar dark interior? For another description of Highland Gardens, see Hunt, *Letters about the Hudson River*, pp. 189-193.

[119] Willis, *American Scenery Illustrated*, I, Introduction, p. 2.

[120] N. P. Willis, "The Highland Terrace above West Point," *The Home Book of the Picturesque*, p. 109.

[121] Calvert Vaux, "American Architecture," *The Horticulturist*, III, April 1853, p. 170. See also Neal Harris, *The Artist in American Society* (New York: George Braziller, 1966), pp. 208-214, for an interesting discussion of Downing as a social reformer.

[122] "The Architects and Architecture of New York," *Brother Jonathan*.

Willis thought he saw the perfect opportunity for it on the plateau to the south of Newburgh. "The HIGHLAND TERRACE we speak of—ten miles square, and lying within the curve of this out-stretched arm of mountains—has an average level of about one hundred and twenty feet above the river. It was early settled; and, the rawness of first clearings have long ago disappeared, the well-distributed *second woods* are full grown, and stand, undisfigured by stumps, in park-like roundness and maturity . . . the houses and barns sufficiently hidden with foliage to be picturesque—the whole neighbourhood, in fact, within any driving distance, quite rid of the angularity and well-known ungracefulness of a newly settled country."[123] The principle of the terrace for the base of a whole community, rather than a single estate, allied itself with the adjoining reality of Newburgh, also on a terrace. The next step would be to try to people the terraces with artists and intellectuals. If a fast passenger train and better roads could be put through on the western (as distinguished from the more open eastern) side, it would permit "a mixture of city and country, *with the home in the country.* And the spot with the most advantages for the first American trial of this new combination, is, we venture confidently to record, the HIGHLAND TERRACE ENCIRCLED IN THE EXTENDED ARM OF THE MOUNTAINS ABOVE WEST POINT."[124] To found a haven for the display of people in the crook of an arm of his Highland Mountains was another opportunity.

TWO LAST OUTPOSTS

Lewellyn Park, West Orange, New Jersey, A. J. Davis, Howard Daniels, and E. A. Baumann, 1853-1857. The dream of Highland Ter-

race, however, was to come true only outside the Hudson valley, in Lewellyn Park in West Orange, New Jersey.[125] Lewellyn Haskell, the founder, had his own additional goal, for he belonged to the Perfectionist sect, a branch of Swedenborgianism, and Lewellyn Park was to be its utopia. Kirk Jeffrey has contended that the family became the unit of social realignment because of increasingly negative associations with urban life in the four decades before the Civil War, rather than after. The logical instruments for this change were the single house and the verdant suburb, of which Lewellyn Park was the first example. "Three utopian themes—retreat, conscious design, and perfectionism—pervaded nineteenth century writings about the family."[126] Lewellyn Park did not long adhere to these reform principles, however. "Nature that was to have been used for contemplation and renewal became an object to be possessed. That which had been a community of high ideals and social experiment ironically became the apotheosis of stability and wealth. In this typically American transformation of ideas into objects, the original meaning was lost."[127] Northern wealth overwhelmed prewar romantic modesty, but the embodiment of dreams into suburban reality was a chronic American difficulty anyway. The proximity of New York City diluted the vision, as was to happen in the initial setting of the Hudson Valley, twelve miles east of Lewellyn Park.

Freedom of layout was the watchword in Lewellyn Park: "The wild freedom of the

[123] Willis, "The Highland Terrace," p. 108.
[124] Ibid. p. 112.

[125] Christopher Tunnard, "The Romantic Suburb in America," *Magazine of Art*, May 1947, pp. 184-187, gives a good insight into this and several other suburbs. See also Jane B. Davies' fundamental "Lewellyn Park in West Orange, New Jersey," *Antiques*, 107, January 1975, pp. 142-147.
[126] "The Family as a Utopian Retreat from the City," *Soundings*, LV, 1, Spring 1972, p. 22.
[127] Richard Guy Wilson, "Idealism and the Origin of the First American Suburb: Lewellyn Park, New Jersey," *The American Art Journal*, XI, 4, October 1979, p. 90.

27. Frontispiece of "Rural Residences," unpublished book of A. J. Davis, 1837 (Avery Library, Columbia University).

mountainside has been allowed, and properly, to set the keynote."[128] The suburb had no sense of being a structured community because its plan was random and undisciplined. The lots, averaging six acres, were irregular in contour, with a labyrinth of roads connecting them, and the houses set off center. The axis of the suburb was off-side at the left, following Willow Brook down the hill and resulting in an open park of fifty acres called The Ramble. The layout was an extreme reaction against the rigidity of the grid plan of New York City, and as such its owners seemed to take pride in appearing to have no plan at all. What was expected instead in the Hudson Valley proper can be seen in the intended frontispiece of A. J. Davis' "Rural Residences" of 1837 (Fig. 27):[129] a large general space, punctuated by several evenly distributed sub-spaces. The farthest distance, across a major river, was terminated by a mountain looking remarkably like Beacon Hill across from Downing's Highland Gardens at Newburgh. A battlemented castle villa, silhouetted by trees, provided the major accent with its lighter tonality, and, along with two bridges, stiffened the landscape in front, consisting mostly of flourishing plants, tropical in their luxuriance. The hill-mountain and castle-villa are nearly equal as interest points. The main rhythm of the space is diagonal along the stream to the left, but the S-thrust never escapes from the embrace of the final enclosure, because this was the most self-contained and domesticated of valleys, a closed system with all values responding to each other, self-renewing in its arcadian innocence.

[128] Samuel Swift, "Lewellyn Park: The First American Suburban Community," *House and Garden*, III, 6, June 1903, p. 328.

[129] H.-R. Hitchcock's *American Architectural Books* (Minneapolis: University of Minnesota, 1962), p. 29, says, "It is doubtful if this work was ever completely issued." Adolf K. Placzek of Columbia University's Avery Library called this picture and its unpublished status to my attention.

How Davis would transfer from this type of Hudson Valley enclosure into another, much less ordered, one is suggested by his watercolor of his summer cottage, Wildmont (Pl. 5), at the top of the Lewellyn Park (also from the Franklin Roosevelt Collection, where it was very appropriately titled *A Gaily Painted House on a Rise of Ground*). The pink and white confection with its pier buttresses, crockets, finials, and board-and-batten walls, tells why wood may be more appropriate than stone in America, because the cottage is so crisp. The lively versatility of wood provided the only excuse for such a bald exposure.

The centripetal effect of the "Rural Residences" of the Hudson Valley (Fig. 27) no longer held everything together in Lewellyn Park. The Lewellyn Park cottage, with its delicate detailing and doll-house scale is brilliantly specific again, but the distant backdrop is overly generalized and muddled, and furnishes no real visual goal. There is no sense of command or mastery from the view, as there had been from comparable terraces in the Hudson Valley. There is no river in the middle distance, no feedback from a wooded shore, no mountain in the offing. Here the sky would be filled only with a staining smoke. At Olana the ascending glow of the sky at least supplied a worthy distraction. Here there was no neat framing by foreground trees, and the cottage, which might look clean and proportional in the Hudson Valley, comes to appear an isolated, distorted, fussy object outside the magic Hudson circle. Although Davis only dabbed in the distance in his watercolor, he was actually looking at the crowded realities of Newark, Jersey City, Brooklyn, and Manhattan.[130] The hopes of private vision could not really be extended to the public sector from this location, the most conspicuous fail-

28. *Catskill Mountain House, 1823* (Bryant, Picturesque America).

ure of all the previous views from the terrace.

The Catskill Mountain House, 1823. The conviction that the landscape might yet prove valid to inhabit as a total room, stage, or picture kept public interest alive along the East Coast. Only when that hope of habitation in a coherent space faltered did the enthusiasm for the backdrop of scenery fall away too. No building or area represents this latest phase better than that of the Catskill Mountain House on the upper reaches of the Hudson near Palenville (Fig. 28). It was perched 2,700 feet above the river, compared to Lewellyn Park's 600-foot height. Martha Lamb called the Catskill Mountain House the culmination of "the glories of the Hudson."[131] Actually it was on an escarp-

[130] Wilson in "Lewellyn Park" documents and clarifies these views further (p. 89), quoting from a letter of Davis, and another by Theodore Tilton.

[131] Martha Lamb, "Residence of Mr. Church, the Artist," *The Art Journal*, 1876 (New York: D. Appleton & Co., 1876), p. 247. A thorough account of the hotel's history is to be found in Roland Van Zandt,

29. View of the Hudson from N. P. Willis' Study Window (Harper's New Monthly Magazine).

ment rather than a terrace. "A line . . . divides it into two equal parts. The Western half is mountain, falling off in a line of rock parapet; the Eastern is a vast semicircle of blue landscape, half a mile lower. Owing to the abrupt rise of the mountain, the nearest farms at the base seem to be almost under one's feet, and the country as far as the Hudson presents almost the same appearance as if seen from a balloon."[132] This described an

orthodox Hudson Valley scene, but at an expanded scale that led to an irreconcilable split between person and place: "No intervening land to limit the view, you seem suspended in mid-air, without one obstacle to check the eye."[133] Willis had been disturbed by this lack of scenic rapport at Idlewild. But he was able to bridge the gap, to reach the river with a little projection of the imagination: "The *beauty* of the view is of less value than the *companionship* there is in it. I find the eye can take in the needed food for

The Catskill Mountain House (New Brunswick, N.J.: Rutgers University, 1966). For the surrounding countryside, see Alf Evers, *The Catskills* (Garden City, N.Y.: Doubleday & Co., Inc., 1972).

[132] Bayard Taylor, "Travels at Home," *New York Tribune*, July 12, 1860.

[133] Willis Clark, "Sketches," *The Catskill Mountains and the Region Around* (New York: Taintor Brothers and Co., 1873), p. 214.

30. Sunrise from South Mountain, Catskill Mountain House (*Bryant*, Picturesque America).

this social craving. At my window, on this terrace of the Highlands, I sometimes look off, from a tired pen, upon the fleets of sails, crowded steamers and lines of tow-boats and barges, and feel, after a minute or two, as if I had been where people are."[134] Comparing this view from Willis' study (Fig. 29) with that from the Catskill Mountain House at dawn (Fig. 30), it is obvious that the boats in the latter have become diminutive dots, evoking little empathy because of their distance. If one were too far from the river to effect human contact, the game of reading the landscape was over.

Washington Irving, although not a painter, understood what held landscape effects together for people in this vicinity. From his first voyage up the Hudson as a boy in 1800 he noticed "Much of the fanciful associations with which [the Catskills] have been clothed may be owing to their being peculiarly subject to those beautiful atmospherical effects which constitute one of the great charms of Hudson River scenery."[135] This luminous atmosphere reached its climax toward the north, and was called "opalescent" by Church. For the traveler Harriet Martineau to absorb the space properly, to come totally in touch with it, it would have to be seen on an instant and in a flash. Martineau described the occasion: "After tea I went out upon the platform in front of the house, having been warned not to go too near the edge, so as to fall an unmeasured depth into the forest below. . . . The stars were bright overhead, and had conquered half the sky, giving promise of what we ardently desired: a fine morrow. Over the other half the mass of thunder-clouds was, I suppose, heaped together, for I could at first discern nothing of the champaign which I knew must be stretched below. Suddenly, and from that moment, incessantly, gashes

of red lightning poured out from the cloudy canopy, revealing not merely the horizon but the course of the river in all its windings through the valley. . . . All the principal features of the landscape might, no doubt, have been discerned by this sulphurous light, but my whole attention was absorbed by the river, which seemed to come out of the darkness like an apparition at the summons of my impatient will. It could be borne only for a short time—this dazzling, bewildering alternation of glare and blackness, of vast reality and nothingness."[136] This startling glimpse into the abyss had, in effect, destroyed the varied unity of the spatial composition, because sixty to seventy miles had to be encompassed on the instant. This accident denied the comfort of a point-by-point, progressive understanding, warmed and humanized by people, forests, sunsets, and ships, the calming and rewarding experience of all previous Hudson River "reveries." Excitement was mounting while there was much more to see and take in.

A second outsized phenomenon for which the Catskill Mountain House was noted was its sunrise (Fig. 30), since it faced east, rather than the more usual west, from its escarpment. "Night is fast melting in the dawn, a deep blue rests upon the whole valley as if it were a sea lying silent at our feet, and the Berkshire Hills seem like immense waves rolling on from the distant horizon. . . . The East is all aglow, and, *as we stand musing the fire burns.* . . . Cities and villages below us spring into being and misty shapes rise from the valley."[137]

Inspiring as the sunrise was, however, it was essentially a repetitive event; the new thirst was for novel spectacles. Another premonition of these appeared with the reflection from the western sun of the colossal porch columns on the filmy stuff of a passing

[134] Willis, *Outdoors at Idlewild*, p. 336.
[135] Washington Irving, "The Catskill Mountains," *The Home Book of the Picturesque*, p. 72.

[136] Martineau, *Retrospect*, I, p. 85.
[137] Wallace Bruce, *Legends and Poetry of the Hudson* (New York: P. S. Wynkoop & Son, 1868), pp. 81-83.

cloud, which did not this time even admit the viewer to the sight or sound of the ground below: "But I was disturbed in my cogitations by a buzz among the guests near the door; and all I could hear was that the house was going past on the outside! . . . It was a great mass of vapour moving from north to south, directly in front, and only about 200 feet from us, which reflected the light of the sun, now beginning to appear in the west, from its bosom like a mirror, in which the noble Corinthian pillars, which for the front of the building, were expanded like some palace built by the Titans for the entertainment of their antediluvian guests. . . . We ourselves, who were expanded to Brobdignags in size, saw the gulf into which we were to enter and be lost."[138] The dimensions of these instantaneous glimpses became extraordinary and intangible. The appetite for prickly sensation was to become more and more difficult to satisfy, much like what had happened in Church's paintings. The edges for "framing" became likewise uncertain. As Irving had suggested from his voyage of 1800, increasing mobility brought on the opportunity to go to more places, but to enjoy them less. "I shall never forget my first view of [the Catskill Mountains]. It was in the course of a voyage up the Hudson in the good old times before steamboats and railroads had driven all poetry and romance out of travel. A voyage up the Hudson in those days, was equal to a voyage to Europe at present, and cost almost as much time; but we enjoyed the river then; relished it as we did our wine, sip by sip, not, as at present, gulping all down as a draught without tasting it."[139] There were not only increasing numbers of signals to challenge intuitive understanding, but also the issue arose of how to handle these multiplying stimuli in relation to the size of a rapidly enlarging nation.

The colossal Corinthian columns on the porch of the Catskill Mountain House were proclamations of patriotic allegiance, signifying the thirteen original states, and, "Through the white Corinthian pillars of the portico—pillars which, I must say, are very well proportioned—you get much the same effects as through the Propylaea of the Athenian Acropolis."[140] The analogy to the outlook from the Acropolis did not seem farfetched then, any more than that the columns equated with the thirteen states: educated citizens knew their Classics. But no tradition of comparable worth had evolved for viewing the United States itself. The columns were there, but only revealed flat, uniform, and colorless views from the intercolumniations. The panorama from the porch began to appear too washed out, as happened with Martineau's lightning-struck storm scene or the image of the hotel on the pale cloud. The landscape, unlike the Classical columns, began to fail the test of solid, substantial, eternal value. Its "undulations have vanished; it is flat as a pancake; and even the bold lines of hills stretching toward Saugerties can only be distinguished by the color of the forests upon them . . . the whole region appears to be lifted upon a sloping plane, so as to expose the greatest possible surface to the eye."[141] The point-to-point factor, the robust, apposite scale, and most of all, the touch of romantic mystery from the forests, had vanished. Too much was exposed. From this height the Hudson itself could appear only as a narrow thread, a retreating middle ground, rather than a series of lagoons to pause and refresh the spirit in, as Downing had done with Newburgh bay in his Dans Kamer reverie, or Irving before him in his voyage up the river, or Church with his minor and major pools on the river, near to this. The older system of tighter spatial calibration was coming apart.

[138] *Nelson's Illustrated Guide to the Hudson and Its Tributaries* (New York: T. Nelson & Sons, 1860), p. 124.
[139] Irving, "The Catskill Mountains," pp. 72-73.

[140] Taylor, "Travels at Home." [141] Ibid.

WHY THE ARTISTS LEFT THE VALLEY

The plain was too wide and the river too narrow, while the mountains were not high enough to provide the impression of permanent stability to dominate the surroundings, which Storm King and Cro'-Nest had afforded at the Highlands (Fig. 16). At the moment of greatest dramatization, to be sure (Fig. 30), "there was a dim resemblance in the scene to a sunrise on the Righi, but, alas! no glacier, no sky-piercing pinnacle of ice, was in sight; no sublimity either was there in our spectacle."[142] Downing's friend G. W. Curtis observed from the Catskill Mountain House that "the whole thing is graceful and generous, but not sublime. Your genuine mountaineer (which I am not) shrugs his shoulders at the shoulders of mountains which soar thousands of feet above him and are still shaggy with forest. He draws a long breath over the spacious plain, but he feels the want of that true mountain sublimity, the presence of lonely snow peaks."[143] The recollection of the European Alps heightened the longing for the more unique mountains of the Far West, which had appeared inhumane and sterile before. The local views

began to seem so innocent as to be naive. "Immediately following his return home in 1869 [Church] settled to the pleasurable task of building his oriental castle, Olana, whose situation commands a breath-taking panoramic view of the upper Hudson Valley. . . . But for the first time a certain feebleness seems to penetrate his art, particularly the larger, more ambitious works. This unfortunate undertone appears in the form of an overly pervasive broadening in the idealization of nature. The details of form are subordinated to the effects of light, and the desire to express the vastness of God's universe [and for others, the West with its mountains] overwhelms him. The attention to detail, which had been an obviously joyful concern of the artist previously, was now all but suppressed in order to avoid interfering with the cosmic impact the scene was intended to convey."[144]

Bierstadt reported from his trip to Colorado and Wyoming in 1859: "We see many spots in the scenery that remind us of our New Hampshire and Catskill hills, but when we look up and measure the mighty and perpendicular cliffs that rise hundreds of feet aloft, all capped with snow, we then realize that we are among a different class of mountains."[145] The Hudson River and White Mountain schools of painting were to be superseded by the Rocky Mountain School. The artist had made a first pledge to the Hudson Valley, but by now was too restless, bored, and tired to keep it: "As we stand on the top of Mount Washington, or the Catskills, the very immensity of the prospect renders it too vague for the limner; it inspires the imagination more frequently than it satisfies the eye. Indeed, general ef-

[142] Rev. Theodore L. Cuyler, "A Sabbath in the Catskills," *Catskill Mountain House Scenery* (No publisher: 1870?), p. 4.

[143] George W. Curtis, *Lotus-Eating: A Summer Book* (New York: Harper, 1852), p. 36. There was a premonition of future attitudes in James Fenimore Cooper's "American and European Scenery Compared" of the early 1850s: "As a whole, it must be admitted that Europe offers to the senses sublimer views and certainly grander, than are to be found within our borders, unless we resort to the Rocky Mountains, and the ranges in California and New Mexico." *Home Book of the Picturesque*, p. 52. However, Thomas Cole felt just the opposite in returning from Europe at about the same time: "Must I tell you that neither the Alps nor the Apennines, no, nor even Aetna itself, have dimmed, in my eyes, the beauty of our own Catskills?" As quoted in Louis Noble, *Thomas Cole: The Course of Empire, Voyage of Life* (New York: Cornish, Lamport & Co., 1853), p. 333.

[144] Richard Wunder, *Frederic Edwin Church: An Exhibition Organized by the National Collection of Fine Arts* (Washington, D. C.: Smithsonian Institution, 1966, p. 10.

[145] As quoted in Hendricks, "The First Three Western Journeys of Albert Bierstadt," p. 337.

fect is the characteristic of American scenery; the levels are diffused into apparently boundless prairies, and the elevations spread in grand but monotonous undulations . . . 'High mountains are a feeling'; but here it is liable to be expansive rather than intense."[146] And they craved intensity. What the artists were looking for had changed from a bower to an eyrie.

Nor was it only disappointment over the place; coupled with that was a disillusionment over why the human character had not developed faster and better within it. Henry Tuckerman, the art critic, accurately predicted in 1852 where the general interest would migrate in the next decades. In the 1850s the image of the "better" American, peculiarly conditioned by the environment in which he dwelt, emerged. Since it was no later, however, Tuckerman did not propose a radical migration to the Far West, but only as far as Kentucky, where Daniel Boone exemplified the unspoiled virtues "embodied in the foresters of Scott and the Leatherstocking of Cooper." In Kentucky, "we find the foundation of social existence laid by the hunters—whose love of the woods, equality of condition, habits of sport and agriculture, and distance from conventionalities, combine to nourish independence, strength of mind, candor, and a fresh and genial spirit. The ease and freedom of social intercourse, the abeyance of the passion for gain, and the scope given to the play of character, accordingly developed a race of nobler aptitudes . . . her legitimate children belong to the aristocracy of nature; without the general intellectual refinement of the Atlantic states, they possess a far higher physical development and richer social instincts."[147] The praise of the simple life and the admiration of nature went together in American romanticism. This was the first turn against the East; Eden was evaporating. As virtue wore thin in the complex and feverish pursuit of material gain, the esthetic ambition for the republic increased in absolute terms until the founding of the great national parks of the west, outsized and away, unspoiled and uninhabited, became inevitable, for that was the only way the esthetic ambition could remain untrampled and pure. Ironically, in them the principles of human settlement, communality, and crowning by architecture were finally abrogated too.

Commerce, industry, and the ever-enlarging influence of New York City as the entrance to the Hudson River gradually undermined valid hopes for an amalgam of natural beauties along the Hudson with newly founded suburbs and villas. The articulate reforms of Downing, Davis, Willis, Church, and others were unfortunately transitory, wedged between two eras of exploitation and dislocation of the landscape, which held to no long term literate philosophy. The period before had been brought on by the intense cultivation of backland farms, away from the river, the crudity of the shoretowns, and deforestation after the English took over from the Dutch. "The desolations wrought by the first settlers upon the grand old forests was felt as almost a sacrilege, when once accomplished, and to their children came gentler feelings, prompting them to restore, in the more delicate and graceful forms of artificial groves and lawns, the beauty they had lost." So, it happened in concert with the old farmhouses that "The absolute necessity of being rid of the chilling, comfortless, ungainly dwellings, which satisfied neither the physical wants nor the demands of good taste, soon induced a change in rural architecture, almost magical."[148] This architec-

[146] Henry Tuckerman, "Over the Mountains, or the Western Frontier," *The Home Book of the Picturesque*, pp. 115-116.

[147] Ibid., p. 126.

[148] Book review of Downing's *Architecture of Country Houses* from *The Home Journal*, reprinted in *The Horti-*

tural change toward the Gothic and Italianate had first been inspired by the positive sight of nature itself, as both Thomas Hamilton and Downing had indicated. The final triumphant feature of the Hudson Valley response was the attempt to link and balance landscape gardening with better architecture, with the Gothic villas taking over the task of ultimate refinement.

Hamilton sketched this triple sequence—past, present, and future—when he visited Dr. Hosack at Hyde Park in the early 1830s and reported, "We drove through a finely-undulating country, in which the glories of the ancient forest have been replaced by bare fields, intersected by hideous zig zag fences. . . . No beauty which axe could remove was suffered to remain; and wherever the tide of population reached, the havoc had been indiscriminate and unsparing. The time at length comes, when another and higher beauty takes place of that which has been destroyed. It is only the state of transition which is unpleasant to behold; the particular stage of advancement in which the wild grandeur of nature has disappeared, and the charms of cultivation have not yet replaced it."[149]

By 1855, Willis felt that progress against this earlier decimation was being made: "*A class who can afford to let the trees grow* is getting possession of the Hudson; and it is at least safe to rejoice in this, whatever one may preach as to the displacement of the labouring tiller of the soil by the luxurious idler. With the bare fields fast changing into wooded lawns, the rocky wastes into groves, the angular farm-houses into shaded villas, and the naked uplands into waving forests [a reversion to the Dutch condition, of course], our great thoroughfare will soon be seen (as it has not for many years) in something like its natural beauty."[150] No single environmental art was intended to be worked entirely alone; the aim was for a mutually reinforcing ensemble. It was time to play for the restitution of the land, to further its conscious, visual redemption. But Willis' estimate implied also that this positive gesture with the combined and newly concentrated arts may have come too late. "From the [Catskill] Mountain House, the busy and all-glorious Hudson is seen winding half its silver length— . . . and the traveller, as he looks down upon it, sighs to make it a home. Yet a smaller and less-frequented stream would best fulfill desires born of a sigh. . . . Where the steamers come to shore, (twenty a day, with each from one to seven hundred passengers,) it is certainly far from secluded enough."[151] He wanted to find another home place besides Idlewild, just as he always sought true friends and good health, but the human swarming had by now made finding that next home practically impossible. Between the lofty vision, aided by the removal of the spectator or artist to a greater and greater height on the terrace or escarpment above, and the harsher reality encamped on the shore below, there was a growing, not a lessening, gap.

That the whole setting was being splintered by a perceptual astigmatism and conflict, is also illustrated by the half-humorous, half-sad, story told by Joel Spingarn about Henry Sargent's famous estate of Wodenethe, across the river at Fishkill Landing from Newburgh, which Sargent purchased and started to improve in 1841, initially inspired by Downing's method of layout. The gamut, from the early achievement of the

culturist, V, 3, September 1850, p. 140. On deforestation, see also Barbara Novak, "The Double-Edged Axe," *Art in America*, 64, 1, January/February 1976, pp. 45-50, and, in the same issue, Jay E. Cantor, "The New England Landscape of Change," pp. 51-54.

[149] Hamilton, *Men and Manners*, p. 79.

[150] Willis, *Outdoors at Idlewild*, p. 47.

[151] Willis, *American Scenery Illustrated*, I, p. 105.

triple vistas of George Morris at Undercliff, to the growing threat of commerce and industry on Newburgh Bay, was run, with the resulting problem of trying to bring all of these accumulating and often contradictory elements into some kind of sliding sequence. Spingarn explained that "three different vistas were visible from the three windows in the bay of the library. One vista was so arranged that from a slight distance the lawn seemed to be overhanging the very brink of the river, which was a mile or so away; and when a lady one day noticed Sargent's young son sitting at the edge, and said she would be nervous about having her children fall into the river, this served as a stimulus to Sargent's love of practical jokes, and thereafter when a stranger arrived young Winthrop would often be ordered to sit at this point with a fishing rod in order to add to the verisimilitude and to the visitor's surprise. Factories, quarries, and other evidences of the growth of industrial civilization have played havoc with most of these vistas, or what remained of them after Sargent's death, but he set an example that all the country-seats of his time, large and small, attempted to emulate."[152] Clever and lighthearted the fishing demonstration was; yet it could not retain any weight of influence.

The evolution of the classic Hudson Valley scene was complete—the natural terrace capitalized upon, the finding of scenic apertures to the river and beyond from the house, the difficulty then of bringing far and near, old and new, into visual and conceptual reconciliation, the futility of determining how big the world was from the terrace, and the final intrusion of commerce and industry to disrupt, with their own oversize,

the whole faithful, naive, gentle, and brave experiment in vision. The pathetic vulnerability of Davis' Wildmont to the accumulating industry and commerce behind it (Pl. 5) tells the same story as the vista from Wodenethe. The final breakdown of the Hudson Valley, the first bastion of romanticism, occurred because of new attitudes arising in the post-Civil War decade of 1865 to 1876: an eagerness for expansion, "a reliance on mechanical solutions, a tendency to subdue nature rather than cooperate with it," and an inclination to look upon nature as a form of opposition to men. Practical attitudes took over from a passive admiration of unblemished nature. "Simply to admire the richness of the land was no longer enough."[153] The smaller and more compact picture was to be exchanged for a much larger one, capped by the technical displays of the Philadelphia Exposition of 1876. Determination to settle the West led to landscape activism, by fiat rather than by coordination, appreciation, or learning.

Willis had reported "Brick-yards are our eye-sore, in the scenery of the Highlands. . . . The traveller is expected to be blind to our 'lower story' of landscape. . . . It is a loose and lively fringe to our quiet American neighborhood of sagacious and thrifty farmers."[154] The farmers were to become a diminishing influence in this rapidly changing milieu, hovering between the unskilled laborers below and idealistic artists and intellectuals above. "As building increased all along the course of the river, and particularly New York, the number of brickyards at the water's edge suddenly grew large. They gave a hearty welcome to the thousands of Irishmen whom hard times, the potato famine, and dreams of a land of plenty

[152] Spingarn, "Henry Winthrop Sargent and the Early History of Landscape Gardening and Ornamental Horticulture in Dutchess County, New York," p. 57.

[153] J. B. Jackson, *American Space: The Centennial Years, 1865-1876* (New York: W. W. Norton & Company, Inc., 1972), p. 19, pp. 37-38.
[154] Willis, *Outdoors at Idlewild*, p. 396.

31. Poughkeepsie Foundry at Night. Not a diurnal peace, but a nocturnal inferno, later prevails on the Hudson (*Bryant*, Picturesque America).

brought to the mouth of the Hudson."[155] These harbor immigrants were also brought farther upriver to work in the forest industry and in cement mining at Rosendale. Iron-works too became a factor, with laborers tending the smoke and flame at night (Fig. 31). From Mt. Greylock in western Massachusetts it was possible to watch the smoke of furnaces all along the Hudson.[156] Daniel

Wise in his book of summer travels, published in 1875, cited the little cottages below the Palisades just above Fort Lee to illustrate his regret over the disappearance of the romantic paradise: "The little cottages, lying in such cosy nooks at their base, wore a charming air of quiet, which led to renewed expressions of regret that this lovely little vale should be spoiled, as a place of residence, by the graceless hordes of uproarious pleasure seekers from New York, who make it their resort, especially on the holy Sabbath. Presently, they passed Guttenberg,

[155] Carl Carmer, *The Hudson* (New York: Grosset and Dunlap, 1968), p. 266.
[156] "In Western Massachusetts," *Harper's New Monthly Magazine*, V, LXI, November 1880, p. 884.

with its huge lager beer brewery built into the cliff, like a fortress of the Evil One. Shortly after, they were opposite Weehawken . . . once the delightful retreat of heat-oppressed New Yorkers in summer time, but now disfigured by the cattle yards of the Erie Railroad."[157] Two decades earlier, writers had voiced apprehension about what the railroads might do to the landscape. "Whether human ingenuity will yet succeed in inventing substitutes for the smoke and other unpleasant appliances of a railroad train, remains to be seen; but we think few will be disposed to differ from us, when we say that in our view of the matter this great improvement of modern intercourse has done very little towards the embellishment of a country in the way of landscapes."[158] Thomas Cole had similar doubts, and in 1840 asked the Catskill Lyceum to debate the question, "Are railroads and canals favorable or unfavorable to the morality and happiness of the present generation in the United States?"[159] Edwin Whitefield's sketch of a train coming into Cold Spring station (Fig. 32), the eastern shore village of George Morris' Undercliff, with Mt. Taurus faintly visible in the background, shrinks the size of the four passenger cars, and the engine still more, in order to reveal the porch of the picturesque station and the arrangement of the natural landscape around it, with a peek at the Hudson and the hills behind Newburgh visible down the tracks. The artist wishes the train were not there. For the committed Hudson River artist it appeared legitimate to make toys out of technology. Previously such objects were seen as miniatures only from the height of the mountains.[160]

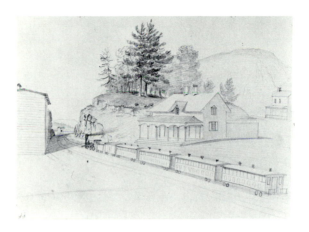

32. *Train at Cold Spring, Edwin Whitefield (Winterthur Museum, Joseph Downs Collection).*

One of Willis' anecdotes illustrated the impact of intrusive activity upon quiet domesticity, even before the industrial boom of the Civil War period had taken its toll: "One of our neighbors, last Saturday noon, March 25, 1854, however, might reasonably have relinquished for a moment his moral appetite for the dinner cooking before him—no less a passenger than a *neighboring hill* crossing the road, as he stood in his kitchen; and, after a leisurely glide, along what was almost a level of three hundred feet, stopping and standing like any other hill, on the bank of the river! His house was a new one, of two stories; and if its foundations had been laid but a few feet further north, it would have been swept under, with all his women and children, like a crushed band-box. It will be understood, of course, that this was a slide of a clay-bank, occasioned by the excavations of brick-making . . . for these brick-yard diggings have been the disfiguring of one of the most lovely spots on the shore of the Hudson."[161]

[157] Daniel Wise, *Summer Days on the Hudson* (New York: Nelson and Phillips, 1875), p. 40.

[158] Cooper, "American and European Scenery," p. 65.

[159] Matthew Baigell, *Thomas Cole* (New York: Watson-Guptill Publications, 1981), p. 66.

[160] Benson J. Lossing, *The Hudson* (Troy, N.Y.:

H. B. Nims & Co., 1866), p. 215, writes of trains and steamers looking like "toys for children," but it is from the considerable height of the summit of Storm King.

[161] Willis, *Outdoors at Idlewild*, pp. 338-339. Such remote and previously idyllic villages as Morris' Cold Spring were even disturbed by the 1880s: "Cold Spring is a black spot on the beauty of the surrounding

There was too much competition, displacement, and intrusion; too many raw materials gashed out by resource-hungry enterprises; too much background noise, dirt, smoke, and squalor; too many trains for the intellectual and artist-in-residence, who sought quiet, detachment, health (in Willis' case), and reassuring unity; and from all of these a certain elevation and satisfaction of the spirit. When the prospect could not be kept in proportion or integrated, because of the increasing number of graffiti being imposed by New York City and its immediate environs, they determined to move west. Wallace Bruce, the travel guide, proposed a hypothetical trip from the Hudson Valley to the far distance of the Yosemite Valley. The "other" valley's sides were eminently higher, smoother, more upright and dense, than those of the Hudson Valley. Its lofty cliffs also promised an equivalent to those remotely remembered European Alps. Because Yosemite had thus far remained above worldly strife and had not been secularized, it represented not a provincial, but a "world's Cathedral":

> Alone in a Temple vast and grand,
> With spire and turret on every hand;
> A world's Cathedral, with walls
> sublime,
> Chiseled and carved by the hand of
> time.[162]

The massive silence of Yosemite, an organic, glyptic entity in equilibrium, like the inside of a stone cathedral, would enable artists and intellectuals to pause, refresh, and reorient themselves within it. If they could not establish serenity in the Hudson Valley landscape, because more aggressive American concerns cropped up more constantly, they would allow the Puritan model of communality amidst the cultivated fields, which had flourished in the Connecticut Valley, and had been so much admired by Downing, to wither and lapse. They would opt instead for an individualistic communing with a still more rare and exquisite object of nature, only recently discovered. It was a quick way out of the chronic American condition of tension and restlessness, when confronted by a rising impotence and frustration in the face of the unfolding Eastern culture. An alternate to the Hudson Valley was known to exist, and that made escape for the intellectual especially feasible. "When the merchant's culture began to spread along rail lines toward the wilderness and his numbers caused human voices to ring through the forest, at least in summer, the obsession with the primeval that drew men up the Hudson in times past now turned their course westward."[163] California would provide a replacement for the now desiccated Hudson scene, an alternate "geography of the ideal." Had it happened too soon? The most positive aspect of California then was that it was understood as being not quite yet in the United States. Thus an appropriate and convincing place and people might still be found outside in Arcadia instead!

scene. It has several iron-foundries, the chimneys of which pour out wreaths of smoke . . . " J. D. Woodward, *The Hudson River by Pen and Pencil* (New York: D. Appleton & Co., 1889), pp. 34-35.

[162] Wallace Bruce, *From the Hudson to the Yosemite: A Holiday Souvenir* (New York: American News Co., 1884), p. 95.

[163] James E. Vance, Jr., "California and the Search for the Ideal," *Annals of the Association of American Geographers*, 62, 2, June 1972, p. 191.

Yosemite

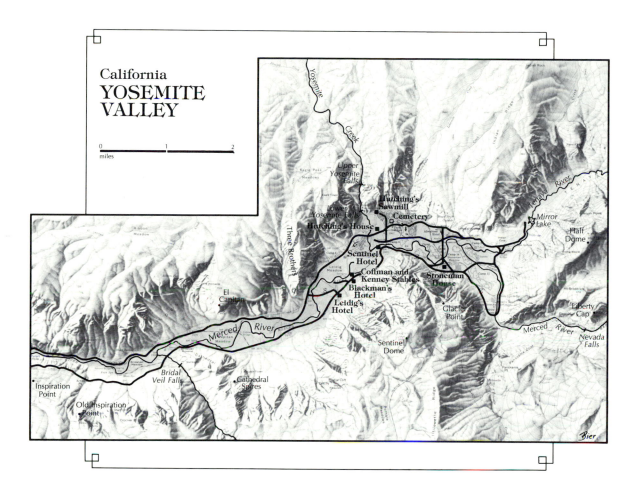

California
YOSEMITE VALLEY

0 1 2
miles

YOSEMITE Valley (see map) came as a startling revelation from within a very remote area of the Sierra Nevada mountains—first after its discovery by Dr. L. H. Bunnell in 1851, and again after the completion of the transcontinental railroad in 1869. Many honed their powers of esthetic analysis on its great spectacle. Its granite domes offered a gallery of monumental sculptures 3,000 to 3,200 feet high, three times the height of the Hudson Highlands. Science, art, and religion were used, sometimes together, sometimes separately, to try to draw meaning from this phenomenon. There were considerable differences of opinion over where Yosemite came from and what to do with it among strong individualists, such as the landscape architect Frederick Law Olmsted, the geologist Josiah Dwight Whitney, and the naturalist John Muir, which were to be partially resolved when Muir finally persuaded Theodore Roosevelt to make every bit of it into a national park after his visit of 1903.

99

Between 1850 and 1910 the Valley gained international repute, and was judged by many the most beautiful spot in the United States. But it remained at least once removed psychologically from its immediate surroundings in California which were often dry, dusty, and immature, with their populations in hot pursuit of minerals—people who did not match the sanctuary. It was a miracle that the contents of Yosemite were saved at all from these unmanageable impulses. The threatened takeover by external agents resulted in the Great Dispute of 1889-1890 as to who was to control Yosemite. Its remoteness, fixity, solidity, and evident derivation from colossal forces, when contrasted with the silver light of waterfalls, the gray stones, and a peculiarly soft blue haze in the void, provided more than enough wonder for all. Its quality as an integrated space made it unique. Yosemite stood apart, but grew into a scenic lodestar without parallel because so many artists and intellectuals wanted to enter into a dialogue over it.

THE Yosemite Valley was simultaneously an unimaginable flight of fancy and a preemptive vision of actual, giant, three-dimensional boulders, standing taller than it was wide. It was particularly congenial to the national mood evolving first out of the era of romanticism and next out of the tragedy of the Civil War. Because it was only seven miles long, compared to the one hundred and fifty miles of the Hudson Valley, it could be taken in with one protracted glance. The art of architecture surmounting was judged unnecessary to its future, and was indeed often rejected as a taint by its custodians. Once the spectator was permanently committed to Yosemite, there was no way to look up and over its ramparts, to encourage the attention to wander outside, as had happened in the Hudson Valley. The disregard of this extraterritorial inference meant that poetic inclinations could be more fully indulged inside.

Transcendentalism assumed that the Supreme Deity would be revealed to the persistent seeker through nature. The discovery and subsequent scrutiny of Yosemite, which offered fortunate proof of this doctrine, was bound to be heralded across the country, and even in Europe, by means of travel books, paintings, prints, and newly developed photographic techniques. The rapid expansion of the nation after the Civil War, and the arrival in California of the transcontinental railroad in 1869, also implied that a democratic population should have ready access to its intricacy, made so exclusive by nature. "Most of the early visitors to Yosemite were Californians, and the number did not amount to one thousand in any one season until the completion of the Union and Central Pacific railroads. Soon after the number increased to many thousands annually."[1]

HOW YOSEMITE APPEARED AT FIRST

In Yosemite, at last, Art might become a consonant part of Science or Religion, as one more of the heretofore unfulfilled pledges to Science and Religion of the nineteenth century. To the geologist Francois E. Matthes in the twentieth century it was a Science display documented through a naturalistic art gallery: "No other chasm of this continent, nor perhaps any continent, possesses within so small a compass so remarkable an assemblage of uniquely sculptured cliffs and monuments."[2] The custom was then, and now, to look into this colossal sculpture gallery from Inspiration Point (Fig. 1), also called the "Stand Point of Silence." The Rev. J. M. Buckley reported one spectator's inability to form an adequate response to this view: "A lady from New England, whom I did not know, stood entranced with the beauty and grandeur of the scene. At last, turning to the lady who accompanied her, she said, 'That

[1] Galen Clark, "Yosemite—Past and Present," *Sunset Magazine*, 22, April 1909, p. 394.
[2] F. E. Matthes, "King's River Canyon and Yosemite Valley," *Sierra Club Bulletin*, XII, 3, 1926, p. 226. See also John Muir, "Mountain Sculpture," *Sierra Club Bulletin*, IX, 4, 1915, pp. 225-239.

is kind of pretty, isn't it!' I felt unspeakable contempt for one who would dare to apply any thing less than sublime to such a spectacle."[3] Yosemite characterized better than any other site, perhaps even better than the Hudson Valley, the disturbing gap in comprehension between the educated and the untutored when confronted with nature.

Quiet contemplation was the most difficult mood for early lay visitors to capture, because they were normally so action oriented, and had never seen anything of such majestic proportions. On the other hand, Reverend Buckley could not carry eighteenth-century English terms as "sublime" too far, since the prospect did not suggest fright. The pioneer from New England was tongue-tied. But Yosemite seemed to make intellectuals loquacious or eloquent. Charles Loring Brace, a friend of Frederick Law Olmsted, wrote on a trip from the East in 1867-1868, "Even the awe-inspiring grandeur and majesty of its features do not overwhelm the sense of its exquisite beauty, its wonderful delicacy, and color, and life, and joy."[4] Sharply contrasted to this were the attitudes of post-Civil War intellectuals toward cities. John Muir and Olmsted regarded them with an uneasiness bordering on alarm. Muir especially felt that one might go astray or become disoriented in any large building or town. For that reason he was unable to visit Olmsted's Central Park in New York. "I saw the name Central Park on some of the street cars and I would like to visit it, but fearing that I might not be able to find my way back, I dared not make the adventure. I paid forty dollars for the trip to San Francisco. . . . As soon as I landed in San Fran-

cisco I asked a man the nearest way out of town. 'Where do you want to go?' he inquired. 'Anywhere that's wild'; and I found my way on foot to this wonderful valley."[5] Even the first and largest public park was regarded with apprehension if surrounded by city buildings, whereas Yosemite Valley with towering cliffs on every side was entered with assurance and relief. Walls of buildings, despite being lower than some natural barriers, were "bad."

Olmsted, too, echoed the feeling of welcome security in his first impression of Yosemite, "Of course it is awfully grand, but it is not frightful or fearful."[6] Olmsted was, in that year, 1864, a refugee from military action, where he had been second to the Rev. Henry Bellows in charge of the War Sanitary Commission, later to be the Red Cross. Yosemite was therefore for him, as it was for many others, a solace from the fratricide of war, as well as from urbanism. Olmsted was also in heavy debt from New York publishing ventures. Nor had things been going well at the Mariposa Gold Mines in nearby Bear Valley, which he had undertaken to manage in 1863 for an eastern syndicate of businessmen, connected with Gen. John C. Fremont, the nominal owner.

On June 30, 1864, President Lincoln signed a bill ceding the Yosemite Valley to the State of California; Olmsted was appointed by Gov. Frederick Low to chair the commission to control it.[7] Olmsted's fundamental attitude toward Yosemite had to do with what might be called the aura of its

[3] Rev. James Monroe Buckley, *Two Weeks in the Yosemite and Vicinity* (New York: Phillips and Hunt, 1884), p. 21.

[4] Charles Loring Brace, *The New West: or, California in 1867-68* (New York: G. P. Putnam and Son, 1869), p. 110.

[5] Brother Cornelius, *Keith: Old Master of California* (New York: G. P. Putnam and Son, 1942), p. 56. Robert U. Johnson mentions that Muir got lost in the corridors of the Palace Hotel in San Francisco when he went looking for Johnson. *Remembered Yesterdays* (Boston: Little, Brown and Co., 1923), pp. 279-280.

[6] Letter from F. L. Olmsted to his father, August 1864 (no day), FLO Collection, Library of Congress, Box 32.

[7] Olmsted to Governor Low, October 19, 1864, California State Archives.

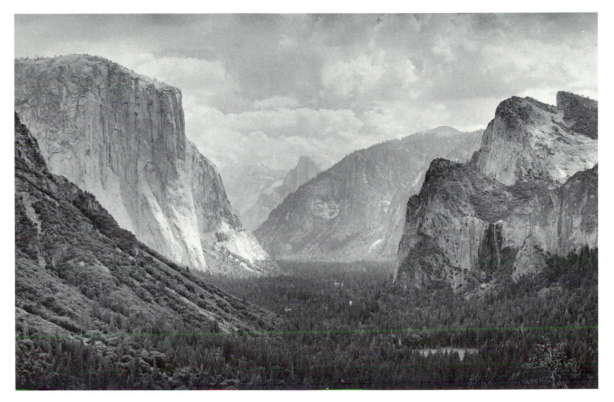

1. Yosemite Valley from Inspiration Point (Thomas A. Heinz).

eternal presence, its welcome timelessness. But the more common American reaction to its multifarious wonders was represented by observations such as those of William and Sara Riley. " 'Surely,' the reader will say, 'you now were in a condition to rest.' Perhaps so, but maybe the reader has never been in the Yosemite and felt the impulse, constantly accelerating, to keep on and see all possible points of interest."[8] Olmsted's preference was to remain more fixed to one spot, "to rest," rather than to scurry about from point to point, in the older, more exploratory American fashion. "No photograph or series of photographs, no paintings ever prepare a visitor so that he is not taken by surprise, for could the scenes be faithfully represented the visitor is affected not only by that upon which his eye is at any moment fixed, but by all that with which on every side it is associated, and of which it is seen only as an inherent part."[9] The volumes, masses, and towering heights were larger than any ever encountered before, there were more of them, and they were each different, but the lateral dimensions were much smaller and looked more tranquil, damping down the pioneer enthusiasm for movement. It combined the reassurance of a valley with the thrill of many different peaks rising above it. The artist or intellec-

[8] William H. and Sara King Wiley, *The Yosemite, Alaska and the Yellowstone* (New York: John Wiley and Sons, 1893), p. 119.

[9] F. L. Olmsted, "The Yosemite Valley and the Mariposa Big Trees, A Preliminary Report," Laura Wood Roper, ed., *Landscape Architecture*, XLIII, 1, October 1952, p. 16.

tual could put a valley totally together in consciousness here, as had been hoped with the Hudson Valley. The swelling anxieties and psychological bruises from the massive physical presence of a whole continent, a war, and a bulging and dynamic urbanism, could thus be reduced and ameliorated in this unique setting.

ANTI-MEASURE AND PRO-MOISTURE

Olmsted recognized without difficulty the preoccupation with point-to-point movement, linear measurement, and overly observed detail, but he was opposed to it from the start. "For the same reason, no description, no measurements, no comparisons are of much value. Indeed the attention called by these to points in some definite way remarkable, by fixing the mind on mere matters of wonder or curiosity prevents the true and far more extraordinary character of the scenery from being appreciated."[10] At first glance, the impression of the valley was monumental, yet in fact it was only a third larger than Olmsted's Central Park. Olmsted objected to fixing attention on waterfalls, tall trees, or even the much-praised reflection in Mirror Lake, for regardless how intriguing these features might be in themselves, they tended to nullify the sense of the whole: "By no statement of the elements of the scenery can any idea of that scenery be given, any more than a true impression can be conveyed of a human face by a measured account of its features."[11]

What Olmsted *was* receptive to as a detail was the "mute" element to carry the unifying message—the stream flowing quietly through "the ferny and bosky glades" among the trees. This subordinate, but quietly con-

stant, feature made it more possible to call attention to what Olmsted considered the main ingredient for the final fusion into the whole—the atmospheric illumination—which reconciled all differences. Hence the emphasis on details seemed to Olmsted a "vulgar blunder." He declared that the cascades "are mere incidents of far less consequence any day of the summer than the imperceptible humidity of the atmosphere and the soil."[12] Spring, with its thunder of waterfalls, was not his favorite season at Yosemite. Like Starr King, the Unitarian-Universalist minister from Boston who preached on the wonders of Yosemite, Olmsted preferred Yosemite in September. Then, he observed, "a light, transparent haze generally pervades the atmosphere, giving an indescribable softness and exquisite dreamy charm to the scenery, like that produced by the Indian summer of the East."[13] It was the sight of that gentle and peaceful atmosphere, on the frontier, which captivated him, for it seemed a paradox. However, another, but earlier, New Englander, Ralph Waldo Emerson, conveyed a starker impression, looking for the underlying strength of the valley in its glyptic forms, which stripped "themselves like athletes for exhibition, and stand perpendicular granite walls, showing their entire height."[14]

The soaring strength of the blue gray cliffs appeared literally to spring from the lush green meadow below (Pl. 6). Olmsted spoke of this as a "rare association." It satisfied the Victorian appetite for a marked richness and contrast in scale, body, tonality, and texture. To substantially modify the cliffs and their waterfalls was far from within the power of those hundreds of visi-

[10] Ibid., p. 17.
[11] Ibid., p. 16.

[12] Ibid.
[13] Ibid., p. 15.
[14] R. W. Emerson, *Journals and Miscellaneous Notebooks*, William H. Gilman, ed. (Cambridge: Belknap Press, 1960), p. 354.

tors increasingly present, together with the factors who served them, but the floor of the valley could be easily uprooted and mangled by them. In a letter of August 1864, Olmsted referred to this floor as the "Meadows of Avon."[15] At the end of this critical era for Yosemite, 1860-1910, Galen Clark, Guardian of Yosemite, described the meadows as having been more like an Indian park: "In the early years, when first visited by white people, three-fourths of the Valley was open ground, meadows with grasses waist high, and flowering plants. On the dryer parts were scattering forest trees, pines, cedars and oaks, too widely separated to be called groves, clear of underbrush, leaving clear, open, extensive vision up and down and across the Valley from wall to wall on either side. The Indians had kept the Valley clear of thickets of young trees and brushwood shrubbery so that they could not be waylaid, ambushed or surprised by enemies from outside and to afford no hiding places for bears or other predatory animals, and also to clear the ground for gathering acorns, which constituted one of their main articles of food."[16] When Clark was reappointed following the protests of 1889, one of the first tasks he set himself was again to clear the underbrush from the floor of the canyon. The guidebook of 1868 also described the meadows much as Clark and Olmsted must have initially seen them: "The bottom is covered with a luxuriant growth of grass, and the greater part of the surface is a beautiful prairie. Trees and bushes abound near the stream."[17] An account published

four years later reads, "The meadows are covered with coarse, scant grass; and innumerable flowers, generally of exceeding delicacy, find choicest beds in slight depressions, where the water lies longest. Through these meadows the Merced River winds from side to side, during the summer an orderly stream, averaging, maybe, seventy or eighty feet in width, the cold snow-water shimmering in beautiful emerald greens as it flows over the granite-sand of the bottom. Its banks are fringed with alder, willow, poplar, cotton-wood, and evergreens."[18]

The essence of Yosemite came from this meadow carpet abruptly contrasting with the towering cliffs. One early visitor pointed out that in Europe one could gaze at the Jungfrau from five miles away and at an angle of twenty-five degrees up, but "at Yosemite you need but climb a few rods up the rocks at the base of that granite wall, and leaning up against it, you may look up—if your nerves are steady enough to withstand the impression that the cliffs are falling over upon you—and see the summits above you, at an angle so nearly ninety degrees; in other words, you will behold a mountain top three thousand feet above you *in the zenith*."[19] From the resilient meadow below to the solid wall adjacent, and thence on up to infinity (Fig. 2) was a natural progression.

THE INCARCERATION RESPONSE

Yosemite was capable of producing other responses, too. John Muir, the son of poor Scottish immigrants and originally from midstate Wisconsin, found the reflection of

[15] Letter from Olmsted to his father, August 1864.

[16] Galen Clark, "Yosemite—Past and Present," p. 395. Robert P. Gibbens and Harold F. Heady, *The Influence of Modern Man on the Vegetation of Yosemite Valley* (Berkeley: University of California Division of Agricultural Sciences, 1975), pp. 21-25, discuss "Changes in the Meadows." This valuable item was brought to my attention by Thomas A. Heinz.

[17] John S. Hittell, *Yosemite: Its Wonders and Its Beau-* ties (San Francisco: H. H. Bancroft & Co., 1868), p. 29.

[18] William Cullen Bryant, ed., *Picturesque America* (New York: D. Appleton & Co., 1872), I, 2, p. 480.

[19] J. David Williams, *America Illustrated* (New York: Manhattan Printing and Publishing Co., 1877), p. 71.

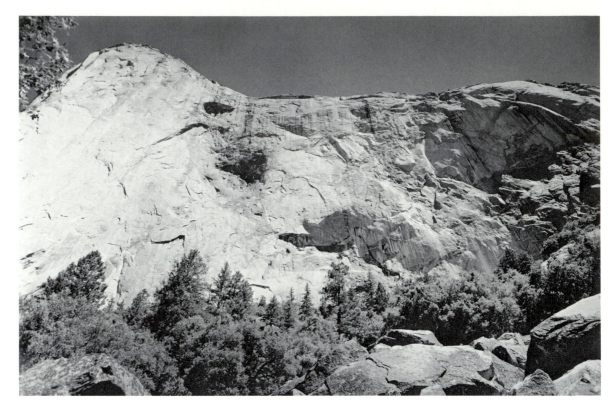

2. Cliff, Yosemite (T. A. Heinz).

his own Byronic energy in the Yosemite, rather than the tranquility sought by Olmsted. He rode the wild tree tops in a storm, inched out under the waterfalls over slippery stones, and strode the dangerous glaciers of the Sierras above Yosemite in attempts to unravel their mysteries. In an earthquake he ran out to exult over the anchorless effect of its vibrations and upheavals.[20] Like Nathan P. Willis in the Hudson Valley, Muir became a popular writer through his commitment to action and enterprise—a peculiarly American type of unintellectual intellectual.

Others were attracted by the sense of subsurface enclosure. This focus on the waiting depths was probably more pronounced at the outset, when ingress was possible only

by pack mule (Fig. 3). "Other valleys you expect to enter and pass through. To get into this you must climb *down* three thousand feet, and when you have seen it, climb *up* out of it again."[21] This experience could be trying, if not downright hazardous, even for a well-seasoned Congregational minister and his wife. "It was truly appalling. . . . The path was not more than a foot wide, and ran in a zigzag course down the mountain side. My wife was secured from falling over her horse's head by a strap which kept her in her seat."[22] The conviction of being there and nowhere else upon reaching the floor, brought the satisfactions of an ultimate goal reached. C. F. (Constance Frederica) Cum-

[20] John Muir, *The Yosemite* (New York: Doubleday and Company, Inc., 1962), p. 59.

[21] John Todd, *California and Its Wonders* (New York: J. Nelson and Sons, 1880), p. 88.
[22] Rev. J. C. Holbrook, *Recollections of a Nonagenerian* (Boston: Pilgrim Press, 1897), p. 138.

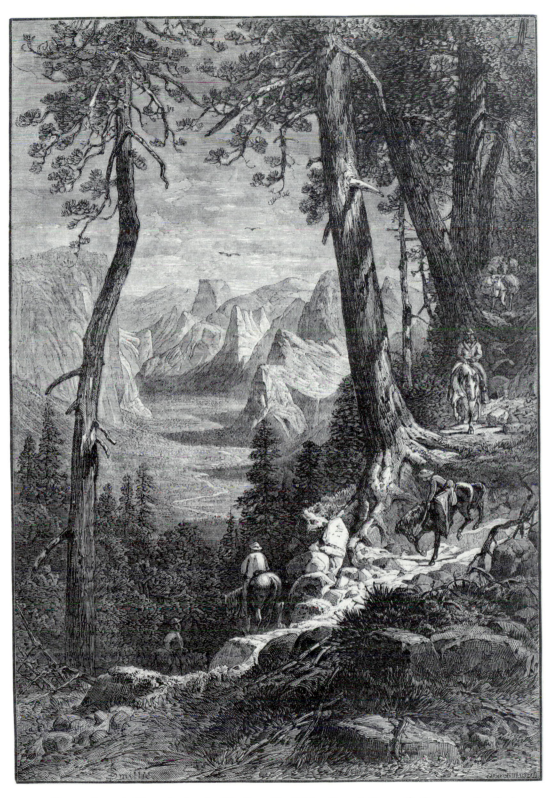

3. Descent into the Yosemite by the Mariposa Trail (Appleton's Journal, *January 18, 1873*).

ming wrote home to England about the wonders of her world tour, which included a stop-over in Yosemite, in 1878: ". . . to me half the charm of this place is, that though there are now a great number of people in the valley . . . there is not the slightest occasion ever to see any one, except at meals." And, "Already I feel quite at home in my granite prison, and love its walls and every corner within them, each day revealing new beauties and interests."[23] Yosemite was a rendezvous in which to take up one's most cherished activity (watercolor painting in her case), but also a place where one might remain hidden and safe for all time, much as in a landscaped cemetery.

The welcome prison theme runs through the assessments of many early observers. The Rev. Thomas Starr King had reluctantly yielded to the call to San Francisco from Boston in April 1860, partly to try to keep California in the Union. His letters to the *Boston Transcript* followed the format of his earlier essays on the White Mountains of New Hampshire, comparing the latter (seat of the White Mountain School of painting, closely allied with the Hudson River School) to the California Sierra Nevada. He sought to bring Yosemite closer to the predispositions of his native Boston. Photographs of the Valley had been regularly exhibited in his drawing room in Boston and in the study of Dr. Oliver Wendell Holmes there.[24] Starr King succumbed to diptheria on March 4, 1864, at the age of thirty-nine,[25] just as Yo-

semite was becoming nationally recognized as worthy of preservation. But, from his trip shortly before into the Sierras he wrote of Yosemite, "The whole trench is seven or eight miles long as we have said, between the highest walls. . . . At our left, on the west, we could follow the course of the beautiful Merced for a dozen miles, as it flowed down from its grim prison, between the dwindling ramparts. No, let me take back both words, the 'prison' and the 'grim.' It ought to look so, but it does not."[26] Instead, it possessed "a grave cheerfulness." New England Unitarians and Transcendentalists, such as Channing and Emerson, and friends of Olmsted, such as the Rev. Henry Bellows and Starr King himself, with both of whom Olmsted had discussed political problems in California, attempted for so long to rethink the social environment that the social imagery fastened itself upon this natural setting too.[27] Neither human nature nor God's nature could be easily ignored in California.

King's writing on the White Mountains followed Thoreau's *Walden* by only five years. He delivered a sermon on Yosemite in July 1860,[28] replete with "religious lessons," such as "Who is insensible to the wonders of nature is indifferent to the patient and continuous art of God." By now he was keenly conscious of the need to seize untoward differences in American environmental proportions, social or natural, for "lessons." He

[23] C. F. Cumming, *Granite Crags of California* (Edinburgh: William Blackwood and Sons, 1886), pp. 189-190. Her watercolors of Yosemite are reproduced in William Truettner and Robin Bolton-Smith, *National Parks and the American Landscape* (Washington, D.C.: Smithsonian Institution, 1972), pp. 113-114.
[24] Fritz Hugh Ludlow, *The Heart of the Continent* (Cambridge: The Riverside Press, 1870), p. 412.
[25] Kevin Starr, *Americans and the California Dream 1850-1915* (New York: Oxford University Press, 1973), p. 104. Pp. 97-105 contain an excellent summary of Starr King's exhausting activity.

[26] Thomas Starr King, *A Vacation Among the Sierras, Yosemite in 1860*, John A. Hussey, ed. (San Francisco: The Book Club of California, 1962), p. 43. In the *Boston Transcript* the articles ran December 1, 15, 31, 1860: January 12, 19, 26, and February 2, 9, 1861.
[27] Albert Fein was the first to bring out this important connection of Bellows and Starr King with Olmsted. See especially his "The American City: The Ideal and the Real," *The Rise of an American Architecture*, Edgar Kaufmann, Jr., ed. (New York: Frederick A. Praeger, 1970), pp. 51-57.
[28] Thomas Starr King, "A Visit to the Yo-Semite: Its Religious Lessons," July 29, 1860, Manuscript 280, Boston Public Library.

highlighted this disparity at Yosemite by pointing out that while the trees at the bottom of the canyon were gigantic, "noble trees of two hundred feet stature," when observed from the crags above they seemed strangely diminutive. Similarly, from across the chasm the waterfalls appeared to be falling slowly, even though the observer knew that they were crashing with great speed. The shock of these contrasts of dimension was needed to bring on a spiritual realization. The towering stone parapets of the valley "break in, for a moment if no more, upon our materialistic and sceptical estimate of the world, and show us that it is penetrated with Divine meaning." King recognized the autumnal gentleness of the meadows, but in the final analysis he also emphasized the Emersonian concept of the manifestation of power. Thus, the dome of El Capitan was "one piece of solid, savage granite, wh. seems to have sprung up over the flowing river and the fertile meadow to show [Pl. 6], by contrast, what the majesty of the *Infinite* is as compared with his beneficence, and how tremendous are the forces of cohesion that have compacted the bones of the globe." The solid sides of Yosemite were so unlike the soft and yielding curves of the New England mountainsides, he said.

But in every Yankee company there were also those who interpreted objects in a straightforward and utilitarian manner. The Rev. John C. Holbrook, a New England Congregationalist, did not admire either Unitarianism or Channing. Holbrook drily reported to a San Francisco paper, "The thought occurred to me that [Yosemite] would be an admirable place for a penal colony or State prison."[29] Another visitor shriveled Yosemite to a hollow monolith by advising folks back home that they should

"Imagine an enormous horse-trough, the sides of which are of solid granite."[30] Others could summon up little more than a "Gosh a'mighty" to describe it. The ministers and poets of Transcendentalism were needed to elaborate and articulate nature because of the muteness and lack of vigilance of their simpler contemporaries, bent on other goals. The country was big, but the run-of-the-mill American sensibility to go with it was not yet big enough.

THE SALUBRIOUS MICRO-CLIMATE

Within Yosemite a diversity of human encounters was possible, depending upon the temperament brought to it; but the pronounced difference between its climates—moral, religious, esthetic, scientific, or physical—and that of the outside brought on the greatest joy. Of San Francisco, the place to begin the journey to Yosemite, Charles Loring Brace said, "There are no large trees in the city, and no parks [the sea winds were too strong]. The dust, too, of San Francisco has never been properly subdued."[31] Olmsted wrote to the Rev. Henry W. Bellows that if he came to San Francisco to take over the pulpit of Starr King, he could justifiably carry on the latter's beneficial influence "in the training of communal civilization in the various vague centers where it has a nebulous tendency to thicken,"[32] which supposedly included outer settlements like Bear Valley, six miles from Yosemite, where Olmsted then resided in charge of the Mariposa Gold Mines. Olmsted described the atmosphere of San Francisco itself as that of "an ordinary Western large town taken up and thrown down on the Pacific shore a little

[29] *The Pacific*, July 7, 1859. Holbrook's entire trip to Yosemite is included in his *Recollections of a Nonagenerian*, pp. 137-146.

[30] William Minturn, *Travels West* (New York: 1878), p. 253.
[31] Brace, *The New West*, p. 39.
[32] Olmsted to Bellows, April 28, 1864, Massachusetts Historical Society.

the worse and a little more disjointed, perhaps, for the jar—of the absolutely superficial, unrooted and veneered character of all that you see of all that which looks like civilization (in its radical sense) in California."

Olmsted promised Bellows that if he came they would travel to Yosemite "very slowly, for you must have time for contemplation and absorption. . . . above the heat and the drought." As on pilgrimage roads abroad, one was meant to suffer along the way to the sanctuary. The heat and dust of the San Joaquin Valley (pock-marked by abandoned mining ravines), and the jolting of the stage were highly stressful, even for the young. One Olive Logan described a trip there in 1870. "We are all youngish persons, gay, healthful, and bound for the Yo Semite Valley. Pretty soon the sun's rays begin to fall heavily. There is not a breath of air stirring. . . . It would be an impossibility for any road in an Eastern State to be so dusty, try as it might, for its soil is nowhere parched with six months drought."[33] Higher up, the atmosphere changed, or rather Yosemite generated its own climate—dry and dust free, with cool downdrafts in the evening, and updrafts on one side or the other on the warmer days.[34] Vegetation came a month earlier on the northern wall, because of its southern exposure. It could be spring on the north side while the south side remained in winter, with the former blooming flowers in rock-protected niches every month of the year.

Starr King implied that one might react spiritually to this micro-climate. Life outside was destitute. "We live on flat barren land." Yet some were also incapable of creating a respite for themselves by the exercise of

their inner resources. "Some have no magnificent landscapes for the heart, no grandeurs of the inner life." But now, after actually crossing the United States, King felt that the Yosemite "was delightful, in the hot July afternoon when the mighty ramparts of the meadows barred the sun's rays, and enabled us to ride or walk in the shade. Then I thought of the verse I have taken for the text, and of those words of Isaiah—'the shadow of a great rock in a weary land,' "[35] by which he meant a war-torn country. The American throve on metaphors, but Yosemite was not a figment of the biblical imagination, rather a genuine shaded location accessible to refresh all after an arduous journey. It was a spiritual surprise enclosed in granite.

In his effort to capture the essence of Yosemite's effect, Olmsted revealed himself again as the inveterate Victorian. Like John Ruskin, whom he had read, he wanted the esthetic experience to be notable, with the mind then setting the tone for the body. "If we analyze the operation of scenes of beauty upon the mind, and consider the intimate relation of the mind upon the nervous system [both Ruskin and Olmsted suffered from nervous disorders] and the whole physical economy, the action and reaction which constantly occur between bodily and mental conditions, the reinvigoration from such scenes is readily comprehended."[36] The Valley conferred an extra benison of wellbeing upon its beholders.

Could these elevated mental states of gentle beneficence actually be carried over into physical wellbeing, as Olmsted appeared to believe? At least two physicians suggested that they could. Dr. Samuel Kneeland, secretary of the Massachusetts Institute of Technology (1865-1878), an inves

[33] *Yosemite: Saga of a Century, 1864-1964* (Oakhurst, California: 1964), p. 15, reprinting an article in *Galaxy Magazine* of October 1870.
[34] F. E. Matthes, "The Winds of the Yosemite Valley," *Sierra Club Bulletin*, VIII, 2, June 1911, pp. 89-95.

[35] Starr King, *A Visit to the Yo-Semite*, p. 34.
[36] As quoted in Roper, ed., "The Yosemite Valley," pp. 20-21.

tigator of puerperal fever with Dr. Oliver Wendell Holmes, a Civil War veteran, and secretary of the American Academy of Arts and Sciences, came to Yosemite on the transcontinental railroad in July 1870. "Among the health inducements for travel here are the invigorating air, the pure cold water, and the exercise, which though often severe, cannot fail to strengthen an ordinary traveller, refreshed as he is, at night, by excellent food and comfortable bed; when to these is added the grand and beautiful scenery in this immense panorama of mountains, surely no further inducement is necessary for one to journey to this valley, brought within a week's easy travel of the farthest Atlantic seaboard."[37] A later assessment remained much the same. Dr. Charles Cross spent a season at Yosemite in 1901 as "pioneer resident physician." He claimed that "as a resort for healthy people few places can surpass the Yo Semite Valley. . . . As a resort or as an outing for convalescent or semi-invalid the Yo Semite and the surrounding country offers the best mountain accommodations and most excellent climate in the West, and as for scenery there is but one Yo Semite in the world, and Big Trees grow only in California."[38] He did not advise those suffering from pulmonary insufficiency or rheumatism to linger too long, but the majority of other diseases were warded off or handled with facility by him: "acne vulgaris, cured; accidental abortion, cured; biliousness, cured; circumcision, cured; fish-hook in finger, cured; three hysterias, relieved; one nostalgia, not improved; one over-exertion, cured." Both physicians expressed concern about responsibility for the grounds from the onslaughts of undisciplined tourists and selfish private interests. Cross made his report during the second, intemperate wave of agitation for the return of the park to the nation from 1889 to 1903: "As a state institution the management of the Yo Semite from beginning to end is a disgrace."[39]

PAINTERS AND PHOTOGRAPHERS

The bankers and robber barons who were eager to exploit the West were also the greatest patrons of the artists who painted it as a glorious, hitherto unexploited, region, "all icebound crags, looming storms, and shafts of golden sunlight." One does not have to seek far for the explanation of this dichotomy. A region developing so fast could use any kind of reuniting motif, that also seemed to authenticate it. Yosemite was a court of last resort for the nation, as well. A poem on a broadside for the Boston exhibit in 1878 of Thomas Hill's *Yo Semite Valley from the Mariposa Trail, California*, sums up the post-Civil War attitudes about Yosemite: "And this will be forever. . . . From this fair realm must last a people's life."[40] The intellectual had recently witnessed the power of northern commerce to build smoky, dirty, and ugly cities and open up and exploit the West, bringing on "city sewerage" to "desecrate the plain," the broadside said. Previously, the artist had had to observe the government conducting a tragic war, plotting "the blasphemy of sordid strife," as the broadside put it. What the intellectual and artist was obtaining now through Yosemite was a ritualistic pause from the war and un-

[37] Samuel Kneeland, "Notes of a Health Trip to the Pacific," *Good Health*, September 1871, p. 159.
[38] Charles V. Cross, "The First Medical History of a Season in the Yo Semite Valley," delivered before the Amicita Medical Club, San Francisco, May 1902, and transmitted to Gov. George Pardee, April 20, 1903. *Yosemite Commission Reports, 1900-1906*, p. 1, California State Archives.

[39] Ibid., p. 5.
[40] A. A. Childs & Company's Art Gallery, Boston, December 27, 1878, Fine Arts Department, Boston Public Library. See also "The Yo Semite Valley" by T. Hill, *Catalogue of the Exhibition of Paintings for the Benefit of the French* (Boston: The Athenaeum, 1871).

happy expansionist experiences leading to distortions.

The painter was immediately able to identify the innate vision and to spread it as far as possible through his productions. At the outset of his major study of the potential of the Valley in 1865, Olmsted wrote to the landscape painters Virgil Williams and Thomas Hill, and the photographer Carleton Watkins, asking what could be done to sustain, and even enhance, the inherent beauty of the Valley. He sent a copy of the letter to his partner Calvert Vaux, referring to the "recognition of their function in society. I have a little scheme on foot for a more tangible recognition of them by the State, to which the Governor has promised me his aid, and several members of the State legislature are committed."[41] The proposal was for traveling fellowships of $400 each from the East Coast to California, "as an inducement to men of scientific note and zealous artists to visit the state."[42]

In her travel book printed in London in 1874, Therese Yelverton made a similar estimate of the relevance of painters to Yosemite. However, she took exception to their idealism if its detachment would compete with the more trustworthy observations of lay persons who soaked up its essence through closer contact. A similar reservation had arisen over viewing the Jungfrau or Mont Blanc from a distance, versus the Yosemite closeup of a chasm wall (Fig. 2). One could look at Vesuvius from a considerable distance, she noted, but the advantage of Yosemite was that the lay person would become immersed in its depths and dimensions, and therefore be "thoroughly satisfied."[43]

The analogy, which it had become impossible to fulfill in the Hudson Valley, because the mountains were not high enough, was again with the peaks of Europe. Brace predicted in 1868 that with the arrival of the railroad, "The great pleasure trip of the American continent will hereafter be the journey to the Yosemite. There is no one object of nature in the world—except Niagara—to equal it in attraction. . . . I have been tolerably familiar, by foot-journeys, with Switzerland, Tyrol, and Norway, and I can truly say that no one scene in these grand regions can compare equally, in all its combinations, with the wonderful Canon of the Yosemite."[44]

On May 10, 1869, the golden spike connecting the Union Pacific and the Central Pacific was driven at Promontory Point, Utah. Thomas Hill, one of the artists consulted by Olmsted, painted the scene, which today hangs in the capitol at Sacramento and includes among the most prominent railroad figures, Mark Hopkins, Leland Stanford, and Charles Crocker. Hill had sold his first exhibition picture, a view of Yosemite (1867), to Crocker in San Francisco.[45] Another painting of Yosemite by him was shown at the Boston Arts Club, Child's Gallery on Tremont Street, and the Boston Athenaeum in 1871 for the benefit of French War Relief. (Hill had a studio in Boston during 1867-1871.[46]) A chromolithograph was printed from Hill's painting of Yosemite by Prang of Boston in 1870 (Pl. 7), which further popularized the site through its democratic availability. Like his fellow New Englander Galen Clark, Hill had been

41 Olmsted to Calvert Vaux, September 19, 1865, Olmsted Collection, Library of Congress, Container 32, III. The letter to the artists Williams, Hill, and Watkins is also in Container 32, II.

42 Roper, ed., "The Yosemite Valley," p. 25.

43 *Teresina Peregrina* (London: Richard Bentley and Son, 1874), I, pp. 38-39.

44 Brace, *The New West*, p. 81. See also William Brewer, *Up and Down California in 1860-64*, Francis P. Farquhar, ed. (Berkeley: University of California Press, 1949), p. 405.

45 Newspaper clipping in the Yosemite Library of August 19, 1896, reporting that Hill had had a stroke.

46 Irving Bell, "They Painted Hills," *Historical New Hampshire*, February 1946, p. 15.

threatened by early consumption, then known as "the New England disease," and had gone west to die, "as my friends thought"; but, also like Clark, he was destined to live out his normal life span. Hill was the master of the "soft exquisite blue haze, that hangs over the Valley of Yosemite."[47] Another Yosemite view by him, belonging to Leland Stanford, along with Carleton Watkins' photographs of Yosemite, were exhibited at the influential Philadelphia Exposition of 1876. Watkins' photographs had also been shown at the Paris Exposition of 1867-1868. Albert Bierstadt had exhibited western scenes in his studio in Rome, Italy, in 1868, at which a view of Yosemite had been the chief attraction.[48]

Among photographers, C. L. Weed and R. H. Vance were the first into the Valley in 1859, and they exhibited their photographs of it at the Sacramento State Fair the same year.[49] Carleton Watkins was in one respect the most noteworthy, however, because he was official photographer for J. D. Whitney on the Geological Survey of California (Fig. 4), and for Olmsted in his attempt to analyze the scenic values of Yosemite at about the same time. Well-known later photographers included Eadweard Muybridge and Ansel Adams, the latter able through modern techniques to catch its subtlety and variety of tone even more successfully than his predecessors.

THE INDIANS

White men of goodwill and Indians had a similar attitude toward the Yosemite Valley, inasmuch as they valued it for its intrinsic qualities. The threat of banishment was always present for both, however. The Indians appear to have been neater and more conservative in their stewardship, as they regarded Yosemite even more as a physical refuge, at times from their own people. As Barrett and Gifford have pointed out, the beginning of the end for the Indians came six months before the gold rush at Sutter's Mill. In June 1848 gold was discovered at Woods' Creek near Jamestown, Tuolumne County, precipitating a move into this Central Miwok territory.[50] But the Indian occupation of the Valley had been mainly seasonal in any case, because of its intermediate position between the mountain peaks and lower plains. "It was the resort, in summer, of the adjacent Miwok, and of parties of Washo and Mono who came from the east to trade. A few Miwok seem to have resided there the year round."[51]

The Indians had no tradition of esthetic appreciation of the Valley, although they did attach names and legends to every prominent landmark, a fact that intrigued Whitney: "The Indian residents in and about Yosemite Valley are said to have been a mixed race, made up of the disaffected of the various tribes from the Tuolumne to King's River. . . . little is known of their language; but it is well ascertained that they had a name for every meadow, cliff and waterfall in and about the Valley. The families of the tribe had each its special 'reservation' or tract set apart for its use, each of these, of course, having its distinct appellation. It were much to be desired that these names could be retained and perpetuated, but it is impossible;

[47] Flora Hill McCullogh, "Memoirs of Mr. Thomas Hill, California Landscape Artist," in the Yosemite Library, 1962. She was the only surviving child.

[48] Now in the James Lenox Collection of the New York Public Library.

[49] Hans Huth, "Yosemite: The Story of an Idea," *Sierra Club Bulletin*, 33, 3, March 1948, p. 65.

[50] "Miwok Material Culture," *Bulletin of the Public Museum of the City of Milwaukee*, 2, 4, March 17, 1933, pp. 128-129.

[51] Ibid. See also S. A. Barrett, "The Geography and Dialects of the Miwok Indians," *University of California Publications in American Archaeology and Ethnology*, 6, 2, 1908, p. 335.

they have already passed into oblivion."[52] There were an estimated 200-500 Miwoks in the vicinity when Yosemite was opened to white men in the early 1850s.[53] By 1866, when Whitney arrived in the Valley to carry forward his survey, their presence had become elusive: new diseases, whiskey, and intermarriage appear to have been the cause of this. By 1910, 90 per cent of the Miwoks had disappeared.

Whitney hired the best linguist he could find to recover the Indian names of the chief landmarks, only to have to give it up as impossible. He finally admitted that even the Indian appellation of the Valley itself was of uncertain "origin and orthography." Yosemite was named around a campfire in the Valley on March 25, 1851, when Lafayette Bunnell suggested it be called after the tribe that had been driven out. Yosemite means "Grizzly Bear." Earlier Indians, however, appear to have called the Valley Ahwahnee, "Deep Grassy Valley." Responsible and intelligent whites were full of regret about the exile even at this early date. As late as 1958 the disappearance of certain animals and birds was still being regretted by experts and treated as analogous to that of the Indians. "No grizzly will grace a Yosemite meadow again; the rams of Yosemite may be gone forever; the giant condors, verging extinction, are pushed into limited mountain areas of California. These animals, like the Indians, are victims of civilization."[54] The Indians, as later tourists came to know them, were finally reduced to a few individuals, rather than holding together as tribes—Maggie Howard (Ta-bu-ce), Maria Lebrado, and Captain Paul being among the last.

The Indians appear not to have been organized on definite tracts of land (as ascribed to them by Whitney), so much as in small, localized villages made up of clusters of dwellings. The primary architectural element in the village was the conical "u-ma-cha" of poles covered with cedar incense bark. They also built larger, earth-covered roundhouses for ceremony, and small earthen sweat houses for cleanliness and curative treatments. The latter were much like the Finnish sauna in function, including the inhaling of resinous fumes and the after-plunge in a cold stream. These customs were discouraged by the white men, as being liable to bring on respiratory diseases.[55]

THE GLORIOUS GEOLOGICAL DISPUTE

There was a void in the understanding of the remoter origins of the Valley which invited by-play in the name of objective science. The maelstrom tended to center, beginning in 1860 and carrying on for over a decade, in the Geological Survey of Josiah Dwight Whitney. Later conjecture over the ancient origin of Yosemite depended mainly on John Muir's idea that it had been sculptured by a glacier.[56] The imperious Whitney would

[52] J. D. Whitney, *The Yosemite Book: A Description of the Yosemite Valley and the Adjacent Region of the Sierra Nevada, and of the Big Trees of California* (New York: Julius Bien, 1868), p. 15.

[53] Mrs. H. J. Taylor, *Yosemite Indians and Other Sketches* (San Francisco: Johnck and Seeger, 1936), p. 3n. Mrs. Taylor, the librarian at Yosemite, was citing figures of the University of California anthropologist, A. L. Kroeber.

[54] Roy Christian, "From the Past," *Yosemite Nature Notes*, XXXIII, 7, July 1958, p. 100.

[55] A. L. Kroeber, "Indians of the Yosemite," *Handbook of Yosemite National Park*, Ansel F. Hall, ed. (New York: G. P. Putnam's Sons, 1921), p. 55. See also Elizabeth H. Godfrey, "Yosemite Indians Yesterday and Today," *Special Issue of Yosemite Nature Notes* (Yosemite: Yosemite Natural History Association and National Park Service, n.d.), p. 19. Also see C. Hart Merriam, "Indian Villages and Camp Sites in Yosemite Valley," *Sierra Club Bulletin*, January 1917, pp. 202-209.

[56] Israel C. Russell of the U. S. Geological Survey gives Muir credit for the discovery of the glacial origin in his *Glaciers of North America* (Boston: Ginn & Co., 1897), pp. 202-209.

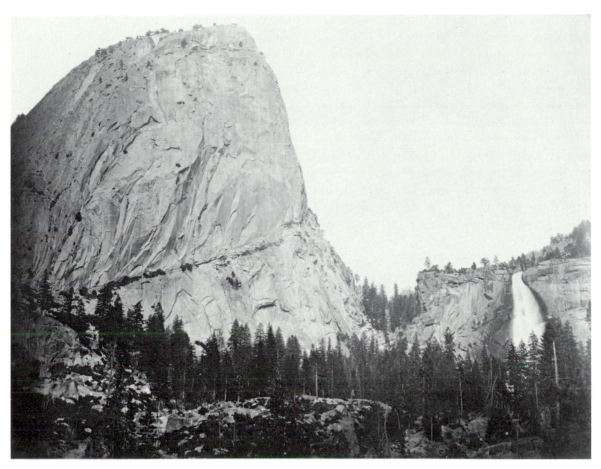

4. Nevada Fall and the Cap of Liberty, Photo by C. E. Watkins. This view was Plate 17 in Whitney's geological report of 1868 on the Valley. The contrast in scale between the waterfall of over 590 feet and the dome, soft and hard, was one aspect of the Valley early artists appreciated, the individualistic distinction of each stone another (Print Department, Boston Public Library).

have none of that. "A more absurd theory was never advanced. . . . This theory, based on entire ignorance of the whole subject, may be dropped without wasting any more time upon it."[57] Whitney could not find the resulting moraines during his sojourn in the Valley. Ultimately Muir and

[57] J. D. Whitney, *The Yosemite Guide Book* (Cambridge, Mass: Harvard University Press, 1869), pp. 83-85. The glaciation is well delineated in M. E. Beatty, "A Brief Story of the Geology of Yosemite Valley," *Yosemite Nature Notes*, XXII, 4, April 1943, pp. 6-7. The moraine Whitney missed is described there, pp. 7-8.

the "absurd theory" were proved indisputably right, and the missing moraine found. Matthes reported in "John Muir and the Glacial Theory of Yosemite," an attempted last word in 1938, that "to be sure, the glaciers did not reach down to the foothills, nor did they excavate the canyons in their entirety, as Muir supposed. The ice age, it is now clear, was preceded in the Sierra Nevada by long periods of canyon cutting by the streams in consequence of successive uplifts of the range. But let no one cite these recently determined facts to Muir's dis-

credit, for geologic science in the sixties and seventies of the last century had not advanced to the point where any man, however expert, could have detected and proved them."[58]

Whitney's presumption belonged to what was then known as the "dropped block" school, as distinguished from the more widespread "cataclysmic," or "catastrophic," theory.[59] The latter borrowed its title not from science, but from a literary and artistic movement of 1810-1845, which attempted to use such imagery to enhance the experience of the sublime, while taking a more pessimistic view of nature than that of the sanguine Transcendentalists. It included among its representatives the writers Poe and Hawthorne and the painters Peale, Allston, Durand, and Cole.[60] Whitney believed that "during the process of upheaval of the Sierra a universally agreed occurrence, accompanied by a tilting down toward the Pacific, or, possibly, at some time after that had taken place, there was at the Yosemite a subsidence of a limited area, marked by lines of 'fault' or fissure crossing each other somewhat nearly at right angles. In other and more simple language, the bottom of the Valley sank down to an unknown depth, owing to its support being withdrawn from underneath, during some of those convulsive movements which must have attended the upheaval of so extended and elevated a chain, no matter how slow we may imagine the process to have been."[61]

Whitney's tenacity and rigidity on this issue may be rooted in the fact that his natural history report, intended to be the last word, was an integral part of other literary pursuits then being taken up in California. Cornelius Bradley observed that California's "chief literary activity was no longer creative [following Bret Harte and Mark Twain], but scientific and statistical, displaying itself in an eager search for all historical data which might throw light on its new origin, and for a science which should put it into rational possession of its own fair earthly heritage. It was a period typified, let us say, by Bancroft's Histories and [Whitney's] Geological Survey."[62] It was also at this moment that the University of California was being organized to have an emphasis upon the "observation of nature," which appeared now to call for a "new study and classification."[63]

[58] *Sierra Club Bulletin*, XXIII, 2, April 1938, p. 10. Muir tells in *The Mountains of California* (New York: The Century Co., 1901), p. 28, that in October 1871 he first discovered the Black Mountain Glacier that once led down into the Yosemite Valley. He was surprised, "not expecting to find any active glaciers so far south in the land of sunshine." He traced its ancient path carefully, pp. 28-35.

[59] On the boat to California in 1867 Brace met a mining superintendent: "It was curious that both he and the other geologists were *catastrophists* in their theories of the Pacific Coast." *The New West*, pp. 16-17. The catastrophic theory could apply to the whole West Coast, not just to Yosemite.

[60] See Curtis Dahl, "The American School of Catastrophe," *American Quarterly*, XI, 3, Fall 1959, pp. 380-390.

[61] Whitney, *The Yosemite Guide Book*, pp. 83-85.

[62] "Stevenson and California," *Sierra Club Bulletin*, June 1911, p. 114.

[63] Whitney to Governor Low, November 26, 1865, Geological Survey File, California State Archives. That the Survey and the founding of the University of California were out of the same basket shows up in several sources. Whitney, in his third report as state geologist before the legislature, spoke of the desirability of having a state university, and later in *An Address on the Propriety of Continuing the State Geological Survey of California, Delivered before the Legislature, January 30th, 1868*, p. 19, said "that the Geological Survey is a necessary preliminary to the establishment of a University which can claim to be anything more than a name." At this new institution, "There will be little call for Latin and less for Greek; but nature will be interrogated, and everything that aids in familiarizing the student with her teachings will be in demand." On the other hand, he did not want to have to "pull the survey up by the roots in order that the University may be planted in the same hole, with the idea that there would be economy in that operation" (p. 23). Other pamphleteers had much the same anxiety and association. J. Ross Browne in a *Letter from J. Ross Browne in Relation to the State Geological Survey of Cali-*

Whitney was on the legislative commission of 1863 to found the University. It, like Yosemite, was supposed to remain remote and protected from the starting society around it. As early as 1866, when they were investigating a site for the "College of California," Olmsted and Vaux enunciated the principle that "while presenting advantages for scholarly and domestic life, it should not be calculated to draw noisy and disturbing commerce to the neighborhood, or anything else which would destroy its general tranquility."[64] A luminous bed of tranquility seven miles long and one and a half miles wide had been offered at Yosemite. Contrary to this encouraging dictate from Olmsted and Vaux, Whitney had to report reluctantly that President "Gilman is engaged in a hard fight to save the University from the claws of the Grangers who want to make a manual-labor school of it. Gilman feels very much discouraged, especially as he now realizes fully that a state institution must always be in hot water."[65]

Precisely why Whitney initiated the California Geological Survey is almost as much of a conundrum as why Gilman took on the University. Whitney's was too ambitious a project from the outset, and he admitted as much: "in a State of such an immense area as California, our labors have more the character of a geological reconnaissance, than of a detailed survey,"[66] and he noted that the average dimension of a county in California

was equal to half the size of his native Massachusetts. The motive of the state legislature—when it yielded to the urging of Judge Stephen J. Field; John Conness (soon to be a U.S. senator, friend of Lincoln, and major draftsman of the 1863 bill signed by Lincoln to give Yosemite to the State); and Whitney's brother-in-law, S. Osgood Putnam—to commission Whitney in April 1860 to undertake the Geological Survey, has never been entirely explained either. It was realized that the Gold Rush had produced detrimental side effects. The question now was whether it might constitute a recurring social malaria: ". . . the object of the survey may be to promote land speculations, and the Governor may have an eye to some gold vein," wrote Joy, and a still less believing adviser warned, "Keep your honesty out of sight, or you are a gone coon."[67]

It was probably significant for the legislature that Whitney's reputation arose from his monumental book of 1854, *The Metallic Wealth of the United States*. But the members soon tired of his reports on "birds, shells, and bones," instead of the "relevant" minerals, and funds were entirely cut off by 1873. In 1865, Whitney wrote the governor that since the "Survey is dead," he had decided to take the position of Professor of Geology and Director of the School of Mining and Practical Geology at Harvard University.[68] He had heard that he was becoming "exceedingly unpopular" in California because he would not connive with "swin-

fornia (Boston: Little, Brown and Co., 1870), p. 12, asked, "What guarantee can we have that the same policy will not be pursued towards the University, now threatened in the case of the Geological Survey?"

[64] Olmsted, Vaux and Co., *Report upon a Projected Improvement of the Estate of the College of California at Berkeley, near Oakland* (New York: 1866), p. 4.

[65] Edwin Tenney Brewster, *Life and Letters of Josiah Dwight Whitney* (Cambridge, Mass.: Riverside Press, 1909), p. 288.

[66] J. D. Whitney, "Annual Report of State Geologist," 1863, p. 14, State Geological Survey Folder, California State Archives.

[67] Brewster, *Life of Josiah Whitney*, p. 188.

[68] Whitney to Governor Low from Northampton, Mass., July 30, 1865, State Geological Survey Folder, California State Archives. Whitney's speech was spare, direct, and colorful. He observed in 1868 before the legislature, when already on very shaky political ground, that "A bill has been, or is to be, introduced, I am told, abolishing the State Geologist and consigning him to the tomb of the Capulets. . . . If the Act is to be of any value it must be passed in a hurry, or you will be hanging a man who has just died of starvation" (*Propriety of Continuing the State Geological Survey*, p. 4).

dling" mineral exploiters with their "monster capitals." He had also heard that his reports were being described locally as "fancy values," without a tangible worth in dollars and cents. Perhaps in retaliation for his unrelenting candor, word was passed that (unkindest cut of all) the Survey had been a put-up job to strengthen the natural history collections of Harvard![69] Still hurling barbs, he persisted as the part-time, on-again, off-again state geologist while professor at Harvard. In 1872, just before the final denouement of the Survey, we find him explaining once more to Gov. Newton Booth that since he served the state for two years without salary, he cannot see too much harm in his going annually back to Harvard to give twenty weeks of lectures, at the leisurely pace (even in our own enlightened day) of "never over 2 a wk."[70]

Although full of bombast and overweening pride, Whitney had enormous energy, and was a great intellectual and political force. As has at last been made clear, he was able to get the famous "lost" report on Yosemite by Olmsted of 1865 truly lost,[71] even though he had been on the Yosemite Commission with Olmsted. His motive was to prevent Olmsted from obtaining $37,000 to develop his own study on Yosemite parallel to that of the Geological Survey.[72] Whitney

aimed to place "the interests of science above party politics,"[73] as his idealistic scientific friends wrote to the governor to aid him in starting the Survey. Consequently he had little respect for Olmsted's esthetic and more generalized principles.

But a greater issue was who was to be finally responsible for Yosemite and its unprecedented resources. They fell into two camps, according to Charles Loring Brace. "No American community ever had so many energetic and educated men in proportion to its numbers, and none so many adventurers. . . . California began its growth with mining speculation; the fever of those first years of tremendous excitement will never altogether leave the blood of her people."[74] A better association with the landscape would result from an oncoming special breed of educated men, the young geologists. Brace had met Clarence King, one of Whitney's brilliant young following, on the boat coming out to California in 1867: "Best of all for us, was a most interesting scientific party, Mr. CLARENCE KING and his corps. . . . It was a truly American phenomenon: here was a young man of twenty-four who had already on the State geological survey of California, proved himself one of the most daring of living explorers. . . . His stories of the years of wild

[69] Brewster, *Life of Josiah Whitney*, p. 289.

[70] Whitney to Gov. Newton Booth, February 12, 1872, State Geological Survey Folder, California State Archives.

[71] Minutes of informal meeting of the Yosemite Commissioners on November 29, 1865, at which Whitney, Ashburner, and Raymond were present. "The Commissioners present, having examined the Olmsted draft of a report and bill intended that it was not expedient, at present, to lay the report before the legislature, or to call for an appropriation so large as $37,000, the sum demanded by Mr. Olmsted." At this meeting Whitney was also given a charge to further explore the Valley of the Yosemite and prepare an "elegant and ornamental" guide book. "Yosemite Valley and Big Tree Commissioners, 1872-1899," California State Archives.

[72] Charles McLaughlin, "Selected Letters of Fred-

erick Law Olmsted," Ph.D. Thesis, Harvard University, 1960, p. 61.

[73] Letter of August 2, 1860 from the American Association for the Advancement of Science, Meeting in Newport, R. I., State Geological Survey File, California State Archives. The letter was drafted by A. D. Bache, Superintendent of the U. S. Coastal Survey, and also signed by Louis Agassiz of Harvard; Joseph and John Le Conte of Columbia College in South Carolina (the brothers had not yet fled the South and the Civil War to the University of California); Wolcott Gibbs of New York; Joseph Lovering, Professor of Physics at Harvard; and A. H. Worthen, State Geologist of Illinois. Their endorsement was finally placed at the head of a flyer Whitney put out in 1872, during a last-ditch effort to save the Survey, entitled *What Eminent Men, in All Parts of the World Have Said about the Geological Survey of California*.

[74] Brace, *The New West*, pp. 66-67.

life on the plains and among the mountains showed what a field of manly training and scientific work there is now on the Pacific slope for our *jeunesse dorée*, who have no taste for business or the professions. The civilized man comes down and gathers up the best qualities of the barbarian—quickness of hand and eye, firm nerve, contempt of cold, hunger, and privation, power to use his body to the best advantage, and the ability to front coolly danger and death—and with them he combines all which training and culture have given, to gain new conquests over Nature and to advance the frontiers of knowledge. It is a good thing to see such aims and works in an age of fraud, profit, and comfort."[75]

Despite all the dislocation, Whitney did provide a legacy for this region and the nation, in the new breed of American geologist, including besides Clarence King (to become director of the United States Geological Survey when it was founded in 1879), William Brewer, Charles F. Hoffman, and James T. Gardner. King had been a charter member of the Society for the Advancement of Truth in Art, which had sprung from Ruskin and the Pre-Raphaelite movement. He was able to join the outlooks of both Science and Art, as his mentor, Whitney, evidently could not. Like many before and after, King became disaffected by the esthetic and social myopia of Americans: "From Bangor to San Diego we seem never weary of contriving for ourselves belongings which are artistically discordant and customs which are wholly inappropriate."[76] The best-known and last of these brilliant young California geologists, seeking to better society as soon as possible through the direct methods of engineering, would be Herbert Hoover, with his idealistic interest in Bel-

gian War Relief and housing reform in America. Hoover stayed at the Ahwahnee Hotel in Yosemite in July of 1927, during the first two weeks it operated, and fished the Merced on many occasions afterwards. Their scope of responsibility was a large one; these were the action-oriented intellectuals, but somewhat deeper than Whitney, for all his action.

CLARK, MUIR, BUNNELL, AND HUTCHINGS

Much more limited in worldly experience than Olmsted or Whitney, or their brood of helpers, but significant because of their early and intimate knowledge of Yosemite, were Galen Clark, John Muir, Dr. Lafayette H. Bunnell and James M. Hutchings. Clark came to Wawona near Yosemite and built a cabin in April 1857. He had arrived in San Francisco in the fall of 1853, when he was thirty-nine years old, and moved to Wawona only because he sensed an even chance there to survive his worsening tuberculosis.[77] He lived to be ninety-six in this new clime. At ninety he began three short books and an article about Yosemite and the surrounding region. Brace described him in the 1860s as "one of those men one frequently meets in California—the modern anchorite—a hater of civilization and a lover of the forest—handsome, thoughtful, interesting, and slovenly."[78] The inventory of Clark's library showed him to be yet another transplanted New Englander (from Dublin, New Hampshire), who depended for his insight into nature upon the authors of that region, particularly Thoreau.[79] He was also greatly interested in the theory of evolution. He was

[75] Ibid., pp. 14-16.
[76] David Howard Dickason, *The Daring Young Man* (Bloomington; Indiana University Press, 1953), p. 97.

[77] Shirley Sargent, *Galen Clark: Yosemite Guardian* (San Francisco: The Sierra Club, 1964), pp. 52-53.
[78] Brace, *The Way West*, p. 86.
[79] James Fox, "Galen Clark's Library," *Yosemite Nature Notes*, December 1959, pp. 160-167.

the first Guardian of the District from 1866 until March 1881 (when Hutchings took over, both having served jointly since September 1880), and again from 1889 to 1896. Clark was the discoverer in 1857 of the Mariposa Grove of giant sequoia trees, where most of the celebrities visiting the Valley sought him out. Like Olmsted, he ruminated on what was the shortest time in which one could begin to comprehend Yosemite. "A week is the shortest time that should be allowed for a trip to Yosemite. Two weeks are better. The grandeur of the Valley cannot be fully appreciated in a few days."[80] At the end, after well over half a century, he was still reinterpreting it.

His book of 1904 was on the Indians. That of 1907 dealt with the big trees. *The Yosemite Valley* of 1910 was printed from a manuscript delivered two weeks before his death. Persistent, introspective, always occupied with this one precinct, Clark carved his own rugged tombstone in the Yosemite cemetery, which he laid out to go around his stone. The trees he planted there by hand grew to a considerable height before his demise.

He was ever solicitous for the comfort of the visitor. "There is no hardship, risk or danger in any part of the Yosemite trip. Many old people and children visit the Valley without difficulty."[81] But he recognized that the rugged nature around, in contrast to the placid meadow, could reverberate to the effects of a mighty power, suddenly unleashed. "In the early part of the season, when the snow on the mountains in the near vicinity of the Valley is melting rapidly, the volume of water in the Upper Yosemite Fall is so great and heavy that it jars the ground a mile distant, frequently coming down with such force and weight as to make a report like distant artillery."[82] It was an environment in which the strength of nature could be directly, if only intermittently, sensed. But that strength would never injure or hurt.

The drive to learn the history of Yosemite before humans arrived, to know as well as to feel the geological past, appears to have been due in part to this contrast between the prevalent indigenous hush and the occasional upheaval of noisy violence. The contrast between the soft and hard versions of nature in only seven miles of chasm intrigued everyone. In his book on Yosemite, Clark reviewed the main theories of its origin, beginning with that of Whitney. The second theory, of Prof. Benjamin Silliman, Jr., of Yale, proposed a subterranean rupture on the western side of the Sierra Nevada, which had then gradually filled with earth. "The third theory, and perhaps the most popular one at the present time, is that the origin and general formation of the Valley is due to the agency of glaciers." Then followed Clark's own, inevitably independent, view: "In some period of the earth's existence, while its granite crust in that locality was in a semi-plastic condition, by some great subterranean force of gases or superheated steam, its surface was forced up in places, forming these great dome elevations. In some instances this force was sufficient to burst open the surface and make a complete blow-out, forming a great chasm with vertical sides. . . . This great cataclysm I think must have been caused by some tremendous subterranean force upheaving this part of the earth's surface."[83] He could see the slow-moving, lachrymal glaciers in the Sierra Mountains above, and the lakes and streams below in the valleys. But he was convinced that the evolution arose from cataclysmic or catastrophic causes exclusively. Nothing but

[80] Galen Clark, *The Yosemite Valley: Its History, Characteristic Features, and Theories Regarding its Origin* (Yosemite Valley: Nelson L. Salter, 1910), p. 105.
[81] Ibid., p. 107.

[82] Ibid., pp. 55-56.
[83] Ibid., pp. 23 and 44.

a divine impulse could have brought forth such splendor. The biblical Genesis was never far from Clark's mind, followed by his curiosity about evolutionary theories. As Whitney's biographer had observed, "Geology in the fifties was still more than half cosmology."

The typical expositor of Yosemite was expected to exhibit a dash of eccentricity. John Muir was another unorthodox figure, a wilderness St. John the Baptist: "He was spare of frame, full-bearded, hardy, keen of eye and visage, and on the march eager of movement."[84] An English novelist described his clothes as having the "tatterdemalion style of a Mad Tom."[85] Saturation with nature and biased opinions seemed synonymous with these people. Muir confided to his fellow Scotsman, the artist William Keith, "Willie, that false high-priest Whitney, and Hutchings with him, teach that this valley was formed by the sinking down of the ground, I contradict that and tell the tourists the true cause. For that reason Hutchings has gone back on me; and now I have left his employ."[86] To quit Hutchings over an abstract theory was a large step because he had worked in Hutchings' sawmill from 1868 to 1871. He had also boarded first with Hutchings, and it was there that Joseph LeConte, the geologist from the University of California, who was to help him with some of his glacial theories, first discovered him in 1870.[87]

The "final truth" arrived from the science

of geomorphology (which had not developed even as late as the 1880s). To fully determine the origin of Yosemite now appears impossible, but if one were to seek only an understanding of the beginnings of what is still clearly visible, one might start with the birth of the Merced River forty million years ago. It was then a broad stream winding through a broad valley. Gradually it cut deeper until, with the eastern upthrust of the Sierra Nevada, it picked up velocity to become a rapid, straight-running stream, flowing quickly west toward the Pacific. The tributaries north and south could not keep pace with the increased speed and erosion of the east and west system, and so were left hanging, to initiate the waterfalls—Bridal Veil, Yosemite, Nevada, Vernal, and Illilouette being the five chief examples. This occurred one to two million years ago, during the Pleistocene Epoch. Then, as an overlay, came the great Ice Age, with at least three glaciers following. They scooped out and fractured the valley which the Merced had already formed as a V-shaped canyon. The final change was to a deeper, more U-shaped section, with escarpments running up to 3,000 and 3,200 feet, rather than the older 1,200 to 1,500 feet. Hence in redefined shape it became a more hollow and capacious vessel, while in height it became even more awesome—with a wider stage readied at the base.

The ice could not grind away the hard granite cores of Sentinel Dome, El Capitan, Half Dome, Glacier Point, and the Three Brothers, and indeed it did not even reach the tops of several of them. Granite domes usually assume well-rounded, shell-like curves, one layer peeling off after another, in the weathering. Half Dome is an example of two forces at work, an erosional dome together with a master slice fracture to cut a half portion off, which resulted in a sheer drop. These stones constituted a gallery of cyclopean forms of extraordinary variety,

[84] R. U. Johnson, *Remembered Yesterdays* (Boston: Little, Brown and Co., 1923), p. 283. See also R. U. Johnson, "John Muir," *Proceedings of the American Academy of the Arts and Letters* (New York: De Vinne Press, 1922), IX, p. 25.

[85] Therese Yelverton, *Zanita: A Tale of the Yo-Semite* (New York: Hurd & Houghton, 1872), p. 7.

[86] Cornelius, *Keith: Old Master of California*, p. 57.

[87] Ralph S. Kuykendall, "History of the Yosemite Region," *Yosemite National Park* (New York: G. P. Putnam's Sons, 1921), pp. 18-19. See also Joseph Le Conte, *A Journal of Ramblings through the High Sierra of California* (San Francisco: The Sierra Club, 1930).

"rocks of ages" poised and enduring in the timeless light (Fig. 4). Below were the smaller glyphs like Cathedral Spires, which had been more easily worn away because of a less radical and more complex joinery. The majestic meadow was provided by the filling of Yosemite Lake with silt, sand, and rock accumulated as the ice melted, probably less than 20,000 years ago. The quantity of softer material deposited accounts for the flat, parklike quality of the extended meadow, along with its fertility.[88] The soft and hard rhythms seemed unlikely to be joined in nature, so puzzlement was constant. Majesty overlooked peace (Fig. 5).

Careful scientific investigation begun in 1913 by Francois E. Matthes and Frank C. Calkins resulted in their classic *Geologic History of the Yosemite Valley*,[89] which wound up the disputation (rousing as it had been) among the adherents of at least twelve theories. Their research demonstrated that the main action had been "strictly an erosional" one, and fairly brief and modern at that. No one appears to have noticed at the time, nor thereafter, that in 1865, before Whitney, Muir, and the others had marshaled their arguments and received the repute due them as polemicists, the non-scientist Olmsted had quietly and modestly observed, "a glacier has moved down the chasm from among the adjoining peaks of the Sierras."[90]

Dr. L. H. Bunnell and J. M. Hutchings

represent in many ways the more superficial, naive, and self-centered reactions to Yosemite, but they were the earliest, and for that reason deserve our attention. Bunnell, a physician, made a point of his heightened awareness of the Valley, in contrast to the indifference of the soldiers he accompanied in the first penetration of March 25, 1851. His reaction was a romantic leftover: "It seemed to me that I had entered God's holiest temple, where were assembled all that was most divine in material creation."[91] The military was on a punitive expedition because of an Indian attack on the trading settlements of Maj. James D. Savage and others. The major was tense and had his mind on other things, and "viewing the valley under snow and through a clouded sky, disappointed in his search for Indians, the only one found being an old squaw, our major seemingly had no appreciation of the Yosemite."[92] He withdrew shortly afterward.

[88] See M. E. Beatty, "A Brief Story of the Geology of Yosemite Valley," *Yosemite Nature Notes*, Special Number, National Park Service, 1943; Norman E. A. Hinds, *Evolution of the California Landscape*, Bulletin 158, California Department of National Resources and Division of Mines, December 1952; and Francois E. Matthes, "El Capitan Moraine and Ancient Lake Yosemite," *Sierra Club Bulletin*, IX, 1, January 1913.

[89] Professional Paper No. 160 (Washington, D.C.: U.S. Geological Survey, 1930). See also, F. E. Matthes, "Studying the Yosemite Problem," *Sierra Club Bulletin*, IX, 3, January 1914, pp. 136-147.

[90] Olmsted, "The Yosemite Valley and the Mariposa Big Trees," p. 15.

[91] Lafayette H. Bunnell, "The Date of the Discovery of Yosemite," *The Century*, XVIII, 18, September 1890, pp. 795-797. See also, L. H. Bunnell, "How the Yo-Semite Valley was Discovered and Named," *Hutchings California Magazine*, May 1859, pp. 498-504, and L. H. Bunnell, *Discovery of the Yosemite* (Los Angeles: G. W. Gerlicher, 1911). Julius H. Pratt in the December 1890 *The Century*, XIX, 19, p. 193, asserted that a punitive expedition discovered Yosemite on January 10, 1851, rather than three months later in March. Bunnell himself also claimed to have sighted El Capitan in Yosemite from Mt. Bullion forty miles away in 1849, "but nothing could be learned concerning it" (*The Century*, September 1890). Joseph R. Walker is said to have seen but not to have entered it in 1833, and William Penn Abrams and U. N. Reamer, gold seekers, are supposed to have seen it between October 7 and 17, 1849. They called Half Dome "Rock of Ages," appropriate for the biblical feeling always in the background at the time. *Yosemite Nature Notes*, April 1957, p. 33. For Walker's first sighting, see Francis P. Farquhar, "Walker's Discovery of Yosemite," *Sierra Club Bulletin*, XXVII, August 1942, pp. 35-49. A good summary of these diverse claims is contained in a typescript by C. P. Russell, "A Short History of Yosemite National Park," pp. 2-3, National Park Service, Washington, D.C., File 14.

[92] Bunnell, "The Date of the Discovery of Yosemite," p. 797.

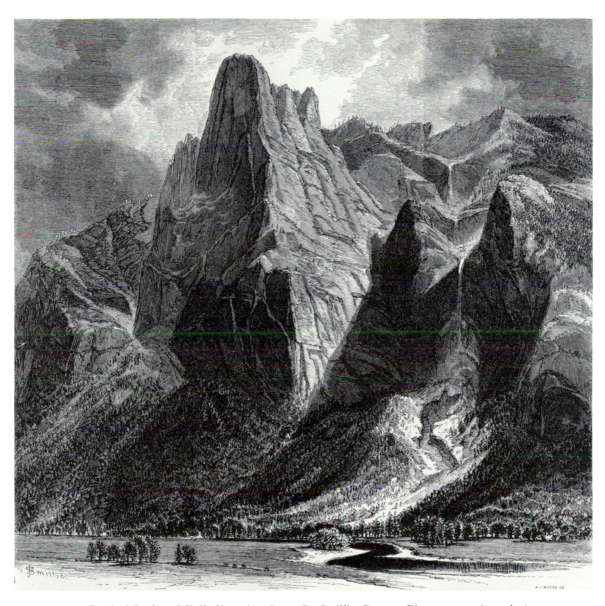

5. Sentinel Rock and Fall, Yosemite, James D. Smillie (Bryant, Picturesque America).

Much of the rest of Bunnell's career was taken up with proving that he was the first one in, the first to write about it, and the first to admire Yosemite, etc. There is an overly individualistic, pioneer rawness in his comments, but the shift toward a more democratized appreciation began as early as four years later when Hutchings brought a commercial party into the valley, including two ladies and an artist, Thomas Ayres. His clients were almost as rapturous as Bunnell, according to a report in the *Mariposa Gazette* of July 12, 1855: " 'What,' exclaimed one at length, 'have we come to the end of all things?' 'Can this be the opening of the Seventh Seal?' cries another." The pictures by Ayres are literal and slightly contrived, like Bunnell's and Hutchings' accounts, representing the amateur realism of the 1850s as distinguished from the softer and more modulated renderings of the better disposed and more knowledgeable in the wake of the Civil War.

Hutchings was a lively promoter and desecrator, simultaneously. He spread the fame of Yosemite Valley, and provided its earliest accommodations, but he also tried to take advantage of any opportunity for personal gain. On September 24, 1864, shortly after the Valley had been ceded to a state commission by the Federal Government, William Ashburner for the Commissioners sent an urgent note to Governor Low, asking that he issue a proclamation "forbidding the cutting of any timber or the erection of any building in the Valley."[93] Ashburner enclosed a letter from a James B. Williams with his own, which said that the petitioner must speak up against a proposed sawmill for which "that man Hutchings" had already ordered the machinery. Williams believed the sawmill was bound to beget a progeny of hotels, bridges, and houses, and a second, win-

ter, home for Hutchings himself. The governor responded four days later with the requested proclamation from Sacramento. "I hereby warn and command all persons to desist from trespassing or settling upon the said territory, and from cutting timber or doing any unlawful acts within the limits of the said Grants. All propositions for the improvement of the aforesaid tracts of land, or for leases, should be made to the Commissioners through Fred. Law Olmsted, Bear Valley, Mariposa County."[94]

This was properly attested by the Secretary of State and displayed the state seal. Hutchings paid no attention. The forbidden sawmill was put up and was where John Muir made his early livelihood. Hutchings went steadily on with all of his structural projects, giving the license of his initiative to other entrepreneurs, who would later be hard to eradicate. In a follow-up from Hutchings to Governor Low in January 1866,[95] Hutchings reported that he preempted his land in 1857 and 1858, bringing his family to it in May 1864, a month or more before the Lincoln grant was effected. He contended that the governor should therefore exempt his land. He could not believe Congress was entitled to give away his 160 acres, he said. He did not want a ten-year lease, because ten years would not allow him sufficient time to bring up his orchard, garden, and vineyard. To clinch his case, he presented himself as a pioneer publicist, as well as an earthy man of the plow.

[93] California State Archives.

[94] Ibid.
[95] Ibid. Hutchings subsequently stated that he only put up his notorious sawmill "several years after the deeding," and that he merely cut up timber already fallen (*Investigation of the Yosemite Valley Commissioners*, 28th Session of the Assembly, Sacramento, 1889, p. 324). The situation of Hutchings and J. C. Lamon as chief squatters was also described in Whitney's *Report of the Commissioners to Manage the Yosemite Valley, 1868*, pp. 8-10. The original grant to the state came through the Thirty-Eighth Congress on June 30, 1864 (*Thirty-Eighth Congress*, Session I, XIII, 28, p. 325).

"I believe that I was the first (in 1855) to introduce the wonders of the Yosemite valley to public notice. By lithographs; by illustrated articles in my magazine ('Hutchings California Magazine'); and since then a little volume of 'Scenes of Wonder and Curiosity in California,' I have published more concerning it than anyone else." Small wonder that the later record was strewn with barely concealed pique against Hutchings on the part of governors and other high officials, much like that toward Whitney. By 1875 the state was finally able to shake him off by paying him $24,000 to get out, escorted by the sheriff. In September 1880 he returned triumphantly as a Guardian of Yosemite, where he finished his life by getting thrown from a carriage, moments after having his picture taken in it with his wife, for commemorative purposes.[96] Such were the unpredictable detours of democracy when visited by extreme individualism.

EMERSON'S VISIT, 1871

Emerson's visit to Yosemite in 1871 marked the end of the romantic and Transcendental phases of the Valley, just as the arrival of Theodore Roosevelt in 1903 signified the culmination of the Progressive era of Federal reorganization and codification of natural resources. The former period was characterized by contemplativeness following the Civil War, while the latter was marked by the idealistic activism preceding World War I. When contemplation and reverie became difficult to achieve in the general culture, as during the Civil War, they were featured in Yosemite. When adventure became less possible in society, it tended to be emphasized in Yosemite. Emerson and Roosevelt both were hosted by Muir. The principals, deeply interested in nature, wished for a certain continuity among themselves, however absent it might be from the society at large. Although John Burroughs resented John Muir's occasionally mocking tongue, he visited him and later his gravesite at Yosemite,[97] and the two were photographed together in the Valley. Muir took the trouble later to visit the grave of Emerson in Concord, Massachusetts. He was forever searching for congenial spirits, and he was prepared to attract their attention with bold approaches. He wrote to Emerson, inviting him to Yosemite (although Emerson indicated later that he himself took the initiative).[98] Muir said, "During my first years in the Sierra I was ever calling on everybody within reach to admire them, but I found no one half warm enough until Emerson came."[99] Yet Emerson's spring visit of 1871 was a letdown for Muir. Emerson was not permitted by his friends, for fear of the night air, to camp out of doors as Muir proposed, either in the mountains or under the Mariposa Big Trees. He was housed, instead, at Clark's Station, while his young friends spoke patronizingly of Muir's "amusing zeal" for camping. "And to think of this being a Boston choice!" grumbled Muir, "Sad commentary on culture and the glorious transcendentalism. . . . To commemorate [Emerson's] visit, Mr. Galen Clark, the guardian of the grove, selected the finest of the unnamed trees and requested him to give

[96] *Yosemite: Saga of a Century*, pp. 35-36.

[97] William B. Rice, "A Synthesis of Muir Criticism," *Sierra Club Bulletin*, XXVIII, 3, June 1943, pp. 86-87. Portrait of Muir and Burroughs illustrated in *Yosemite Nature Notes*, September 1957, p. 94.

[98] "Emerson's Visit to Yosemite," *California Historical Society Quarterly*, 33, pp. 245, and 17, pp.18-19. "Discovering that the naturalist John Muir lived not far from one of their stops, Emerson insisted on visiting him." See also Samuel T. Farquhar, "John Muir and Ralph Waldo Emerson in Yosemite," *Sierra Club Bulletin*, XIX, 3, June 1934, p. 48.

[99] John Muir, *Our National Parks* (Boston: Houghton, Mifflin and Co., 1906), p. 131.

it a name. He named it Samoset, after the New England sachem, as the best that occurred to him."[100] The age gap was too great. "The poor bit of measured time was soon spent, and while the saddles were being adjusted I again urged Emerson to stay. 'You are yourself a sequoia,' I said. 'Stop and get acquainted with your big brethren.' But he was past his prime, and was now as a child in the hands of his affectionate but sadly civilized friends, who seemed as full of old-fashioned conformity as of bold intellectual independence. . . . Emerson lingered in the rear of the train, and when he reached to the top of the ridge, after all the rest of the party were over and out of sight, he turned his horse, took off his hat and waved me a last goodby. I felt lonely, so sure had I been that Emerson of all men would be the quickest to see the mountains and sing them."[101]

THE GREAT DISPUTE OF 1889-1890

The popularity of California increased so rapidly after the advent of the transcontinental railroad in 1869 that it was inevitable that a second stock-taking would be made of Yosemite. This occurred in the Great Dispute of 1889-1890. The sliver of Yosemite Valley then became representative of the immensity of the country and its fragility and expendability. Thus it was identified to Theodore Roosevelt in 1903 as a critical symbol of the future of the conservation movement, leading to his White House Conference of 1908, from whence came the full-blown national park system. The Great Dispute arose from three basic causes, of which the oldest was the rebuilding of national strength following the Civil War. By the 1890s there was a recognizable healing of the war scars. Another factor was that the transcontinental train, by

bringing a flood of visitors to the state, put abnormal pressure on the transport system in and around Yosemite, which was made up of carriages, stage coaches, and riding and pack horses. Those who wanted to give the Valley back to the Federal Government complained that the meadows had become one vast feed lot for horses and cows for the custom trade. The proprietors replied that it was too expensive to haul in hay and grain for their animals. A third cause, never mentioned in the official documents, was that on October 16, 1890, Pres. Benjamin Harrison made a great rectangle around the Valley, and turned it, as a frame, into Yosemite National Park. The compulsion was then to put the beautiful picture of the inner Valley itself into the national frame.

The main characters in the Great Dispute were the same as previously, with J. M. Hutchings, Galen Clark, and John Muir playing large parts. New figures were Charles D. Robinson, an artist, and Robert Underwood Johnson, editor of *The Century Magazine*, from New York City, who published two articles in August and September 1890 by Muir—"The Treasures of the Yosemite" and "The Proposed Yosemite National Park." The ostensible purpose of these articles was "to attract general attention" to the condition of the valley.

Drawn into the dispute, but kept more or less in the dark as to its finer points, were John W. Noble, Secretary of the Interior under President Harrison; the governors of California; and, from afar, Olmsted himself. As Johnson told it, he was able to persuade Secretary Noble to look into the problem of the Sequoia Forest and Yosemite Park in June 1891, when both were receiving honorary degrees from Yale University.[102] This meeting Johnson described as the beginning of the agitation for a unified park,[103] but the

[100] Ibid., p. 134.

[101] Muir, *Our National Parks*, p. 135.
[102] Johnson, *Remembered Yesterdays*, p. 293.
[103] "Letters between R. U. Johnson and T. R. Roo-

dispute had been going on locally with some intensity since 1889. In his editorials to preface the Muir articles, Johnson brought up the 1889 testimony before the California legislature to investigate the Yosemite Valley Commissioners, and Olmsted's "lost" report. "Mr. Olmsted's suggestions contemplated as little alteration to the natural growth as would be consistent with a public use which would not impair the sentiment of wildness and grandeur characteristic of the valley. . . . Had these suggestions been followed, visitors to the Yosemite in the past few years would not annually have seen the spectacle of the most phenomenal of the national pleasure grounds ignorantly hewed and hacked, sordidly plowed and fenced, and otherwise treated on principles of forestry which would disgrace a picnic ground."[104]

Professional competence was to be the watchword, and official respect for beauty the new public goal. That was why Olmsted's name was brought up so often in the dispute, to the regret of many, including Olmsted himself. Johnson was seeking to reestablish the debate on the romantic bias of the 1860s in order to institute better management principles in the 1890s. The bugaboo for these conservationists was the mistreatment of Niagara Falls. As early as 1868 the state legislature had attempted to grant outright ownership of 160 acres of land each to Hutchings and Lamon, the original squatters, over the heads of the Commissioners, who called attention to the terms of the original Federal grant of June 30, 1864, which declared that the land should be held "inalienable for all time" and was for "public use, resort and recreation," and that this proposed grant to private persons was a breach of both of those terms of gift. The Commis-

sioners sent this reminder to Congress. Point 7 contained the observation that "The Commissioners are not without a strong hope that the people will eventually rise to a sufficiently elevated plane of intelligence to appreciate the value of the Congressional gift," a patronizing sentiment that could have come straight from the mouth of Whitney, who was still on the Commission. The final point warned, "Let Congress indorse the short-sighted policy of the Present [State] Legislature, and this stupendous valley will become, in time, as notorious as Niagara Falls and many other places in this country and Europe now are, for extortions practiced on travelers, and for the barbarous disfigurement of their surroundings."[105] The effort of Hutchings and Lamon to homestead legally in the meadows of Yosemite then failed in the Fortieth and Forty-First Congresses.

R. U. Johnson saw the dispute as a struggle between the incorruptibility of nature in a particular place, and the ubiquitous corruption of society, an ancient American theme. Buildings and fenced fields were a token of unjust intrusion from that society. At first he objected only "to lack of expert supervision of the scenery," but now there were hints of much bigger scandals in the offing, which had been whitewashed by the state legislature in 1889. "I believe there is good ground for the charge that the reservation is in the hands of a ring, in whose interest most of the farming and tree-cutting has been done," he wrote Secretary Noble in October 1890.[106]

As is so often the case, the bigger controversy was precipitated over a comparatively trivial incident. Charles D. Robinson had been trying to build a studio in the Valley.

sevelt, Relating to the Origin of the White House Conference of May 1908, A Footnote to History," Roosevelt Collection, Harvard University.
[104] "Amateur Management of the Yosemite Scenery," *The Century*, September 1890, p. 798.

[105] "Memo to Members of Congress from Yosemite Commissioners," San Francisco, March 18, 1868, Houghton Rare Book Library, Harvard University, Gift of Charles Sumner.
[106] October 10, 1890. "Sequoia and General Grant," Box 83, National Archives.

Up to that time Thomas Hill had been the only painter allowed to do so. Robinson first petitioned to be permitted to build a whole house. This was approved and then re-scinded. He next asked if the state would build and lease him a studio, with the same negative result. He then wanted to bring in a portable, prefabricated, sectional building. The disapproval of all his proposals seems to have derived from uncertainty on the part of the Commissioners as to how to enforce the principle of human habitation, which was supposed to be kept down to those persons necessary for service to visitors. Was an art-ist necessary? They finally rented to Robin-son on a yearly basis a surplus building, twelve by eighteen feet. However, in Janu-ary 1886 this studio was broken into and Robinson's art materials taken out. It was then moved and converted into a Wells Fargo and post office by W. E. Dennison, the Acting Guardian.[107] Thereafter, Robin-son refers to having been "driven" from the Valley. The immediate result was a petition of grievances from Robinson to the legisla-ture against the Commissioners, involving, among other charges, the wanton destruc-tion of timber, the plowing of meadows, and the fencing of fields, all largely for the ben-efit of the equine feeding interests.[108] Smaller and larger grievances coalesced in the heat of resentment. "I was told that it would be foolish for me to apply for over thirty by fifty feet of ground for my studio, but I thought it was a little mite tough that Coffman & Kenney [the horse factors] should be given nearly the whole valley bed to conduct their business."[109]

Pioneer attitudes were clashing with the succeeding instinct to preserve, stabilize, and legalize the ambiance. America had grown too fast, and it was becoming appar-ent that insistence upon individual opportu-nity, property, and the empirical approach might have been pushed too hard. Secretary Noble, trying to delve to the bottom of the dispute, requested comments from six ex-perts recommended by R. U. Johnson. The reply of Julius Starke is probably the most pertinent. He had been in the Valley since 1878 and regarded himself as a well-in-formed pioneer. He confirmed that barbed wire fences were indeed up in many areas, interfering with the free movement of visi-tors. The enclosed areas were being used as stock ranges by cattle men holding leases. Much acreage was devoted to raising barley, "which is sold to camping parties and others at 45 dollars per ton. Exorbitant prices are charged for hotel accommodations, for trans-portation, guides, &c by the people in charge."[110] The two hotels permitted no competition. There were, to be sure, no sheep pastured in the valley proper, but they were certainly on adjoining lands, including the grounds of the proposed national park, where they were concentrated in large num-bers. Starke closed by declaring that the ar-ticles by John Muir in *The Century* were by no means an exaggeration.

Another major party in the dispute was the *San Francisco Examiner*, which tried to drag the senior Olmsted into the fracas. Be-tween 1888 and 1890 it kept up a steady bar-rage against the handling of the valley. Epi-thets like "mercenary ignoramuses, vandals, and den of thieves" were freely employed by the paper. It concluded that "there are no more meadows, no more carpetings of bright-hued flowers . . . the natural grasses

[107] *Investigation of the Yosemite Valley Commissioners, 1889*, pp. 297, 345-349, 363, 375.

[108] Charles D. Robinson, *List of 22 Charges Read to Assembly Committee at Sacramento, Tuesday Evening, Feb-ruary 5, 1889* (Sacramento: 1889).

[109] *Investigation of the Yosemite Valley Commissioners, 1889*, p. 365.

[110] "Department of the Interior, General Corre-spondence, 1878-91," Box 146, National Archives. See also "Starke to Noble," Box 83, 1890-1891, National Archives.

and flowers have been rooted up and burned off,"[111] in favor of hay, ringed with barbed wire, the American invention. A scoop for the paper came late in 1888, when it was able to catch Olmsted while he was in San Francisco to work on the campus of Stanford University. He explained reluctantly (the press made him nervous), "At best I can only tell you what the ideas of the original commission were. It was our judgment that the natural features of the landscape should be preserved intact and that all necessary improvements should be made in such a way as not to be apparent to any general view. All structures were to be as inconspicuous as possible, and roads were to be built where they could best be hidden. . . . We stopped the cutting, and did not intend to permit the felling of any timber for building purposes. . . . The meadows were to be preserved carefully."[112] As to the allegations that almost every inch was plowed up to grain, the groves mutilated, and enclosures hemmed by barbed wire, they were exaggerated in his opinion. The *Examiner* referred to his observations as "guarded utterances." The following summer Olmsted also refused the invitation of R. U. Johnson to become a guest author in *The Century*, which caused Johnson to turn to Muir. In spite of Olmsted's forebearance, Gov. R. W. Waterman released a stinging indictment to the legislature, claiming that the whole movement was instigated by disappointed office seekers, including especially Hutchings, Johnson, and Olmsted. Why, he asked, did J. M. Hutchings keep importuning them when he had already been paid off? A sub-theme was that the best way to clean up the Valley itself would be to sweep out the old guard, the early pioneers. However, his most marked invective was reserved for Olmsted and Johnson. "Mr. John-

son, the other instigator in this Yosemite movement, boldly announced here that if his uncle, Frederick Law Olmsted, was appointed landscape gardener of the valley he would withdraw all his opposition to the management of the Commissioners."[113]

R. U. Johnson explained that he had been badly misunderstood and misquoted, although there *is* a letter from him six months later to Secretary Noble recommending Olmsted for what Johnson apparently considered a job opening.[114] Olmsted on his part evidently felt compelled to bring out a flyer on *Governmental Preservation of Natural Scenery*, explaining his position. He advised that artificiality be avoided at all costs, and he recalled his responsibility for the park during 1864-1865, reviewing the steps he had taken to refrain from intruding into the present controversy. In an unusual plea for more public humility, almost Lincolnesque in tone, Olmsted asked for practical faith in abiding democratic values. If they were not supported and sustained, neither the full potential of the people nor the places they occupied could be reached. He was anxious lest the technical and practical skills, and personal power, rapidly accumulating in a prosperous society, ultimately impede its spiritual and esthetic development. "If the Governor and the Commissioners are in error, their error probably lies not in any intentional disregard of the State's obligation, but in overlooking the fact that in natural scenery that which is of essential value lies in conditions of character not to be exactly described and made the subject of specific injunctions in an Act of Congress, and not to be perfectly discriminated without other wisdom than that which is gained in schools and colleges, counting-rooms and banks."[115]

[111] November 26, 1888.
[112] December 22, 1888.

[113] *Sacramento Chronicle*, February 18, 1890.
[114] September 30, 1890, "Yosemite Correspondence, 1878-91," Box 146, National Archives.
[115] March 8, 1890.

When Olmsted left Yosemite and California in 1865, he had remarked that he himself had "not yet half taken it in." He declared that he had "never been so unfortunate as to need to solicit public employment, or to have any one solicit it for me."

What was the result of this unseemly dispute? It was evident by 1892 that the Commissioners were attempting to mend their ways by clearing underbrush. Fences were removed, and old clusters of buildings, "which had remained to testify to the natural tendency of the pioneer occupants for village effects," were torn down in order to return the Valley to its "primitive condition."[116] Nevertheless, the financial insufficiency of state appropriations remained chronic. As late as 1904 the Commission was still complaining: "We desire to protest most strongly against the insufficient appropriations that have been made in the past for the general care and maintenance of the Valley. . . . The result of it all has been that such necessary improvements as the bettering of the roads, the protection of the river banks and the clearing out of underbrush, have been neglected."[117]

Galen Clark testified that about 150 acres were plowed up and sown to grain and commercial grasses, much of it for Coffman and Kenney, the furnishers of horses.[118] The closest one can come to the amount of land actually sealed off is that 600-700 of the 750 acres of meadow, and 360 acres of fern land, were fenced. As for the trees, they too had reduced by encroachment the expanse of the meadow from thirty years before, according to Clark.[119] The most irritating indictment

6. *Stump Forest, Yosemite. Photograph supplied by John Muir for his article of 1890 in the Great Dispute (Century Magazine).*

over the trees was that the Commissioners had cut numbers of them down around the Stoneman House and Barnard's Hotel in 1886 and 1887 so that the guests could more easily view the falls. Those about the Stoneman House had been large oaks. Robinson and Hutchings insisted that at Barnard's Hotel a lane thirty to forty feet wide had been ruthlessly cut to give a better view of the Yosemite Falls from the back door of the barroom![120] Another controversial site was Fagenstein's meadow, on the edge of the river, where a hundred cottonwood trees were cleared during the summer of 1887.[121] Thousands of other trees were supposedly eliminated without a thought, with stumps left conspicuous at thirty or more inches above ground, as shown in the photographs in Muir's articles of 1890 for *The Century* (Fig. 6). During their testimony, Robinson and Hutchings also showed pictures of individual trees that had been dismembered.

The fundamental confusion appears to have arisen from the fact that when squatters and visitors came flooding in, there was no system, law, or organization which could be

[116] "Yosemite Commission Book Record B, Report of the Executive Committee, June 30, 1892," p. 155, California State Archives.

[117] *1904 Biennial of the Commissioners to Manage Yosemite Valley and Mariposa Big Tree Grove* (Sacramento: 1904), n.p.

[118] *Investigation of the Yosemite Valley Commissioners*, 1889, pp. 177-178.

[119] Ibid., p. 175. Holway R. Jones, *John Muir and the*

Sierra Club (San Francisco: Sierra Club, 1965), pp. 186-187, has a map of the conditions of the fields between 1883 and 1890.

[120] Ibid., pp. 322, 325, 354, 356.

[121] Ibid., pp. 352-353.

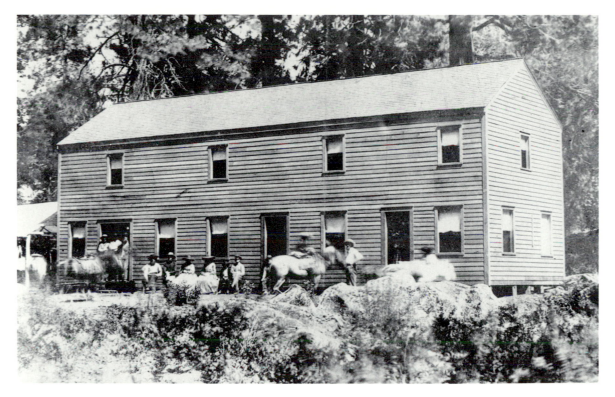

7. Hutchings House Hotel, Yosemite, 1858, Photo C. L. Weed (Yosemite Library, National Park Service).

readily invoked to keep the Valley free of the bad effects of their presence. With the advent of the white man, the hope for an ecologically balanced system also vanished. Olmsted realized that the valley floor—the meadow—was the key to the salvation of the whole gorge. Yet that was where signs of exploitation appeared first. Hutchings' House "Hotel" (1858-1940) was little more than a two-story shack with blank windows, three front doors, and no porch (Fig. 7), and the other two hotels were little better architecturally. Similar incongruities appeared in other, larger, valley bottoms of the Far West as they were settled, between crude buildings and the magnificent, given scenery. Timberline Lodge on Mt. Hood near Portland of the Depression years was to prove the most brilliant later exception. It looked down on three handsome valleys.

THEODORE ROOSEVELT'S VISIT, 1903

The visit of Pres. Theodore Roosevelt in mid-May 1903 was quite different from Emerson's. There was much less indication that the former would succumb to the dominance of friends, including Muir. By then Muir, host again, was older by three decades, and he was about to meet his match for aggressive showmanship and promotional flair. Roosevelt was a different, and later, American in that the exercise of his freedom in nature was bound to be deeper and more self-conscious. That the memory of Emerson's pathetic visit lingered on is indicated in Roosevelt's recollection of his trip after Muir's death at Christmas 1914: "He had written me, even before I met him personally, expressing his regret that when

Emerson came to see the Yosemite, his (Emerson's) friends would not allow him to accept John Muir's invitation to spend two or three days camping with him, so as to see the giant grandeur of the place under surroundings more congenial than those of a hotel piazza or a seat on a coach. I had answered him that if ever I got in his neighborhood I should claim from him the treatment that he had wished to accord Emerson."[122]

Muir wrote his wife immediately after the epoch-making visit: "I had a perfectly glorious time with the President and the mountains. I never had a more interesting, hearty, and manly companion."[123] From Sacramento a day later Roosevelt thanked Muir: "I shall never forget our three camps: the first in the solemn temple of the great sequoias; the next in the snow storm among the silver firs near the brink of the cliff; and the third on the floor of the Yosemite, in the open valley [Pl. 6] fronting the stupendous rocky mass of El Capitan with the falls thundering in the distance on either hand."[124]

Despite the tendency of the romantic imagination to wander, Roosevelt evidently believed in intense attachment to specific sites, but he made these contacts in the most positive, optimistic, and out-going manner possible, thus distinguishing himself from the earlier, more introspective and troubled, visitors. He wanted little or nothing from modern improvements or civilized amenities. A magnificent repast had been prepared at the Sentinel Hotel, complete with speeches, distinguished guests, silver plate and dishes from a San Francisco club, accompanied by a French chef. He boycotted it.[125] Jorgensen's studio cottage had been fixed up for him, but he would not sleep indoors, and came out of the woods there only to drink a glass of champagne and wave to the crowd.[126] In addition to his insistence on only one companion, John Muir, he asked that there be no acknowledgment of his presence by fireworks, search lights, or dynamite bombs. He wanted to live as in the pioneer days, as many other Americans wished to do by the turn of the century, but no longer could. On the other hand, true frontier Americans were accustomed to set the stage and show their approval by explosions and cheering, like the noisy celebration in 1875 when Hutchings was conducted out of the Valley by the sheriff.[127] So they set off the Roosevelt bombs for their own satisfaction, "in a private salute, but just as deafening and reverberating as if Teddy had been present."[128]

Between Roosevelt and Muir the strictly "natural" adventure, with other humans excluded, wove a mood and a bond, as recorded

[122] Theodore Roosevelt, "John Muir: An Appreciation," *The Outlook*, CIX, January 6, 1915, p. 28.

[123] A. Lincoln, "Roosevelt and Muir at Yosemite," Yosemite Library, n.p.

[124] Ibid. The first president to visit Yosemite was James A. Garfield in 1876, six years before he took office. He wrote in the hotel register, "No one can thoughtfully study the Valley and its surroundings without being broadminded thereafter." Then followed U. S. Grant in October 1879 on his world tour at the conclusion of his presidency. In 1883, after his term, Rutherford B. Hayes arrived with a party of twelve and stayed at the Sentinel Hotel. President Taft was there in 1909 and met Galen Clark, the year before he died, besides having his picture taken with Muir. F. D. Roosevelt was there on July 15, 1938. An interesting sidelight is that Theodore Roosevelt said that he had never been in California before (speech at Raymond, 1903). See also Marvin R. Kroller, "Presidential Visits to Yosemite," Part I, *Yosemite Nature Notes*, February 1959, pp. 16-19; Part II, *YNN*, March 1959, pp. 30-34; Part III, *YNN*, April 1959, p. 49.

[125] Augustus Macdonald, "John Muir, Some Personal Recollections," *Quarterly of the California Historical Society*, XVII, 1938, pp. 18-19.

[126] Letter from Lawrence Degnan to John C. Preston, Superintendent of Yosemite National Park, December 9, 1956, Yosemite Library. See also *San Francisco Examiner*, May 19, 1903, Yosemite Library.

[127] *Investigation of the Yosemite Valley Commissioners*, 1889, p. 175.

[128] Degnan to Preston.

in a report dictated by their guide, Charles Leidig, the first white child born in the Valley: "When Charlie returned to the camp site [having persuaded hundreds in Bridal Veil meadows to desist from their effusive effort to greet him, since the President was very tired. Some tip-toed away.], the President said, 'Charlie, I am hungry as hell. Cook any damn thing you wish. How long will it take?'

Charlie told him it would take about 30 minutes, so the President lay on his bed of blankets and went to sleep and snored so loud that Leidig could hear him even above the crackling of the campfire."[129]

Leidig's report also revealed that "Roosevelt and Muir talked far into the night regarding Muir's glacial theory of the formation of Yosemite Valley." They spoke about the conservation of forests in general and Yosemite in particular, and about setting aside other areas in the United States for parks. Two strong characters met and joined their powerful wills (Fig. 8). Leidig observed that Muir seemed to bother Roosevelt by picking twigs for the President's buttonhole. Further difficulty was encountered because "both men wanted to do the talking." These two distinguished figures could appear comical or mismatched (besides snoring, Roosevelt had to be pried with a log out of a five-foot snow drift by Leidig), but they were incomparable in their determination. In that sense, they were fully up to this magnificent scene and the many others they were instrumental in preserving. The only difficulty was that there was little or no custom for exchange about such matters. That was the American disadvantage in the midst of unprecedented scenery. Even individuals of good will toward the environment and each other sometimes found it hard to match their minds. Between Muir and Roosevelt the uni-

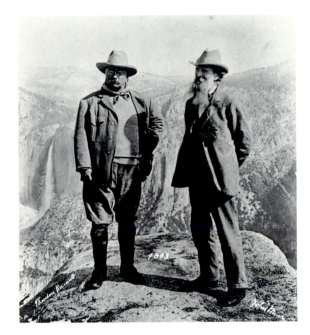

8. *Theodore Roosevelt on Glacier Point with John Muir, Yosemite Falls in the left distance, 1903 (Bancroft Library, University of California).*

fication worked so far as long-term intentions were concerned. It was another awkward occasion, but this time, unlike between Emerson and Muir, it prospered.

After the Yosemite visit, in the sympathetic milieu of the University of California at Berkeley, Roosevelt observed to the faculty, "No State can be judged to be really civilized which in the treatment of its natural resources does not take account of, or aim to, preserve the beauty of the land in which its people live. An esthetic as well as economic factor is involved in the problem of conservation." He reminded the sober-eyed, intellectual, professors, "This country has glorious mountain ranges and valleys, splendid forests, great snow-peaks, the wonderful sequoias—and for all these things none of you deserve the slightest credit" (applause and laughter).[130] The result of Roosevelt's

[129] "Charlie Leidig's Report of President Roosevelt's Visit in May of 1903," Yosemite Library, n.p.

[130] "Theodore Roosevelt on the Occasion of Receiv-

meet at Yosemite with Muir was to be the final securing of the nucleus of the Valley, to be transferred from the state to the Federal Government. "Muir had convinced Roosevelt of the great desirability of having California turn over the control of the inner core, since it was to be isolated by the surrounding Yosemite National Park anyway. At Muir's request the secretary of the Sierra Club [which Muir was instrumental in founding in 1892,[131]], William E. Colby, drew up the necessary bill providing for the transfer. It was passed by the state legislature in January, 1904. In his annual message of December 6, of the same year, Roosevelt had urged the inclusion of the Yosemite Valley in the national park system. When the federal Congress delayed action on the matter, the President, on June 6, 1905, sent an urgent message to Senator George C. Perks of California. 'It would be a real misfortune,' the note said, if, 'either from indifference or because of paying heed to selfish interests,' the Congress adjourned without accepting the 'munificent gift' of California. A few days later the Senator got a bill to enlarge Yosemite National Park to include Yosemite

Valley and the Mariposa Big Trees out of the committee where it had been delayed for months. Spurred on by Roosevelt, Congress passed it immediately."[132]

Theodore Roosevelt set aside 148 million acres of land as forest reserves, created sixteen national monuments, and greatly assisted the establishment of five national parks. In 1908 he created the National Conservation Commission, prophetic of Franklin Roosevelt's ill-fated National Resources Planning Board and his Tennessee Valley Authority. That year signaled the beginning of a firm managerial policy for national conservation at last, when "the preservation of these values [was] initiated at the now famous Conference of Governors in 1908 through the leadership of J. Horace McFarland, at that time President of the American Civic Association,"[133] coming along, of course, with a vigorous prodding from R. U. Johnson.

ing a Book, Prof. Willis Linn Jepson's, The Silva of California, at the Faculty Club of the University of California," *Sierra Club Bulletin*, VIII, 2, June 1911, pp. 131-132.

[131] See Jones, *John Muir and the Sierra Club* pp. 7-10.

[132] A. Lincoln, "Roosevelt and Muir at Yosemite."

[133] Hans Huth, "Yosemite: The Story of an Idea," *Sierra Club Bulletin*, 33, March 1948, p. 47. For R. U. Johnson's part, see especially "Letters between R. U. Johnson and T. R. Roosevelt," Roosevelt Collection, Harvard University. The movement appears to have started in reference to the resources of Appalachia in 1906, when Johnson called for a conference of eastern governors on the subject (letters of August 28, 29, and September 15, 1906). That conference also had serious intimations of the Tennessee Valley Authority of the 1930s under Franklin Roosevelt.

Mount Hood National Forest and Timberline Lodge

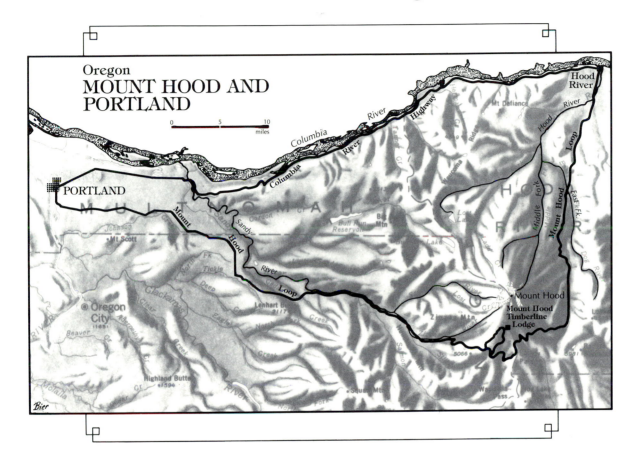

Oregon
MOUNT HOOD AND PORTLAND

M T. HOOD was a freestanding object (see map) in the Northwest that commanded unusual attention between 1870 and 1940, particularly in the 1890s and 1930s. In the dark economic days of the 1930s, Mt. Hood was reaffirmed by the building of Timberline Lodge under the auspices of the WPA. Timberline was certainly superior to the nondescript hotels in the Yosemite Valley, and yet was even more dedicated to the ideal of democracy than they were. Timberline was by no means a people's non-architecture, as Jefferson and Downing had feared in their time and place. It was opened by Franklin and Eleanor Roosevelt, who lent it buoyancy and status.

Like Yosemite, Mt. Hood communicates great strength as well as subtle gentleness. Up close, it is an overwhelming presence. Experts at observing mountains

claimed that Hood "felt" physically closer to them than the other Cascade mountains because of its impression of approachability and intimacy. And people did wish to approach the cool, white, pyramidal mountains of the West. They were the final positive, large-scaled, symbolic trophies in the American game of self-identification and realignment.

The snow descended low upon the slopes of Hood due to a constant replenishment of moisture from the offshore Japanese Current. It could be seen in its whiteness for a hundred miles from the fertile and self-contained Willamette, Hood, and Columbia valleys. Its singularity in that circumscribed setting made it the cynosure of all eyes, including those in the city of Portland, sixty miles away. From there it offered a single surprise to contrast to all the proliferated and individualistic buildings. The democratic visual experience was more often becoming a pluralistic one now, frequently fragmented. For some, especially in the 1890s, Mt. Hood was an enduring symbol of unique purity in the unlikely precinct of the public domain. On the other hand, when the mountain withdrew into the mist and fog, as often happened, it took on an indefinite and mysterious air, like one of Herman Melville's whales suddenly surfacing. It then appealed to the uncertain, restless, and seeking side of the American character, as evinced by the compulsive mechanical approaches, pedestrian climbings, and red fire illuminations of it. In Jeffersonian language, it "loomed" forth its distinct attractions, whether clear and startling or veiled and elusive.

THE Pacific shore is a valley culture backed by mountain ranges. Mt. Hood in Oregon represents the quintessence of this relationship. Its centrality and conspicuousness were major reasons for its influence; it is visible for a hundred miles or more over the Columbia, Hood, and Willamette valleys (Figs. 1-2). If Yosemite served as a symbol of the introversion of the 1860s through the 1880s, then Mt. Hood would begin, at least, to stand for the more optimistic, extroverted, and formal habits of the 1890s and early 1900s, with a second great moment occurring during the Depression of the 1930s with the building of Timberline Lodge on its southern slope. The Lodge reflected the struggle to regain identity and dignity during the social and economic dislocations of the 1930s, but also carried on the esthetic momentum of the Progressive era of the 1890s.

Recognition of Mt. Hood's pervasiveness began early. In October 1792 from the confluence of the Columbia and Willamette rivers, east of the present city of Portland, Lt. William Broughton of the British Navy named the mountain after Admiral Hood, who had signed the instructions for the voyage he was on under Captain George Vancouver. It rose "beautifully conspicuous" as a "termination to the river."[1] Its relation to the lower surroundings was especially noted by Broughton. Because of the drizzle, bringing snow at all seasons to the upper elevations, the cone can descend into the moraines and green uplifts, making the mountain often appear closer and higher across the lower land than it really is. In the Northwest the climate is calm and temperate, while the land forms are powerfully dramatic, sometimes standing stark, sometimes looming through the mist, sometimes stopping the weather with their bulk, the green of the trees growing darker and glossier and the white of the snow shining forth like ivory to illuminate the mountain sides.

Mt. Hood is sixty-one miles from Portland and stands at 11,235 feet. The eruptive Mt. St. Helens (which Broughton named and which was often thought of as belonging also to Portland from the northeast) is sixty-three miles away and as of now lacks 1,300 of its former height of 9,677 feet. After the Revolution the designations became presidential: Mt. Adams, eighty miles away and higher than Hood by about a thousand feet; and Mt. Jefferson, seventy-three miles to the southeast and a little less than a thousand feet lower than Hood. Hood was to have been renamed Washington after the Revolution because of its preeminence, but nothing came of the idea. The Indians called it "Wy'east." Even as late as the 1890s settlers in the vicinity could not resist converting it to literal measurements, making its prominence serve mundane ends. "The mountain also serves the people as a standard of comparison. 'Not so high as Mt. Hood'; 'Not so

[1] Lt. W. R. Broughton, *The Exploration of the Columbia River, October, 1792: An Extract from the Journal of Captain George Vancouver* (Longview, Washington: n.d.), pp. 23-25.

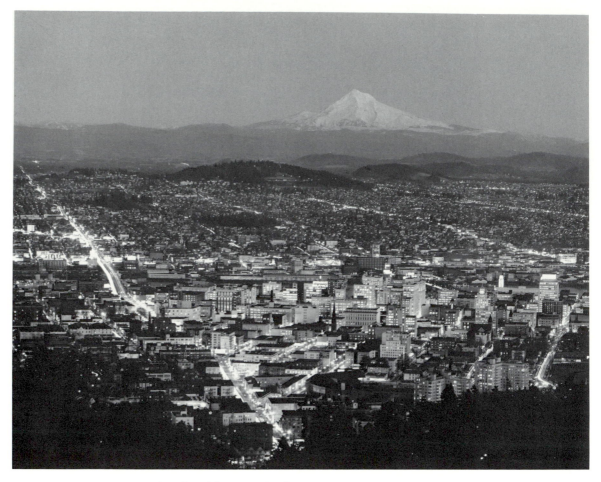

1. Mt. Hood from Portland, Oregon, at dusk (Ray Atkeson).

grand as Mount Hood'; 'Easier to climb than Mount Hood,' & c."[2] Yet Broughton's expedition saw it in almost the same way in the late eighteenth century. With their steeping in the esthetics of the Sublime and the Picturesque, they first called it "magnificent" and "remarkable," and then lamented that they could not mathematically "acquire sufficient authority to ascertain its positive situation, but imagined it could not be less than twenty leagues [sixty miles, impres-

[2] William and Sarah Wiley, *The Yosemite, Alaska and the Yellowstone* (New York: John Wiley and Sons, 1893), p. 125.

sively accurate] from their then station." Lewis and Clark also tried to guess at its height as they passed down the Columbia in 1805.

The magnetism of the peak when seen from Portland, and the compulsion to seek it out, led to the introduction of mechanical devices to speed access to it, such as a converted Portland city bus (Fig. 3) redesigned to ascend the mountain on a hung cable up the "Magic Mile" from Government Camp, the settlement at the base of Hood, in the early 1950s, or the proposed tram to the top of Cooper's Spur on the northeast side a

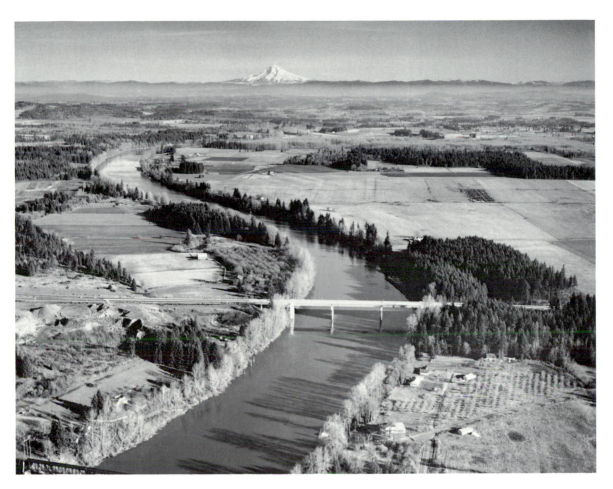

2. Mt. Hood from the Willamette Valley, looking east to it. It has lower surroundings than the other Cascade peaks, so can be more easily seen (Oregon Highway Department).

quarter-century earlier, which was to be followed to the summit for a distance of about a mile by a suspended cableway. The latter proposal came about following completion of the Loop Road around the mountain in 1925 (Map D). The debate as to whether cableways would mar the flanks of the mountain became so heated that the Federal Government called in F. L. Olmsted, Jr.; John C. Merriam, then president of the Carnegie Institution in Washington, D.C.; and Frank Waugh, the famous teacher of landscape architecture at Massachusetts State College and a longstanding adviser to the Forest Service on recreation, to mediate the issue. Olmsted and Merriam were opposed.[3] The cableway was thought to be too conspicuous on the snow above the timberline. It was not until 1937, when Timberline Lodge itself was completed, that the first chairlift built by the Forest Service was erected on the south slope, although the Mazama and Cascade Clubs had private rope tows as early as 1934. The airplane, another mechanical device, was the unknown quantity, as far as

[3] *Public Values of the Mount Hood Area, Document No. 164* (Washington, D.C.: U. S. Government Printing Office, 1930), pp. 9-10.

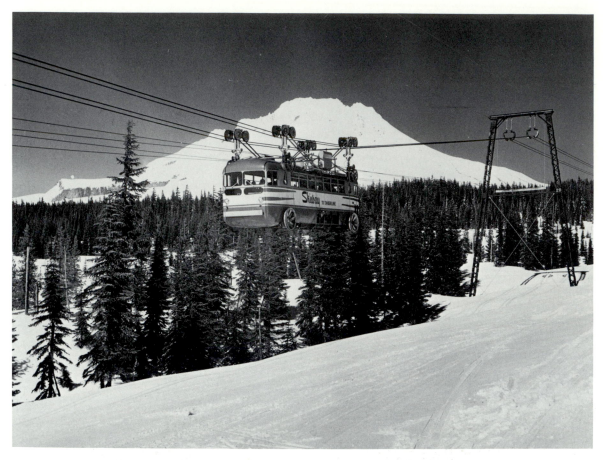

3. The Skiway Bus to Timberline, 1950-1951 (Oregon Highway Department).

the committee was concerned. With coast-to-coast travel imminent, they asked how soon the airplane might increase the popularity for mountain climbing in the Far West, much as the railroad had "opened up" Yosemite.

The committee was also fascinated by the profile of the mountain. In Hood they saw "the element of magnitude, which insensibly in another form represents power, more than is true in the case of Mount Shasta or Rainier." At the same time, the peak, "varying as it does according to its sculpturing, as seen in different views, reproduces on the sheer faces of the mountain an exceptionally beautiful type of reflection or illumination such as can rarely be seen in the more mas-

sive mountains." Its capacity for floating iridescently over the surrounding countryside was unmatched. At the same time, "There is a general character of intimacy about Mt. Hood, partly implied in what has already been said, but worthy of a separate remark. The whole mountain is approachable, accessible, and friendly in a way and to a degree differentiating it from comparable peaks in the Northwest."

THE PRIME REALIZATION

The strongest feeling about Mt. Hood occurred in the 1890s, when interest in city planning following Burnham's Chicago Columbian Exposition of 1893, the Beaux Arts

style in architecture, and landscape amenity were at their height. The appreciation for sheer, towering, monumental scale was never greater, whether in natural or man-made forms, nor the identification with a seemingly incorruptible purity more welcome. For Oregon this "new wave" was typified by the Mazama Club, or "Mountain Goats," a variant of the Sierra Club in California. According to the 1894 Mazama prospectus, "The Cliff Climbers," its first purpose was "to minister to the social and physical enjoyment of its members by creating a motive for bringing them more frequently in contact with the beauties and grandeur of our mountain scenery; to disseminate information tending to facilitate the exploring and climbing of mountains, and regarding the best means of reaching points of interest; and to develop and encourage a more thorough appreciation of the unrivalled natural beauty of the Northwest; secondarily, to enlist scientific investigation, to attract attention of artists, writers and tourists to the undeveloped field for art, literature and recreation in the Cascade and other Pacific Coast ranges of mountains, and to unite the artistic and practical among mountain climbers."

The first Mazama magazine contained a poem to Mt. Hood by Prince Lucien Campbell, a founding member and president of the University of Oregon:

> Lo, thou dost satisfy the long desire
> Of human souls for type of worthy
> men,
> As God would have them—image once
> again
> Of the Creator, kin to the immortal
> choir
> Who sings His glories in undying
> strain—
> Pure, rugged, calm,—but filled with
> inward fire![4]

[4] *Mazama*, Portland, 1896, p. 23.

Under Campbell's leadership the university emphasized the arts, particularly crafts. Campbell himself taught a freshman course in ethics. As there had been a gesture in the past toward preserving personal and artistic integrity by leaving the Hudson Valley for the Yosemite Valley and the snow-capped mountains of the West, so there was now a virtue in approaching them from the immediate locale even closer, in a further integrating process. Campbell's ideal of outer imperturbablity and inner fire and intensity was reflected in the later writings of northwesterners such as Luther Jerstad, English instructor at the university, who had climbed Mt. Everest so as to know himself better.[5] American restlessness and aspiration thus became fundamentally more inward seeking. The "better" American was to be helped to realize himself by a nature of nobler scale and size, as in California around Yosemite and the Sierra Nevada with men like Whitney's young breed of geologists.

The 1890s' exultation in nature, and the ceremony on the mountain to mark it, was made most apparent on July 17, 1894, when nearly three hundred future Mazamas met at the Government Camp base to climb Mt. Hood, and a similar number arrived at Cloud Cap Inn on the northeast slope. The next day they moved farther up to the timberline (Fig. 4) in preparation for the founding of the club. The two parties were then to meet at the summit at noon on July 19, where "a simple but appropriate banquet was to be spread, followed by toasts and speeches; the Mazamas were then to organize in due form, and a quantity of tar was to be burned in order to give a smoke-signal to all the surrounding country that the organization was effected; while the day was to end

[5] Luther G. Jerstad, "Conversations on Mountain Peaks," *Old Oregon*, January-February, 1968, p. 17. For the climbing of Mt. Hood in recent and earlier times, see Fred Becky, *Moutains of North America* (San Francisco: Sierra Club, 1982), pp. 191-196.

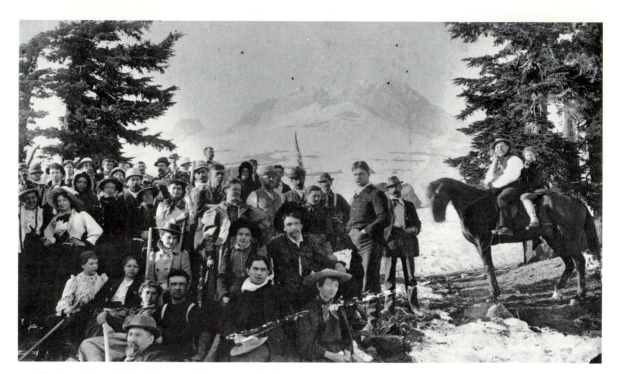

4. The founding of the Mazama Mountain Climbing Club, at timberline on Mt. Hood, July 18, 1894 (Oregon Historical Society).

by the exhibition of red fire on the summit in the evening."[6] But "unforeseen circumstances" in the form of a furious snow and hail storm, even though it was mid-July, suddenly arose, and only forty hardy climbers remained by 3:00 p.m. The society was officially formed by "all huddling together on the one sheltered ledge which the summit afforded." The constitution was adopted, officers elected, and three carrier pigeons were released, but only Pickwick reached Portland, "so completely worn out [by the head winds] that it was hardly able to stand." Signal smoke from as far south as Eugene was observed. Mirror flashes were witnessed from the mountain at Portland and to Hood from several places in the Willamette Valley, and from eastern Oregon on the other side of the Cascades. To see and be seen from the

distant wild in the civilized community denoted the consummation.

THE REQUIRED APPROACH

In the nineteenth century it took three days by carriage to reach the base of Mt. Hood from Portland. In August 1903, John B. Kelly drove his White-Stanhope steamer to Mt. Hood, completing the first automobile approach. The trip proceeded in short bursts: "The first twenty-five miles, the road was fairly good, the next fifteen miles was as bad as bad could be."[7] Slippery mud called for ropes around the tires. The rocks between the wagon ruts were so high that the rear wheels came off the ground. Kelly bravely advanced into a bog with only one hundred pounds of steam, got stuck, and

[6] "Historian's Report for 1894," *Mazama*, 1896, p. 16. See also *Harper's Weekly*, August 25, 1894.

[7] Ivan M. Woolley, *Off to Mt. Hood* (Portland: Oregon Historical Society, 1959), p. 105.

had to wait until five hundred pounds accumulated so that he could "wiggle out" by "backing forward" to get more power.

Yet, not only he but also the campers at the base of the mountain felt his chauffeuring exertions were fully justified. When Kelly drove into Government Camp with his steamer puffing five and a half hours later, he was greeted with "the waving of dish aprons, coats, hats, handkerchiefs, or anything they could lay their hands to, and a mighty 'hurrah' when they realized that the puffing they had been hearing was made by the coming of an up-to-date automobile." This was no mental act, merely a blind impulse to reach the mountain, now made feasible to satisfy by mechanical power. After spending a few days with his family, who had been camping on the mountain, Kelly loaded the steamer with "mementoes" (including fifty pounds of Mt. Hood snow), his wife, and three children, and headed back to Portland. The return trip (of seven hours) revealed a peculiarity about his vehicle—it went uphill faster than down, even after the brake casing had been scraped off by the rocks. Kelly felt that any person who attempted the trip with a gasoline vehicle would end up "paralyzed." Roads were to be the key to all of the forest's future development as a wilderness, presenting the same paradox of purity invaded by democratized accessibility as when Yosemite had been opened up to automobiles in 1913. Indispensable to that process was the Mt. Hood Loop Road of 1925.

THE NEWER SPORTS

During the first decade of the twentieth century snowshoeing and skiing were also introduced on Mt. Hood.[8] They succeeded, but

did not supersede (as the automobile did the stagecoach), the art of mountain climbing. To understand these changes, the form and silhouette of the mountain itself should be taken into account. Below the peak are prominent shoulders, or buttresses, down which fall eight glaciers, intermixed with snow fields, crevices, chutes, and steaming fumaroles. The same varying tactility which made the mountain visibly satisfying also gave it a special magnetism for these sports. A painting from the WPA era by Charles Heaney (Fig. 5) presents this rudimentary sculptural shape with its modeling, and also effectively outlines the area behind the mountain to the northeast with its rich fruit fields, called the Hood River Valley. The green uplifts, appearing as subordinate hills, bring stability to the base. Mountain climbing and snowshoeing were at first centered on the northeast slope, where accessibility from the Columbia Gorge via the Hood River Valley made the construction of Cloud Cap, a log inn, practicable as early as 1889 at 5,827 feet, about halfway up. This was where the most challenging ridges and snow fields for the ascent were accessible, especially Cooper Spur and Eliot Glacier. The south side, with its more continuous and gentler slopes, was better for steady downhill skiing. This condition set the stage for the later construction of Timberline Lodge (Fig. 6) on the south slope, at the end of the long ski runs.

THE EVOLUTION OF THE LODGES

A mountaineers' shack was built at the timberline in 1912 about a half-mile west of the present lodge by the renowned guide "Lige"

[8] Wesley Ladd founded the Snowshoe Club, oldest of winter sport groups, at Cloud Cap Inn in 1904 (Louise Aaron, "This Was Portland," *Oregon Journal*, September 14, 1958). In 1906 six young men from

Portland made up the first skiing party. They came to Boring by electric tram and then to Hood by four-horse stage and skis. The skis were homemade and copied from a picture (John Clark Hunt, "Mt. Hood Becomes Winter Play Area," *Oregonian*, April 3, 1967, see also *Sunday Oregonian Magazine*, February 8, 1953).

5. Mt. Hood by Charles Heaney, in Timberline Lodge, 1937 (Friends of Timberline).

Coalman.[9] But this shift from the north to south slope appears to have been caused more by changes in the type of sport activity, by the fact that the most exciting feat from the earliest days was to climb over the mountain from Cloud Cap Inn to the southern slope, and by the declaration of the Sec-

retary of Agriculture on April 28, 1926, that Mt. Hood National Forest should henceforth be more devoted to public recreation. This decision was critical for public access, as is shown by the events which led, a decade later, to the construction of Timberline Lodge. The declaration also had much to do with the decision to spend so much money and effort for the construction of a lodge in the midst of a depression.

The proprietor of Cloud Cap Inn, Homer A. Rogers, observed before the construction of the Loop Road that car owners would soon be able to travel to Hood from Portland and return in one day. In his view, that sig-

[9] "Timberline's First Lodge," *Oregonian*, February 5, 1956. The Lodge was first predicated as a simple ski shelter and rest house from the experience with the previous timberline shelter, as interpreted by E. J. Griffith and Jack Meier. That "Hotel at Timberline," built three-quarters of a mile west of the present Lodge, was put up in 1924 and measured eight by sixteen feet, with three tents to back it. Carl Gohs, *Timberline* (Portland: R. L. Kohnstamm, n.d.), p. 8.

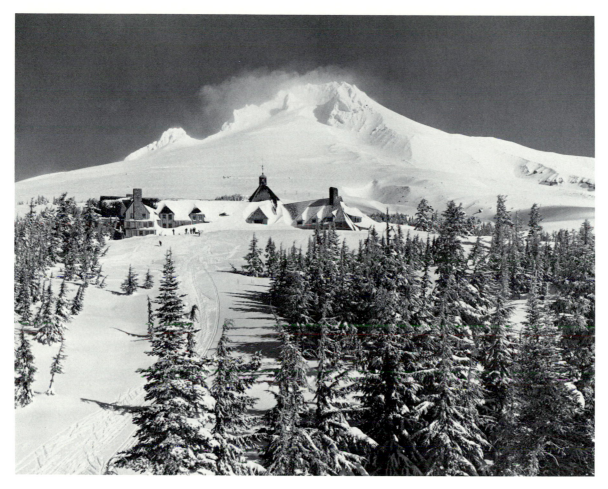

6. *Timberline Lodge, Mt. Hood, W. I. Turner, supervising; Gilbert Stanley Underwood, consulting; Linn A. Forrest, design; Howard Gifford, interior design; Dean Wright, hardware and interiors; Margery Hoffman Smith, furnishings; Ward Gano, structures; A. D. Taylor, landscaping; and many others, 1935-1938 (Ray Atkeson).*

naled the end of his overnight hotel business and caused the sponsorship of the road by the state government to take on even more ominous tones for private enterprise. However, the extension of recreational opportunities proved irresistible, as was already indicated in 1897 by the president of the Mazamas; "The time when the tide of American pleasure travel which has hitherto swept through the Alps shall turn to the mountains of the Pacific Coast may be safely limited, I think, to the building of good roads and comfortable accommodations within what

are now, to the tourist class, practically inaccessible regions."

Col. W. B. Greeley of the Forest Service, articulate in discussions about the proposed cableway, suggested as early as 1923 that Rogers should expand Cloud Cap Inn. With the opening of the Loop Road in 1925, Greeley became even more vocal, while Rogers became more resistant. Greeley complained to Oregon Senator McNary, in early January of 1925, "The main point involved is that at the cost of the federal government, the state and the county, the Mount Hood

7. Plaster Model of the Hotel Project of the Cascade Development Corporation, Carl Linde, 1929. The basic design appears to have been by locally renowned architect, John Yeon, who then continued support, interesting E. J. Griffith and Margery Hoffman Smith (National Archives).

region has been made much more accessible to public travel and recreation. These developments have greatly enhanced the value of the site at Cloud Cap Inn and also the opportunity for public service which can be rendered by a suitable hotel at that point."[10] Rogers remained unreceptive. Therefore, Greeley called for bids for a new structure. Between 1929 and 1931, another, larger, hotel, promoted by L. L. Tyler of Portland, was put into the planning stage, under the aegis of the Cascade Development Corporation at a proposed cost of two million dollars. Carl Linde, a local architect, made a plaster model for the peak of the mountain—cubistic and abstract in the setback mode of urban skyscrapers of the 1920s (Fig. 7)—which again brought forth howls of protest. This proposal was actually tied to the contested cableway and again elicited comments from the three outside experts—Olmsted,

Merriam, and Waugh. Waugh summed up the group's opinion: "When this difficult problem is put in the hands of an architect who visualizes every building in terms of city streets, a situation seems to me hopeless." As a result, both the plans for the cableway and the new hotel were finally abandoned and major attention was turned from the north to the south slope for recreational reasons: as suggested first by Francis E. Williamson in *Oregon Geographic Names*: "Plans and drawings for the formal compilation of a recreation plan for the south slope of Mount Hood was started by me in 1927. . . . The plan, as developed, authorized a lodge at the timberline along with ski club and mountain climbing chalets."[11]

By 1929, the economic climate had chilled, but the recreational trend, already in motion, was picked up again on December 14, 1935, when Pres. Franklin Roosevelt ap-

[10] *Oregonian*, September 3, 1964.

[11] Lewis A. McArthur, ed. (Portland: Binfords and Mort), 1952, p. 602.

proved the release of $246,893 of WPA funds for a ski lodge hotel, provided that an initial $20,000 of debenture bonds (required by law) could first be raised locally.[12] The Mt. Hood Development Association, with Berger Underdahl as chief mover and Jack Meier as president, was organized in the spring of 1936 to respond to this challenge grant, and $13,900 was pledged. Meier's father, Julius, who became governor in 1930, had been one of the most active promoters of the Loop Road. The elimination of Williamson's proposed chalets near Timberline Lodge may have been the result of the threat of the snows and winds at this elevation, although the word from Washington, reflected in the official log, suggests that the determining attitude was that too many on location extravagances should not be permitted in times of general economic stringency.

THE STRUCTURE TO SATISFY THE PROSPECT

Why, indeed, was Timberline Lodge itself to be so rich in handicrafts and splendid in materials? Certainly it provided employment for the blacksmiths, shinglers, timber buckers, stone masons, hardwood floor layers, mill-wrights, and furniture builders in the abnormally depressed building trades. The range of architectural hand skills available elsewhere in the 1920s before the onset of the Depression has never been recovered. In that respect, Timberline was a ten-year anachronism, because elsewhere the government was rapidly dropping to minimal, mechanistic, standards in its buildings. After these skilled workers, came those who concentrated on furnishings—the weavers, loom builders, seamstresses, wood sculptors, yoke benders, painters, potters, dyers, leather

workers, and finally the bull cooks and writers. Douglas Lynch, one of the artists involved, observed, "Some people have called the project a renaissance of the arts, but I think it was more like a Gothic effort. Each craftsman and artist produced his best as part of something much bigger."[13] It was an unusual event in modern times, a cooperative artistic endeavor on the part of a whole community, on the model of the English craft guilds in the Cotswold villages at the turn of the century, headed by C. R. Ashbee.

If Yosemite stood for the exhaustion of the Civil War, then Hood symbolized the resurging energy of the late postwar period. At first the patriotic ardor was dampened by a hygienic consideration, a recurring question in all the landscapes here studied. One was not supposed to be able to survive the night air on the summit. Perry Vickers ascended the mountain one evening in 1873, and with magnesium flares in ten displays demonstrated that it could be done without fatality. It was tried again in 1877 on the Fourth of July, and in 1885, when a party of young men set up two alarm clocks which would jerk a string at 10:00 p.m., upsetting a "liquid preparation" to ignite the red fire. The device was efficient. As they walked away from the cache at 4:00 p.m., they heard a sound like "an avalanche." "Looking back their eyes were dazzled by a tremendous flash, as their red fire was touched off. A rock, the disappointed party explained, had hit the bottle and caused the illumination six hours early."[14] In 1887, Will G. Steel,[15] of the Oregon Alpine Club, later

[12] "Notes on Progress of Timberline Lodge," Mt. Hood, Forest Service Log.

[13] Mariel Ames, "Timberline Treasure," *Oregonian*, May 21, 1967.

[14] Fred H. McNeil, *Wy'east the Mountain* (Portland: Metropolitan Press, 1937), p. 64.

[15] William Gladstone Steel was a great promoter of the local beauties. He was initially responsible for Crater Lake becoming a national park. See Lawrence Rakestraw, "A History of Forest Conservation in the

the first president of the Mazamas, led a party which ignited one hundred and fifty pounds of lycopodium powder. The *Oregonian* next morning assured them that it had been seen in Portland. In fact, "a bright red light shone away up in the clouds above the eastern horizon, which was greeted with cheers from the thousands congregated on the bridge, wharves, roofs, boats on the river and on the hills back of the town, and with vigorous and long-continued whistling from every steamboat on the river." In 1888, with a military escort from the Vancouver, Washington, barracks, the event was repeated. The Mazamas in 1894, who also intended to ignite red fire at their founding, merely formalized and demilitarized such events.

Essentially separated from the rest of the United States by mountains, these people wanted to light up their little world to the farthest corners, taking the environmental measure of it as they did so. Compared to the spread of the Midwest river basins and the continuous threshold of the East Coast, the Pacific Coast culture was too often interrupted and kept apart by its dales. The least they could do therefore was to signal back and forth across them. Mt. Hood and the other snow peaks of the Cascades act as a rising line of chief accents, north to south, which then gain visual prominence over the more random pattern of the land below them.

THE BUILDING OF TIMBERLINE LODGE AS A CROWNING TOUCH

It seemed inevitable that a permanent architectural monument would have to crown or collate these festivals and rallies at the summit. The pessimistic economic and social

Pacific Northwest, 1891-1913," Ph.D. thesis, University of Washington, 1955, pp. 29-30.

conditions of the 1930s brought from the optimistic impulses of the 1890s a suitable renewal in the creation of Timberline Lodge. Rumor persisted that the inspiration for what, in its size, was a great Victorian hotel, came from Washington, D.C.—from the president himself or Eleanor Roosevelt; from Harry Hopkins, the confidant of the president, who inspected the Lodge with a party of thirty-five on September 14, 1936, well before its completion; or the director of the Federal Art Project, Holger Cahill. But the Forest Service log shows that local people provided the greatest incentive. The most prominent was E. J. Griffith, the Oregon WPA administrator. C. J. Buck, the regional forester, acknowledging the transfer of Timberline to the Forest Service when completed, rendered tribute to Griffith in a letter in the Forest Service archives of January 17, 1938: "I feel you have rather personally, as well as officially charged me with this public trust. I say personally, because I know there is a great deal of E. J. Griffith in the structure. You have developed this Lodge as a tangible expression of your concept of what Mt. Hood should mean to the people—in enjoyment, and in fostering the aesthetic and higher values in life. . . . Your aggressiveness and persistency in the face of difficult governmental procedures have accomplished this wonderful creation—a monument to the W.P.A. and to worthwhile New Deal accomplishments. It should do much to make Oregon and Portland known and appreciated by untold thousands in the years to come." W. I. Turner, the supervising architect representing the Forest Service, was also a witness to the difficulty of accomplishing such a task. In the fall of 1937 he observed with some asperity, "Due to the spending spree indulged in prior to the President's visit, there remains but some $6,000 for the completion of funds available. It is understood that $53,000 was expended within a three-weeks' period immediately before the dedi-

Pl. 1. Blue Ridge Mountains from northwest window of Monticello (Thomas A. Heinz).

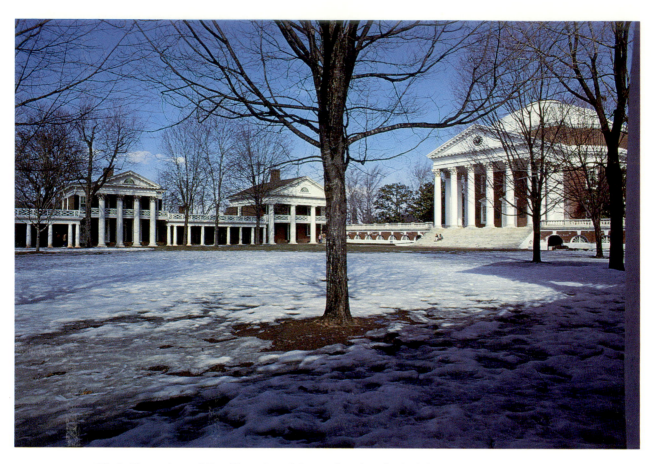

Pl. 2. Rotunda and Pavilions I and II, University of Virginia (T. A. Heinz).

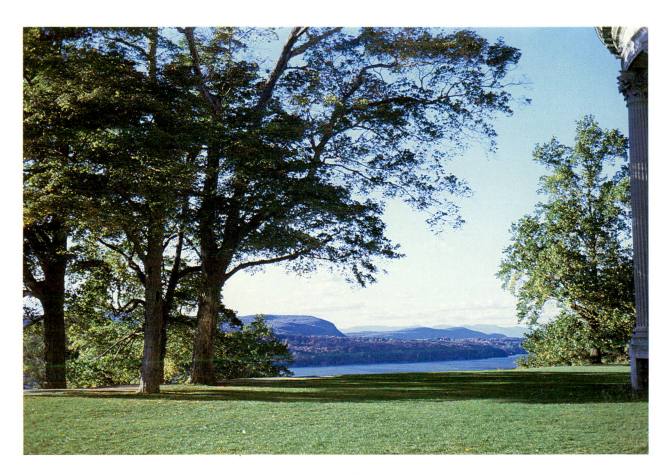

Pl. 3. View from terrace, Hyde Park Estate, Hyde Park, New York (Walter Creese).

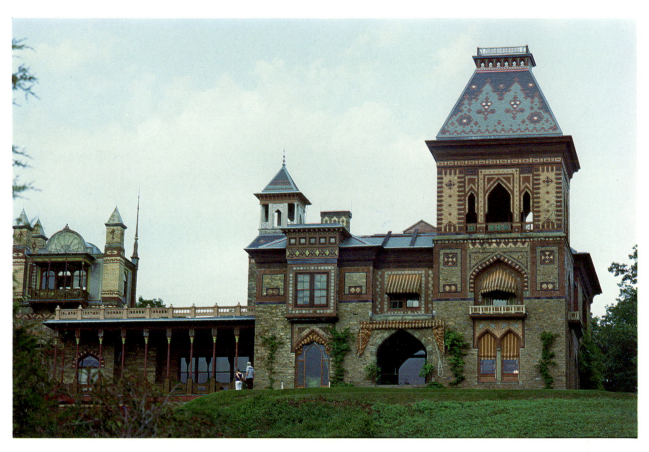

Pl. 4. South front, Olana, estate of Frederic Church, opposite Catskill, New York (Thomas A. Heinz).

Pl. 5. Wildmont, home of A. J. Davis, Llewellyn Park, New Jersey, Watercolor by Davis (Franklin D. Roosevelt Library).

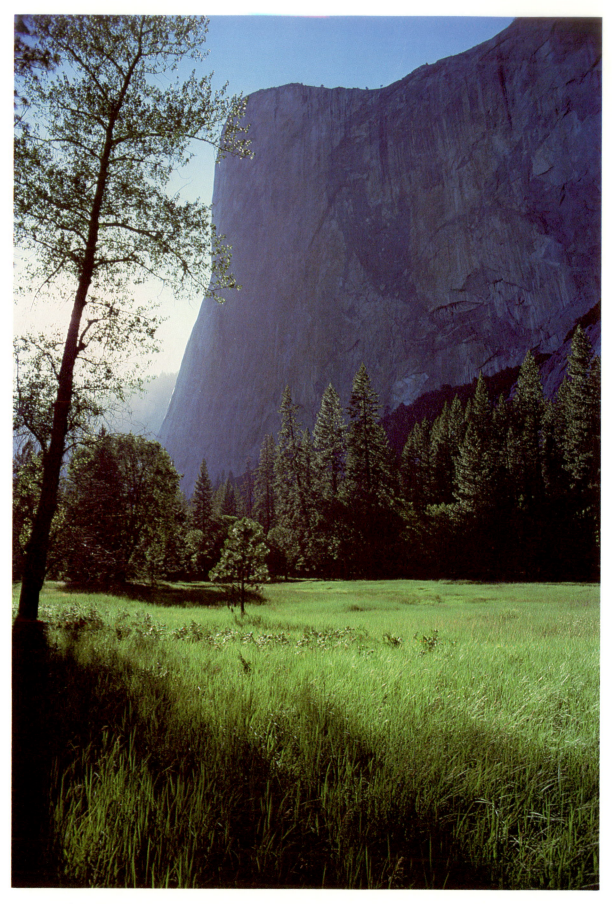

Pl. 6. Meadow, Yosemite Valley, with El Capitan, rising 3,600 feet (Thomas A. Heinz).

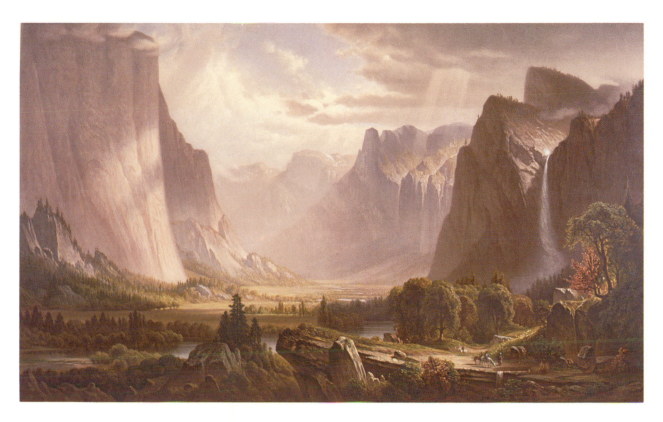

Pl. 7. Yosemite Valley, chromolithograph by Louis Prang of Boston, after a painting by Thomas Hill, 1870. Hill was the painter of the blue haze (Print Department, Boston Public Library).

Pl. 8. Veranda of 144 Scottswood, Riverside, William Le Baron Jenney (John Janicek).

cation."[16] This meant that items like refrigerators, kitchen equipment, and coffee shop counters and seats had to wait until after the visit of "The Chief."

THE ROOSEVELTS' VISIT

The brief but exceedingly buoyant visit of the Roosevelts for the dedication of Timberline Lodge and Bonneville Dam on the Columbia River added to the local importance of Timberline Lodge, but was significant in other ways as well. It was a holiday for local Democrats, according to the predominantly Republican newspapers. It could also be taken as a regional manifestation of Mrs. Roosevelt's aspiration to build up the arts and crafts. Or it could be understood as an occasion for the president to take stock and elaborate his views about what he would like for the rest of the country, given the stimulus of these great projects. Both Roosevelt presidents, and Jefferson, desired to relate their governing efforts to the actual fabric and feel of the land.

The plebeian, Roman holiday, atmosphere of the visit, an event up against a mountain and encouraged by a patrician president, represented a curious contradiction of classes and conditions in the gray light of the Depression. The dedication ceremonies actually began in Boise, Idaho, where, after praising local children and trees, Roosevelt declared to the rural homesteaders that he had had a lovely day, and that "I am grateful for your coming and saying 'Howdy' today, just like the plain folks all of us are." As the trip unwound, everyone became even more lightheaded. At Baker, Oregon, he invited Cong. Walter M. Pierce to make a few comments from the back of the presidential train. Someone gave too soon the signal to leave. As the train pulled out the congressman was still singing the praises of the President, who "knows our problems. He knows what a cow means, and the potatoes and—!" When the presidential limousine, through some similar miscalculation, ran out of gas on Rushton Hill during the sixty-mile drive from Bonneville Dam to Timberline, the proprietress of the gas station into which the official car rolled could not crank the pump for some minutes, so overcome was she on recognizing her unheralded customer.

In Portland an enthusiastic bystander threw his hat so high that it landed in the President's lap in the open touring car in the motorcade, despite the frantic efforts of Secret Service men to wave it off. In the Depression it was newsworthy that it was a brand new, ten-dollar hat. The president's didn't look as good.[17] The magnetism of the whole occasion and Timberline Lodge, the desire of so many to draw as near as possible to him and it, were reflected in the organization of The Hospitality Committee, dubbed in the papers the "Committee of 700": "Not content with the groups of several hundred names, prominent and not so prominent first selected to 'receive' President Roosevelt when he visits this section next week, persons with more or less authority have been adding names and setting up additional committees until the thing has reached the point where the term 'city directory committee' has been derisively applied."[18]

At Timberline a WPA amphitheatre had been built with a liberating view to the south along the Cascades. While awaiting the noon arrival of the president, dances were staged, accompanied by the music project band. The dances followed in the sequence of the representations of flax scutching machines,

[16] October 14, 1937, "Notes on Progress of Timberline Lodge," Mt. Hood, Forest Service Log.

[17] *Oregon Journal* and *Oregonian*, September 27-29, 1937.

[18] *Oregonian*, September 26, 1937.

8. Heliographing by "Forest Flash" from the left gable of Timberline Lodge. This was for entertaining the crowd while awaiting the arrival of President Roosevelt (Les Ordeman, Oregon Journal).

an Indian celebration, a Black American interlude, and the dance of the 1930s sophisticates, succeeded by the quick steps of the WPA workers, contrary to popular opinion about their usual work tempo. The old custom of heliographing (Fig. 8) was reinvoked to send messages by "forest flash" to the plains below, while awaiting the president.

The reporters observed that Mrs. Roosevelt was disarmingly frank and gracious. Even more than the president, she seemed to realize that the focus of the occasion should

be on Timberline Lodge and that she should share the pleasure of local citizens in its accomplishment. At Bonneville Dam she was asked whether she was the source of inspiration for its art. Her answer was, "No, no. There is no more truth to that than to lots of other stories which are told. But my interest in art projects is strong. They will give us something in the future, it seems to me, which will be of great value, although we may not see that now!" She had been criticized at times for being overzealous in her promotion of such projects. As if to protect her husband's reputation, she added with a total lack of candor, "I can't claim any credit for anything anywhere."[19]

But the next day she made a discreet inquiry of Mrs. Griffith as to whether "this might lead to a permanent arts and crafts center?"[20] Newspapers of at least a year before suggest that she had been watching the evolution of the Lodge with keen interest. At the suggestion of Harry Hopkins she had previously invited Griffith to the White House. "She liked the plans and is enthusiastic about it," Griffith reported upon his return to Portland; "She had an especial interest in the arrangements we are making for employment of Oregon artists in the decoration, and I am fairly confident she will be out for the dedication next fall."[21] Indeed, the decoration and the Lodge promised well to become *the* WPA example of the visual arts.

That week the papers were filled with military threats from Germany and Italy. In Asia, the Japanese were becoming increasingly restive. The AFL and CIO unions were struggling violently for control of West Coast waterfronts, including that of Port-

[19] "Mrs. Roosevelt Charms Bonneville Welcomers," *Oregon Journal*, September 28, 1937.
[20] Ibid., September 29, 1937.
[21] Ibid., March 26, 1936. Mr. Jack Meier told the author that this visit was at the behest of Harry Hopkins.

9

land. Physical illness was much in the news—cholera in China and flu and infantile paralysis in Portland, only possible to treat by the iron lung, of which Oregon possessed but one—being used alternately to permit two boys, fifteen and seventeen, to continue breathing. Little wonder that there was a sense of release and exultation from the dedication (Fig. 9) of Timberline Lodge at last. Yet there was decent restraint, too. None of the newspapers photographed or reported the president's difficulty in moving about as a result of his own crippling infantile paralysis. Instead there were comments on the extraordinary strength of his constitution and an anxiety lest the crowds press too close. That many were genuinely grateful to this man was apparent in such fugitive items as a handmade Thanksgiving Day card sent to him by the workmen on Timberline in 1937 (Fig. 10). They were part of another of his loyal and peaceful armies, like the Citizens Conservation Corps.

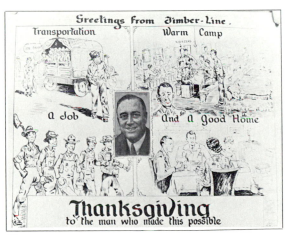

10

9. *Pres. Franklin Roosevelt dedicating Timberline Lodge, September 28, 1937 (U. S. Forest Service).*

10. *Thanksgiving card to President Roosevelt from the WPA workers at Timberline, Harold Ruland, 1937 (Les Ordeman, Oregon Journal).*

151

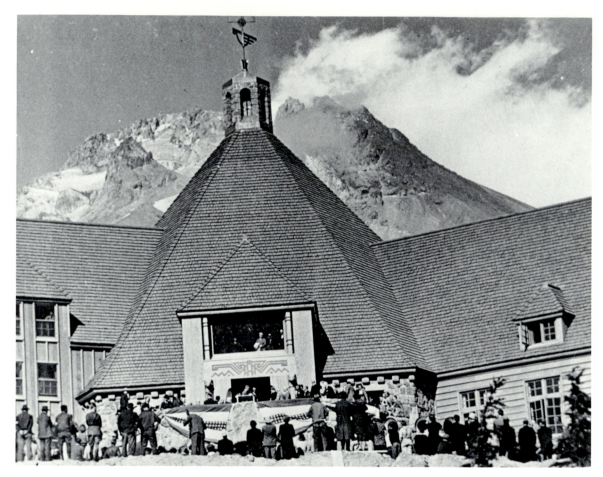

11. The Head House of Timberline Lodge on the day of Dedication, with President Roosevelt on the terrace. The Indian motif on the lintel over his head stands for "Everlasting Life and Abundance." The summer has freed the peak behind of snow, a rare occurrence. The news of the day stated, "From the north windows, Mount Hood seemed to be within a hand's reach from the building" (Les Ordeman, Oregon Journal).

Roosevelt was reported on this trip to be politically non-contentious,[22] and his genial mood worked a further alchemy on those around him. Although he paused only to take lunch at Timberline, he had assembled a larger picture during his progression from Boise to Bonneville Dam. Now he was immensely stimulated by the unmatched panorama from the Head House terrace of Timberline (Fig. 11), with its uninterrupted line of snow-capped peaks along the Cascade Range (Fig. 12). It was by this time rare nationally to be able to examine so much nature from such a distance. "I am trying to think of the bigger objectives of American life—to think about planning,"[23] he declared. This was to be the *new* Progressivism. The needs of resource protection and recreation might be served together in this unusual place: "Out here you have not got

[22] Carl Smith, "Roosevelt's Addresses Brief and Friendly: Crusading Idea Missing," *Oregon Journal*, September 28, 1937.

[23] For full texts of the Boise, Bonneville, and Timberline speeches, see the local newspapers of September 27, 28. 1937.

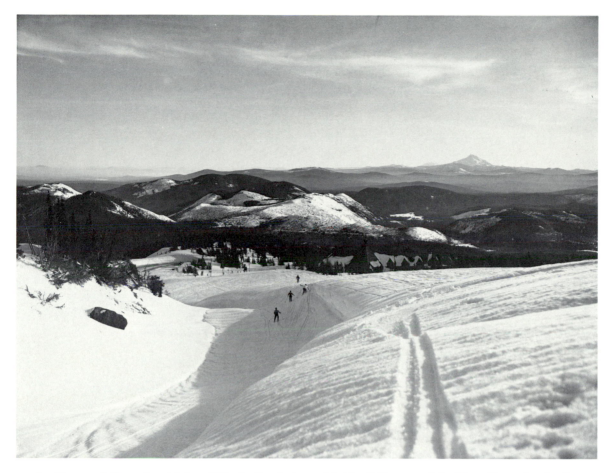

12. *Looking south from the vicinity of Timberline Lodge, with Mt. Jefferson and the Three Sisters in the distance along the Cascade Range. This is the approximate view Roosevelt had as he spoke from the terrace (Oregon Highway Department).*

just space, but you have got space that can be used by human beings."

He approached his main concern in a typically roundabout way. For further resource development the United States could be divided into seven or eight great regions or districts, under commissions. Such boards had already been proposed in Congress, he reported. The Columbia Valley suggested another TVA to him. He had begun to think about such possibilities as early as 1920. These thoughts had borne a result in 1933, when Bonneville Dam was begun. About

1929, while still governor of New York, he had been similarly interested in harnessing the St. Lawrence River for power. His first views had differed from those of many in that he had not wished to employ cheap power on the St. Lawrence to build yet another industrial conurbation, a second Pittsburgh. Instead he had wanted "postage stamp" power rates to make it easier for rural decentralization, for settlements to filter out across the unoccupied country through the widest use of electricity in homes, farms, and shops. "It is because I am thinking of

153

the nation and the region 50 years from now that I venture the further prophecy that as time passes we will do everything in our power to encourage the building up of the smaller communities of the United States. Today many people are beginning to realize that there is an inherent weakness in big cities—cities too large for the occasions of the time—and there is an inherent strength in a wider geographical distribution of population." He wanted a more gradual, and a more widely and evenly distributed settlement.

If such electrification, reforestation, navigation, and soil conservation could have come about forty, thirty, or even only twenty years before, the vast migration of Okies, Arkies, and other economically deprived groups would never have had to be made out of the ecologically destitute ten-state area on the other side of the Rockies into the lushness of California, Washington, and Oregon, as his audience knew it had. The basic national wealth lay in the land and its proper treatment. Washington, Oregon, Idaho, and part of Montana ought to form a key region. Every governmental agency should be a regiment in the same army, whether from the Forest Service, as here, from the PWA, or the WPA. Augmentation and reinforcement of these agencies within a wonderful environment like this was a thought to conjure with! "In the past few days I have inspected many great governmental activities—parks and soil protection sponsored by the Works Progress administration; buildings erected with the assistance of the Public Works administration; our oldest and best known national park under the jurisdiction of the national park service, and a few hours ago a huge navigation and power dam built by the army engineers.

"Now I find myself in one of our many national forests. Here on the slopes of Mount Hood.

"The people of the United States are singularly fortunate in having such great areas of the outdoors in the permanent possession of the people themselves—permanently available for many different forms of use." This view added seriousness and scope beyond the previous goal of combining scenic and recreational values. Roosevelt was speculating with the older ideal of a national park, held over to the practical needs of a depression age. There should be a signaling back and forth among the environmental interests. There was a great deal of optimism beneath the surface, and he did not allow himself to reflect upon the clouds of oncoming war. He contrasted the United States with other countries as one where natural resources rather than weapons should make up the stockpile for humanity.

TIMBERLINE LODGE

The physical and spiritual center of Timberline Lodge was the Head House, or central lounge, which physically echoed the shape of the mountain behind. Occasionally it was said to have taken its roof shape from the Indian tepee, since Indian inscriptions and pioneer motifs were featured on it (Fig. 11), but the immediate form seems to have derived more from the vernacular architecture of the temperate valleys below,[24] such as the fruit and hop drying sheds (Fig. 13). Physically closer, equally like in style, and more appropriate to the actual function, was Cloud Cap Inn of 1889 on the north slope, by Whidden and Lewis, who had come to Portland from the office of McKim, Mead and White in New York. In the report fol-

[24] For an excellent review of the vernacular architecture of the valley, see Philip Dole, "Farmhouses and Barns of the Willamette Valley," *Space, Style and Structure: American Building in the Northwest*, Thomas Vaughan, ed. (Portland, Oregon: Oregon Historical Society, 1974), pp. 209-240.

13. Hop-drying barn, Willamette Valley (Oregon Historical Society).

lowing the dispute over the projected cableway in 1926, the younger Olmsted had observed, "The right sort of designers attacking the problem afresh can, I am sure, work out something much less objectionable than anything the [Cascade Development] Company has submitted."[25] Olmsted mentioned his preference for a sloping roof with dormers, rather than the flat roof and box-like shape of the private hotel then being proposed by the Cascade Company, which was to be built of concrete. Above all, "designers who are both generally competent and really appreciative of the esthetic qualities of the locality" could be found to bring the potential of the large and dramatic setting out by "hard work *on the spot*—not by absent treatment or off hand suggestions like mine." Olmsted was calling for the reassertion of an indigenous architecture which harmonized with the landscape. He thought that two angles of vision would be most rewarding, one up from timberline where the roof would be a silhouette against the sky,

and the other down from the summit looking toward superb panoramic views. This marginal combination between snow and trees was exactly how the siting of Timberline Lodge was arranged in the 1930s by local people.

Although the style carried the appellation "Cascadian" from the mountain range it was in, the character of the facade (Fig. 14), with its picturesque silhouette, followed the late English Domestic Style made popular in Portland by architects such as Lawrence Holford and Wade Pipes, the latter, although Oregonian, being trained in London. This was the last corner of the country to feature the English Domestic Style, which essentially ended in England by 1910, and elsewhere in the United States by the late 1920s. The regional character of domestic work of Pietro Belluschi and John Yeon beginning in the 1930s in Portland sprang partly from the English style. This was joined with the American Stick Style, which in Timberline Lodge became the "Big" Stick Style, presenting a paradox, for in Portland itself the English Domestic Style was of small proportions and very finely detailed, like the original English houses. The broader planes and generous volumes of the facade suggest the 1930s instead. The ponderosa pine columns in the Head House, an afterthought to reinforce the regional image, are five and a half feet in diameter and forty feet high. The pegged floor boards of oak are unusually wide and the window panes large with thick muntins. On the outside the battens were placed on two-foot centers. On the valley floor they were kept at one-foot intervals, or less. Stones in the outside walls were picked for their large size, some being eight feet long.[26] It was as if the Depression re-

[25] Letter and memorandum from Olmsted for Commission of Fine Arts and Maj. R. Y. Stuart, Forester, U.S. Department of Agriculture, Washington, D.C., February 18, 1931.

[26] George McMath, "Emerging Regional Style," *Space, Style and Structure*, Vaughan, ed., p. 349. However, too much emphasis should not be given to the uniqueness of the function and style of Timberline

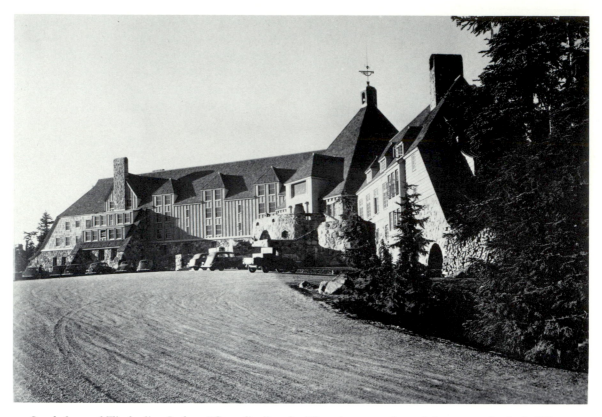

14. South front of Timberline Lodge, "Cascadian" style. The wings turn in and slant to make the building seem smaller and more domestic (Oregon Historical Society).

quired a special kind of bravura, so there was a renewed improvising out of the prosperity of a style just past.

Structural strengthening and insulating for storms could be noted in the use of a double roof for the Head House (Fig. 15), internal iron strapping, butterfly wedges, and cross-bolted morticing. Reflections from the snow through the sub-spaces of the

Lodge in the light of the fact that there was already some tradition of such rustic hotels in the national parks, as distinguished from the national forests, beginning with the Old Faithful Inn at Yellowstone Park, completed in 1904. Within Oregon itself, Crater Lake Lodge had been finished in 1923 and the Oregon Caves Chateau in 1934. The Ahwahnee, privately owned, built in the Yosemite Valley in 1927, had as architects Gilbert Stanley Underwood and Co., who were also to be consultants on Timberline Lodge in the 1930s.

Head House provided an airiness, keeping the upper public space, in contrast to the lower, from becoming too closed in or cavelike. Wood and plaster surfaces were softly tonal as well as richly textural. The exterior, with its volcanic stone of an opaque gray or brown, and its sawn boards and shakes, was rough and somber. In the two wings of the Lodge the indirect lighting of the 1930s was effective, spreading a pool of light, or letting shadows fall without interference into darkness. The handmade fixtures were constructed in the WPA iron shop under the supervision of light designer Fred Baker of Portland. The indoor illumination suggested the mute, elegiac, and indistinct character of Northwest regional painting, and sometimes made it that much more of a surprise to step

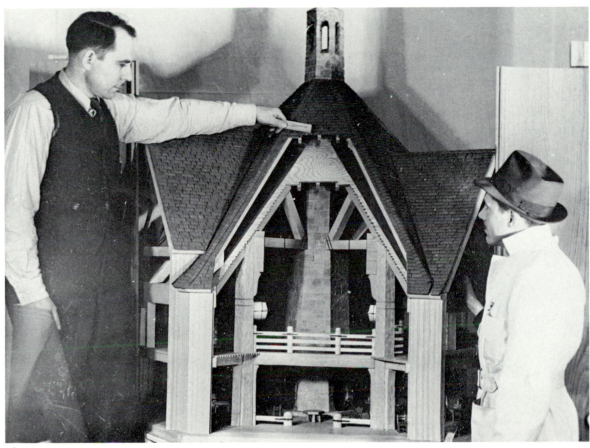

15

out into the luminous snow. Among the painters represented in the Lodge were Darrel Austin, C. S. Price, and Charles Heaney. The railings of the Head House and the fence-rail beds (Fig. 16) were inspired by the rail fences of the vegetable and fruit farms in the valleys below. The door to the terrace had an enormous thickness (Fig. 17), with elaborate strap hinges and iron castings, and bolt heads plainly seen. The newels of the stairs displayed animals and birds, likewise hand-gouged from cedar utility poles, bought for $2.10 each (Fig. 18). Nothing told more about the Northwest than this huge door, with the crafts which had died out in the 1920s in other parts of the country still flourishing upon it, and the sense of removal, detachment, and insularity, brought

16

15. Model of the Head House, Timberline Lodge. It was to be a feature for the WPA exhibit at the New York World's Fair of 1939. The chimney in the real building was ninety-two feet high. Ray Neufer at the left was the supervisor of woodworking and carving (Les Ordeman, Oregon Journal*).*

16. Fence-rail bed, Timberline Lodge (Portland Art Museum).

17. *Upper terrace door, Timberline Lodge, O. B. Dawson. The door is five feet wide and ten feet high (T. J. Edmonds, Oregon Historical Society).*

18. *Badger newel from a cedar utility pole, Timberline Lodge, Florence Thomas (T. J. Edmonds, Oregon Historical Society).*

on by the wet lava stone pavement and the elevated view to the line of distant volcanic mountains. This was the farthest away one could get in the United States. The building helped the people rediscover themselves, as the Roosevelts wished it to do as an antidote for the Depression, which would have been much more difficult to accomplish in a less removed part of the country, and nearly impossible after World War II, when interregional migration became even more pronounced.

The furnishings were gathered by Margery Hoffman Smith, who was then assistant director for the state, and later director, of the Federal Art Project.[27] Here again, the

land below provided inspiration. Stylized local plants comprised patterns and borders. Upholstery and bedspreads were woven with a flax warp and wool weft, local materials from plants and animals that could not find a market in those times. The dyes were colors from the Cascades—deep spruce green, earth tones, and the delicate shades of autumnal wild flowers. The rugs were hooked from scraps from the cutting of garments by the WPA sewing units for welfare distribution, and worn blankets and uniforms from the CCC camps. Twenty-one of these crafts were represented at Timberline. Over one hundred skilled craftsmen were

[27] Letter to the author from Linn Forrest, March 27, 1968. Again, there was much precedent for the huge timbers, as represented by the Forestry Building of the

Lewis and Clark Exposition of 1905 in Portland by Whidden and Lewis. See George McMath, "Lewis and Clark Exposition," *Space, Style and Structure*, Vaughan, ed., pp. 315-318.

19. Watercolor of Squaw Grass for Timberline Lodge (Portland Art Museum).

studies (141 were made) of wild flowers (Fig. 19) were hung in frames along corridors and in rooms. The mildness and wetness of the mesothermal climate encouraged a greater variety of wild flowers here than in any other part of the country (Fig. 20).

It was not entirely coincidental that Roosevelt's prime choices for regional authorities were to be the Tennessee Valley of the South and the Columbia Valley of the Northwest, but the Northwest was in its fertile parts a far smaller region. Thus, regional ties could be stronger even than in the South. The Cascades and Rockies are a double barrier to the east, while the Siskiyous isolate it from California, especially in winter. The northwesterner attaches great weight to mountains as visible guarantees for introspective thought and independent action. Hood thus meant more because it towered in the relatively limited geographic area of western Oregon. When Roosevelt offered funds to place a lodge upon that mountain, therefore, the local craftsmen, officials, and writers hastened to seek its fulfillment. The remarkable fact was that these citizens anticipated a trend toward affluence, leisure, and the celebration of sport, which was to happen nationally only in the 1950s and 1960s. The populace, encouraged by the Roosevelts, made its handsome and bold architectural offering upon the mountain—not at the peak, but just below it on a shelf. The purity of the snow on the mountain was seen to be

employed. The shops were housed in old public schools in Portland: Atkinson, Boise, Failing, and Holman. These turned out 820 pieces of furniture, 912 yards of hand-woven drapery and furniture fabric, 100 pairs of hand-appliquéd curtains, 119 hooked rugs, and 181 pieces of ironwork.[28] Watercolor

[28] The two handsomest (and rarest) sources about the evolution of the Lodge and its furnishings are Claire Warner Churchill, *Mt. Hood: Timberline Lodge: The Realization of a Community Vision Made Possible by the Works Progress Administration* (Portland, Oregon: Metropolitan Press, 1936), printed in thirty-two copies with color plates; and "The Furniture and Crafts of Timberline Lodge," two volumes, hand painted, hand bound, July 16, 1942, now in the Multnomah County Library. Especially valuable for the role of Margery Hoffman Smith is Jean Weir's "The Arts and Furnishings," *Timberline Lodge*, Rachael Griffin and Sarah Munro, eds. (Portland, Oregon: Friends of Timberline, 1978), pp. 30-45. This essay was adapted from her Ph.D. thesis at the University of Michigan. Other sections of this handsome compendium cover the history and restoration of the building. Also worthwhile, besides the numerous handbooks, are *The Builders of Timberline Lodge* (Portland: Works Progress Administration, 1937), with pen and ink drawings and woodblocks, rich in the idealistic spirit of the times, and Virginia Darce, "Furniture and Decorations of New Mountain Lodge Represent Work of Artists," *Oregon Sunday Journal*, December 19, 1937. For more recent views, see Carl Gohs, "The House the Artists Built," *Oregonian*, January 5, 1969, pp. 6-11; Gohs, *Timberline*, and Elizabeth Walton Potter, "Auto Accommodations," *Space, Style and Structure*, Vaughan, ed., pp. 529-538.

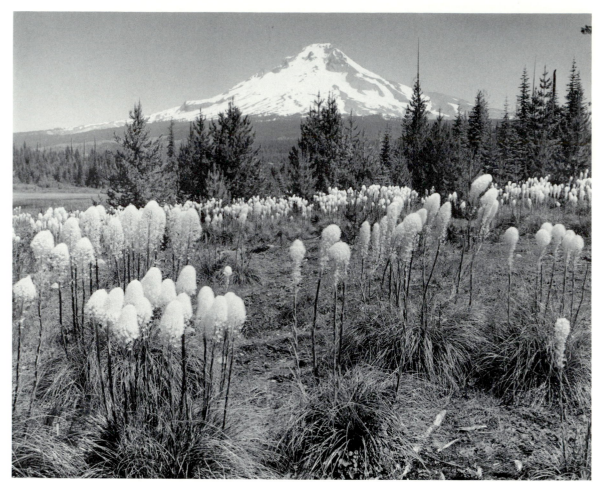

20. Bear, Squaw, or Basket Grass on the Mt. Hood Loop Highway (Ray Atkeson).

everlasting. To be near such a prominent preserve was to establish in the scattered Northwest community a lasting sense of the stability, unity, and power Americans coveted. Mt. Hood and Yosemite also proved to educated easterners that they had not been entirely wrong in once expecting so much import from scenery.

THE SUBSEQUENT FATE
OF THE LODGE

World War II closed Timberline Lodge from 1942 to 1945, and the prewar, Depression dream was over. Furniture rotted and vandals slashed fabrics and broke windows. Many of the craft items disappeared. Some recommended that the lodge be burnt. From 1945 until 1955 it saw a half-dozen managers, everything ending in bankruptcy.[29] There was an undignified lawsuit, lasting six years, over the ownership of the guest register, which the Roosevelts had been the first to sign. The contrast of this demeaning plight with the hopeful beginning was sym-

[29] *Oregonian*, July 3, 1955. See also January 23, 1955, for the first of three articles on the managerial troubles of Timberline Lodge.

bolized by the crude sign nailed on the hand-somely crafted door: "Because of Lack of Elect. the Lodge is Closed to Public as a Safety Measure." Did Americans care? Time turned over so fast in the first half of the twentieth century! Had the vision, as so often before, proved literally and figuratively too distant and elevated for their limited per-ceptions? Even nature, to which the Lodge was so carefully attuned, would not cooper-ate any longer. In a matter of a few years wind and snow eroded the magnificent wooden heads of the bighorn sheep on the piers of the main door (Figs. 21-22). An-other, less subtle, means of obliteration came from the seasonal snows of twenty feet. It seemed as if the ultimate wish of the nature lover, voiced at Yosemite many years before, to which Olmsted, Jr., Merriam, and Waugh subscribed, that architecture and landscape become indistinguishable from na-ture and every conspicuous detail be blended and hidden, was to be completely realized. Since 1975, however, it has been gradually and happily restored.

THE SYMBOLISM OF MT. HOOD

Mt. Hood provided a freestanding symbol of rectitude and beauty from what was plainly a new city of enterprise (Fig. 23). Beautiful objects were often set aside in the bustling American culture, as if they did not entirely belong, and Hood's out-of-town location fit-ted easily into that assumption; yet it ap-peared to belong to Portland too, "perched there on the very rim, it has always seemed a part of the city."[30]

President Charles W. Eliot, Harvard champion of popular involvement in the arts and culture, and managerial expert par ex-cellence from the 1890s in the East, wrote in

[30] McNeil, *Wy'east the Mountain*, p. 19.

21. *Ram's head on upper door frame, Timberline Lodge. It is of ponderosa pine and is being stained by James Duncan, the paint foreman (U. S. Forest Service).*

22. *Ram's head, eroded by weather (David Falconer, The Oregonian).*

23. Portland, with Mt. Hood in the distance, 1888 (Oregon Historical Society).

1905 of the comparable view of Mt. Rainier from Seattle: "When, at rare intervals, the snow-clad Mount Rainier reveals itself, touched by the rays of the setting sun, to far-off Seattle, the enjoyment of the solitary street-sweeper who had first noticed it is only enhanced when the people run out of their houses to enjoy the magnificent spectacle. In their spiritual effects aesthetic pleasures differ widely from pleasures, like those of eating and drinking, which are exhausted on the individual who enjoys them."[31] Eliot's message was that esthetic pleasures from nature, however intangible, should be shared in a democracy—one person, the humblest street-sweeper, to be joined by many others in a chain reaction of enjoyment, endlessly repeatable. Bridging esthetic experiences between intellectuals, like Eliot, and the masses was to prove a difficult maneuver, however, as had been shown in the Yosemite Valley. Mt. Hood and Mt. Rainier, for all their relation to Portland or Seattle, were also regarded by the natives as distant, isolated, objects, dependent upon their own wilderness rules.

The mountain and the Lodge were at the very edge of the hold of awareness from the city. As a metaphor on the land, Hood was an elusive white whale, such as Herman Melville might conjure up from his long sea voyages. In America, the mystique of the ocean extended across the land. His nautical observations often had reference to the continental mass. Captain Ahab glimpsed the white whale, Moby Dick, from his ship as "a snowhill in the air," "a hump like a snow-hill,"[32] which could lie hidden on the surface of the water "within the smoky mountain mist." At other times, when fully visible, Moby Dick recalled Mt. Monadnock in New Hampshire. Since we are inclined "to throw the same snowy mantle round our phantoms; all ghosts rising in a milk-white fog,"[33] we might not see the mountain at once, but we would know it was there. Likewise, where "a traveller is continually girdled by amphitheatrical heights," as in the Northwest valleys, one would "catch passing glimpses of the profiles of whales defined along the undulating ridges."[34] Hood and its

[31] "The Appreciation of Beauty," 1905; as reprinted in *Charles W. Eliot, The Man and His Beliefs*, William Allan Neilson, ed. (New York: Harper & Brothers, 1926), pp. 555-556.

[32] Herman Melville, *Moby Dick or the White Whale* (New York: Dodd, Mead and Company, 1923), pp. 499, 523.
[33] Ibid., p. 174.
[34] Ibid., p. 251

companion peaks were the epitome of Melville's visions of landlocked white whales, suddenly revealed, as they epitomized in another way Jefferson's previous hypothetical vision of a single volcano in the distance from Monticello. Hood represented a definite national, as well as a regional, fulfillment. Yet the American uncertainties over distances on land and sea, and particularly the ability to comprehend them, were also inescapably involved. The White Mountains of New Hampshire, the largest range in sight to the west in Melville's, as in Thoreau's time, had once provided the symbolism Melville sought,[35] but he also wished to venture farther in time and space, as into the ghostly, hidden, distances portrayed in the moody seascapes of fellow New Englanders Albert Pinkham Ryder, Winslow Homer, and Fitz Hugh Lane. They all looked very intently into nature, in the manner of the American artist, but could never be quite sure of what they saw, also typical of the American experience. Mystery and monumentality were combined. Mt. Hood is a mighty, but enigmatic, prominence.

The Cascade Mountains could be brought closer after the 1920s with the automobile, airplane, and chair lift, but the peak of Hood, still "ghostlike," continued to elude

the immediate perceptual grasp, to dissolve into the weather or the city dusk (Fig. 1). The dream for snow-capped or volcanic mountains was filled in abundance by the Cascade range, but the literal model of Hood was still elusive because of the sixty mile distance from Portland and the abundance of mist between. The phenomenon of whiteness instead of grayness, reaching so much farther in space than the enclosed experiences of Yosemite, is what mattered to the pioneering generations among the Oregon valleys.[36] Yosemite's sheer gray cliffs had permitted exceptions in direct transcendental communication between man and nature. An even more basic American need, after that for confidence and security, was for something permanent and looming to be searched out through the mist to whatever destination. A mythology that had begun on the Atlantic edge, long before, finally turned inland and away from the Pacific too, since the north-south row of quiescent volcanos covered with snow had risen from the pressure and heat generated by the Pacific Ocean plate pushed under by the more dominant continental mass. The scale of these forms and actions was at last deemed worthy of the imagined size and destiny of the nation.

[36] See Loren Baritz, *City on a Hill: A History of Ideas and Myths in America* (New York: John Wiley & Sons, Inc., 1964), p. 297.

[35] Ibid., p. 175.

Part II

SMALLER SPACES,
*Treated More Directly
and Actively So That
They Might Even
Be Called Inventions*

The Boston Fens

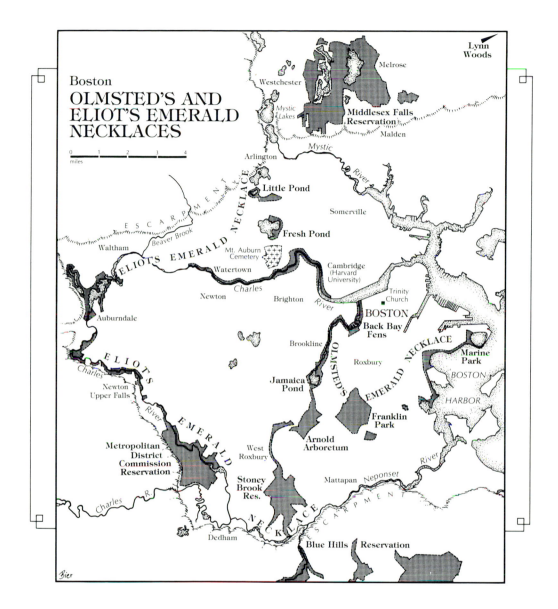

Boston
OLMSTED'S AND ELIOT'S EMERALD NECKLACES

THE Fens was so humble in origin—it was developed from a noisome mud flat—that its emergence as a flourishing green park seemed highly unlikely. Yet that is exactly what happened under the guidance of Frederick Law Olmsted. The emotional receptivity of the age, stimulated by many converging influences, such as the equation of beauty with virtue, and the confidence that the resolute intellect could conquer the most dismal and obtuse prospect, led to a strong endorse-

ment of the undertaking by such notable figures as Oliver Wendell Holmes, Sr. and Richard Henry Dana, Jr. The imagery peaked when the park was seen as a replica of an improved coastal salt marsh (a fen) for the esthetic solace of those who had recently come into the city from the country. The motif had meant much to the early settlers as a guarantee of life support from its grasslands and inlets.

Charles William Eliot (1834-1926), president of Harvard, and son Charles (1859-1897), the landscape architect, were indispensable in this evolution because they became caught up in the notion that a sense of community could be fostered in the rapidly expanding industrial setting only if it could be brought to grips with nature. They, along with Olmsted, emphasized the principle that patience and time should be accorded to fashioning the landscape, and that this process should be undertaken from the philosophical assumptions of Emerson and Thoreau. Everything would change more slowly and thoughtfully than it had if they were to have their way. Out of these ratiocinations were to arise the Metropolitan Park System of Boston, and the Public Reservations of Massachusetts, the first such organizations of land in the world (see map).

TO bring the Fens (Boston's Back Bay Park) into being, in the years 1879 to 1885, Frederick Law Olmsted overcame major economic, political, and topographic obstacles, yet little exhibitionism was involved. From a tiny plot of little more than a hundred acres came a final spreading forth to encompass over five hundred square miles within two decades, represented by the whole Boston Metropolitan Park System. Sylvester Baxter, active in the organization of the Metropolitan Park Commission in the 1890s, remarked, not without awe, "In the necessity of meeting these difficulties [of the Fens] the entire modern park system of Boston had its beginning."[1] By 1900 at the Paris Exposition the Olmsted firm could claim that Boston, through its park system, had "gained a vitality in its later history which enabled it to over-ride the plan of nature,"[2] by which was meant Boston's acute geological drawbacks. To demonstrate, the firm exhibited at Paris a round topographic model in marble and plaster (Fig. 1), weighing a ton.[3] The metropolitan plan was intended to overcome whatever might transpire from the expansion of this dynamic city over a difficult terrain. However, the historic landscape would be sustained, "to save from extinction and to preserve for present necessity something of the beauty and life-giving qualities of the original forest mantle, the original meadows and early pastures, the pure waters and the untroubled horizons of the first civilization,"[4] i.e., the Puritan settlement.

Permanence and sensibility were goals of the Victorian psyche. Yet the geology of Boston was almost too permanent and stark. One Elizur Wright, calling for a "Park of the Future" in 1877, before Olmsted's proposal was under way, saw the Boston basin (Fig. 2) as a field for a futile trial: "The tract was left in the shape of a nearly circular basin rimmed with hills, which here and there rise fifty feet above the top of Bunker Hill monument. . . . The interior of the basin is so rugged that our rugged ancestors, after checkering it all over with their characteristic stone fences, and planting apple-trees which seemed to find soil where little is visible to the naked eye, gave it up in despair, and let Nature resume her work of covering and beautifying her own bones in her own way."[5]

Boston was surrounded by an extended glacial escarpment, running in a half-moon from Cape Ann on the north to Cohasset on the south. Filling this three-quarter circle was debris—random and abrupt outcroppings of granite, clay, and gravelly rocks, long drumlin hills, scrub trees, meandering rivers, and marshes, with which a not overly

[1] Sylvester Baxter, *Boston Park Guide* (Boston: Small, Maynard & Co., 1898), p. 5.
[2] A. A. Shurtleff, *For the Board of Paris Exposition Managers* (Boston: Metropolitan Park Commissioners, 1900), p. 6.
[3] George C. Curtis, sculp., *A Description of the Topographical Model of Metropolitan Boston* (Boston: Wright & Potter, 1900).

[4] John C. Olmsted, "The Metropolitan Park System of Boston," *Transactions of the American Society of Landscape Architects* (Harrisburg: 1912), pp. 65-66
[5] *The Boston Transcript*, September 25, 1877.

1. *Topographic plaster and marble model of Boston, shown at the Paris Exposition of 1900 by the Olmsted firm, George C. Curtis, Sculptor (Geological Museum, Harvard University).*

2. *Olmsted Topographic Model of Boston, Detail. Where the third bridge and the steeple coincide on the Charles River, the Fens Back Bay Park can be seen changing the direction of the city. In the upper right, pale in front of the Boston escarpment, are the Lynn marshes. At the bottom are the Blue Hills, the most prominent feature of the escarpment (Geological Museum, Harvard University).*

generous glacier had endowed the basin upon its last retreat. Contained within it, in 1840, at the moment when Boston was beginning to grow, were 93,000 people. By 1870, the number had swelled to 250,000, by 1890 to 448,000. These conditions, the geologic and the demographic, reveal the urgent need for open space, and the difficulty of filling that need.

THE MATRIX OF A POETICAL, NOT A PRACTICAL, FEELING

Olmsted believed that "the withdrawal of people from rural conditions"[6] to the city explained much of the psychological dislocation of the increasing population. By arriving in Boston they had reached a place that already, geographically, they should not have been in. He noted that leadership and other "forms of wealth and worth" had been rapidly drawn off from the outlying towns of New England into Boston. His friend Henry Bellows, Unitarian minister and follower of Channing, similarly observed in 1861: "One does not need to be a graybeard to recall the time when every country-town in New England had, because it needs must have, its first-rate lawyer, its distinguished surgeon, its comprehensive business-man—and when a fixed and unchanging population gave to our villages a more solid and a more elegant air than they now possess. The Connecticut river-villages, with a considerable increase in population, and a vast improvement in the general character of the dwellings, have nevertheless lost their most characterizing features—the large and dignified residences of their founders [the earlier architectural joy to Timothy Dwight's eyes in The Connecticut Valley], and the presence of the once able and widely known men that

were identified with their local importance and pride. The railroads have concentrated the ability of all the professions in the cities, and carried thither the wealth of all the old families."[7]

Wealth, talent, and professional skills had been concentrated in the city, but was the human mosaic better distributed or arranged now? Olmsted thought not. He proposed to step into the street in order to test the human encounter. It was not so much the Darwinian ability to survive in the city that concerned him, but the Emersonian will to do so. As he walked about he discovered that "Our minds are thus brought into close dealings with other minds without any friendly flowing toward them, but rather a drawing from them. Much of the intercourse between men when engaged in the pursuits of commerce has the same tendency—a tendency to regard others in a hard if not always hardening way. . . . People from the country are even conscious of the effect on their nerves and minds of the street contact—often complaining that they feel confused by it. . . . It is upon our opportunities of relief from it, therefore, that not only our comfort in town life, but our ability to maintain a temperate, good-natured, and healthy state of mind, depends."[8] The sense of dislocation in the midst of so many people dissolved the integument that previously held the indigenous New England community and culture together.

THE SALT MARSH METAPHOR

Olmsted set about to prepare a place where people could be partly relieved from such overbearing environmental problems—a reverie in the midst of a necessarily busy city. Although the Fens was to deal boldly with

[6] F. L. Olmsted, *Public Parks* (Brookline, Mass.: 1902), p. 11.

[7] "Cities and Parks," *The Atlantic Monthly*, VII, 52, April 1861, p. 419.
[8] Olmsted, *Public Parks*, pp. 25-26.

3. Summer Showers, Marsh near Newburyport, Mass., *Martin Heade, 1865-1870. Salt hay ricks sprinkle the marsh. The hay was often collected with barges, called "gundalows" (The Brooklyn Museum).*

water pollution through ingenious engineering, it was never to be entirely present or accountable, but rather was supposed to unlock memories of an "untroubled horizon," those no longer easily reachable stretches of marsh along the open Atlantic Coast (Fig. 3) (now called "wetlands" by conservationists), where the new inhabitants of Boston had roamed as children. There was to be a march, to the ancient rhythms of the countryside, into an unknown urbanism with newly obtained knowledge. Geologist Nathaniel Shaler of Harvard, who evaluated for the government the swamps and inlets of the Atlantic Coast in the 1880s, exemplified this commitment to beauty in nature through increased knowledge. He considered himself a pure scientist, but his wife said that "he appropriated the beauty of the landscape superimposed upon the skeleton of the geological history; making it a part of his every-day life. . . . He believed that 'he who would become a lover of the landscape must accustom himself to seek it alone, and must learn to

know that his mere presence at its doors will not make him free to its treasures.' As a result of experiment he further became convinced that knowledge may vastly enhance the intensity of aesthetic impressions."[9] To collect liberating impressions, to be attached to the geologic core, but fleshed out by feeling and intelligence, was the Boston way. The Fens might appear a trifling gesture toward the alleviation of ugliness and crowding, but a serious remedial effort was involved. Bostonians believed that mental exercise and hard work were keys to the future, but relaxation in the landscape was now to be part of the formula, too.[10]

[9] Nathaniel S. Shaler, *The Autobiography of Nathaniel Southgate Shaler*, Memoir appended by his wife (Boston: Houghton Mifflin, 1909), p. 355.
[10] *Map and Description of Proposed Metropolitan Park for Boston* (Boston: Rand, Avery & Frye, 1870), p. 1: "Boston claims to have paid great regard to the intellectual needs of her people. But, in her provision for them, has she not forgotten that health lies at the root of all sound culture, and that recreation is imperatively necessary to relieve mind and body from the pressure of too constant labor and anxiety?"

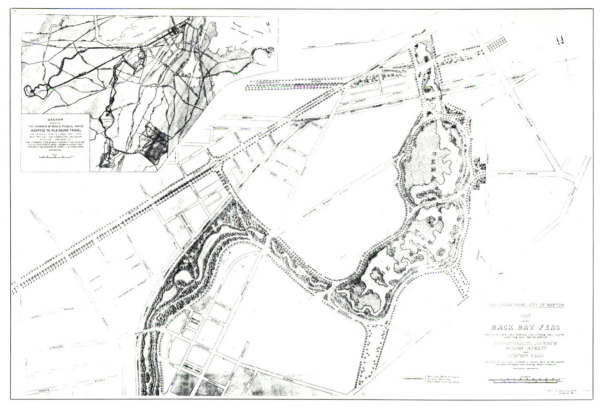

4. *Back Bay Fens, Frederick Law Olmsted, as of 1887. The inset in the upper left shows that the Fens was intended to begin a great loop about the city, ending with Marine Park on the ocean in South Boston* (City Park Report, *1887*).

The Fens was just such a coastal aspiration as Emerson had once vaguely described: "But what I see now,—the feeblest intellection, rightly considered,—implies all the vast attributes of spirit, implies the uprising of the one divine soul into my particular creek or bay, & apprises me that the Ocean is behind."[11] The mitering of the ocean to the shore mesmerized New Englanders for generations. The two pools of the Fenswater (Fig. 4) were slightly differentiated versions in miniature of the Massachusetts bayline a short distance away in miles, but by now eliminated from the everyday encounter. The pool to the north was supposed to emulate a salt marsh; that to the south, with its islets and prominent bits of upland planting, was intended to recall the inland reaches of the Atlantic, such as Emerson had in mind for the comprehension of deity.

Although Olmsted never distinguished clearly in his own writing between "marsh" and "fen," English people around the mother city of Boston in the British Isles certainly did. There, a fen represented the recovery of tillable land from the marsh, from the seventh to the seventeenth centuries. The marsh would be on one side of a road, the more cultivated fen on the other, farther in from the sea.[12] Anthony Garvan in his pioneer essay on *Colonial Connecticut* indicated

[11] Ralph L. Rusk, ed., *The Letters of Ralph Waldo Emerson* (New York: Columbia University Press, 1939), II, p. 156.

[12] W. G. Hoskins, *The Making of the English Landscape* (London: Penguin Books, 1970), p. 95.

that the fens held a life-and-death meaning for the first settlers. "First settlements were generally made in the vicinity of what are today tidal marshes or river lowlands. . . . The colonists' large flocks of animals could not survive even a year without adequate pasturage; to drive them inland away from natural marshes and meadows would have doomed the animals to starvation and upset the agricultural unity of the town group." Prominent Englishmen invested heavily in "both the drainage of the [English] Fens and the settlement of New England; many more New England settlers in 1640 knew the Fens by their reputation in their own time as the most radical English merger of Puritan investment and land division."[13]

Olmsted's greatest admirer, Mrs. Van Rensselaer, explained that his family belonged to the second migrating wave of Puritans, who first "settled at Plymouth" but were soon "among those to cross the wilderness and establish a new colony by the Connecticut River." Thus, Olmsted's early vision of The Fens would be qualified by that idyllic valley. "He boated, of course, on the Connecticut, and he now believes that this river-meadow scenery influenced his mature taste more forcibly than anything else."[14] In his mind he may have blended river meadow and salt marsh, hence the lack of any further distinction between marsh and fen in the Back Bay Fens.

Olmsted's boyhood was colored by the influence of the Connecticut Valley and Yale University. During summer trips through the countryside the family often consulted the travel journals of the Yale savants Timothy Dwight and Benjamin Silliman. Later, Olmsted read Jefferson's *Notes on Virginia*.

His pupil and eventual partner Charles Eliot, the son of the president of Harvard, in trying to resolve in theory the nearly impossible geographic situation farther east around Boston Harbor, acknowledged that everyone agriculturally engaged there had wanted to vacate the coastal land and migrate west to the Connecticut Valley. But the majority did not—they held on: "So reluctant were the colonists to attempt the subjugation of the great woods and the slopes of boulders, that, when the open spots near at hand had been occupied, hundreds of people braved the dangers of a long march over Indian trails to reach and settle in the soft intervals of the Connecticut valley. Had the prairies of the West been accessible, the rougher parts of the district would hardly yet have been tamed. As it was, when population increased, men were forced to take up the axe and crow-bar in grim earnest . . . and at last the rounded hills stood forth as mounds of green, marked and divided by walls of field stones, and sometimes crowned, as at Clapboardtree Corner in Dedham, with the white churches of the victors." The coastal people had resculptured the rocks and hills, rather than yield to the temptation to move to the more fertile Connecticut Valley and beyond. The younger Eliot respected them for this. Even more, he admired them for not disfiguring the marshland. "The broad or narrow marshes still lay open to the sun and air, through them the salt creeks wound inland twice a day, about them lay fields and pastures backed by woods upon the steeper slopes, and across their sunny levels looked the windows of many scattered houses and many separate villages."[15] These village houses with their opaque windows, built in

[13] *Architecture and Town Planning in Colonial Connecticut* (New Haven: Yale University Press, 1951), pp. 14, 60.
[14] "Frederick Law Olmsted," *Century Magazine*, XLVI, 6, October 1893, pp. 860-861.

[15] Charles Eliot, *A Report upon the Opportunities for Public Open Space in the Metropolitan District of Boston* (Boston: Wright & Potter, 1893), pp. 8-9.

the two previous centuries, were internally private, owned by "indwellers," as Thoreau called them. At the same time the crisp New England light called for an external limning, often by sharply defined shadow on white walls, as an outer testimonial to inner virtue. "What now?" the younger Eliot asked of the onset of urbanism. Perhaps an answer would lie in the use of supplemental wasteland space, which would then sustain the environmental structure that people were used to, but at the same time continue the Puritan habit of struggling against outcroppings and adversity.

Defending his Fens plan before the City Council in the spring of 1880, Olmsted claimed: "There are many sea-coast nooks of Massachusetts Bay with wooded banks into which the tide occasionally rises, and which are commonly spoken of by country people as marshy, very different in character and appealing in a very different way to the imagination from the marsh which [the opponent] assumes that I have had in view."[16] The "better" marsh was streaked with white, emerald, and bice water like beautifully veined marble.

> Dear marshes! Vain to him the gift of
> sight
> Who can not in their various incomes
> share.

Olmsted pointed out that he did not wish to establish an unlimited wasteland, but only to restore a small and choice wasteland motif for the country people in the city.

Ten years later, in a letter to Francis W. Lawrence, chairman of the Brookline Park Commission, to persuade him to establish a Brookline park as part of a chain reaching up the Muddy River, from the Fens (Fig. 5),

Olmsted described each successive open green area, not as they actually had become by 1890, but as he hoped they might eventually be. Beyond the Common and the Public Garden at the very center of the city "would be the broad dignified, urban residence street—Commonwealth Avenue—with its formal tree-shaded central mall. This extends to the cross street called Westchester Park [Massachusetts Avenue], where the avenue turns a slight angle and the formal arrangement yields to a gracefully curving drive and walk embellished by long irregularly planted, undulating grass plots, which prepare the mind for the strong contrast to everything urban presented by the next link in the chain, called the Back Bay Fens. This is a ground of considerable breadth and extent, which in its general aspect, will appear a fortunately preserved reservation of a typical small passage of New England sea shore landscape, including a salt creek bordered in part by salt meadows and in part by gravelly shores, both hemmed in by steep, irregular sylvan banks. There will be in it no shaven lawns or pastured meadows: the planted ground above the salt marsh being occupied by bushes or low, creeping, flowering plants, in a condition suggestive of natural wildness."[17] The area would be turned from the dross of an abandoned waste into a burnished natural form with the "tints, lights, and shadows and movement of salt-marsh vegetation," a prospect which utterly satisfied Olmsted. This darker, inward-looking, swaying, and flickering spectacle held an almost hypnotic fascination for the New Englander, brought up on the glimmerings of Transcendentalism and the swirls of the incoming tides.

As early as 1860 it was said that the "moral and intellectual elevation of Boston

[16] *American Architect and Building News*, VII, 223, April 3, 1880, p. 145. The challenge of S. M. Warren to Olmsted's treatment of the Fens appeared in the same magazine on March 20, 1880.

[17] Letter to Francis W. Lawrence, January 28, 1890, Box 24, Olmsted Papers, Library of Congress, pp. 3-4.

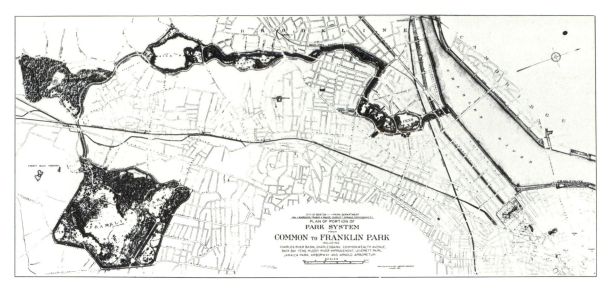

5. The Chain of Parks, Including the Fens, Jamaica Pond, the Harvard Arboretum, and Franklin Park, Connected by Arborways, as of 1894 (City Park Report, *1894*).

was, in good degree, owing to the inspiring and refining influences of the scenery with which we were familiar from childhood."[18] Such recollections took on a pronounced moral tone because of the agency of Unitarianism, "the Boston religion." "Aesthetic taste in the emotional sense—the power of deriving pleasure from beauty—was a 'sentiment.' Like 'moral taste,' it was an affection for a rational principle. The two feelings had much in common . . . for they were respectively 'a capacity of being deeply moved and affected by a view of right actions and beautiful scenes.' Harvard Unitarians tended to assume that the two capacities would go hand in hand. The man of refined sensibility whom they idealized would have an acute emotional sensitivity to both virtue and beauty." So it was that "the aesthetic emotions, like the ethical ones, were to be kept in subjugation to the intellect and cultivated according to 'the wholesome discipline of rules.' "[19] The feeling for the landscape would be made more feasible through rules. Boston was to be different in that its romanticism was so rationalized. Reality would thus be adapted by system and order, however romantically expressed.

Regardless of this inherent taste for rules, the intention would extend to that of Boston mavericks and prophets as well. The architect Louis H. Sullivan, who grew up on his grandfather's farm in South Reading, Massachusetts, a few miles north of Boston, beginning in 1862, wrote of his favorite retiring spot on the farm, a freshwater swamp or marsh that he called his "domain": "How beautiful—covered with water half-knee deep, filled with groups of tall bulrushes, of reeds, of blue flag, and slender grasses; and bright flowers here and there along the wavering edge."[20] To the New Englander the modeling of the water's edge mattered enor-

[18] George H. Snelling, "Testimonials in Favor of the Modification of the Plan of Building on the Back Bay Territory: April 2, 1860," Manuscript, Art Department, Boston Public Library, p. v.

[19] Daniel Howe, *The Unitarian Conscience: Harvard Moral Philosophy, 1805-1861* (Cambridge, Mass.: Harvard University Press, 1970), p. 188.

[20] Louis Sullivan, *The Autobiography of an Idea* (New York: Peter Smith, 1949), p. 67.

mously. Sullivan built dams in the brook (as Olmsted was to place water gates in the Fens to create artificial basins). This early experience "doubtless bred into [Sullivan] during the formative years of his youth the almost ecstatic love of nature and the strong individualism which characterized his later years."[21] It was the carry-over of the passion for nature into the city which distinguished those generations. Sullivan went to high school very near the future Fens and used to wander freely over the area. How deep the New England commitment to a watery medium was, is perhaps best exemplified by another maverick, Thoreau. He too expressed his choice of the perfect reverie: "Would it not be a luxury to stand up to one's chin in some retired swamp for a whole summer's day, scenting the sweet-fern and bilberry blows, and lulled by the minstrelsy of gnats and mosquitoes?"[22] When he wished to obtain solitude, to "recreate" himself, it was into the swamp that he retreated.[23] "Yes, though you may think me perverse, if it were proposed to me to dwell in the neighborhood of the most beautiful garden that ever human art contrived, or else of a Dismal swamp, I should certainly decide for the swamp." Or further along, as if to anticipate both the Fens and Trinity Church in Boston, he said, "Hope and the future for me are not in lawns and cultivated fields, not in towns and cities, but in the impervious and quaking swamps. When, formerly, I have analyzed my partiality for some farm which I have contemplated purchasing, I have frequently found that I was attracted solely by a few square rods of impermeable and unfathomable bog,—a natural sink in one cor-

ner of it. That was the jewel which dazzled me."[24] The imagery of the outlying meadow and bog, by the salt marsh, beside the sea, all finally pyramiding around the spire of the village church (the "victors' " white spire, the crowning touch, the younger Eliot called it), played an indispensable role in unifying the New England psyche.[25] Behind this overall view, piling up in crescendo from the uncertain edges of the water to the final triumphant building, are the numerous inherent contrasts in color and texture, from aquatic blue to meadow yellow and green, to architectural white, which brought spatial viability to the whole community.

THE EQUITY WITH ARCHITECTURE

As the Fens angled southeast into the open country from the axis of the uncompleted Commonwealth Avenue, Huntington Avenue turned diagonally southeast across Copley Square in front of Trinity Church (1873-1877) designed by Olmsted's friend, H. H. Richardson. Outside, the church was a picturesque pile of stone; inside, it was a daring and novel flareup of the spirit. Its space glowed and flickered into the flue of its great hollow pyramidal tower (Pl. 9), recalling Olmsted's comment about "*the broadening combining way of scenery*"[26] and the emphasis he placed on the need for hollowness in his parks. Richardson told Olmsted that he and the artist John La Farge chose the wall and ceiling colors of Trinity,[27] which provided relief from the noise and dirt of the city outside. The Fens and Trinity Church were further developments of the American concept of the outdoor room. The architect and

[21] Hugh Morrison, *Louis Sullivan: Prophet of Modern Architecture* (New York: W. W. Norton, 1935), p. 24.

[22] Bradford Torrey and Francis H. Allen, eds., *The Journal of Henry D. Thoreau* (Boston: Houghton Mifflin, 1949), I, p. 141.

[23] Henry David Thoreau, *Excursions* (Boston: Ticknor & Fields, 1863), p. 190.

[24] Ibid., pp. 188-189.

[25] Edward Chapman, *New England Village Life* (New York: Benjamin Blom, 1971), p. 6.

[26] Olmsted, *Public Parks*, p. 111.

[27] Letter from H. H. Richardson to F. L. Olmsted, November 26, 1876, Collection of Shepley, Bulfinch, Richardson and Abbott, Architects, Boston, Mass.

critic Henry Van Brunt, commenting on the unprecedentedly bold color scheme in 1879, the year Olmsted began the Fens, described the interior of the church as "a box filled with light. It is pervaded by the dull red tone of the walls and upon this background has been placed a profuse enrichment." The central tower weighs nineteen million pounds; forty-five hundred wooden piles were sunk below the water table; four great stone piers rest upon footings of solid granite, thirty-five feet square at the base and seventeen feet high, but the interior, including the giant piers, is encased in furring and plaster. "The whole apparent interior is thus, contrary to the convictions of the modern architectural moralist, a mask of the construction," wrote Van Brunt. The outdoor bowl of the Fens would be a still more animated and feathery (Pl. 10) version of the interior box of light of Trinity, whose color, "Either in fact, or by the effect of light, or by variation of surface . . . submits to variations in tone, so that it really has different values in different parts of the church."[28] Similarly, in the Fens, the iridescent, flashing plumage of birds would contribute "tints, lights and shadows and movement," along with the shimmering reflections from low plantings in the breezes at the all-important edges of the water. Olmsted had hit upon "one element of value" in the Fens (Fig. 6), so near Trinity Church, to surpass "any public park in the world; I mean that of birds, and especially of water-fowl. The rushy glades and bushy islands will supply well-guarded seclusions in which they can breed; the extent of quiet water and of shores, and the character of the vegetation upon them will allow large numbers and a great variety to be taken all necessary care of

with little trouble or expense."[29] The Victorians harbored little apprehension of artistic overloads.

The rector for whom Trinity was built, six-foot, four-inch Phillips Brooks, ventured forth in a sermon for the same purpose of enlarging human understanding by a spiritual path, much as geologist Nathaniel Shaler had a scientific one in looking at marshes to obtain a more intense feeling. "But now supposing that the object of our scrutiny, being something really rich and profound, were brought out of the darkness into a sudden flood of sunlight, would it grow less or more mysterious? Suppose it is a jewel, and instead of having to strain your eyes to make out the outline of its shape, you can now look deep into its heart, see depth opening beyond depth, until it looks as if there were no end to the chambers of splendor that are shut up in the little stone; see flake after flake of luminous color floating up out of the unseen fountain which lies somewhere in the jewel's heart."[30] This was the esthetic reason for being of both the Fens and the interior of Trinity Church.

Richardson often spoke of the quietude he wished to introduce through his architecture,[31] a feature that distinguished his work in part from that of British Victorians. The contemporary literature is also full of contrasts between the British colonial past and the American democratic future: "As dynasties and thrones have been predictions of the

[28] William A. Coles, ed., "The New Dispensation of Monumental Art, 1879," *Architecture and Society: Selected Essays of Henry Van Brunt* (Cambridge, Mass.: Harvard University, 1969), pp. 136-139.

[29] *1879 Park Commissioners Report* (Boston: City Document 15, 1880), p. 13.

[30] As quoted in Charles Carroll Everett, "Phillips Brooks, 1835-1893," *Sons of the Puritans* (Boston: American Unitarian Association, 1908), pp. 105-106.

[31] I owe my much better understanding of the "quiet" in Richardson's architecture to "Richardson and Olmsted: Partners in the Environment," an unpublished paper delivered by Professor James F. O'Gorman at the Graduate School of Design, Harvard University, April 24, 1975. In the text, which Professor O'Gorman generously sent me, he gave the intellectual baton to Olmsted.

6. *Detail of a view of Boston, 1880. This picture demonstrates that the Fens was originally in sight of Trinity Church. The first Museum of Fine Arts (1870-1876), the destruction of which President Eliot of Harvard regretted, can be seen to the left of Trinity as a tripartite building, while just to the right is the slimmer tower of the new Old South Church (1877). The Fens has the curving walks and the two pools in the field out front of Trinity Church (Library of Congress).*

royalty of the people, so old courts and old capitals, with all their pomp and circumstance, and their parks and gardens, galleries and statues, are but dim prefigurings of the glories of architecture, the grandeur of the grounds, the splendor and richness of the museums and conservatories with which the people will finally crown their own self-respect and decorate their own majesty."[32] A monumental norm from the past was being sought in order to revitalize and dignify the present and future. In the Fens, "It was above all the physical pleasures and privileges of Jeffersonian America that Olmsted sought to bring intact into the industrial age. . . . It was a time when intellectual Americans had turned to nature for inspiration as an earlier age had turned to religion."[33] As older Puritan rules weakened and seculari-

[32] Henry Bellows, "Cities and Parks," p. 421.

[33] Julius Fabos, Gordon Milde, V. Michael Weinmayr, *Frederick Law Olmsted Sr.* (Amherst: University of Massachusetts, 1968), p. 12.

zation increased, Transcendental attitudes toward nature hardened into Unitarian resolutions around naturalistic romanticism, especially to be noticed in the urging to spend Sundays on walks in the open air and in social exchange.

The Jeffersonian ideal of "physical pleasures and privileges" for everyone found another expression in Boston in Isabella Stewart Gardner's Museum of 1899-1903, Fenway Court, on the skirt of the Fens, with its skylit, multi-storied, enclosed court in which cultivated flowers still bloom year round. It is the last, contrived, monument to the Boston need for creating internalized color boxes, splashed with light. Again "the people" were to be invited to intrude and mix, after Mrs. Gardner's esthetes and intellectuals had set the stage and identified the limits of the enterprise. San Francisco had its Palace Hotel courtyard, Los Angeles its Bradbury Building, and Chicago its skylit Rookery vestibule, finished by Wright, all very handsome, but completely commercial, and completely without major plantings. Boston's internal spaces were entirely inspirational. Another example of such democratized splendor in Boston would be the quiet Renaissance reading court of the Public Library across from Trinity Church, by Richardson's apprentices McKim, Mead and White (1888). In 1869, at the first promotional meeting to establish a park, Edward Crane had asked: "Are we not, in New England, a little apt to hug the Almighty Dollar too close, and are we not, with this intense stimulating air that God has given us to breathe here,—are we not apt to err in the direction of the intense application to business and leave very little room for recreation [art appreciation, reading, or intense contemplation]?"[34]

Mount Auburn, the Rural Cemetery of Bigelow

In some respects, the young landscape architect Charles Eliot understood the reason for the Fens better than his master and its creator, Olmsted. "Here and there, to be sure, is found a small public ground of such strongly marked shape and character that it by right rules its surroundings, whatever they may be—as the Back Bay Fens in Boston call a halt to the city structures."[35] The Fens was more a striking interruption than a smooth link of continuity in the fabric of the city, as Olmsted executed it. Odd landscape punctuation was frequent in Boston.

Although Mount Auburn, the first rural cemetery in the country (Fig. 7), was placed for good reasons outside Boston, between Cambridge and Watertown, and the Fens was situated inside at the busy point of traffic intersections between Back Bay and the several suburbs, the Fens was derived from the same forces that fostered Mount Auburn Cemetery. Both resulted from strong population pressures on Boston, subsequently acknowledged by definite innovations in layout. In his dedication address for the cemetery in 1831 Judge Joseph Story stated, "The tide [of population] which is flowing with such a steady and widening current into the narrow peninsula of our metropolis not only forbids the enlargement of the common limits, but admonishes us of the increasing dangers to the ashes of the dead from its disturbing movements."[36] The idea of a landscaped cemetery had been introduced by Jacob Bigelow, a young physician—"Professor of the Application of Science to the Arts of Life in Harvard College"—who had also written on Gothic Revival architecture and corresponded with

[34] *Report and Accompanying Statements and Communications Relating to a Public Park for the City of Boston* (Boston: City Document 123, 1869), p. 4.

[35] "Parks and Squares of United States Cities," *Garden and Forest*, I, 26, October 24, 1888, p. 413.

[36] As quoted in *History of the Massachusetts Historical Society 1829-1878* (Boston: 1880), pp. 71-72.

7. Mount Auburn Cemetery, Cambridge, 1831. A new feature was the specially planted trees, creating a vale of memory. The focus, as in the Fens, was preeminently inward on a small body of water. It was a way of concentrating feeling (N. P. Willis, American Scenery).

Jefferson on botany. In November 1825 he met with friends in his house on Summer Street to organize Mount Auburn Cemetery. He was "a gentleman who early became impressed with the impolicy of burials under churches or in churchyards approximating closely to the abodes of the living."[37] This signaled another break with English custom, and indicated an interest in the earlier nineteenth century landscaped French national cemetery in Paris, Père La Chaise. Because of their education in Latin and Greek, these Bostonians also knew of Classical burial customs outside city walls, and there were ref-

erences as well to Turkish and Egyptian customs (the entrance gate into Mount Auburn was to be Egyptoid).

Soon another accident of circumstance arose. The Massachusetts Horticultural Society was formed four years later, in 1829, "and whilst in its infancy, and when the project for the cemetery also was but in embryo, it was thought by the parties concerned, that by a union of the objects of each, the success and prosperity of both would be finally insured."[38] The ground was therefore consecrated as a combined "rural

[37] James Smillie and Cornelia W. Walter, *Mount Auburn Illustrated with Descriptive Notices* (New York: 1847), p. 10.

[38] Ibid., p. 11. For background, see also Barbara Rotundo, "The Rural Cemetery Movement," *Essex Institute Historical Collections*, 109, 3, July 1973, pp. 231-240.

cemetery and experimental garden," oddly anticipating the Arnold Arboretum arrangement of 1872, when a second such division of responsibility was made. The Arboretum was to be partially maintained at the expense of the City of Boston and held by Harvard on a low-cost, thousand-year lease from the municipality.[39]

The whole network of cost savings in pursuit of heightened feelings was tied together, on paper at least, by a report of a special committee to examine the feasibility of the new park, ultimately to become the Fens. The committee recommended that the hope for one large recreation ground like Central Park in New York be abandoned. "The shape of the city forbids it. . . . We need many open spaces in every part; a series of Parks, of various sizes and shapes, where the land may be found best fitted for them, connected by broad driveways. This system of roads should also connect with Forest Hills, Mount Hope, and Mount Auburn Cemeteries; and if an arrangement can be made with Harvard University, with the Arnold Arboretum, which is to be located on a part of the Bussey Farm in West Roxbury."[40] The fondness for joining diverse elements— parks, cemeteries, and an arboretum—and the romantic aura of warm remembrance from funereal customs and cemeteries, lingered on. However, the limited terrain allowed only certain spots to be utilized for such purposes. By the same token, the proposed point-to-point peregrinations in the report, envisioned here in the early 1870s, clearly anticipated both Olmsted's ring of

parks within the city of the 1880s, and Charles Eliot's outer Metropolitan Park System of the 1890s.

The joint commitment to Mount Auburn lasted only a few years, until 1835.[41] But with fine planting once begun (Fig. 7), and distinguished sculpture added, great crowds were attracted. As Olmsted noted, A. J. Downing had begun the campaign for public parks with the example of Mount Auburn as early as 1849.[42] In that year, the latter had inquired, "If the road to Mount Auburn is now lined with coaches, continually carrying the inhabitants of Boston by thousands and tens of thousands, is it not likely that such a garden, full of the most varied instruction, amusement, and recreation, would be ten times more visited. . . . It is only necessary for one of the three cities which first opened cemeteries [Boston, New York, and Philadelphia] to set the example, and the thing, once fairly seen, it becomes universal." In this role, Downing might even be called the godfather of the Boston park system. Although he has been occasionally dismissed in our day as a sycophant of private fortunes and the *nouveaux riches*, Downing took an early and favorable view of the beneficial effects of Jacksonian democracy: "The true policy of republics, is to foster the taste for great public libraries, sculpture and picture galleries, parks and gardens, which all may enjoy, since our institutions wisely forbid the growth of private fortunes [!] sufficient to achieve these desirable results in any other way."[43] However, Downing objected

[39] *Printed Letter of Appeal of Committee Appointed by Overseers of Harvard College to Visit the Arnold Arboretum*, Boston, May 28, 1901, pp. 1-2. See also letter from F. L. Olmsted to Charles E. Norton, May 7, 1880, in the Norton Papers in the Houghton Library, Harvard University; and S. B. Sutton, *Charles Sprague Sargent and the Arnold Arboretum* (Cambridge, Mass.: Harvard University Press, 1970).

[40] *Report on the Establishment of a Public Park* (Boston: 1874), pp. 12-13.

[41] Albert E. Bensen, *History of the Massachusetts Horticultural Society* (Norwood, Mass.: 1929), pp. 40-41.

[42] Olmsted, *Public Parks*, p. 91. For his indebtedness to Downing, see Olmsted's revised article, "Park," in *The New American Cyclopaedia* (New York: D. Appleton & Co., 1875) XIII, p. 105. Olmsted's first contribution to Downing's *Horticulturist* was in January 1852, where he wrote on "The True Soldat Labourer Pear," pp. 14-15. Downing described Olmsted's *Walks and Talks of an American Farmer in England* as "extremely fresh and honest" in the next month's issue (p. 135).

[43] See "Public Cemeteries and Public Gardens," *The*

that people might go to a cemetery in an improper frame of mind, looking only for "parks and gardens." Park and cemetery should therefore be clearly separated. The Fens took strength from nostalgic memory, like Mount Auburn, but it differed in its aim to elicit a positive attitude for the living within, not the dead outside, a city, so that the inhabitants might attain that "temperate, good-natured, and healthy state of mind"[44] Olmsted so earnestly wished for them.

THE METROPOLITAN PARK SYSTEM OF ELIOT

If Mount Auburn Cemetery was the forerunner of the Fens, the Metropolitan Park System represented its evolutionary glory (Map E). Olmsted sought to make the best of a wasted swamp; Eliot's metropolitan system used boulder strewn wastelands on an epic scale. Already in the early 1890s, the younger Eliot was working his way along the outer edges, under the Boston escarpment: "Thus we find that the rock-hills, the stream banks, and the bay and the seashores are the available and the valuable sites for public open spaces; available because they present both the grandest and the fairest scenery to be found within the district."[45] In 1895, Olmsted helped him by calling for the acquisition of land away from the "financially productive area of town."[46] The crowning result was that 9,342 acres of land and water were acquired before 1902, consisting of the Middlesex Fells, Beaver Brook, Revere Beach, the Blue Hills, and the Charles and Mystic River areas.

This third innovation, after the Fens and Mount Auburn, had associated with it a fourth unique private institution, The Trustees of Public Reservations. It was the younger Charles Eliot, the landscape architect son of the president of Harvard, who suggested this organization too, and was its leading spirit up to his death in 1897.[47] The Trustees carried a multiple responsibility, which was to be "like that of the trustees of a public art museum, standing ready to undertake the care of such precious things as may be placed in its charge."[48] They pioneered in another form of private stewardship, that of acquiring and maintaining "beautiful and historical places and tracts of land,"[49] preceding the British National Trust for the preservation of landscape and buildings by two years. The latter body, upon its founding, requested a nomination from the Trustees of Public Reservations for its provisional council, and Professor Charles S. Sargent, Director of the Arnold Arboretum, was appointed.[50]

Elizur Wright of Medford and Wilson Flagg and John Owen of Cambridge had agitated for the purchase of the Middlesex Fells for public purposes very early, Wright going so far as to conduct a field trip for the Massachusetts Horticultural Society to the Fells in the mid-1880s, which led its garden committee to support Eliot's cause.[51] However, it was not until the early 1890s that land was first acquired, coincident with a rising national interest in the combination of landscape and architecture in the attainment of civic beauty, and also the attempt in Boston to answer the question, first brought up in

Horticulturist, III, 4, October 1848, p. 157, for the cemetery connection of the parks.

[44] Olmsted, *Public Parks*, p. 11.

[45] Charles Eliot, *A Report upon the Opportunity for Public Open Spaces in the Metropolitan District of Boston* (Boston: 1893), p. 12. See also Charles Eliot, "The Boston Metropolitan Reservations," *The New England Magazine*, XV, 1, September 1896, pp. 117-122.

[46] F. L. Olmsted, "Parks, Parkways and Pleasure Grounds," *Engineering Magazine*, IX, 2, May 1895, p. 254.

[47] Sylvester Baxter, "A Trust to Protect Nature's Beauty," *American Monthly Review of Reviews*, XXIII, 1, January 1901, p. 48.

[48] Ibid., p. 42.

[49] Ibid., p. 43.

[50] Ibid., p. 48.

[51] Baxter, *Boston Park Guide*, p. 41; and Benson, *History of the Massachusetts Horticultural Society*, pp. 250-251.

the Fens, of how to reconcile the thirty-seven highly independent suburbs to the mother city.

Sylvester Baxter, in a brochure of 1891 called "Greater Boston," recommended a federated metropolis with parks to encircle the city from the Lynn Woods at the north (which Olmsted had been asked to plan for the City of Lynn in 1889), to the Blue Hills, the last park on the south. Soon after, Baxter met Charles Eliot, the son, and the latter, enthusiastic about a metropolitan park system, proposed that they work together to realize it. In 1890, at the suggestion of Eliot, the Appalachian Mountain Club incorporated the Trustees of Public Reservations, of which he then became the first secretary. In that capacity he called a meeting of the park commissioners of Greater Boston in 1891, and the actual metropolitan park system resulted. In 1920 the functions of parks, water supply, and sewage were put under one commission. "In this way there has come to pass a common administration for all metropolitan purposes, thus practically realizing the aims set forth in the Greater Boston brochure just a third of a century ago."[52] The first duty would be to "hand down from one generation to the next the treasure of scenery which the city has placed in their care," because "a landscape park requires, more than most works of men, continuity of management. Its perfecting is a slow process."[53] Sustained time was creative, and landscape architecture its most appropriate medium. This was a new concept in hustling America. The premise opened up a larger role for the Boston intellectual, who would now be required to invent, monitor, and defend the values of slower change on a larger scale.

THE INGENUITY OF THE SOLUTION

The challenge of the age, and of the Fens, centered about the need to bring humane improvements out of artificial means and lasting solutions out of temporary problems. It was the permanent benefit that Olmsted sought the hardest: "I will but add that the problem of a park . . . clear of unfortunate, temporary political necessities, is mainly the reconciliation of adequate beauty of nature in scenery with adequate means in artificial constructions of protecting the conditions of such beauty, and holding it available to the use, in a convenient and orderly way, of those needing it; and in the employment of such means for both purposes, as will make the park steadily gainful of that quality of beauty which comes only with age."[54]

From the 1820s on, Boston's dilemma was that of increasing population and intensifying pollution on an unfortunate geologic base. The city was bursting forth, and the suburban areas were draining in. The point where their effluents met was where the new park was to be built (Figs. 8-9). "In 1875 it became apparent that this population had at least one great problem before it which could not be solved effectively by the independent action of the separate municipalities. The problem was the problem of sewage disposal."[55]

Stony Brook was the most significant filament in this drainage pattern because it came from farthest away, in Hyde Park. It emptied an area of approximately 7,800 acres from the south, the watershed being comprised of nearly all of West Roxbury, much of Roxbury itself, a little of southeast Brookline, and part of Dorchester. The Muddy River, which empties nearby, also collected from about half of this field (3,700

[52] Sylvester Baxter, "Thirty Years of Greater Boston's Metropolitan Park System," *Boston Evening Transcript*, Part Five, September 29, 1923, p. 1. See also Charles Eliot, Letter to the Editor, *Garden and Forest*, March 5, 1890, pp. 109-110, 117-118.
[53] Olmsted, "Parks, Parkways and Pleasure Grounds," p. 254.

[54] Olmsted, *Public Parks*, p. 114.
[55] J. C. Olmsted, "The Metropolitan Park System of Boston," p. 56.

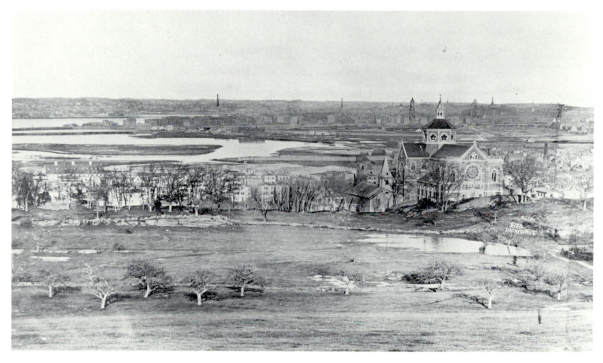

8. *Fens area before construction, from Parker Hill, Roxbury, 1878. The extent of the mud flats is shown. At the upper left is the old mill dyke. Just below it is Boylston Street crossing the flats. To the right of the octagonal crossing dome of the Romanesque church in the foreground can be seen the tower of Trinity Church, with the side of the first Museum of Fine Arts. This picture proves, like Fig. 6, that Trinity Church once looked directly onto the Fens. Over Trinity is the glistening dome of Bulfinch's State House (Boston Atheneum).*

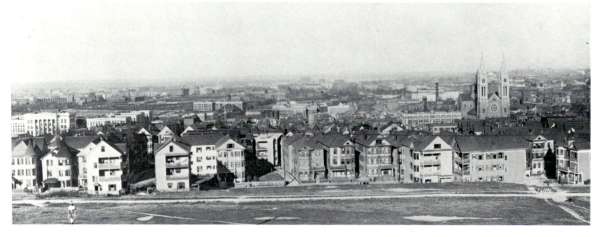

9. *The Fens from Parker Hill, 1910. The same church which appears in Fig. 8, the Catholic Basilica of Our Lady of Perpetual Help (1875-1876), popularly known as The Mission Church, is seen on the right with its twin spires added in 1902. To the right of its right spire can be seen Trinity Church, although all but hidden in the infill of later buildings. To the left of the other spire is the new white building of the Museum of Fine Arts, without the Evans front, added four years later. At the far left is another set of Beaux-Arts buildings, the Harvard Medical School complex of 1900. In the foreground are the Boston type of three-decker tenements, derived from the neoclassic temple forms of the 1840s (Boston Atheneum).*

acres), particularly on the west from Brook-line (then thought of as the most attractive "rural village" in America and thus where Olmsted and Richardson settled), and from portions of Roxbury, a small part of West Roxbury, and Brighton. Both streams received heavy discharge from private sewers that existed along the way. Fusing at the foot of Parker Hill and Commonwealth Avenue, they moved at ebb tide into the Charles River. If a back flow set in with an unusually high tide, however, and joined with east or northeast storm winds, or if a spring freshet suddenly tumbled down from Stony Brook or the Muddy River, an area of 300 acres, including streets and cellars, would be flooded with badly polluted waters.[56] Part of this water would afterward be retained in the so-called Full Basin of 160 acres which had been left over from the building of a dyke by the unsuccessful Boston and Roxbury Mill Corporation for a tidewater mill in 1821. Today's Beacon Street follows its line. Horizontally (and this was vital for the way in which the Back Bay Fens was able to emulate the coastal marsh), there were three water levels to be dealt with—a tidal creek, or as Olmsted called it by the New England name, "a gullet," which could run as deep as thirty to forty feet; extensive mud flats on either side of the gullet; and above, or around, narrow "plateaus" (also an Olmsted term) of sedge and salt grass which were kept by their owners until relatively late in the century for the salt hay for cattle fodder and bedding. When the storm had passed and the Full Basin drained into the receding tide, the sun poured down on the flats and raised a stench. Eels and clams could not even live in them. Olmsted admitted that the "substance of the locality was not like that found in those parts of the Back Bay that had been built upon, but was a flowing mud."[57] By 1878, the Board of Health was so aroused by the problem that it injected a note of unbureaucratic eloquence into its description of these areas: "Large territories have been at once, and frequently, enveloped in an atmosphere of stench so strong as to arouse the sleeping, terrify the weak, and nauseate and exasperate nearly everybody. . . . It visits the rich and the poor alike. It fills the sick-chamber and the office. . . . It travels in a belt half way across the city, and at that distance seems to have lost none of its potency, and, although its source is miles away, you feel it is directly at your feet."[58] Stench maps with wind directions (Fig. 10) (in which the future Fens held a prominent place) were prepared to make the condition traceable.

The difficulties became so pronounced by 1879 that Olmsted in his annual report to the Park Commissioners suggested that all hope for recovering the site for building (as had been done in the adjoining Back Bay elite district to everyone's satisfaction) be abandoned. Already in the previous year the Commissioners had admitted their error in not realizing sooner that the property would be so constrained by its drainage problems. They concluded that "the plan of the park must therefore conform to conditions outside its borders," even though they surely "would prefer to construct the park without reference to [Stony Brook]."[59] The Commissioners at the same time urged that Muddy

[56] Letter to City Council from S. H. Durgin, Chairman, Board of Health, April 19, 1877, in the *Fifth Annual Report of the Board of Health, 1877* (Boston: City Document 67), p. 6. For other observations on the flats, see F. L. Olmsted, "On the Back Bay Problem and Its Solution," speech before the Boston Society of Architects (1885?), F. L. Olmsted Papers, Library of Congress, Box 24, pp. 33-35; and Cynthia Zaitzevsky's *Frederick Law Olmsted and the Boston Park System* (Cambridge: Harvard University Press, 1982), pp. 52-54.

[57] F. L. Olmsted, ibid., p. 19.
[58] *Sixth Annual Report of the Board of Health, 1878* (Boston: City Document 68), p. 3. *The Fifth Report, 1877,* sets the stage on pp. 1-3, and indicates that the nuisance essentially began in 1873.
[59] *1878 Park Commissioners Report* (Boston: City Document 15), p. 7.

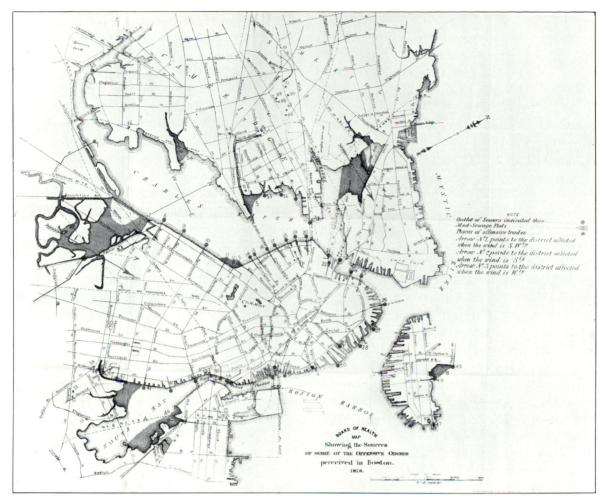

10. *Boston Board of Health Map of 1878. It shows the mud flats of the city, where the offensive odors were concentrated, together with the wind directions, indicated by arrows. The Fens is the biggest shaded area, at the left, with the wind arrows aiming back into the city. This is from the year before Olmsted began to transform the Fens (Boston Public Library).*

River be completely diverted before it reached the proposed park. This measure was soon to be thwarted too, apparently laying another heavy liability on Olmsted. Yet he typically turned this ostensible handicap to advantage when he used the entry of the Muddy River into the park as a ready enough reason for the expansion of the park system up to Jamaica Pond and on to Franklin Park (Fig. 5), thus forging the first links of the inner circle of green about the old city, which eventually lost its volition with-

out Olmsted to give it a push, and hence was never closed. Between 1880 and 1886 Olmsted and the city engineer launched a cleanup campaign for the Muddy River which soon took on the appearance of an inevitable thrust of destiny, so that, to no one's surprise, "the roads leading up that valley to Jamaica Pond would be the beginning of a Park-way leading from the Back Bay to the Arboretum & West Roxbury [Franklin] Park."[60] Like the land speculators poised all

[60] Olmsted, "On the Back Bay Problem," pp. 74-75.

about, waiting for him to finish the park, Olmsted was parlaying every possibility, but for the purpose of improving the quality of life for everyone, rather than for private or personal gain.

The synchronization of the Fens depended in no small measure upon Olmsted's wisdom in choosing his associates. He asked that the City Engineer, Joseph P. Davis, join him as soon as possible. It became such an effective alliance that it surprised even himself: "That a landscape architect should have been associated with a sewer engineer in the planning and superintendence of a public work, and of the two should rather have been given the first place is certainly remarkable."[61] For the shelters, bridges, and gatehouses he set the standard as early as he could by recommending his Brookline friend and former neighbor (on Staten Island), the architect of Trinity Church, H. H. Richardson. Olmsted had walked beneath the approaches to the Brooklyn Bridge and was convinced that it would someday be respected as a great work of art by "painters and etchers," because architects had been asked to consult with the engineer, Roebling, although not quite soon enough.[62] Finally, Olmsted was uniquely fortunate in his association with the Commissioners, who first brought him from New York for consultation in 1876. This experience was to be very different from that in Central Park, which was torn by politics. Even a decade

later Olmsted still spoke of the Boston Commissioners as "three gentlemen of notable position and character, of great commercial ability, liberal and public spirited."[63] For him they stood for the best of Boston.

The Fens—Back Bay Park—was about to emerge from its chrysalis. The first response from it to the weather brought forth elation from Olmsted's often heavy heart. He wrote to the younger Eliot, his eventual partner, on his European *wanderjahr*: "You will have heard of the great flood. The Back Bay and Muddy River arrangements worked smoothly and with perfect success, the water never rising more than three feet and normal conditions returning without the slightest apparent damage."[64] The maximum allowable variance had been calibrated at four feet. This tolerance within the Fens corresponded with a tidal rise on the Charles River from nine to eleven feet, causing Eliot to observe in return that Venice with its rise and fall of only two feet had a relatively easy time of it. When the spring freshets gushed down from the Stony Brook and Muddy River, to be met with the highest tides, the two pools would become emergency holding basins. Such basins are now common devices for river engineers, but they do not usually, even today, come up to the ambidexterity of these.

Moreover, the whole apparatus was self-activating, except for the necessity of manually removing the flash-boards at the top of the dam into the Charles River in times of freshet. When this machinery worked, it thwarted the keenest observer above ground. The sleight-of-hand in the exchange of salt and fresh waters was accomplished through balancing city grade levels in numbers of

That the Muddy River clean-up campaign was no idle gesture is evident from G. K. Sabine, M.D., "The Muddy River Improvement Petition," to the Park Commission, October 3, 1881 (Massachusetts Historical Society), which tells of a bad epidemic of typhoid fever along the river, and of the hope for improved health coming out of the Olmsted plan.

[61] Ibid., pp. 11-12. The actual construction of the Fens was carried out under the next city engineer, Henry M. Wightman. For the sequence of dates of construction, see also Zaitzevsky, *The Boston Park System*, pp. 54-57, 156-157

[62] Ibid., pp. 5-7.

[63] Ibid., p. 14. The Commissioners were T. Jefferson Coolidge (great-grandson of Thomas Jefferson), Charles H. Dalton, and William Gray, Jr.

[64] Olmsted to Charles Eliot, February 25, 1886, Olmsted Papers, Library of Congress, Box 24.

feet, and in accommodating two forces from opposite directions often acting upon the Fens simultaneously—the incoming tide and the freshet flow from Stony Brook. Thirty acres of the park were designated a permanent holding area for water at eight feet above the city base, while twenty acres in addition were utilized for overflow above eight and a half feet of the city base. The water of Stony Brook would ordinarily run through a wooden conduit, seven feet, two inches in diameter (taken out in 1905). At high tide, however, the outer discharge gate would close to prevent back surge. If, as a result, the water in Stony Brook rose too high before the next low tide, another gate would open into the thirty-acre park pond. Salt water at high tide could also be taken in at any time back through the Stony Brook and Muddy River gates so as to refresh the pond.[65]

Olmsted knew that the easiest way to stabilize the sides of the two basins of the thirty-acre pond would be by a straight stone revetment, as originally planned and endorsed by the city engineer. Instead he elected to use more difficult but appealing sculptured banks at a slope of one in six feet. His attitude toward manifest naturalism was well exemplified in his *Justifying Value of a Public Park*: "I have seen a low rocky shore having what I regard as a park-value beyond estimate, in tints, lights, and shadows, and reflections of translucent and opaque foliage over rippling water and full of poetic mystery—of beauty such as no painter can render. I have seen such a shore so changed that the water lay dead upon a wall of raw stone."[66] The method parallels that of the luminist paintings of Martin Heade (Fig. 3) and the atmospheric reveries of George In-

ness. Yet Olmsted's light mutations are achieved more by means of changing tonal values from wind and water than through static color schemes.

To increase picturesqueness and efficiency above the mirrored surface of the waters during flood times, Olmsted cut the banks with deeper and higher inlets. The two pools were never allowed to become too wide or straight, in order to nullify the force on the banks of the cross swells from the storms. It was also a device to resist the chronic East Wind, which exacerbated the spring freshets and flood tides. Beneath the waterline the sides were graveled over the mud for additional stability. During the floods, water was allowed to spread across the artificial marshes of twenty additional acres with the plantings of sedge, rushes, and salt grasses, which would then be renourished by the salt-fresh mix. Slashes of goldenrod and aster, such as already appeared naturally along the tidal banks of the Charles River, were planted. At high tide a few inches of salt water were let into the pools so that "mosquitoes were prevented from breeding or lurking in the salt marshes."[67]

In his 1879 Parks Department Report, Olmsted announced that one of his three goals for the Fens was to bring a "convenience of communication between different quarters of the city." But in those horse and carriage days of three to ten miles per hour he meant that the roads would come to a focal point, more than pass through, for he also insisted that thoroughfares traversing the park be kept at a minimum. The bridges were regarded as outlooks and decks, as

[65] E. W. Howe, *The Back Bay Park, Boston* (Boston: Society of Civil Engineers, 1881), pp. 130-132. See also Zaitzevsky, *The Boston Park System*, pp. 154-155.

[66] Olmsted, *Public Parks*, p. 88.

[67] Olmsted Brothers to John H. Dillon, Chairman, Park and Recreation Department of Boston, December 26, 1916, p. 6. Olmsted Office Material, Brookline, Mass., File 916. For a narrative of the planting, see Zaitzevsky, *The Boston Park System*, pp. 186-190. She makes the point that it is naturalistic, not natural, p. 187.

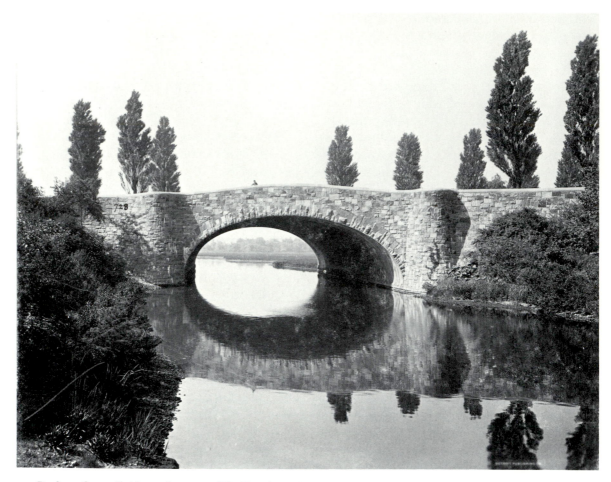

11. Boylston Street Bridge, when new, The Fens beyond, H. H. Richardson, 1879-1883 (Boston Public Library).

much as necessary links on the way. There were four bridges over the Charlesgate waterway in from the Charles River. The last and most monumental attracted special attention. The others, being more pragmatic as to usage, were lower, to correspond to their more humble function. Boylston Street curves freely at this point in order to accommodate the shore of the first, or north, pool. This final Boylston Street Bridge (Fig. 11), a magnificent piece of sculpture, "will be an elliptical arch of sixty feet span, at a right angle to the abutments and eighteen feet rise above the surface of the water. The bridge will be one hundred and eleven feet wide at the easterly abutment, the arch being straight at one end and askew at the other; the span at the skew end on the face of the arch is sixty-seven feet."[68] Olmsted was fond of testing the coherence of the view of the Fens from this deck (Fig. 12), which was raised and aligned according to nephew-stepson John C. Olmsted's instructions to Richardson.[69] The view toward it from Common-

[68] Howe, *The Back Bay Park*, pp. 132-133.
[69] Cynthia Zaitzevsky, "The Olmsted Firm and the Structures of the Boston Park System," *Journal of the Society of Architectural Historians*, XXXII, 2, May 1974, p. 170. In a letter to Sylvester Baxter of January 1898, quoted by Ms. Zaitzevsky, John C. Olmsted also declared that, "in the case of the Boylston Arch, for instance, the preliminary plan which I devised shows it just as it now is with the exception of the projecting

12. The Fens from the Boylston Street Bridge. This was Olmsted's favorite outlook on his creation. Planting was kept thick and low. The flood plains are visible at the right (Boston Public Library).

wealth Avenue and the railroad bridge was improved by grading and planting as well.[70] One could thus look easily under it into the Fens, through a kind of moon gate (Fig. 11), in a liquid progress finally reaching a vision by piercing through a solid, hulking mass,

bay or tourelles and a blind arch in the northwest wing wall. All the curves, both vertical and horizontal, were accurately indicated on my design, and Mr. Richardson added the tourelles and arch and determined the choice of stone to be used. . . . For the following bridges no architect was employed, and my designs were followed directly by the engineers—Agassiz Bridge, Fen Bridge, and all other boulder bridges and culverts in the park system, including the Ellicott Arch."

[70] Letters to J. B. Shea from J. C. Olmsted, August 6 and 8, 1919. Olmsted Office Material, File 916.

which bends with concern over the stream to protect a delicate memory. In the same way, the hulk of Trinity Church provided a sweet citadel for its parishioners against the impersonality of the urban evils surrounding it.

One of Olmsted's standing ambitions was to relieve the city of its rigid conformity to the grid. To take such a position with Central Park in New York was only nominally possible, but in Boston it was highly possible, and in looking under this bridge one senses not only what is immediately beyond, but also the implication of a whole new suburban prospect. In nineteenth-century industrial cities in England and America, mar-

ginal land was left vacant, as the unseemly haste of expansion strung main arteries outward in fan shapes. The Fens used such a leftover wedge. Since there was an additional constriction, because political opponents were determined to keep the Fens asymmetrical and purchase only the cheapest land,[71] it became the ugly duckling of Victorian parks. But a further look under this bridge shows that British and American Victorianism were not strictly identical, despite the evidence of British influence in Olmsted's work and the "Englishness" of Boston. Under the auspices of Olmsted and Richardson, the Fens became a linear venture into the topography of an uncertain future, at the same moment that an attempt was made to reinstate a dispersed past. Eliot and Olmsted are remarkable not so much for the draping of two "emerald necklaces" about the neck of Boston, as for the agility and dexterity of their thinking, which enabled them to spring from emerald to emerald, outpacing even the breakneck expansion of the city itself, at the same time that they revived a facsimile of a territorial memory. If the American was destined to become an eternal wanderer, then some kind of anticipatory imagery had to be found for him to pursue out there, just as Thoreau imagined he could view "The West" when he climbed 2,000 feet to the top of Mt. Wachusett, only thirty miles west of Concord.

Olmsted moved the main channel in the pond from west to east so that it might be seen better from under Richardson's arch, but also so as to reduce the expense of graveling the bank to the west, where reaching a stable bottom was more difficult.[72] The rustic Agassiz Bridge (Pl. 10), with its huge, undressed boulders and cascading plants, divided the two major basins by narrow arches, varying in height. The five irregular openings in it were needed for the rapid exchange of waters during the level fluctuations in the basins. In contrast to the Boylston Street Bridge it was purposely kept low, like the Charlesgate bridges, or "sagged" as John C. Olmsted put it, so that the view from the higher Boylston Street Bridge would be less interrupted. An early park enthusiast, the New England public education reformer Horace Mann, had observed that "water is to the landscape what the eye is to the face."[73] The eye was one of the chief instruments of Transcendentalism, especially for Emerson. Sherman Paul has spoken of "the angle of vision" as being Emerson's greatest contribution to comprehension.[74] It is perhaps not insignificant that Emerson, Olmsted, and the college presidents Timothy Dwight and Charles W. Eliot were troubled by chronic deficiencies in eyesight, and Dwight had to walk out-of-doors because of resulting headaches.

In 1910 the Charles River was dammed

[71] When the Park Commission was authorized in July 1877 to buy one hundred acres, another stipulation was that only ten cents a square foot could be spent. It was further ordered that "said park to be of such shape as not to require other adjoining lands to make it symmetrical." J. C. Olmsted recalled in 1905 that "The peculiar shape of the Fens and its entrances was due mainly to the limitations of cost for land which the opponents of the project in the City Council succeeded in fastening upon the ordinance authorizing the park. . . . It is probable that some of those who voted for this limitation fully believed that it would indirectly kill the whole scheme, thus saving the city much money." "The Metropolitan Park System of Boston," p. 43.

[72] "Notes on a Perambulatory Tour through the Park System with Messrs. Olmsted and Pettigrew, August 16, 1910," Olmsted Office Material, File 916, pp. 22-23.

[73] Snelling, "Testimonials," p. v, footnote.

[74] Sherman Paul, *Emerson's Angle of Vision* (Cambridge, Mass.: Harvard University, 1952), p. 73. Perhaps the most eminent passage in this connection by Emerson was, "Standing on the bare ground,—my head bathed by the blithe air, and uplifted into infinite space,—all mean egotism vanishes. I become a transparent eye-ball; . . . I am part or parcel of God." Ralph Waldo Emerson, *Nature, Addresses, and Lectures* (Boston: Houghton Mifflin, 1895), I, pp. 15-16.

against tidal fluctuations.[75] The Fens was then intended to be altered from a salt to a fresh water ecology. The Charles River had been put at a level six inches above that for which the pond of the Fens had been originally prepared, so there could be no more out-flows or grand torrential expansions of the Fens. Son F. L. Olmsted, Jr., suggested a flatter meadow with a narrower stream be substituted for the salt marsh memory, "a river meadow alongside of a meandering fresh water stream just as it was originally designed to suggest a salt marsh along a salt stream."[76] In 1921 the Fens was thus re-planned by Arthur Shurtleff of the Olmsted office, but the plan itself was never executed. The inspiration for the effect in the Charles River appears to have been derived in part from the large lagoon of the Chicago Columbian Exposition of 1893.[77] The choice was no longer to be Boston's alone. Regionalism was quickly passing wherein the sphere of reference could be only thirty to forty miles in diameter.

THE RISE, FALL, AND REDEMPTION OF THE FENS

Medical doctors made their appearance, along with the ministers, at Faneuil Hall in 1876, for the second great agitation for a Back Bay park. That these medical men then belonged to the honorable company of intellectuals and social leaders is obvious from a report of 1875 to the Mayor: "For many years past there has been a growing feeling among the more intelligent of our community, and particularly among physicians, whose habits of study lead them especially to watch the public health, that our high death-rates are connected more or less directly with the defects and evils of our sewerage-system, more especially in the low-lying and original tidal districts,"[78] These physicians demonstrated a praiseworthy concern for the common lot at the Faneuil Hall meeting. Oliver Wendell Holmes, Sr., M.D., declared with tongue in cheek that the audience should not expect too much eloquence from him, as he was a member of "the silent profession." His observations centered on the benefits the young might receive from a park, interesting in the light of his reputation for investigating the cause of puerperal, or childbed, fever. He spoke of the waves of cholera-infantum in the summer (Fig. 13), which the fresh air and open sunshine would be bound to dissipate, asserting that "air poisoning kills a hundred where food-poisoning kills one."[79]

Another influential physician, Dr. Edward H. Clarke, who had succeeded Jacob Bigelow as professor of Materia Medica at Harvard Medical School in 1855, questioned the worry over house sewers and drains, and their noisome vents, when no one seemed to be paying the least attention to the adequacy of the ventilation of the city as a whole. "The foul air of the streets will not only envelop those who pass through them, but will penetrate the houses that line them. . . . In proportion as a city increases in size, large open spaces should be reserved. Parks are the lungs of a city. . . . They produce atmospheric currents, which sweep through

[75] See especially Charles W. Eliot, 2nd, "The Charles River Basin," paper delivered before the Cambridge Historical Society, May 23, 1961, *Proceedings* of 1961-1963, vol. 39, Cambridge, Mass.: 1964), pp. 34-35.

[76] "Notes on a Perambulatory Tour," p. 23.

[77] William Howe Downes, "The Charles River Basin," *The New England Magazine*, XV, 2, October 1896, p. 208.

[78] *A Report by a Commission to Samuel C. Cobb, Mayor of Boston* (Boston: City Document 3, 1875), p. 2.

[79] *Proceedings of a Public Meeting Held at Faneuil Hall, June 7, 1876* (Boston: Rand, Avery & Co., 1876), pp. 22, 25. See also *Boston Daily Advertiser*, June 8, 1876, and *The Boston Medical and Surgical Journal*, XCIV, 1876, pp. 755-756.

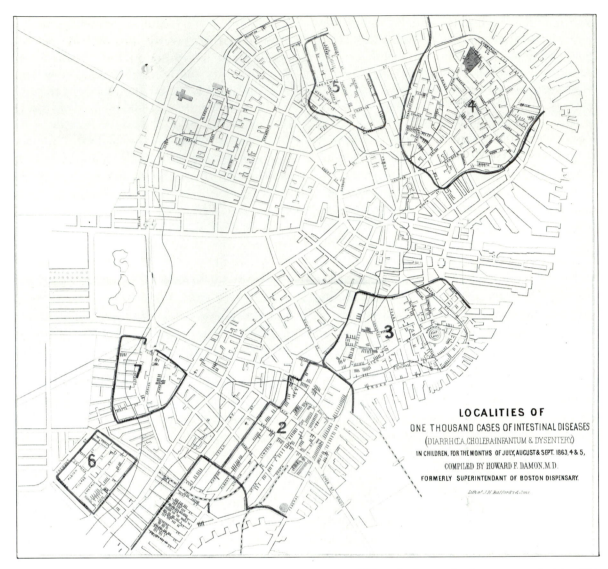

LOCALITIES OF
ONE THOUSAND CASES OF INTESTINAL DISEASES
(DIARRHŒA, CHOLERA INFANTUM & DYSENTERY)
IN CHILDREN, FOR THE MONTHS OF JULY, AUGUST & SEPT. 1863, 4 & 5,
COMPILED BY HOWARD F. DAMON, M.D.
FORMERLY SUPERINTENDANT OF BOSTON DISPENSARY.

13. Map showing location of 1,000 cases of intestinal disease in children in Boston in the summer of 1863. This chronic condition was one of Dr. Oliver Wendell Holmes' arguments for the Fens. Each case is shown by a dash (Boston Public Library).

and purify the streets." Clarke lifted the matter from the scientific to the moral plane, and declared unscientifically, "Clean hands and a pure heart go together. Foul air prompts to vice, and oxygen to virtue." Moral forces simply could not operate as effectively in a polluted setting, said Dr. Clarke. "It makes one tremble to think of the thousands of youth in our cities whom the school and the church do not reach, and who

are moulded by these influences into the worst and lowest forms of humanity . . . the city should therefore bring the country to them, and give them a chance, at least, to experience its humanizing and blessed influence." Clarke, ninth child of a Congregationalist minister, had to leave Harvard to finish his medical degree at the University of Pennsylvania "because of the less harsh climate of that city," since his lungs had begun

to hemorrhage; thus his equally divided interest in moral and physical climates is understandable. He seems, like Holmes, to have been "modern" in every respect, for he lectured at the medical school on the use of light, heat, air, and the effects of the imagination on the treatment of disease, and even wrote a book on *Sex in Education*, which caused a gratifying stir when it was published in 1837.[80]

Although Richard Henry Dana, Jr., was not a physician, just a famous author, he believed in the brisk Boston walk, and indulged in the same adamant manner of speaking as the doctors. He observed that there could "hardly be a question here in Boston, the Athens of America, the Hub of the Universe, as to whether the intellectual should supersede or the animal."[81] In this atmosphere the intellectual was as much a moral as a scientific or literary figure. He remarked that the proposed park circuit would enable him to walk from Fort Independence on the ocean shore to Harvard Square via Massachusetts Avenue (then known as East and West Chester Park), making it convenient to learn in Cambridge at the same time that he inhaled the salt-saturated air of his *Two Years Before the Mast*. Dana presented another rather unusual image when he added that it would be fairly harmless to set one Robinson Crusoe wandering about Boston, since as a single individual he could not exhaust the local resources very rapidly, but if hundreds of thousands of Robinson Crusoes (i.e., highly independent New Englanders) were to appear, there would be such a crisis within a few square miles as would require all the patience, science, money, and industry that modern civilization could summon to deal with the problem. So the ecology

needed a more delicate adjustment now than it once had. Curiously, Boston had once had its Robinson Crusoe, in the person of the hermit Reverend William Blaxton, who rode a bullock and settled on Beacon Hill and, much to their astonishment, cheerfully greeted the Puritans on their arrival.

On the trail of the vigorous infusion of enterprise from the Victorian doctors came the indifference and categorical ignorance of the politicians and architects. Changing architectural styles got much in the way of landscape intent, which required above all an adequate period in which to gestate, as Olmsted often said. What Olmsted preferred for the buildings surrounding his creation is generally apparent. "The park should, as far as possible, complement the town. Openness is the one thing you cannot get in buildings. Picturesqueness you can get. Let your buildings be as picturesque [as silhouetted] as your artists can make them. This is the beauty of a town. Consequently the beauty of the park should be the other [openness or hollowness]."[82] The colorful buildings that Olmsted had in mind as backdrops would be like the Main Pavilion project of the Philadelphia Exposition of 1876 by his and Downing's former partner, Calvert Vaux (and G. K. Radford), or even more the picturesque Jefferson Market (1874) in New York by Frederick Withers, another Downing protégé. These buildings appeared in a scrapbook owned by the Olmsted firm, which was finally presented to Harvard University by John C. Olmsted.[83] Perhaps most relevant (Fig. 14, being from the same scrapbook) was Richardson's Oakes Ames Memorial Hall in North Easton, Massachusetts, where the "architect had the advantage of Mr. Olmsted's assistance." Here Olmsted left the great granite outcroppings fully revealed (and partly remodeled by explosives)

[80] Howard A. Kelly and Walter L. Burrage, eds., *American Medical Biography* (Boston: 1920), p. 225. Thomas F. Harrington, *The Harvard Medical School* (Cambridge, Mass.: 1905), II, p. 870.
[81] *Boston Daily Advertiser*, June 8, 1876.

[82] Olmsted, *Public Parks*, pp. 49-50.
[83] "Scrapbook of J. C. Olmsted," MS AM 1843, The Houghton Library Harvard University.

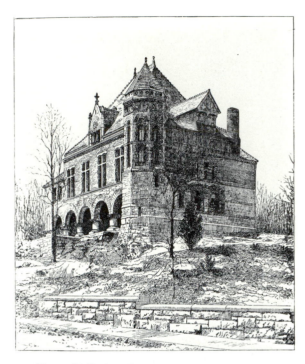

14. Town Hall, North Easton, Mass., H. H. Rich-ardson, Landscape by F. L. Olmsted, 1879-1881. This illustration was among the Olmsted papers given to Harvard (Harper's, February 2, 1884).

right up to the building, repeating in micro-cosm the whole New England scene. Me-diating vines were supposed to be woven be-tween the two. North Easton was described as a "picturesque" village in the text accom-panying the illustration,[84] the word Olmsted used to describe the Victorian buildings he preferred.

Indeed, North Easton contained samples of nearly everything important that passed between Olmsted and Richardson for achieving a coherent and distinctive three-di-mensional setting. The Ames Gate Lodge shows Richardson taking up, for building walls, the earlier Olmstedian adaptation of field boulders from the last glacier,[85] which

the farmers of the region had employed (as Charles Eliot noted) for fences not easily moved or blown down. The wooden garden-er's cottage on the estate with its porch and swelling tower, covered with a gossamer cape of shingles, is a metaphor of the seaside cottages of New England, just as the Fens was reminiscent of the seashore. Richard-son's railroad station at North Easton (1881) repeats this associationism in the long hori-zontal roof over the platform of the depart-ing trains. It hugs the ground and soothes apprehension with its widely sheltering can-opy. Like Trinity Church and the Fens, the station had the purpose of making people feel better in a destabilized or intrusive greater environment which might otherwise make them feel much worse.

Olmsted "was not so surprised and en-chanted by the grandeur and dazzling white-ness and symmetry of the [Chicago Colum-bian Exposition of 1893] as most of his countrymen had been. He had hoped in-stead for something colorful, picturesque, and intriguing rather than for something monumental and apparently permanent."[86] He thought the buildings there were " 'too assuming of architectural stateliness,' " or, in a word, were too large and pretentious.

Around his parks Olmsted was wont to put "screening plantations" and "the bound-aries of each should be so placed as to in-clude all essential elements of local scenery and to produce the utmost possible seclusion and sense of indefinite extent."[87] In the Fens the inclusion of local scenery was possible, but not the protraction of it, so Olmsted laid out slopes punctuated by "trees, copses, and thickets" in order to keep the surrounding

[84] "A Picturesque Village," *Harper's Weekly*, XXVIII, 1415, February 2, 1884, pp. 73-74.

[85] According to Olmsted, "Richardson's work at North Easton was conceived after he had examined two works of rough-hewn stones and boulders, built

in Central Park twenty years before." Quoted in Zait-zevsky, "The Olmsted Firm and the Structures of the Boston Park System," *JSAH*, May 1973, p. 170.

[86] Charles McLaughlin, "Selected Letters of Fred-erick Law Olmsted," Ph.D. thesis, Harvard Univer-sity, 1960, pp. 412, 418.

[87] Olmsted, "Parks, Parkways and Pleasure Grounds," p. 255.

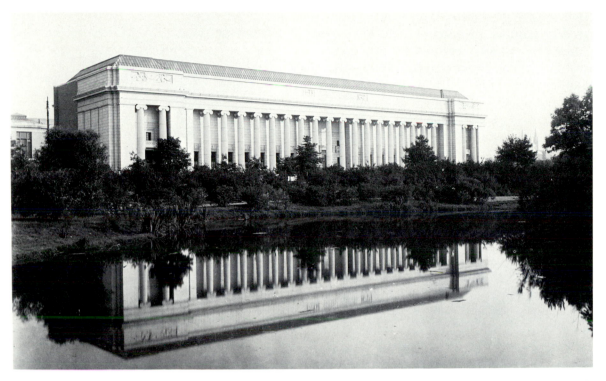

15. Robert Evans Memorial Gallery and Front, Museum of Fine Arts, Boston, 1914-1915 (The Society for the Preservation of New England Antiquities).

buildings as far at bay as he could. But he was to be penalized for this viability eventually, because the Fens quickly attracted the rising institutions in which the citizens took the greatest pride. And these were to be in the conspicuous style Olmsted had only reluctantly accepted at Chicago—that of the Great White City. The public's idea now was that white and conspicuous buildings ennobled the landscape around the Fens, whereas Olmsted and Richardson's final persuasion at North Easton and elsewhere had been just the opposite. The hope of holding the buildings back collapsed utterly with the construction of the Evans Wing facade of the Boston Museum of Fine Arts (Fig. 15) of 1914-1915.[88] Olmsted's fol-

lower, Arthur Shurtleff, was then employed to bring the Fens water closer to the museum's columned back by means of an artificial pool so as to give it "greater charm of environment: with possible reflections in the water."[89] The dazzle of the Classical effect was to be doubled by the reflection in the Fens water, much as with the Lincoln Memorial pool in the capital of the same era.

Nearby in the same two years the Forsyth Dental Infirmary with a similar white, luminous, classical facade was built. The light had shone from within the Victorian buildings. Here it gleamed in reflection on the facades from the sun and water. The earliest Beaux-Arts ensemble of the type in this vicinity was the Harvard Medical School of

[88] See Sylvester Baxter, "Boston's Fenway as an Educational Center," *The Outlook*, LXXXVI, 17, August 24, 1907, pp. 894-907.

[89] Sylvester Baxter, *The Better City* (Boston: Metropolitan Improvement League of Boston, 1912), Bulletin 3, p. 11.

1900-1905 (Fig. 9). Around it would be clustered a number of teaching hospitals, for which ground was reserved by the school, such as the world-renowned Children's Hospital of 1915, with its functions moved from Huntington Avenue, and the Boston Lying-In obstetrical center, both also in the Renaissance or Classical mode, now taking on a second, medical meaning from the professional whiteness. In the Chicago environs, the "Great White City" of 1893 was a symbol of civic reform, of a clean-up campaign against the mushroom growth and wickedness of that metropolis, whereas in Boston the same style was an affirmation of an already existing New England rectitude, like the white houses of the New England villages. These medical buildings did not impinge on the Fens directly, but rather thrust a straight and entirely incompatible French avenue out toward it for communication purposes, the Avenue Louis Pasteur (Fig. 16).

Olmsted's anxiety that the Fens might someday be found "wanting in attractions of popular interest for a public property so near the heart of the city," began to become all too true, for "popular attractions" in it were indeed so often later proposed as to constitute a persistent threat to its integrity. He asked again in 1883, "Whether, accepting difficulties such as are thus suggested, it will be possible to avoid an offensive incongruity of character between the basins and the structures presumable to be built in the neighborhood."[90] This "offensive incongruity" would surely derive from "large and conspicuous buildings . . . completely subversive."[91] Olmsted's worst premonitions

[90] *1884 Park Commissioners Report*, p. 14. See also Charles Eliot, "Landscape Gardening in its Relation to Architecture," *Transactions of the Boston Society of Architects, 1891* (Boston: The Society, 1892), pp. 65-74.
[91] Olmsted, "Parks, Parkways and Pleasure Grounds," p. 259.

16. *Beaux-Arts Plan of the Boston Society of Architects, proposed for the Fens in 1907 (Boston Public Library).*

were realized through the Beaux-Arts preferences of architects, museum trustees, and university officials. Each profession, each specialty, was becoming more bumptiously self-confident with the growing polish and urbanity of the city itself. Rusticity or ruralism was not the politic direction to go—Paris and Chicago had corrected that impression.

The most disruptive series of acts occurred between 1907 and 1911, when there was an attempt to project Westland Avenue on a bridge straight from Hemenway Street, destroying the Agassiz Bridge, and the Huntington Avenue entrance beside the art museum would have been extended across the Fens from a small treed square between Tremont Street and Columbus Avenue (Fig. 16). It would have then been opened to all types of through traffic, including streetcars. The Boylston Street Bridge was threatened, but finally saved by the intervention of the

Metropolitan Improvement League.[92] The Boston Society of Architects, which wanted to penetrate the Fens with more French avenues in order to have it match the white or cream Beaux-Arts buildings going up around the perimeter, was behind such moves. Another square, with a building facing over a formal pool in the Fens northwest up Avenue Louis Pasteur toward the Harvard Medical School, was mapped out (Fig. 16). A large traffic circle (rond-point) was placed near the center of this proposed realignment of the Fens, tying avenues in from all directions.[93] Back of the architects' vision was the not inconsiderable figure of Mayor John F. Fitzgerald, grandfather of John F. Kennedy. Commenting on the architects' report of 1907, he said, "The Fenway at present constitutes too much of a barrier, and it should be crossed by one or more new streets, as proposed by the report,"[94] exactly what Olmsted had not wanted.

The salt marsh memory was pushed even further back, and finally lost, its contiguity completely frayed out. In 1911 there was a proposal to the legislature to locate the High School of Commerce in the Fens, but that was voided.[95] A stadium was discussed. In 1915, as a result of the Boston Youth Conference and the encouragement again of Mayor Fitzgerald, plans were drawn for baseball and football fields by A. R. Sargent on the old plateaus.[96] In 1916 there was a move to erect a Shakespearean Village of a dozen buildings.[97] World War I put an end

to that. There was a great deal of cultural vitality in Boston shortly before World War I, but much of it was superficial. World War II brought a large number of victory gardens (utilized to this day), and a war memorial (1949). A rose garden was laid out. Mayor James Michael Curley had to be dissuaded from planting five miles of lilacs, his favorite bloom, along Olmsted's soft bridle path from the Fens to Franklin Park.[98] Land was filled and inappropriate grass planted upon it Bulrushes and sedge were allowed to overgrow, and the all-important (by New England terms) shores of the basins lost their sculptural definition. There was no attempt in this Athens of America to maintain the balance among the dozen or more coastal plants Olmsted had so painstakingly chosen for those same carefully delineated banks.[99] After so much care and thought to keep the overpasses at Beacon Street, Commonwealth Avenue, Ipswich Street, and the railroad bridge as low as possible and in concert with the canallike waterway that led from the Charles River up into the Fens through the higher arch under Richardson's Boylston Street Bridge (Fig. 11), an elevated expressway of bright concrete, with an aiguillette of curving ramps was thrown unprotectively over it in the 1960s, following the addition

[92] Baxter, *The Better City*, p. 1.

[93] *Report of Committee on Municipal Improvements, March 21, 1907* (Boston: Alfred Mudge & Son, 1907), p. 11, Fig. 25.

[94] *Message of the Mayor, John F. Fitzgerald, Relative to the Report of the Committee on Improvements of the Boston Society of Architects* (Boston: 1907), p. 13.

[95] Baxter, *The Better City*, pp. 7, 11.

[96] *Boston Herald*, Friday, March 22, 1912.

[97] Letter to John F. Dillon from Olmsted Brothers, December 26, 1916, Rare Book Room, Boston Public Library.

[98] Letter to James Michael Curley from James Frederick Dawson, March 28, 1922, Olmsted Office Material, File 916.

[99] With his first planting at the Waterside District from the Beacon Street entrance south to Westland Avenue, low and exposed on the east bank, Olmsted indicated that "In nearly corresponding condition along the open coast the ground is often covered densely with a mixture of sweet gale and sweet fern . . . sometimes and in some localities mottled with patches and flecks of lighter tint from the woad-wax and darker from the little running dewberry. Prostrate juniper, berberry and beach-plum occur with these plants in the bleakest situations." (Letter to William Gray, Jr., Park Commission, from F. L. Olmsted, April 1, 1882, Olmsted Office Material, File 916.) Olmsted attempted to enrich appearances, but his planting plans were also very authentic.

of Storrow Drive along the bank of the Charles River in 1937. In 1964 an even worse eight-lane inner belt was proposed to run through the Fens, with the museums and colleges in the area to be left "sitting on the rim of a traffic canyon," according to Perry Rathbone, then director of the Boston Museum of Fine Arts, who staunchly opposed it. The muted color and tone of the Charlesgate inlet and Beacon entrance had been completely negated, its investment in internal reverie descaled. The authorities were ignorant of and indifferent to the past. Feeling and reason, the natural and technical, were never again to be so closely or well aligned as creative tools. The two themes now split and went their separate ways, perhaps gathering sophistication, but losing much of their mutually reinforcing effect. The cover of romance was torn off the wholesome husk and blown relentlessly across the country. The West then took up and tried to reabsorb the early frustrations of the East, in an even more nostalgic and dreamlike vein, as Yosemite Valley did for the Hudson Valley. This is especially evident in the close association of Maybeck's nostalgic Palace of the Fine Arts in San Francisco for the Fair of 1915, with its dreaming lagoon and planting, gently interlocking in a way which Trinity church—which Maybeck greatly admired—and the pond of the Fens might have achieved if the urban fates had taken a slightly different turn.

THE POSTSCRIPTIONS OF CHARLES W. ELIOT, PRESIDENT OF HARVARD

Olmsted's generation sought to focus its increasing wealth, education, and refinement on what had been in jeopardy during and after the Civil War. Morality was duly affixed to the romantic dream, and held in

alignment by the rules. No figure better illustrates this general trend than Charles W. Eliot, longtime president of Harvard University and father of the aforementioned landscape architect, Charles Eliot, who died of meningitis at the age of thirty-seven. Eliot wrote a biography of his son, published in 1902, subtitled "A Lover of Nature and His Kind, Who Trained Himself for a New Profession, Practised it Happily, and Through it Wrought Much Good."[100] In 1904, he issued a booklet on *The Right Development of Mount Desert*, a scenic island of three villages off the Maine Coast (Fig. 17) where he took his vacations, and which he ultimately helped to bring up to an even more exalted status as the first eastern national park, today called Acadia, created through the donation of parcels of land by his wealthy friends. Its significance lay in the fact that it was an actual perfection of the New England coast, just as the Fens was supposed to be a perfection of the coast in urban memory. Olmsted visited Eliot on the island. The booklet urged the islanders to take advantage of their own characters, indigenous skills, and the natural assets of what Eliot considered "by far the handsomest piece of land on the Atlantic coast."[101]

[100] *Charles Eliot: Landscape Architect* (Cambridge, Mass.: Harvard University, 1902).

[101] See Sargent F. Collier, *Mt. Desert Island and Acadia National Park*, ed. G. W. Helfrich (Camden, Maine: Down East Books, 1978), pp. 89-113, 125-126, for the role of the Eliots in connection with Acadia National Park. It is surprising that no one has written of the influence of this family, and a number of other distinguished families, on the American landscape. The only inkling of such an approach the author could locate was in a book review by Professor Peter Hornbeck of Eliot Porter's *Summer Island: Penobscot Country* (edited by David Brower and published by The Sierra Club), in *Landscape Architecture*, LVII, 4, July 1967, pp. 306-307. In his review Hornbeck pointed to this familial brand of appreciation of Maine from the Porters and the Eliots and described it as "a New England experience and attitude." See also George B. Dorr, Ernest Howe Forbush, and M. L. Fernald, "The Unique Island of Mount Desert," *The National Geographic Magazine*, XXVI, 1, July 1914, pp. 75-89.

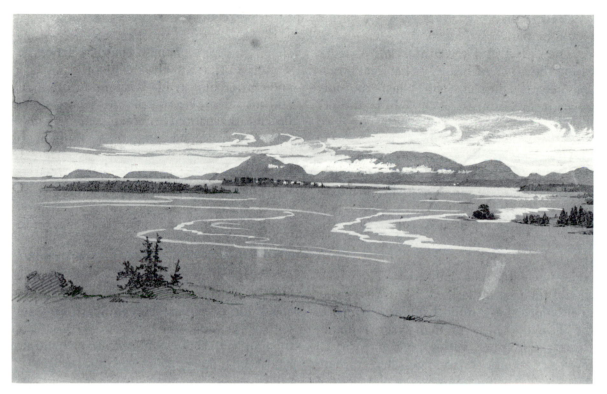

17. Study of Mt. Desert Island, Maine, Frederic Church, ca. 1850. The people of the eastern coastal region were fascinated by the marbling of the water from the sky as it approached the shore; Eliot of Harvard looked upon this as the handsomest part of the Atlantic shoreline. The mystique of the sea never left the American mind (Olana Historic Site).

He tried to convey to the untutored residents that the tiny year-round society could be reconstituted from its natural setting by self-help without yielding to off-island ambitions, which could only lead to uniform work hours and an unhealthy desire for material possessions. He wanted to protect people from neglecting themselves by upgrading their environment. In a talk the next year at the dedication of the Albright Gallery in Buffalo, New York, he elaborated on his purposes: "The Puritan, establishing himself painfully on the eastern rim of the wild continent, thought rather of duty than of beauty, and distrusted pleasurable sensations and emotions as probably unworthy of a serious soul, not looking for happiness in this life but only in the next; and to this day

his descendants and followers, spreading across the broad continent, pay far too little attention to the means of promoting public happiness. They seek eagerly material possessions and the coarser bodily satisfactions, but are not at pains to make available the emotional and spiritual sources of public and private happiness. It is therefore an interesting inquiry how the sense of beauty, and the delight in the beautiful, are to be implanted, cultivated, and strengthened among the masses of the American population." He, like Olmsted, wished to take hold of the actual physical setting, and not remain aloof from it in despair, as his Puritan ancestors had done. Further, beauty must be creatively evoked. For that purpose a green reserve with a spot of water in the middle of a

city, even more than an arcadian island, would be particularly advantageous.

"The oldest and readiest means of cultivating the sense of beauty is habitual observation of the heavens, for which the only things needed are the open sight of the sky and the observing eye."[102] City people lived at the bottom of deep ditches made from buildings and therefore could only see narrow strips of the heavens. But the cities had not risen so high that commons, marshes, and ponds of water within or near them could no longer be used to contemplate the sky. Access to nature, particularly to the sight of sky and water, should be made widely available on a daily basis. The effects should then be intensified: "The direct way to promote that public happiness which is the ultimate object of democracy is to increase the number, variety, and intensity of those sensations and emotions which give innocent and frequently recurring pleasure." It was as Emerson felt, the extraordinary had to be made more ordinary and accessible without becoming diluted or neutralized. Thus, Emerson had said, "We need nature, and cities give the human senses not room enough. I go out daily and nightly to feed my eyes on the horizon and the sky, and come to feel the want of this scope as I do water for my washing."[103]

The older Eliot was eager to reap the benefits of a republic while avoiding the pitfalls of urbanism and industrialism. It was the better coordination of the adolescent reach and grasp of democracy which was at stake for him. He had as a young man been offered the superintendency of the mills of the Lowell family because of his presumed executive ability, so early apparent. Textile mills stood for the most advanced applied technology of their day. He had also been a

professor, both at Harvard and MIT, of chemistry and mathematics. But the socially shaping powers of these "hard" sciences, as well as Puritanism, had evidently not been enough for him as his wisdom accumulated and his sense of responsibility enlarged. He became the national ombudsman, the great postscripter. As his biographer, William Allan Neilson put it, "Other leaders of opinion have come and gone, and some for a time have been more conspicuous; but it is impossible to name a figure who so continuously dominated our intellectual horizon for so long a period."[104]

He transferred private concerns to public precincts on a great scale, while turning more toward an art than his previous sciences for direction. He credited Emerson with providing the motivation for this thought and action. Indeed, the combined landscape and planning initiatives of Olmsted; his partner, Charles Eliot; President Charles W. Eliot of Harvard; and Charles W. Eliot II were, in many ways, later embodiments of the aspirations of both Emerson and Thoreau. What we haven't known before is that the latter pair had actual physical, as well as literary, influences beyond Concord and Walden Pond. In an address at gigantic Symphony Hall in Boston in May 1903, entitled "Emerson as Seer,"[105] President Eliot reported that "Landscape architecture is not yet an established profession among us, in spite of the achievements of Downing, Cleveland, and Olmsted and their disciples; yet much has been accomplished within the last twenty-five years to realize the predictions on this subject made by Emerson in his lecture on The Young American. He pointed out in that lecture that the beautiful gardens of Europe are unknown among us, but might be easily imitated here, and said that the land-

[102] William Allan Neilson, ed., *Charles W. Eliot: The Man and His Beliefs* (New York: Harper & Brothers, 1926), II, pp. 557-558.
[103] *Journal*, IV, p. 34.
[104] Neilson, *Charles W. Eliot*, I, p. ix.
[105] Charles W. Eliot, "Emerson as Seer," *The Atlantic Monthly*, XCI, DXLVII, May 1903, p. 852.

scape art 'is the Fine Art which is left for us. . . . The whole force of all arts goes to facilitate the decoration of lands and dwellings. . . . I look on such improvement as directly tending to endear the land to the inhabitant.' . . . Emerson pointed out that in America the public should provide these means of culture and inspiration for every citizen. He thus anticipated the present ownership by cities, or by endowed trustees, of parks, gardens, and museums of art or science, as well as of baths and orchestras." Then the senior Eliot went on to provide a quotation peculiarly appropriate to the unusual character of the Fens itself. Emerson, he said, "saw good not only in what we call beauty, grace, and light, but in what we call foul and ugly. For him a sky-born music sounds

> From all that's fair; from all that's
> foul:—
> T'is not in the high stars alone,
> But in the mud and scum of things
> There alway, alway something
> sings."[106]

Bostonians would resolve to overcome the distaste for, and handicaps of, the wasteland sites, the negative patches, so frequent in the landscape as in life. To bring something up from below, or spot it at a distance, like a snow-capped mountain, was a public contribution. Guiding the public to a more complete understanding of the potential of the beauties or ugliness of its natural setting was also this new intellectual's obligation. One was urged in New England to apply excellence of intellect to the common weal, to begin with the specific and expand to the abstract, with the small and grow to the large, and with ugliness and waste and overcome them with mental agility. The intellectual had to learn to reach down in order to rise. Thoreau had suggested it: "Let us remember not to strive upwards too long, but some-

times drop plumb down the other way, and wallow in meanness. From the deepest pit we may see the stars, if not the sun."[107] The surrounding city ought also to remain lower for that reason. As a first step, Olmsted had kept the vegetation low around the pools of the Fens (Fig. 12), so that the sky and water might be more easily joined, with the city blanked out. The Fens provided the urban respite, but it was also true from the simile with the stretch of the New England shore that "All days are open over the salt marsh. Like a treeless plain, it is a place for the sky to enter."[108] Skyscrapers would be a negative factor for the city under this regimen, of course.

Eliot of Harvard, originally the scientist and managerial expert, articulated these broader environmental concerns, expressing what others were unable or unwilling to voice. His was the last word, the very senior view. He spoke to the national meeting of the American Society of Landscape Architects at Boston as late as 1911. That was the year he celebrated his eighty-seventh birthday and the Fens was beginning to be violated by the "better-informed" generation of architectural professionals and politicians, eager to bring Boston up to the Chicago City Beautiful Movement of 1893 and Paris of 1850 to 1870. In his talk Eliot first referred to the general condition of the population, making it evident that the park movement had been an indispensable force in the broad uplift of the cities: "There is a great deal of public effort now being made to raise the condition of the less fortunate classes of our population, and among all these efforts there is none more important than the effort to counteract in some ways the evils which have arisen from congestion of population.

"That is a phenomenon of the last 50 years

[106] Ibid., pp. 852-853.

[107] Torrey and Allen, eds., *Journal of Henry D. Thoreau*, I, p. 146.
[108] John Hay and Peter Farb, *The Atlantic Shore* (New York: Harper & Row, 1966), p. 153.

in this country, following, of course, the introduction of the factory system on a large scale into our country; and this congestion of population is something which can only be dealt with by taking account of considerations not economic." By these "considerations" he meant the values of amenity, community, and visual beauty. He reminded the landscape architects that it was they who would dispense "all sweet and wholesome pleasures for mankind." He described how on the way over to this speech he had passed Trinity Church and the adjoining site of the former Museum of Fine Arts on Copley Square (Fig. 6), which had opened its doors in 1876.[109] He, himself, he noted, had helped to raise money for that fabric, which had been abandoned and subsequently torn down when the collection was moved to the new, white building on the Fens. The architect's work with urban buildings was bound to be heartbreakingly ephemeral. His own, with education, was likewise transitory. But, he pointed out to these shapers of the landscape, they, above all others, should rest content, for, "Earth work is more durable than any other human work."[110] The underlying land supported the favorable existence of the passing culture on top of it. The

mound builders should be the memory builders in this new society, just as mountains mattered more in it than they ever could in Europe. Emerson had said it in "The Young American" in 1844, and Eliot would agree, despite his faith in academic effort, that "The land is the appointed remedy for whatever is false and fantastic in our culture. The great continent we inhabit is to be physic and food for our mind, as well as our body. The land, with its tranquilizing, sanative influences, is to repair the errors of a scholastic and traditional education and bring us into just relations with men and things."[111] Abstract or runaway scientific learning was not to be enough. A broader and more stable base and context would have to be furnished. There was yet another obligation awaiting the young American scholar outside his study window. Because he was inside and safe, he should not fall blind to the out-of-doors, or remain ignorant or uncaring of what it might mean to others. Like a good Transcendentalist, he should exercise his newly trained eyes on it. Both the Eliots, pedagogues by inclination and training, wanted to enlarge Olmsted's tiny organic study of the Fens into a metropolitan pattern of public reservations. Something had to appear now from first, rather than last, causes. Profundity and attachment had turned up missing in the modern day. Olmsted and the Eliots were trying to eliminate the "pain" of the occupation by the early Puritans of the shore, but they remained Puritans in that they believed that popular "pleasures" could only be favorable if they were also communal. Olmsted had said at the outset of planning for the parks that Boston could be "got the better of." The satisfaction rested in being thus able to take hold of this rocky and cruel, but intellectually endowed, site at long last.

[109] See Margaret Henderson Floyd, "A Terra-Cotta Cornerstone for Copley Square: Museum of Fine Arts, Boston, 1870-76, by Sturgis and Brigham," *Journal of the Society of Architectural Historians*, XXXII, 2, May 1973, pp. 83-103.

[110] "Dr. Eliot Talks on Life Work, Tells the Landscape Architects their Profession is Growing in Esteem," *Boston Sunday Herald*, April 2, 1911. This theme is developed by him at greater length in "The Need of Conserving the Beauty and Freedom of Nature in Modern Life," *The National Geographic Magazine*, XXVI, 1, July 1914, pp. 67-73. He was now ninety. He said (p. 67), "By far the most important social study today is the study of the means of improving men's emotion and thought environment from earliest youth to age." And (p. 69), "The profession of landscape architecture is going to be . . . the most direct professional contributor to the improvement of the human environment in the twentieth century. . . . The vital question of modern life is how to feed the mental health and spiritual growth of multitudes."

[111] *The Dial*, IV, 4, April 1844, p. 488.

Graceland Cemetery and the Landscaped Lawn

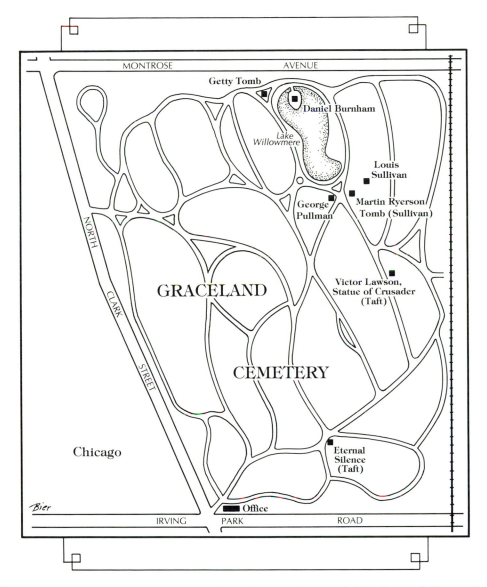

THE cemetery was the spark of inspiration from which the public park sprang. The "rural," "garden," or "landscaped lawn" cemetery was a native invention. However, it was offered against great odds; and its basic atmosphere was the atypical one of nearly total withdrawal.

The hunger for land in Chicago pushed the cemetery to the edge of the urban frame and nearly beyond cultural consideration. Graceland Cemetery (see map)

merged novel forms: the landscaped lawn and the long prairie view, with a vocabulary derived from local nature, but having a divine, faraway goal; and the more immediate manifestation of bravado against Chicago itself through colossal funeral monuments in large numbers, most of them mundane, but a few of exemplary quality. In all of this there was the intention of defending the temporal status of the family or person, an aim that was most successfully carried out in the Martin Ryerson and Getty tombs by Louis Sullivan. These exhibited a three-dimensional balance and stability and registered a concentrated presence that responded to the shifting moods of urbanism and nature, but which also retained a sense of fixed place, human scale, internal peace, and quiet dignity.

The motif of the Getty Tomb later found its way into small-town banks by the Prairie School architects—from the sacred to the secular—providing dignity and permanence on Main Street, a reciprocation to the Midwest culture, but with a bow by this time to the small town rather than the big city. Chicago itself was bypassed by this means.

THE cemetery was more of a beginning effort to provide an improved habitat for living Americans than might be realized. The desirability of formulating a policy for public parks on the model of cemeteries was early indicated by Downing in a letter to Pres. Millard Fillmore about his effort with the Washington Mall, never completed because of Downing's tragic death by drowning, on his way to Washington to do further work on it in 1852. "A national Park like this, laid out and planted in a thorough manner, would exercise as much influence on the public taste as Mount Auburn Cemetery near Boston has done. Though only twenty years have elapsed since that spot was laid out, the lesson there taught has been so largely influential that at the present moment in the United States, while they have no public parks, are acknowledged to possess the finest rural cemeteries in the world."[1] Downing enunciated a similar principle in the *Horticulturist* of July 1849, "Indeed, in the absence of great public gardens, such as we must surely one day have in America, our rural cemeteries are doing a great deal to enlarge and educate the popular taste in rural embellishment."[2]

Graceland Cemetery, the last of the line, is often compared to Mount Auburn in Cambridge, the first, and to Laurel Hill in Philadelphia, Green-Wood in Brooklyn, and particularly to Spring Grove in Cincinnati. Graceland lacked the hilly setting of most of its predecessors, but it did have a direct relation to the genesis of a public park, as they did not. As a result of the cholera epidemic of 1855, there was agitation to move the burials farther out of Chicago, hence to make the main public cemetery on the near north side, founded in 1840, over into what would eventually become Lincoln Park. In response, Oak Woods Cemetery in 1855, Rose Hill and Calvary in 1859, and Graceland in 1860 were initiated. With the possible exception of those of Mount Auburn, Graceland's sculpture, architecture, landscape architecture, and engineering have the greatest national significance. Like the Fens, it was shown at the Paris Exposition of 1900, where it won a medal.

Graceland's evolution reveals why the cemetery type was so much experimented with. In addition to the necessity for burials and the romantic preoccupation with death, Graceland Cemetery provided relief from the distraction and weight of daily existence in Chicago itself. The city grew so fast that the strain of competition became incessant. It was said of Mount Olive Cemetery that the mourners "are permitted to bring the remains of their departed loved ones to this beautiful park cemetery, and take away the consoling thought, that they have left the form that no longer feels the vexations and struggles of life, in the midst of all this peaceful beauty."[3] Through death alone

[1] "Improving the Public Ground of the City of Washington," Letter to His Excellency, The President of the United States, Winterthur Document, n.d. #4838, pp. 6-7.
[2] "Public Cemeteries and Public Gardens," IV, 1, pp. 9-12.

[3] The superintendent of Mount Olive Cemetery,

there might be an opportunity to occupy this area of the Midwest permanently and positively, almost as if by last resort or second chance. The typical American tension between idealism on the one hand and pragmatism on the other was bound to be greatest in booming Chicago.

Chicago would have to struggle harder to create reason, beauty, and repose by artificial means. The site of the city was acknowledged to be most unpromising. "Nature has done but little for the City of Chicago or its immediate suburbs; but many of the most beautiful effects of landscape gardening have been produced where the natural opportunities seemed most unpromising. By a lavish expenditure of money and the exercise of good taste and engineering skill [of William Le Baron Jenney] the low and unattractive part of Graceland has been made by far the most beautiful portion of the grounds, and it now rivals the parks of Chicago [also by Jenney, the inventor of the skyscraper] in landscape effects, and is worthy to rank with the famous cemeteries of America. . . . There is an almost endless variety of foliage, and a diversity of surface which is a surprise to those who think of the surroundings of Chicago as a monotonous prairie."[4]

Not only was the dearth of interesting features in the original landscape a drawback, but time demanded a constant reassessment of it because of the rapid expansion of the city. Everett Chamberlin predicted of Graceland in 1873 (prematurely it turned out) that "ere long, internments there must cease and the field of Chicago's dead be fixed at a greater distance from the city."[5] The

town of Lake View (later, Buena Park) in which Graceland was placed, became the focus of numerous cemetery promotions as another result. It was bidding fair to become a town of cemeteries, since Rose Hill Cemetery had preceded it there. In 1861, Graceland's managers purchased 45 acres at the west, adding to the original 86 acres. In 1864, another 35 acres was added on the east, and in 1867 the holding was increased by 109 acres to the north. In the same year the town, its patience by now worn thin, brought suit against the founders of yet a third cemetery, apparently endorsed by the Graceland management. The town lost its case in the Illinois Supreme Court, which made its decision by envisioning an artificial bloom: "A cemetery may be placed as to be injurious to the public health, and therefore a nuisance. It may, on the other hand, be so located and arranged, so planted with trees and flowering shrubs, intersected with drives and walks, and decorated with monumental marbles, as to be not less beautiful than a public landscape garden, and as free from all reasonable objection."[6]

However, James B. Waller, an adjacent landowner, not content with the verdict, delivered an "able argument" in the town hall. Printed and distributed were a thousand copies of it. His ideal was "Progress," which no Chicagoan of the second half of the nineteenth century could afford to ignore. Waller was disappointed by the action of the court, but felt there was an inexorable force from destiny which would overrun the cemeteries. It had already happened with the municipal cemetery, he noticed, which had incited Graceland and the others: "Providence, who rules the nations of the earth and the destinies of its mighty cities, indicates the development and growth of Chicago to an

J. S. Birkeland, had worked for seventeen years at Graceland. Andreas Simon, *Chicago: The Garden City: Its Magnificent Parks, Boulevards and Cemeteries* (Chicago: Franz Gindele Printing Co., 1893), p. 175.

[4] *Chicago Illustrated* (Chicago: N. F. Hodson, 1883), pp. 48-49.

[5] *Chicago and Its Suburbs* (Chicago: T. A. Hungerford & Co., 1874), p. 346.

[6] William C. Reynolds, *The Limit of the Police Power in the Control of Corporations: A Statement of the Condition, Property, and Franchises of the Graceland Cemetery Co.* (Chicago: Chicago Legal News Co., 1872), p. 17.

extent in the future which will demand as a necessity the *ultimate removal of Graceland Cemetery.*" Chicago had started with practically nothing to commend it, no canals, no railroads, "and even at the commencement of the second decade in 1850, having but one railroad fifty miles in length";[7] but now with railroads branching out in every direction, it was bound to become a city of destiny. The message was unmistakable. Destiny would push memory aside. Find a "more sequestered spot" than Chicago if you were about to terminate. Another party asked rhetorically about Rose Hill, Graceland, and other nearby cemeteries two decades later, "How long will it be before the cemeteries mentioned. . . . will have to give way to the living, their necessities and improvements? Nothing will be able to withstand the growth of this still young giant [Chicago]—not even death."[8]

However, there were other influences accumulating: an increased respect for the dead following the casual and detached attitudes of the eighteenth century, and the galaxy of young artists and intellectuals lately attracted to the city. With Graceland a number of such talents were to be associated, some passively (nearly all of the nationally known architects of the Chicago School were to be interred there, including Sullivan, Burnham and Root), and others actively. Architect Ossian C. Simonds devoted a large part of his life to Graceland, and was finally buried there.

One can appreciate the attachment of feeling and sentiment—with its romantic overtones—to the cemetery more than to other landscape types. It was the most receptive to the aspiration for proceeding from individuality, through nature, to the Deity: "In former times the cemetery was literally the church yard. . . . The light of sanitary sci-

ence, and the growth of a tenderer religious sentiment, have led to a better system. The one forbids our attempting to resist the progress of inevitable decay. The other finds in the voices of Nature a language of hope and consolation. The cemetery has become a garden, where Grace, Beauty, and Light render less sombre the solemn associations of the tomb."[9] In *Chicago: The Marvelous City of the West* it was declared that the newly found preoccupation with encouraging beauty in cemeteries for "The Garden City" of Chicago was to be taken as a literal promise of the Coming Resurrection.[10]

The model was of a continuous green lawn passing beneath a canopy of trees, much as in the nearby suburb of Riverside and at Spring Grove Cemetery in Cincinnati. Adolph Strauch of Spring Grove called his version the "landscape lawn plan." More specifically, "The intention of the management of Graceland is to preserve the wide and beautiful sweep of the lawns by excluding, as far as possible, stone and marble from the new grounds, the monuments being restricted in number, and the headstones being kept low and unobstructive, and all the old-fashioned and repulsive stone edges, fences, posts and chains, and all the other unsightly lot-enclosures once in vogue being forbidden."[11] Mounded graves interrupting the continuity were also to be discouraged. The initial rural cemetery type of Mount Auburn was being gradually readapted through the lawn system of Spring Grove into the greater lateral spread of Graceland, harking to the Grand Prairie.

[7] James B. Waller, *Right of Eminent Domain and Police Power of the State* (Board of Trustees of Lake View, Illinois, 1871), p. 16.

[8] Simon, *Chicago*, p. 123.

[9] Reynolds, *The Limit of the Police Power*, p. 6.

[10] John J. Flinn (Chicago: National Book and Picture Co., 1893), p. 160.

[11] *Chicago Illustrated*, p. 50. Stanley French makes a major point of the fact that Spring Grove progressed beyond a rural cemetery, such as Mount Auburn, to become a "lawn cemetery," largely by omitting iron fences. "The Cemetery as a Cultural Institution," *Death in America*, ed. David E. Stannard (Philadelphia: University of Pennsylvania Press, 1975), pp. 83-84.

The incorporators of Graceland Cemetery in 1860 were Thomas B. Bryan, William B. Ogden, Sidney Sawyer, Edwin H. Sheldon, and George P. A. Healy. The first interment was that of Daniel Page Bryan, son of Thomas, who died on April 12, 1855, and was first buried in the city cemetery (later Lincoln Park), and then removed as a result of the cholera fright of 1855, along with 2,000 others.[12] It was probably this crisis that triggered Bryan's decision to buy the first eighty-six acres for the future Graceland.[13] Another incorporator, Healy, was the painter of the famous seated Abraham Lincoln, executed at the behest of Thomas Bryan. Healy also did landscapes in the style of the Barbizon painter Daubigny. William Ogden, the first mayor of Chicago and another incorporator, had persuaded Healy to leave Paris and come to Chicago, where he stayed from 1855 through 1865.[14] Because the records of Graceland were destroyed in the Chicago Fire of 1871, and there is a dearth of documentation on Healy, we do not know more of his influence on the original landscape of Graceland. He reported cryptically in October 1861, "Our Lord has helped me by inducing my neighbor Thomas B. Bryan an offer to take upon himself $18,500 of my $23,000 debts for my interest in Graceland Cemetery."[15]

The golden age of Graceland, from the late 1870s until just before World War I, took place under Bryan Lathrop and O. C. Si-

monds. Lathrop was born in Alexandria, Virginia. During the Civil War (like the architect H. H. Richardson) he was sent abroad by his parents, for safety reasons, to study under private tutors in Dresden, Paris, and Italy, where his interest was aroused in art, music, and, significantly for Graceland, landscape design. In 1865, at age twenty-one, he arrived in Chicago to go into the real estate business with his uncle, Thomas B. Bryan.[16] The European experience caused Lathrop to view America in an unflattering light: "In Europe [the intelligent traveler] sees almost everywhere evidences of a sense of beauty. In America, almost everywhere he is struck by the want of it. . . . In this new country of ours the struggle for existence has been intense, and the practical side of life has been developed while the aesthetic side has lain dormant."[17] Lathrop was to be president of Graceland Cemetery from 1878 until his death in 1916 and was a trustee of the Art Institute.

Ossian Cole Simonds' posthumous article, "Graceland at Chicago," tells of his meeting with Lathrop and relation to William Le Baron Jenney: ". . . in the fall of 1878 I met Mr. Lathrop and first saw Graceland Cemetery. At that time the cemetery occupied a rather high sandy ridge largely covered with oak trees. The new and undeveloped portion was then low—partly swamp, partly slough, and partly a celery field. The changing of this treeless land into an attractive part of the cemetery called for some engineering skill in putting in drains, excavating a lake (Willowmere), grading and building roads, and in grading the various sections. In this work the knowledge gained in acquiring the degree of civil engineer, which I had received

[12] Charles Gordon, "Graceland: A Sanctuary," Typescript, Chicago Historical Society, n.d., p. 1.

[13] Wilhelm Miller, *The Prairie Spirit in Landscape Gardening* (Urbana: University of Illinois, 1915), Circular 184, November, p. 2. Miller states that Graceland became perhaps "the most famous example of landscape gardening designed by western man."

[14] Clement M. Silvestro, *Prominent Chicagoans Sit for G.P.A. Healy*, Exhibit Booklet, Chicago Historical Society, June 7, 1967, p. 1.

[15] As quoted in Marie de Mare, *G.P.A. Healy: American Artist* (New York: David McKay Co., Inc., 1954), p. 202.

[16] *Sixtieth Anniversary Year Book, Chicago* (Chicago: Chicago Historical Society, 1916), pp. 173-175.

[17] "A Plea for Landscape Gardening," as quoted in O. C. Simonds, *Landscape Gardening* (New York: The Macmillan Co., 1920), Appendix, p. 323.

from the University of Michigan the previous June, made me somewhat useful to the cemetery company and to W.L.B. Jenney, the architect who had drawn an outline of the lake and planned its outlet. As the work progressed, I was advised to read up on landscape gardening, a subject that was entirely new to me. . . . I liked the subject more than any I studied, and this liking, together with Mr. Lathrop's influence, changed my life's work from architecture to landscaping."[18] Simonds states that he and Lathrop went to Spring Grove Cemetery in Cincinnati and talked with Adolph Strauch.[19] Jenney's first association with Simonds had come from the latter's attendance in his classes from 1876 through 1878, when the University of Michigan ran out of money to carry on architectural instruction, and Jenney was forced to return to practice in Chicago. He then took Simonds as an assistant. Lathrop began his campaign for the beautification of Graceland between 1878 and 1880. Simonds organized in 1880 the architectural firm of Holabird and Simonds, which next became Holabird, Simonds and Roche, and finally Holabird and Roche in 1883.[20] This firm designed the gatehouse and chapel at Graceland.

What kind of inspiration did Simonds and his patron, Lathrop, hope to offer? They spoke of the world of nature as a series of pictures which the landscape gardener should elaborate and make more succinct. Lathrop had remarked that a humble roadside could appear like a Theodore Rousseau painting of the Barbizon School, if properly treated;[21] and Simonds said, "One should visit a park as he would visit an art gallery." Even after burials ceased, perhaps in three generations, Graceland "should still continue to serve the living by being a place of quiet retreat, a place of beauty, a place of park-like character."[22] Cemeteries "should be, as the name implies, sleeping-places, places of rest and freedom from intrusion. It seems natural that one should seek for such a place the very best production of landscape-art." The effects to capture were the relieving ones of spreading lawns, clouds or sunsets, and trees and bushes, with singing birds. The cemetery should be a memorial park, without memorials, minus "obelisk after obelisk, stone posts and slabs of all shapes and sizes, and stone tombs."[23] In this description can be sensed an alternative environmental type, the purpose of which was to create beauty artificially, as would be appropriate to Chicago. Graceland was a park for the living as well as the dead, just as Riverside would be both a park and a residential area. To appreciate either design, some feel for ambiguous or dual functions must be achieved, along with that of the need for unequalled courage. The purpose was to identify and achieve a place apart, where relief and peace could be found.

The necessity of submitting to death, as opposed to the collective urge of Chicagoans to keep forever going, caused Graceland to seem a constant paradox. This impression

[18] *The American Landscape Architect*, 6, 1, January 1932, p. 12.

[19] Ibid., p. 16. There is no record at Spring Grove of the meeting. John Vinci, "Graceland: The Nineteenth-Century Garden Cemetery," *Chicago History*, VI, 2, Summer 1977, p. 89, suggests that the "accomplished architect" mentioned earlier than Simonds in connection with Graceland was none other than the well-known Horace Cleveland, landscape architect, and that the latter also knew Strauch's work at Spring Grove.

[20] "Ossian Cole Simonds," *The American Landscape Architect*, 5, 6, December 1931, p. 17. See also J. William Rudd, "Holabird and Roche: Chicago Architects," *Papers of the American Architectural Bibliographers*, ed. William B. O'Neal (Charlottesville: University of Virginia, 1966), II, p. 55.

[21] Lathrop, "A Plea for Landscape Gardening," p. 325.

[22] O. C. Simonds, "Graceland at Chicago," *The American Landscape Architect*, 6, 1, January 1932, p. 16.

[23] Simonds, *Landscape Gardening*, pp. 306-307.

resulted from the inappropriately large monuments of families like those of George Pullman, William Kimball, or Potter Palmer. As Lathrop and Simonds' ideal was one of a vast landscape painting, so the families' was one of a well-filled sculpture gallery. The Chicago families ached for a literal, consolidated permanence, Lathrop and Simonds for a permanent beauty seen at a distance and in perspective, somewhat hazily. This latter aim was to be carried out through the native plants of the prairie. What, Simonds asked, could be done through local floriculture and arborculture. Useful examples were the thickets of wild crab apple in the corners of farmers' yards, and the prairie roses and hawthornes along the edges of country roads. On the farm would be the orchard, "which helps to carry the sky-line up to the top of the bur oaks."[24] Bur oaks were native trees that clustered on the edge of the original prairie. The crab and hawthorne had striated blooms which echoed the horizontality then being advocated by the Prairie School of architecture and landscape architecture. The later literary champion of the movement was Prof. Wilhelm Miller of the University of Illinois. Together, these men—Lathrop, Simonds, Miller—strove to idealize the prairie. They were highly conscious of the spatial affinity conveyed by the "broad view" of the prairie horizon, which, like death, brought loneliness and fear to some and promised relief to others. They wanted to contain and control the mood of fear within the cemetery grounds by framing, confining, and channeling the distant views. The experience of close-up and distance was to be reconciled through the device of the improved country road. Seen through frames of foliage at each side of the road, the broad view of the prairie would be cut down and transformed into a series of "long" views (Fig. 1). Thus, Graceland's vignettes would become lively versions of Barbizon paintings with a local color. Wildwood Avenue in Graceland (Fig. 2) simulated a prairie road, but was greatly enriched by native blooms, and devoid of fence posts, telephone poles, ditches, and weeds, which seemed to stretch monotonously on to the horizon in the typical example (Fig. 3). The experience was intended to furnish a more immediate and meaningful contact with nature between rows of carefully arranged and blended native plantings, reinforced internally in its effect by the secondary and parallel "Long View" axis (Fig. 4), which was not a road but a walking path. Miller pointed out that it "occupies only about 10 x 400 feet, or say one tenth of an acre," but even with that limitation it presupposed "the promise of the resurrection of the soul."[25] From the inside, from the ideal segments of a prairie road, Wildwood Avenue and the "Long View" Walk, Simonds and Miller hoped to keep in touch esthetically or spiritually with the smoky line of the distant prairie horizon, often expressed in cream or pearl gray tonalities, just where it joined the sky.

Miller was even less tolerant of the stone monuments than Simonds, calling them "The Straight-Way to Bad Taste."[26] He wrote that the Pullman column was a desecration because of its display of wealth, and called for "one landscape cemetery with high ideals in every Illinois community." Ironically, the "Long View" in Graceland today (Fig. 5) is even more "desecrated" by stone monuments, which sprang up even faster than the trees and bushes that were supposed to flourish along it. Furthermore, while the rural cemetery was initiated as an ideal in the romantic era, it was carried out

[24] Ibid, p. 213.

[25] Miller, *The Prairie Spirit*, p. 18.
[26] Ibid., p. 18, Fig. 61.

1. *The ideal midwestern vista. It was to be determined by a series of vignettes of the prairie, made up with frames of roadside trees and hedges* (Wilhelm Miller, The Prairie Spirit in Landscape Gardening).

2. *Wildwood Avenue, Graceland Cemetery, O. C. Simonds. Wilhelm Miller used this avenue as a model for prairie roads* (Miller, The Prairie Spirit).

3. *Typical prairie road, as shown by Wilhelm Miller. Miller declared, "Some farmers believe that bare roads, decorated only with poles, wires, fences, and weeds have a depressing or deadening effect on their families"* (Miller, The Prairie Spirit).

largely in the Victorian age, with its different premises, especially in connection with individualism.[27] No matter how often Simonds and Lathrop admonished plot owners to keep their memorials in proportion to the grounds, and consonant in materials, there appeared to be an irresistible urge to reassert individuality and family memory at a grand scale, and hence to subvert group interest in the site. Lorado Taft's *Eternal Silence* of 1909 (Fig. 6) and his *Crusader* of 1931 (Fig. 7) display the rudimentary midwestern instinct to immortalize and personify through sheer volume and size, the same impulse seen in the Chicago invention of the "monumental" skyscraper. Whatever was created in Chicago had "side." Ordinary, everyday life was not as acceptable for depiction. There was an unquenchable thirst for the epic, the great, and the noble which could not then be easily satisfied with the psychological means at hand. Each attempt at past personification for the future, such as Taft's attempt to represent the pioneer in *Eternal Silence*, was likely to be encased in a physical mandorla or hard psychic shell, as Pullman's grave was, with its lead-lined coffin wrapped in tar paper and asphalt in a concrete room topped with bolted steel rails, and marked on the surface by a magnified Corinthian column. Compare, for instance, Taft's *Eternal Silence* to the Adams Memorial, *Grief* (Fig. 8), by St. Gaudens in Washington's Rock Creek Cemetery of 1891. The former was undoubtedly influenced by the latter, and by Rodin's heavily draped *Balzac* (1897). The seated figure is reflecting somberly, vulnerable to the viewer's curiosity, but still dignified and noble. *Eternal Silence* stands bolt upright and protects its privacy with a

4. *The long view in Graceland Cemetery. This was called "The Straight Way to the Great Hope," and the open view at the end counted the most* (Miller, The Prairie Spirit).

great fold of pylonic, depersonalized drapery, used like the *Crusader's* shield. One is not allowed to understand *Silence* or the *Crusader* as easily as *Grief*, despite the physical prominence of the first two. The midwestern vision is harder to trace and acknowledge. There is more interest in the surface of the shell, as in the screen wall of the skyscraper.

The same naive insistence upon physical bulk and spatial invulnerability as an indication of spiritual mystery and worth, can be witnessed in the Martin Ryerson Tomb of 1889 (Pl. 11) by Louis Sullivan, but in more subtle ways. The tomb first appears to promote the memory and insulate the privacy of Ryerson through its assertion of glyptic strength. It also takes individuality

[27] Edmund V. Gillon, Jr., has observed, "The Victorians, with their sense of the personal, felt that individual achievement should be used to distinguish such different types of grief." *Victorian Cemetery Art* (New York: Dover Publications, 1972), Introduction, p. ix.

5. The long view today, Graceland Cemetery (Thomas A. Heinz).

from a very remote source in time. The form is reminiscent of an Egyptian Middle Kingdom mastaba tomb, although its lines are more rationalized, its walls of Quincy granite seen in a cooler northern light. The walls, flaring out at the bottom, and the dark color, anticipate the Egyptoid Monadnock Building of 1891 (named after Mt. Monadnock in New Hampshire), the last Chicago skyscraper to have thick, self-supporting walls. Yet the Ryerson Tomb does become vulnerable and responsive to the immediate surroundings too, for, as Hugh Morrison noted, and as can be seen in the illustration (Pl. 11), "on a clear day the polished black walls form a dark mirror in which one sees ethereal reflections of green trees, blue sky, and moving clouds."[28] That capacity for absorbing

light and scenery was the architectural equivalent of the vulnerability of *Grief*. Sullivan was that much further ahead of his Chicago contemporaries in means of expression.

The Getty Tomb of the next year (Pl. 12), also by Sullivan, makes up for the overweening pride and sheer bulk, even the crudity, of the other statues and tombs. It tells us little about the Getty family. It offers a perfect poise instead, providing architectural redress for nearly every other mistake—social, economic, or esthetic—perpetrated in Graceland in the name of the Chicago outlook. A simple understated rectangle on a base, it has two equal wall bands—a lower, plain one, and an upper one of octagons filled with stars. Its glyptic equanimity appears all the more remarkable when the dramatic verticality of Sullivan's Wainwright Building in St. Louis of about the same time

[28] *Louis Sullivan: Prophet of Modern Architecture* (New York: W. W. Norton & Co., 1935), p. 128.

215

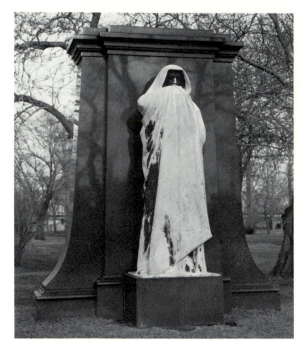

6. Eternal Silence, *Lorado Taft, 1909. It commemorates Dexter Graves, the leader of the first settlers in 1831 (T. A. Heinz).*

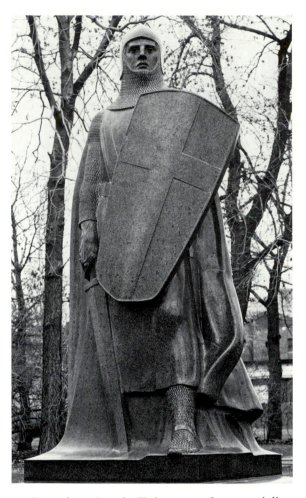

7. Crusader, *Lorado Taft, 1931. It memorializes Victor Lawson, crusading founder of* The Chicago Daily News *(T. A. Heinz).*

is recalled. The Getty Tomb shines forth with the light of Indiana limestone, but by now a more mature taste forbade any high polish to reflect nature, as in the Ryerson Tomb.

Yet, when the shadows from the trees fall across the Getty Tomb surfaces, the two ingredients of Sullivan's ornament—underlying, powerful geometry, and rich, overflowing, arabesque in natural patterns—are merged and revitalized. The tomb treats with nature on all four sides by fragmenting and then absorbing the light, which does not excite the surfaces as on the Wainwright skyscraper, but rather suits quite another purpose by assuring the tomb of its own inner tranquility and permanence. As an architectural gem it is reflected off-white in the blue water of the tiny artificial lake of Willowmere, laid out by Jenney.

The distinction comes from its being so small (out of correspondence with the massive Chicago buildings for the living), and its ethereal calm. The type was transformed a decade later in Frank Lloyd Wright's village bank project in *The Brickbuilder*. Wright reported that his bank design was conceived "with a monumental and significant simplicity arbitrarily associated in the popular mind, perhaps, with a tomb or mausoleum."[29] By upgrading the scale slightly and conservatively opening the walls of his bank

[29] V, 10, August 1901, p. 160.

216

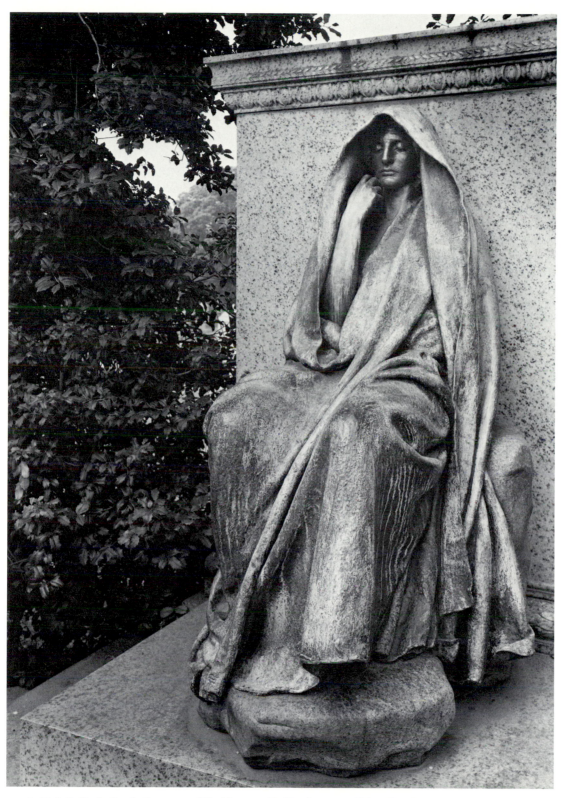

8. Grief, Rock Creek Cemetery, Washington, D.C., Augustus Saint Gaudens, 1891 (Jack Boucher).

at the top register he strove to give a commercial building the dignity he thought it deserved in a growing democracy, transforming the sacred into the secular, since his pioneer world would not turn out such ideal forms fast enough. The Getty Tomb remained attractive to Wright, for he was still mentioning it in his biography of Sullivan half a century later as one of the three Sullivan designs he admired the most.[30] The underlying fascination was, of course, with the "timelessness" of memory, stone, or money. Americans always sought timelessness in art or nature as a rare commodity. It was their chief reason for seeking such exotic architectural motifs, from however far away.

As with the poignancy of the Boylston Street Bridge by H. H. Richardson in the Fens, the Getty Tomb was a superbly designed artifact within a calculated natural space in relation to a restless and uncertain city. The compact cube was to be carried even further at the end of Sullivan's life, in his small banks, the lyrical "jewel boxes" he introduced for the smaller midwestern towns.[31] In reversal of the normal teacher-

pupil relationship, Wright appeared to have paid his debt to Sullivan through his own village bank project, from which Sullivan, his teacher, then took inspiration. They did not want to despair over the larger geometry of the confused urban scene, but rather to reduce that outsized geometry, and give it back instead in a purified, crystallized form to the smaller towns, where it would hopefully take hold and also have continuity. Together, they tried to revive the dispirited main street of the post-pioneer prairie town with their idealized bank models, much as Simonds, Lathrop, and Miller wanted to relieve the monotony of the austere and endless prairie roads with the ideal model of Wildwood Avenue in Graceland Cemetery, by giving it borders and screens of native trees and bushes, and revealing vignettes out to the prairie horizon through them. They were all little poems against naiveté, rawness, and hard fate, precociously made up by the younger, talented people attracted to Chicago, for the older, beleaguered, and less matured midwestern people of the time. This was a different and perhaps more favorable, certainly a more sensitive, manifestation of sudden wealth and imminent youth.

[30] *Genius and the Mobocracy* (New York: Duell, Sloan and Pearce, 1949), p. 79.

[31] This evolution of the bank form was brought up in *The Prairie School Review*, 4, 3, 1967, pp. 34-36, through a letter to the editor from David Gebhard, in which he included, besides Wright's "Village Bank in Cast Concrete" of 1901, the project for the Security Bank of Minneapolis by Harvey Ellis, which was first published in 1891, as another prototype for the Sulli-

van banks. Whatever the immediate inspiration, they all follow the Getty Tomb ultimately. I owe guidance in this literature to Craig Zabel, completing his Ph.D. thesis at the University of Illinois on these midwestern banks.

Riverside:
The Greatest American Suburb

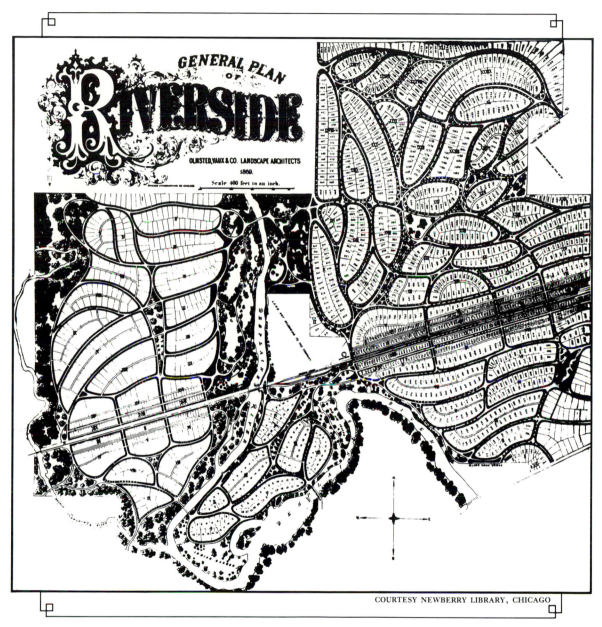

GENERAL PLAN OF RIVERSIDE

OLMSTED, VAUX & CO. LANDSCAPE ARCHITECTS
1869.

Scale 400 feet to an inch.

THERE were more talents concentrated in the making of the suburb of Riverside (see map) than in any such American composition before or since. There was also more continuity among them, beginning with Downing's helper, Frederick Withers, through Olmsted and Vaux (another assistant to A. J.

Downing), to Jenney and Sullivan, and then Frank Lloyd Wright and sundry other members of the Prairie School of domestic architecture.

Riverside's novelty is that it was designed as a self-contained community from the start. This need for containment and psychic self-sufficiency had carried between the Hudson Valley and Yosemite, but now the purpose and forms were taken up more deliberately in the middle of the country.

Since there were no heights to climb from which to obtain lengthy vistas, the containment was likewise modest and monochromatic, and smaller dramas such as boating and driving were featured for inside the community. Everything worked by proximity. The impression of dwelling beneath a low green cloud of foliage to protect the premises from the brightness of the prairie sky was carefully cultivated. The slow, rhythmic turns of the roads meant that the inner space of 1,600 acres might appear to be almost infinitely varied. So the ambiance achieved the maximum effect with the minimal means of foliage and curving roads, but with extraordinary domestic architecture all along the way.

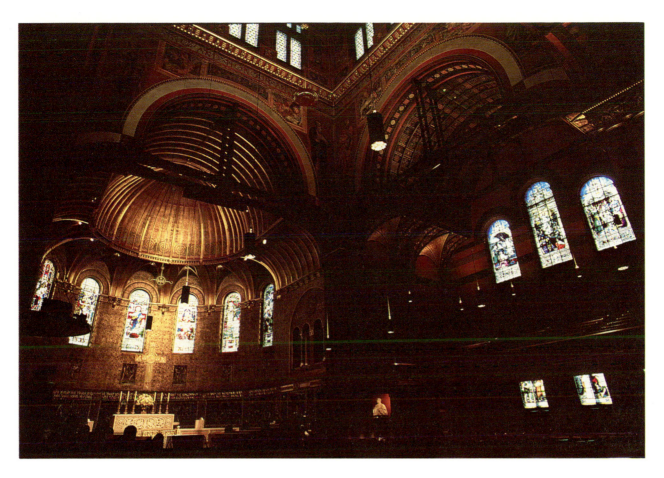

Pl. 9. Interior, Trinity Church, Boston, H. H. Richardson (Thomas A. Heinz).

Pl. 10. Agassiz Bridge, the Fens, Boston, Olmsted Brothers (Guy O. Creese). The Fens shared the glow and flicker of Trinity Church (Pl. 9).

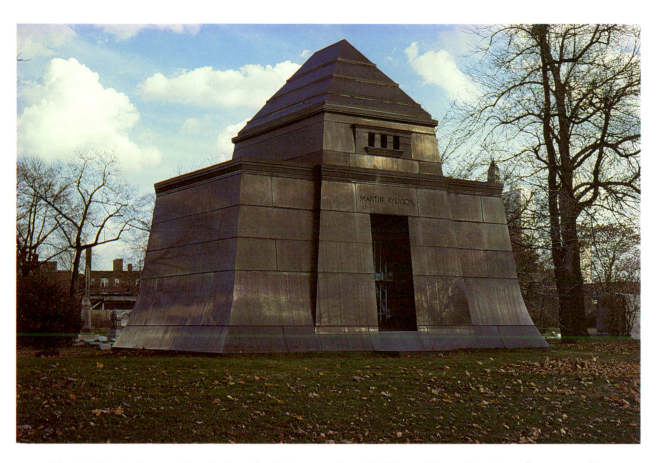

Pl. 11. Martin Ryerson Tomb, Graceland Cemetery, Louis Sullivan. The walls mirror the surroundings darkly (Thomas A. Heinz).

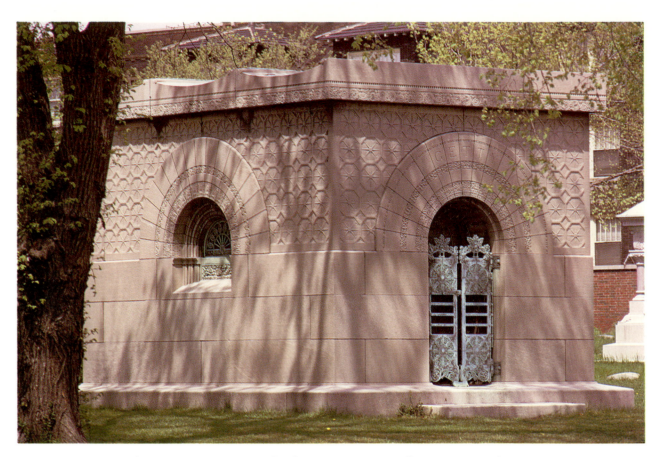

Pl. 12. Getty Tomb, Graceland Cemetery, Louis Sullivan (T. A. Heinz).

AT THE inauguration of Riverside, Illinois, in 1868 a positive orchestration of the environment hardly appeared possible. The designer, Frederick Law Olmsted, described the land around Chicago as "low, flat, miry, and forlorn."[1] As Leonard Eaton has brilliantly shown, between Riverside, as the post-Civil War prototype on the one hand, and Allen Park Subdivision near Detroit, an aphorism of post-World War II government-endorsed suburbanism on the other, nothing had been learned for the public benefit. Indeed, there had been a regression. Riverside was the nineteenth-century dream that turned into a generalized nightmare in twentieth-century subdivisions.[2] The reason for this negative result was that the Riverside model was not recognized early enough, nor carefully enough studied thereafter. Government postwar policies through guaranteed loans throve on bureaucratic minima. The formation of suburbs was no longer regarded as an art. Riverside provides a unique example of the most talented architects, engineers, and landscape and community planners of the last hundred years working together. The testing of the suburban means in the midst of a virtual nothingness thus made it especially valuable as a final art object.

This consanguinity began with two young English employees of A. J. Downing. Calvert Vaux came to the United States in September 1850, and Frederick Withers joined the firm in 1852. Although Downing died in July 1852, Vaux and Withers lasted long enough on the Downing mission to be active at Riverside, and with Frederick Law Olmsted. Withers conceived the first business block there in 1870, the Arcade Building.[3] Placed beside these imported Hudson Valley buildings were the more localized designs of William Le Baron Jenney, the inventor of the skyscraper, who lived in Riverside, promoted it, and was involved in landscape improvements all around Chicago. "The rustic quality" of his early house designs derived from Downing.[4] His domestic inventions at Riverside reveal an elaboration of detail, fitted within airy wooden frames to give a sense of unprecedented venture in an enclosed bower (Fig. 1). This innovation led to the more modulated domestic "symphonies" of Louis Sullivan and Frank Lloyd Wright here, together with the "tone poems" of slightly less known figures in the Prairie School, such as J. L. Silsbee, Wright's first employer; Guenzel and Drummond; Tallmadge and Watson; and Purcell and Elmslie.

THE CHICAGO SITUATION

Indians roamed the woods around Riverside until 1836-1838, when the Potawatomies, like the Cherokees of the southeast, were

[1] Olmsted, Vaux & Co., *Preliminary Report upon the Proposed Suburban Village at Riverside, near Chicago* (New York: Sutton, Browne & Co., 1868), p. 3.

[2] Leonard Eaton, "The American Suburb: Dream and Nightmare," *Landscape*, 13, 2, Winter 1963-1964, pp. 12-26.

[3] Francis R. Kowsky, "The Architecture of Frederick C. Withers," *Journal of the Society of Architectural Historians*, 35, 2, May 1976, pp. 84-85.

[4] Theodore Turak, *William Le Baron Jenney* (Ann Arbor: University Microfilms, Inc., 1967), p. 28.

1. Scottswood Common, Riverside. Jenney's Swiss Style houses are on the left (144 Scottswood, C. L. Cross House) and right (124 Scottswood, house of L. Y. Schermerhorn, Jenney's partner). The left represents the 1880s version, the right the 1870s, with Downing's influence still apparent. The dappling effect from the trees typifies the ambiance (Thomas A. Heinz).

moved westward by the Federal Government, partly as a result of the Black Hawk War, in which Lincoln served in 1832. The ground of Riverside was used as a campsite by those Indians.[5] A little less than three decades later, in 1864, David Gage bought 1,600 acres to found his showplace, Riverside Farm, a name he borrowed from the original twenty-acre farm of William Wesencraft, who settled in the area in 1855, although his plot was never a part of the new plan, and only shows up on maps as a blank spot ("Land Not Belonging to the Company") on the near bank of the Des Plaines River (See Map G).[6] Gage's farm provided

food for his Hotel Sherman in Chicago,[7] in addition to being a gentleman's seat, furnished with livestock and a racetrack with grandstand. Four years later, in 1868, Gage was persuaded to give it up. Emery E. Childs, an Eastern businessman, and his friends invested in the site, and after reading Olmsted's "Preliminary Report" on Riverside decided to proceed with a better-defined suburb.[8]

It was an era and place in which nothing remained the same. Before the fire of 1871, Chicago was known as the "Garden City." "The noble, lake-bordered expanse is divided into lordly domains, embellished with

[5] "And Now a Look Back," *National Association for Olmsted Parks*, 2, 1, Fall/Winter 1981-1982, p. 10.

[6] Marian A. White, *Book of the Western Suburbs* (Chicago: J. Harrison White, 1912), p. 86.

[7] Ibid. See also, "Riverside," *Chicago Tribune*, February 25, 1900.

[8] *Chicago Tribune*, February 25, 1900. The contract with Childs of September 1868 is reproduced in the

lovely gardens. . . . Not only is every street shaded, but entire wooded squares contain each only a single habitation, usually near its centre, thus enabling their fortunate owners to live in park-like surroundings. . . . And to think that in a single night all this wealth of nature disappeared as if it had never been!"[9] The western and southern prospects from the courthouse dome had much the same verdant character as that to the northeast just described, although there nature was not so evenly or lavishly distributed. But a new choice now had to be made, largely because of the fire. In 1870, Chicago, unlike most other cities, had virtually no suburbs.[10] Thus the abrupt disappearance of greenery inside the mother city explained more clearly the subsequent attraction of it at Riverside. There was no gradual creep out to the suburb, but rather a great leap from inside the city to the outside, after the devastation of the fire. "Many booms were on immediately after the fire, and the suburban boom outran them all. 'Why wait for the slow development of time?' spake the tempters. 'A suburb to order, with parks, walks, drives, a club-house, everything exclusive,' that is what the speculative visionaries said was the thing for Chicago. And so a famous Eastern landscape gardener [Olmsted] was sent for, and Dave Gage's farm became the fashionable suburb of Riverside."[11] Gage was also the city treasurer of Chicago, and

2. *Steamroller imported from Europe to do Riverside streets. High tech of the day to achieve amenity* (Newberry Library).

"Riverside proved a bottomless pit." In January 1874, $507,703.58 was found to be missing from the Chicago treasury, presumably siphoned into Riverside,[12] and Gage had to retire in discreet haste to take up hotelkeeping again, in faraway Denver. By then Riverside had cost over two million dollars, with a half-million-dollar overrun, almost precisely the amount absent from the treasury.

The completeness of Riverside's installations was unprecedented, and explained much of the overrun. There were walks of Trinidad asphalt mixed with stones, and gravel streets with solid bases flattened by a fifteen-ton steam roller imported straight from Europe (Fig. 2), storm water and sanitary sewer pipes, and gas illumination for streets and homes. There was the projected parkway to the city to be considered, 200-600 feet wide with tracks for pedestrians, horseback riding, pleasure driving, and heavy freighting. These installations were in charge of Jenney's partner, L. Y. Schermerhorn, and he drove hard.[13] Within two

Riverside News, Centennial Edition, October 8, 1936. See also *Charter and By-Laws: Riverside Improvement Co.* (Chicago: Beach and Barnard, 1869), pp. 7-10. Dorothy H. Unger and Roberta Gates, "The General Plan and Its Development," mimeograph, Riverside, 1982, p. 2, point out that Childs and his group originally had a scheme for a park with uncertain portions to be sold for building purposes. Olmsted found this so "abominable" that he wrote his formal report.

[9] Frederick Cook, *Bygone Days in Chicago: Recollections of the "Garden City" of the Sixties* (Chicago: A. C. McClurg & Co., 1910), p. 178.

[10] *The Western Home Journal*, III, 3, March 1870, p. 33.

[11] Cook, *Bygone Days*, p. 302.

[12] *Riverside Evidence in the Circuit Court*, February Term, 1876, before the Hon. Erastus S. Williams, Judge, p. 3. See also, "The Affairs of the Defunct Riverside Improvement Company to Be Aired in Court," *Chicago Tribune*, April 30, 1882.

[13] A. T. Andreas, *History of Cook County, Illinois*,

years, nine and a half miles of road, seven miles of walks, six miles of water pipe, five and a half miles of gas pipe with two hundred lamp standards, and sixteen miles of drains and sewers had been put in, together with thousands of trees and shrubs (Fig. 3). Attempting to explain the difference between Chicago and the potential of Riverside to the proprietors, Olmsted wrote, "We can not claim that what you will offer in respect to gas, water, drainage, street access, and other matters of convenience will be better than can be found in some of the more desirable residences of the city but what, besides more pure air and other conditions of health, you can offer, is a much higher degree of the gratification of true taste."[14] Olmsted, like Jenney, wanted to utilize technology to the utmost, but to achieve new heights of amenity from it.

As the Civil War was the sharp division for the nation, so the fire of 1871 was for Chicago, except that "the catastrophe that visited this community came near obliterating it, and in no respect was the destruction more complete, or so irreparable, as in the matter of records and landmarks."[15] Riverside was caught in the aftermath of both holocausts, hence its founding could not but be a vivid and therapeutic episode for those who created and inhabited it, since they were reacting against the trauma of both events, fire and war, and the toughness and resilience of Chicago itself.

Bostonians shivered in the biting east wind off the Atlantic: witness Nathan P. Willis' escape inland to the Hudson Valley. Chicagoans expressed similar anxieties. Frank Lloyd Wright's mother chose nearby Oak Park for herself and him because she felt that the winds of Lake Michigan were too cold.[16] Thus Riverside was to be "far enough removed from Chicago to escape the deleterious influences of chilling winds that make a more permanent home on the lake shore undesirable for multitudes of more delicate constitutions."[17] Furthermore, Lake Michigan with its high waves did not offer safety for the more genteel and small-scaled recreations preferred by Victorians. So they turned from the lake to a comparatively rare stream, the Des Plaines River. However, among the refugees from the Chicago Fire staying at the Riverside Hotel a few cases of fever and ague, the pioneer's diseases, broke out. Chicago real estate promoters, eager to gain the slightest advantage, exploited the incident. This led to a slower occupation rate for the suburb, which, further delayed by the subsequent depression of 1873 and the defection of Gage in 1874, meant bankruptcy. Olmsted had to take more than he wanted of odd-shaped lots on the Long Common in lieu of fees, and these lots soon depreciated in value.

THE LAND

The inspiration for much of the layout of Riverside derived from Birkenhead Park across the Mersey from Liverpool, England, which also contained homes and was designed by the great gardener and inventor of the London Crystal Palace, Joseph Paxton. Olmsted had visited there in 1850. Riverside

from the Earliest Period to the Present (Chicago: A. T. Andreas, 1884), p. 876. An excellent, if brief, summary of the creation of Riverside is also contained in Victoria Post Ranney, *Olmsted in Chicago* (Chicago: R. R. Donnelly & Sons, 1972), pp. 11-15.

[14] "Riverside, Illinois: Selections from the Papers of Frederick Law Olmsted, Senior," *Landscape Architecture*, XXI, 4, July 1931, p. 291. *The Western Home*, March 1870, p. 34, indicates that while Riverside was going up, the less-favored parts of Chicago still had wooden stairs connecting higher and lower sidewalks.

[15] Cook, *Bygone Days*, p. xi.

[16] Frank Lloyd Wright, *An Autobiography* (New York: Duell, Sloan and Pearce, 1943), p. 79.

[17] Herbert J. Bassman, quoting a brochure published by the proprietors of the Riverside Hotel in April 1874; *Riverside Citizen*, January 8, 1970.

3. *Scottswood Common, seen in the late 1880s. The gaslight at right stands for the unusual number of underground utilities. The gently curving road, implying slow motion; the generous extent of the Common, which Olmsted referred to as an informal village green; the juxtaposition of public and private property in a great enfolding, with a smattering of bushes to enrich the scene, are characteristic of the way Olmsted worked at the time (Brouse and Martin, Donated by George Denniston, Sr., Riverside Museum).*

and Birkenhead were intended to form future bastions against urban congestion. The maps show that the sines of the curves in both suburbs were rationed according to how much walking or carriage riding was contemplated. The Riverside plan has often been criticized because it constitutes a maze for autos out of which there is no direct or easy exit. Yet, if the plan is turned outside in to judge its worth, the curving becomes yesterday's virtue. The straight-line streets advocated by commuting drivers are even more slow-moving in adjoining towns like Berwyn and Lyons, with stoplights and ugly strip development all along them.

Olmsted insisted on a distinction between park and suburb, although he did not completely honor the distinction in execution, any more than between fen and marsh in the Fens. "Thus the essential qualification of a park is *range*, and to the emphasizing of the idea of range in a park, buildings and all ar-

tificial constructions should be subordinated. But the essential qualification of a suburb is domesticity, and to the emphasizing of the idea of habitation, all that favors movement should be subordinated."[18] Still, the memory of Paxton's Birkenhead "park" lingered, so both were present. Riverside was actually a public "range" in a slower, more convoluted rhythm in which one did not move too far or fast. As Olmsted said, he did not wish to encourage an "eagerness to press forward without looking to the right or the left."[19] Olmsted, Vaux & Co. therefore composed an inward-looking form, widely ordered in its free-form pattern. Olmsted's first intent with those inwardly oriented roads was "to suggest and imply leisure, contemplativeness and happy tranquility,"[20] the mood was a blend of the Beautiful and the Pastoral, of which the latter was predominant at Riverside. The final effect was supposed to be in a state of homeostasis.

The stop on the Chicago, Burlington & Quincy Railroad—in place by 1864 as the first station outside Chicago—and the projected Grand Avenue—were the only straight lines in Riverside, unless the green strip of the Long Common, intended for ending the Chicago avenue in the village, can be taken as straight.[21] From Birkenhead in 1850, Olmsted expressed chagrin that no such "People's Garden" was developing in the United States.[22] He found it admirable

that with the threat of rain all classes could gather in a single pavilion. Of the houses of Liverpool and Birkenhead, however, he said, "The architecture was generally less fantastic, and the style and materials of building more substantial than is usually employed in the same class of residence with us. Yet there was a good deal of the same *stuck up* and uneasy pretentious air about them that the suburban houses of our own city people so commonly have."[23] Olmsted was often anxious about the disruptive potential of architecture for his sylvan compositions; and Wright also used the term "stuck up" to describe suburban houses around Chicago. But the two would-be reformers of "unnecessary" display were destined to be thwarted in their objection, because the Victorian temperament, whether in city, suburb, or cemetery, sought to celebrate individuality through private ownership in a public place. Jenney showed himself highly receptive to this ambition, for his houses in Riverside are often extreme displays of architectural individuality, which may have caused Olmsted to observe that, in Riverside, Jenney was half "feeling his way."[24] However, Olmsted himself took only a "few simple precautions" against untoward effects in architecture, since "we cannot judiciously attempt to control the form of the houses which men shall build."[25] At Riverside the precautions came in the form of a thirty-foot setback for houses, the requirement that the front yard be kept open and free of fences, and that at least two trees be planted in it. The most telling passage in his contrast between Birkenhead and Riverside occurred when he described the peculiar richness and vibrancy of Paxton's effects. He admired them greatly, but found them horticulturally and topo-

[18] Olmsted, *Preliminary Report*, p. 26

[19] Ibid., p. 17.

[20] Ibid.

[21] Theodore Turak, "Riverside's Roots in France," *Inland Architect*, 25, 9, November/December 1981, p. 19, argues that the Long Common derived from the Parisian suburb of Vésinet (1856-1859), where swaths of meadow (*coulées*) were used, although the Ramble in Central Park, or Glyn Ellyn and the Ramble in Lewellyn Park could have provided inspiration as well. For background on Vésinet, see Georges Poisson, *La Curieuse Histoire du Vésinet* (Paris: Ville du Vésinet, 1975).

[22] F. L. Olmsted, *Walks and Talks of an American Farmer in England* (New York: George P. Putnam, 1852), p. 79.

[23] Ibid., p. 83.

[24] Letter of Olmsted to James B. Angell, president of the University of Michigan, January 12, 1876, quoted in Turak, *Jenney*, p. 172.

[25] Olmsted, *Preliminary Report*, pp. 24-25.

graphically overwrought.[26] Paxton's chief device for obtaining a varied surface, in a district which was quite flat, like Birkenhead or Riverside, was through the use of berms. In contrast, Olmsted laid a carpet of continuous green, accepting the prairie flatness, and even sinking the streets two-three feet in order to keep the basic earth plane moving. He wanted the pedestrian to enjoy the "range" of vistas up to a quarter of a mile in some spots.

Besides omitting berms, Olmsted utilized no colorful flower beds or displays of exotic plants, as Paxton had. Stretched above, but not so high as to challenge the human scale, was the canopy of green trees sheltering the monochromatic lawn, like a rippling awning, from the infinite and ever-changing prairie sky. Olmsted described the effect as a "grateful umbrageousness."[27] Although there were already stands of elm, oak, ash, linden, lime, hickory, and black walnut in place, along with pines and fruit trees planted by the earlier settlers, and an undergrowth of hazel and thorn, Olmsted planned to add still more greens, including within the first two years 7,000 evergreens and 32,000 deciduous trees, 2,500 of them large, with trunks up to nineteen inches when transplanted.[28] Forty-seven thousand shrubs were to be added.

Illinois trees are not as tall or monumental as those in some other states; thus they were "to be made subordinate to more interesting and beautiful effects of foliage," with light coming down through and across them. "We expect that in the interest and pleasure to be derived from this source in passing from one point to another at Riverside, its most attractive characteristic will eventually be found."[29] Trees were to be less confined to

streets alone, as also in London's Bedford Park Suburb by Norman Shaw of the same 1870s. Olmsted declared that elms and chestnuts would blend with nearly all oaks, a common tree in Illinois, "and the maples better with chestnuts than with elms."[30] American limes went well with either oaks or elms. Ash integrated with black walnut, hornbeam with beech, and hornbeam with birch in various combinations; but only in statements such as "The Nettle tree and the Hornbeams are good for tailing down a group of elms being of lower growth and somewhat like form but little variety of color"[31] can it be fully understood that Olmsted looked everywhere for a steady interaction among tones, forms, and silhouettes, but seldom for dramatic or individualized contrasts in shape, size, or color. He strove for specimens that would unite "more quietly" and tail off, to breed a uniform milieu. His outdoor spaces are much like the rooms of H. H. Richardson, with light coming through a furnished calm to form a lasting unity. The full effect would subtly engage and enchant the spectator.[32]

Riverside lots had to be a minimum of 200 feet deep and 100 feet wide. Because of the curves of the streets, however, they became wider in some wedges. Such irregularities were brought under permanent control by the limestone markers Olmsted had Schermerhorn install for base lines, blocks, and lots,[33] thus also defining the divisions be-

[26] Olmsted, *Walks and Talks*, p. 79.
[27] Olmsted, *Preliminary Report*, p. 25.
[28] Andreas, *History of Cook County*, p. 876.
[29] "Riverside, Illinois," *Landscape Architecture*, July 1931, p. 291.

[30] Ibid., pp. 288-289.
[31] Ibid. See also paper of John M. Cameron, read before the Riverside Historical Society on May 13, 1938, file of the Riverside Public Library.
[32] Charles Beveridge characterized this process. Olmsted's aim was to provide a "subordination of details to an overall composition whose strongest and fullest effect was to act unconsciously on those who viewed it." "Frederick Law Olmsted's Theory of Landscape Design," *Nineteenth Century*, 3, 2, Summer 1977, p. 43.
[33] Letter from Dorothy H. Unger, May 29, 1983, and Unger and Gates, "The General Plan," pp. 6-7. Survey markers were three and a half feet long and

tween private and public property, espe-
cially important because 700 of the 1,600
acres of Riverside were dedicated public
land. Bushes and trees were all about, so the
houses were difficult for the visitor to locate.
There is an anecdote about a man who found
himself at the back door of a house he
wished to visit, whereupon he was told to go
to the more appropriate front entrance, but
he refused for fear of getting lost again. And
an older resident, still living in a Jenney
house in 1938, observed, "I can look in any
direction here and see trees—just like in a
park. Yet there are houses all around."[34]

However, the impression today is that the
Victorian architecture is a little oversized,
even overbearing, "stuck up," while the
landscaping is a little understated, so
Olmsted never quite reached the effect he
wished. This Midwest proportioning shows
in Wright's Oak Park and River Forest as
well, and is perhaps one reason why he was
to advocate such a small scale for the Prairie
House, which he sometimes hinted was due
only to his own height of five feet, eight and
a half inches. In stepping across Forest Av-
enue in Oak Park from his Nathan Moore
House of 1895 to his Heurtley House
of 1902, one immediately recognizes the
rapid reduction of size and scale that oc-
curred around 1900. But the earlier Jenney
houses in Riverside possessed a distinctly
planar, three-dimensional, pergolalike ele-
gance, which still permitted them to blend
with the dense filigree of the surrounding
foliage. Everything was traditionally large
about this Victorian architecture, but it was
never out of the shade for long (Fig. 1), and
from the foliage as well as the houses a latent
energy emerged.

However unrealized or slightly imperfect

the Riverside environment might be, it had
a powerful affect on the inventor of the Eng-
lish Garden City, Ebenezer Howard, who
was employed as a shorthand secretary in
Chicago at the time Riverside was develop-
ing.[35] Olmsted wrote of Riverside joining the
"town" and the "wilderness." Howard pro-
moted a similar concept in his Garden City
diagram of 1898, where he showed a third
magnet, joining "town" and "country." "The
fortunate dweller at *Riverside* has plenty of
fresh air and sunlight, imparting to himself
and family health and happiness. He has
plenty of elbow room, and can dig to his
heart's content, raise his own fruit and veg-
etables, keep his own cow, and even make
his own butter. And he can do all this with-
out the sacrifice of the urban comforts which
long use has made a necessity to him."[36]
Thus, the new resident of Riverside is seen
as a recent city dweller, not long off the farm
before that, and the suburb as a direct re-
sponse to Chicago, despite the fact that it is
four miles from the edge of the city, much
as the first Garden City of England, Letch-
worth, would be seen to have its greenbelt.

THE BUILDINGS

At its best, the architecture of Riverside en-
ters the mature Prairie School phase, but it
nevertheless continues to draw nourishment
from the Neo-Gothic and Swiss styles of
Downing and Jenney. Riverside is the one
spot in America where the Downing style
can be witnessed leading up to the Prairie
Style, a visible historic progression only pos-
sible to speculate upon elsewhere. The firm
of Jenney, Schermerhorn & Bogart, for-
merly associated with Olmsted & Vaux as
the local anchor, became the chief architects

nine inches square, lot markers two and three quarters
feet long, tapered to five inches square.
[34] Bruce Grant, "Riverside: The Town without
Streets," *Chicago Sunday Times*, October 9, 1938.

[35] Walter Creese, *Search for Environment* (New Ha-
ven: Yale University Press, 1966), pp. 150-157.
[36] *Riverside in 1871*, p. 21.

and engineers after Olmsted & Vaux relinquished the primary responsibility in 1870. (Schermerhorn's house is still standing at 124 Scottswood Road, Figs. 1, 10.) The developers built the tower beside the railroad station in Swiss Gothic Style, which, from its tank, dispensed water up to the third floor throughout the village. Before it burned on the evening of January 1, 1913, the hanging wooden gallery of the tower made it possible to look down on the umbrella of trees (the "grateful umbrageousness") of the whole community through airy trefoil arches.

Frederick Withers, onetime Downing associate, designed the Riverside Union Church as well as the first commercial building. According to the 1871 prospectus, Olmsted, Vaux & Co. were responsible for the G. M. Kimbark, E. T. Wright, and John C. Dore (Fig. 4) houses, the last—a Swiss cottage—is, with a few deletions, still standing (Fig. 5), and recently refurbished.

Jenney's work is carried out with midwestern energy and innocence, its rank eclecticism made possible by its style. The essential idea came from Downing's *Treatise on Landscape Gardening* of 1844; but "To build a Swiss cottage in a smooth and cultivated country, would, both as regards association, and intrinsic want of fitness, be the height of folly."[37] Downing wanted Swiss buildings to be located rather in a "wild and mountainous region." Jenney evidently took only as much of Downing's admonition as he cared to, namely that the Swiss Style should be introduced into a "peculiar situation."

Jenney did note that a Swiss house projected by him for Col. James Bowen in Hyde Park near Chicago was derived from the chalet at the Paris Exhibition of 1867, for the use of the General Commissioners,[38] of

whom Bowen was the American member.[39] In a larger and less literal sense, the Swiss Style is an outgrowth of the post-Downing, French trend of the late 1860s, and was characterized by its use mainly for small and novel types of buildings, its appearance facilitated by abundant and available wood as a building material and the rapid evolution of machinery with which to tool it.[40] It was likely therefore that it would be more often and forthrightly employed in the United States than in Europe. "As a rule walls are of clapboards, openings rectangular and framed with built-up mouldings over boards. Gables and the upper zones of the walls often have vertical boarding, with shaped ends. Roof eaves are supported by ostentatiously strong carpentry of chamfered timbers, and often lambrequins or crestings, fancily cut out, run along them."[41] As with Olmsted's prolific use of trees at Riverside, there was an element of excess in the multiplication and elaboration of the form.

The H. C. Ford House by Jenney, part Italianate, part Swiss, was even more typical (Figs. 6-7). Ford was the first landscape painter in the Chicago area, and together with his pupil Annie Cornelia Shaw he attracted other artists to Riverside. His presence recalls that of the painters of the Hudson Valley of this era, especially Bierstadt and Church, as well as that of artists in the

37 (New York: Wiley & Putnam), p. 362.

38 Sanford E. Loring and William Le Baron Jenney, *Principles and Practice of Architecture* (Chicago: Cobb

Brothers, 1871), p. 55, Plate 1. See also the article by Theodore Turak, "Jenney's Lesser Works," *The Prairie School Review*, 3, 1970, p. 9, and his Ph.D. thesis, *Jenney*, p. 218, Fig. 18.

39 Turak, "Riverside's Roots in France," p. 18.

40 Walter C. Kidney, "The Dragons and the Swiss: An Earlier International Style?" *Nineteenth Century*, 1, 4, Winter 1975, p. 25. Kidney also mentions George E. Woodward's *National Architect* (New York: George E. Woodward, 1870) as a source. Plate 53, Design 12, resembles the Dore House at Riverside, and Plate 32, Design 8, recalls the Refectory of Riverside Hotel, as a Swiss pavilion over the water. Thus the Swiss influence could have come from at least three directions to Riverside.

41 Ibid.

4. *John C. Dore, Esq., House, Fairbank Road, Riverside, Swiss Cottage Style, Olmsted, Vaux & Co. Overhangs and balconies are consonant with the intricate Swiss Style (Riverside in 1871).*

5. *Dore House today, restored by Doris and William Miller. Dore was the first superintendent of the Chicago School System in 1854, and president of the Chicago Board of Trade in 1866 (T. A. Heinz).*

6. *Henry Chapman Ford House, 140 Fairbank Road, William Le Baron Jenney, now razed. Ford was a Civil War veteran, the first landscape painter in Chicago, and the founder of the Chicago Academy of Design* (Riverside in 1871).

7. *Ford House in 1896. As with his skyscraper engineering, Jenney displayed a restless energy in his houses, often using tiny ornaments, beads, and perforations, such as might have pleased a Venetian doge (Riverside Museum).*

English model suburb of Bedford Park outside London. Not regarded so much as bohemians and social rebels in this decade and place, artists ranked more as unusually urbane and refined citizens whom it would be well to cultivate for the suburban sensibility they might eventually bring.

Whereas the raking verge boards of a Hudson River Gothic house would be under the eaves, in the Ford House they were placed on top of the eaves, in a sawtoothed, crow-stepped gable effect, in order to reveal the accentuated brackets underneath. Downing had described the Bracketed Mode as a "less expensive" Swiss style, but here the brackets were themselves overtopped. The dormers were like little Swiss bird cages or chalet barometers; one almost expects a colorful bird or an old woman in an apron and kerchief to pop out. Elements are thin, taut, linear, paneled, beaded, and slightly mannered in their relationships, so as to create a framed domestic space in an artificial, but prolific, woods. "There are several little balconies and upper verandas, which, together with the broad over-hanging roof and square tower, give to the house a very pleasing and picturesque appearance."[42] The Italianate tower with a weathervane on top, which overlooked the river and Pic-Nic Island, was diagonally boarded in a very unorthodox fashion, contrasting with the plainer walls below. Windows were full sized, as usual in midwestern Victorian, in order to view the grounds, as also from the "several little balconies and upper verandas," but the huge window on the right end in the earlier, 1871, illustration (Fig. 6), with its own gable below the main one, still appears somewhat distended, until one realizes that it opens into Ford's two-story studio.

Jenney took on another landscape project at the same time that he became occupied with Riverside (1869): the West Park system of Chicago, which included Douglas, Central (later Garfield), and Humboldt parks, to be finished in 1871.[43] In an advertisement in *Principles and Practice of Architecture*, their book of 1871, Loring and Jenney pronounced themselves ready to design parks, monuments, and cemeteries, as well as buildings, claiming to follow Downing before all others. "There is a want of intelligence in matters of art in American country villages, especially in the West; such books as Downing's have done much to supply this want, and should be more generally read."[44]

The suspicion that there is no legitimate design tradition, no continuity, in America, either in architecture or landscape, and that salvation lies only in blind innovation and specialization in such a new country, finds little support in the examples of Riverside and Jenney. They greatly depended on the Hudson River School and Downing, just as the latter tried to learn from the Agrarian visions of Jefferson.

Jenney was thus not only the cool technician-engineer he is often depicted, the father of the first skyscraper—the Home Insurance Building in Chicago of the early 1880s—but also, like Olmsted, an environmental strategist. The new and broader strategy between architecture and landscape is well illustrated by his Riverside Hotel (Fig. 8), Refectory, and Billiard Pavilion in the Swiss Style, which opened in 1870 and was within easy walking distance of the railroad station and store, and close to the river. This spread, the last unit of which was torn down at the end of World War II, when cultural memory was at its lowest ebb, represents the phenomenon of a resort hotel being introduced into a new suburb. This affinity between suburb and resort had existed on the East

[42] *Riverside in 1871*, p. 29.

[43] For Jenney's work on the Chicago parks, see Theodore Turak, "William Le Baron Jenney: Pioneer of Chicago's West Parks," *Inland Architect*, 25, 2, March 1981, pp. 38-45.

[44] Loring and Jenney, *Principles and Practice*, p. 32.

8. Riverside Hotel, William Le Baron Jenney, Spring 1870 (Riverside in *1871*).

Coast, of course, but in a more attenuated way, for there the two elements were often fifty or a hundred miles apart. It was the proximity, low scale, and amplitude of the hotel which predicted the regional future. The structure was deceptively simple and slightly static in appearance, like a large dollhouse or an elongated summer cottage. It measured 260 feet long, with dual courts 57 by 83 feet each. Extended between the courts toward the Refectory and the Billiard Pavilion on the riverbank was a double-decked walkway of 275 feet. The reason for the separations was to keep the noisier housekeeping, cooking, and recreational services away from the body of the hotel, and reduce heat and odors. Wright's Avery Coonley House (Fig. 9) in Riverside of forty years later has something of this hotel in it, with its low, extended wings, its tendency to revert to pavilions, a floor floating in limbo between the first and second stories, courts with local plantings, and its sheltering overhangs, pergolas, walkways, and open spac-

ings. Similar too is the ready acknowledgment of adjacent informal nature outside the plantings.

Jenney's hotel lies closer to the ground than an eastern hotel. A brochure of 1874 stated that it was "constructed and arranged with a view to avoid lofty flights and crowded dormitories of too many summer hotels."[45] There is nowhere in this vicinity an attraction such as the lofty view of the Hudson from the Catskill Mountain House. The Riverside Hotel had therefore to generate its own humble but manageable returns from Olmsted's immediately surrounding nature. Distance as a romantic enticement, and the need to face it, had been much reduced in attraction. Since there was nowhere to go, the "Swiss" details of the building had added interest. In the middle of the covered walk there was a polygonal gazebo, the Music Pagoda, with views in every direction, as from the top of the

45 Bassman, *Riverside Citizen*, January 8, 1970.

9. Avery Coonley House, 300 Scottswood, Riverside, Frank Lloyd Wright, 1908. The horizontal spread among the trees and the animation of the surface is similar to that of the Riverside Hotel. The landscaping was by Jens Jensen (Wasmuth).

nearby water tower, or the tower on the Ford House. The gazebo had the same wooden trefoil arches, colorism, and candle-snuffer roof as the water tower. Afternoon and evening concerts by an Italian band were held in it, with canvas curtains dropped along the walk in inclement weather. Bunting flags flew from all roof peaks. Jenney, like Wright, trying to find himself in the center of a new country, determined to forge his own romantic kingdom. Wright's Lake Geneva, Illinois, hotel of 1912 (demolished 1970) furthered the evolution from the Riverside Hotel to the Coonley House. It tended to pavilions again and had a long, low roofline. Originally only sixty rooms,[46] the hotel was more a mansion than house, but also more of a country inn than a resort hotel. Like the Riverside Hotel, it had a boathouse on the water, separated from the main building by a walk.

The organization of the Riverside Hotel, as with that of the houses and streets within the suburb, was for holding people together by the rudimentary means of architecture, gathering them and settling them in, while at the same time encouraging them to step out into the limited distance for social contact, so that there was a tight relationship between "in" and "out." From inside the hotel, Jenney himself tells us, the rooms had the Victorian "broad windows looking out, either into the surrounding park spaces, or into the open courts, which are decorated with fountains and lovely flower gardens, so that there is but little choice in the rooms, all being equally desirable."[47] The windows are not organized as continuous Wrightian ribbons, but are drawn in with bug-eyed enthusiasm, the moldings built up in Swiss Style as picture frames. Everything is twice affirmed, and the Swiss Style employed "as the best adapted to a rural hotel, giving opportunities for those most desirable features; extensive broad verandas, overhanging roof, shaded balconies, and many pleasing though comparatively inexpensive details."[48] The mountain chalet was exploited as a model on the flat prairie because of the protection it afforded from the prairie sky, and the opportunity it gave to slip informally in and out of the parklike surroundings. Unlike the height of hotels in the East, height as a symbol of status is not considered desirable here; ironic, when it is recalled that the design was by the inventor of the skyscraper. The balcony of the adjoining Refectory over the

[46] Patrick J. Meehan, "Frank Lloyd Wright's Lake Geneva Hotel," *Frank Lloyd Wright Newsletter*, Second Quarter, 1981, p. 6.

[47] *Riverside in 1871*, p. 25. The ignominious end of the Riverside Hotel is best described in *The Chicago Tribune*, April 22, 1945.

[48] Andreas, *History of Cook County*, p. 877.

water almost exactly suits the edge of the water requirement of Olmsted in his 1868 report: "there should be pretty boat-landings, terraces, balconies overhanging the water, and pavilions at points desirable for observing regattas, mainly of rustic character, and to be half overgrown with vines."[49] These pavilions were included in the 1869 plan, but never built.

In the Schermerhorn (Fig. 10) and Jenney (Fig. 11) houses, in the Swiss Style, but employing Neo-Gothic board and batten, there is the same appearance of a shelter assembled quickly and almost as an afterthought. The houses represent the midwestern innocence, restlessness, and transience to which the monumentality of Sullivan's Ryerson or Getty tombs at Graceland Cemetery was an answer which would not yield. The upper story of the Jenney House projected six inches, with fringed boards; the battens on the boards were triple-beaded; and the lower story had narrower vertical siding. This guileless display is paralleled in the second-story tulip tile decoration of Wright's Coonley House (Fig. 9). The prominent windows have permanent shades, another device for modulating the light of the prairie sky, like Olmsted's surfeit of trees or Jenney's 1,024-foot veranda, shaded balconies, and overhanging eaves on the Riverside Hotel.

In front of the Jenney House (Fig. 11) members of the family are playing croquet, an activity of what J. B. Jackson aptly termed "The Lawn Culture."[50] The porch or veranda is used by the senior members of the family as a platform from which to oversee the young, who were encouraged to move about, but only within the limited distances prescribed by the rules of the games and Victorian propriety. There had been too much moving about of youth during the Civil War, Jenney among them as a Union

[49] Olmsted, *Preliminary Report*, p. 28.
[50] As set forth in the author's class by Professor Jackson on April 29, 1974.

10. *L. Y. Schermerhorn House, 124 Scottswood, William Le Baron Jenney, still standing. This house for Jenney's partner shows Jenney beginning in Downing's Neo-Gothic mode, and then adding "Swiss" details* (Riverside in 1871).

11. *Jenney House, 200 Nuttall Road, William Le Baron Jenney, burned in 1910. The young people play the post-Civil War game of croquet on the front lawn, which the required thirty-foot setback of the house makes possible, an ample but limited space for ordered action, like the suburb itself* (Riverside in 1871).

officer in the Corps of Engineers. Archery, horseshoes, badminton, and lawn tennis, besides the even more common croquet, were the new pastimes of the Lawn Culture. The relationship between observers and participants was further encouraged by the Des Plaines River, which Olmsted proposed damming higher to create more water surface. Boating was held close to the shore, as evidenced by the illustration (Fig. 12). Women and girls, in semiformal dress, played a significant part; social amenities were exchanged; and architecture was again to provide playful observation platforms:

12. View from the River Park. To see and be seen was an important event in the 1870s. The trees are small scale because so new. The number of young females indicates that it is a "safe" place in contrast to the city (Riverside in 1871).

"The river affords pleasant opportunities for boating, and several bridges, balconies and pavilions will give special advantages for observing regattas and other aquatic sports."[51] The observation points and the objects in view were similar to those in the Seine River paintings of the Impressionists of the 1870s, and even of the Post-Impressionist Seurat of the next decade, whose *Grande-Jatte* was eventually acquired by the Chicago Art Institute.

According to Jackson, the climax of the Lawn Culture arrived with the invention of the country club, beginning with that of Brookline, Massachusetts, Olmsted's home town, in 1881-1882. Riverside founded its country club in 1893, the second in the Midwest.[52] The focus of such organizations was a large clubhouse, not unlike the Riverside or Geneva hotels, with spreading lawns to be seen from its porches. The atmosphere would be sociable, but relatively quiet and restrained. An intake of country beauty was indispensable for fixing the mood of secu-

rity. The significance of the family-centered Lawn Culture diminished in the 1930s with the onset of the Depression, the consequent loss of any sense of security at all from the immediate surroundings, and the rise of spectator sports in large stadia, reached by public transport.

Sullivan's Babson House of 1907 (Fig. 13), now destroyed, but on the site of the residence by Jenney of the original promoter of Riverside, E. E. Childs; Wright's Tomek House of the same year; and his Coonley House of the next (Fig. 9), would replace Jenney's tautness with a more restrained and settled quality. Sullivan tended to monumentality in a homemade way. Yet the Babson House retained some of the livelier Victorian attributes—the rich colorism of the upper stucco panels and striped eaves, the stained cypress of the second story and, above, the reddish tapestry brick of the lower floor, and the projecting bays of the first and second floors—but it plainly lacked the bold experimentality of the Riverside Hotel or the Coonley House.[53] Architecturally, it was an interim house, perhaps less receptive to its immediate surroundings, although its twenty-five rooms were arranged to take advantage of the Jens Jensen landscaping, which Jensen called "The Prairie."[54]

The living rooms of Wright's Tomek and

[51] *Riverside in 1871*, p. 13.

[52] Herbert J. Bassman, ed., *Riverside Then and Now* (Chicago: University of Chicago Press, 1958), p. 107.

[53] See Herbert J. Bassman, "Babson Property Question Answered by Referendum," *Riverside Citizen*, August 29, 1970. For a comparison of the Babson and Coonley houses, see "A Departure from Classic Tradition: Two Unusual Houses by Louis Sullivan and Frank Lloyd Wright, Architects," *Architectural Record*, XXX, 4, October 1911, pp. 327-328, and "A Comparison of Master and Pupil Seen in Two Houses," *Western Architect*, XVII, November 1911, p. 95. For an overall discussion of the Babson property, see Leonard K. Eaton, *Landscape Artist in America: Life and Work of Jens Jensen* (Chicago: University of Chicago Press, 1964), pp. 109-111.

[54] Stephen F. Christy, "Jens Jensen: The Metamorphosis of an Artist," *Landscape Architecture*, January 1976, p. 63.

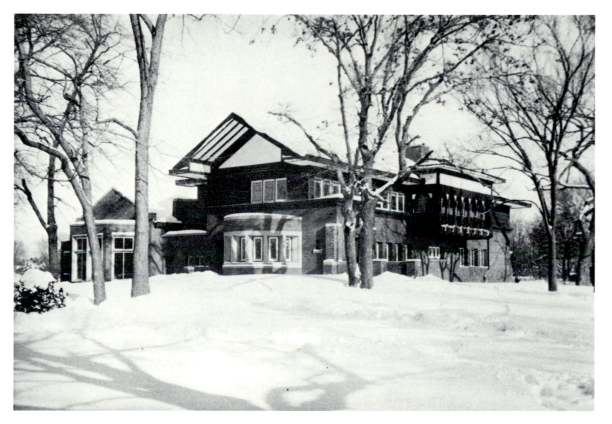

13. Babson House, Riverside, Louis Sullivan, 1907. Torn down in January 1960 by Walter Baltis (Riverside Museum).

Coonley houses, on the other hand, were located on the second floor, where American bedrooms customarily were. The visual imagination was thus freed to float off into the landscaped space beyond, and down to the ground plane below, which included the far-reaching Long Common from the Tomek House, with its many interludes among the trees, and brief glimpses of the slow rounding of the Des Plaines River from the Coonley residence (Fig. 14). One is aloft in these living rooms, but nothing is seen from a steep perspective, and one is reassured by the nearness of everything. The observer is made doubly aware of the stabilizing earth as it flows beneath, and the "grateful umbrageousness" of Olmsted's trees just above.

The capacious aspects of the surroundings are received first by broad overhangs on the houses, and indoors by such irregularly pyramided tent ceilings as that of the Coonley living room (Fig. 15), striped like the Babson House outdoor overhang. The ceiling panels may represent the spreading clouds of the prairie sky; the branches of Olmsted's trees, especially locusts; or a tent, as in the slightly earlier Heurtley House in Oak Park (a sheltering motif which probably originated in the Neo-Gothic houses of Downing and Davis and ends with the great camp meeting canvas roof of Wright's Taliesin West: his grandfather had used such tents for camp meetings at Taliesin Valley); or even a sheltering pergola,[55] reuniting inside and out

[55] The pergola aspect of this ceiling and wall in the Coonley House was called to my attention by Thomas

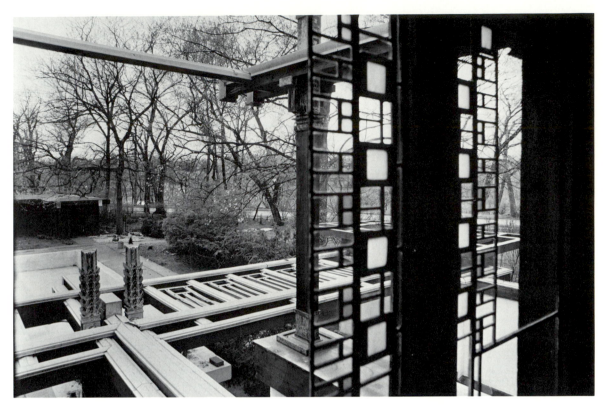

14. Coonley House living room, looking down on the curve of the Des Plaines River. All lines in Riverside ultimately responded to the presence of the river. The pergola is the transitional feature, tying the spaces (T. A. Heinz).

with a skeletonized framework. At certain seasons, especially in fall and winter, outside light reflected brightly off the leaves or snow onto this symbolic ceiling, offering proof of

A. Heinz. He noted that the 1902 *Chicago Architectural Book* contained a project for a pergola for downtown Chicago as a frontispiece by Birch Burdette Long, and a project by Wright in the back. He also informed me, from his own restoration work on the Coonley House, that the original color of the carpet in the living room related to the wall, wood trim, and glass insets, the last being a lime color, like "backlighted leaves." Mark Peisch wrote in *Chicago School of Architecture* (New York: Random House, 1964), p. 55, that in the Coonley House, Wright "based some of his interior decoration on the locust tree, a variety that grew profusely around the site of this house." Mr. Peisch kindly informed me, since the statement had no footnote, that Marion Mahony Griffin had told him of this in an interview in 1957 (letter and card, December 1, 5, 1980).

its universality, like the brightness of the real sky.

As if to furnish lateral relief from any too narrow stratification of earth with trees to temper the sky, the wall is dissolved and the eye directed outward through pergolas of wood and glass over the parklike areas (Fig. 14). Jenney's homes had achieved a similar openness with their lofty fretwork balconies and porches. Householders and their friends might sit on the porches of a weekend, to become used to the greenery. Olmsted wanted conviction to emerge subconsciously, believing this to be the advantage of his landscape art over literature, arising not from words but from a more subtle and graduated legibility. Riverside was also a limited venture, however amplified by its

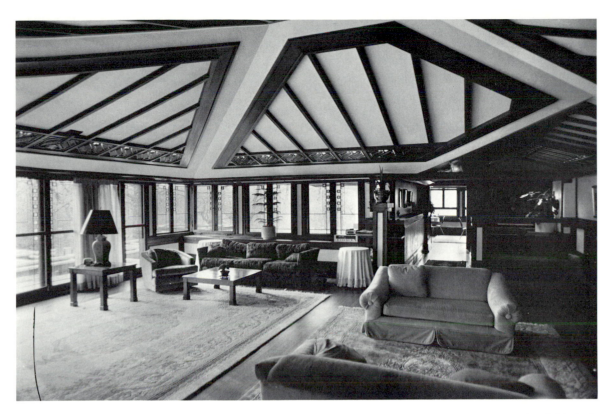

15. Ceiling of the Coonley House living room before the fire of June 11, 1978. Two rows of lights behind the grilles animated it at night (T. A. Heinz).

supplementary devices of generous scale, such as the Coonley House living room or the porch of Jenney's Cross House at 144 Scottswood (Fig. 1, Pl. 8). From the latter one does not look too far down, or out, only about as far as Olmsted intended for inhibiting wanderlust, giving no ready access to the horizon. Everything is even and modulated, nothing alarms by its conspicuousness, or goes too soon out of balance. As Charles Beveridge pointed out in his analysis of Olmsted's styles of the Pastoral and the Picturesque, the landscape architect was inclined to use darker forms close up, and lighter, less distinct ones farther away.[56]

This was to make the latent distance more "obscure." Riverside's major theme was of a pastoral tranquility, but a minor goal was to prove it "in a moderate way, positively picturesque."[57] The rest of the country, because of the Civil War and subsequent urban growth, had become too obvious, garish, multicolored, and boisterous. A quieting catalyst of a uniform green lawn, with only a little distraction of mystery at the borders, was plainly needed. The repose of the scene eventually yielded a positive purpose. It was a microvision of a yet smaller kingdom within a region, a model of what America might become if properly shaped and outlined by precocious artists and intellectuals.

[56] Beveridge, "Olmsted's Theory of Landscape Design," p. 41.

[57] Olmsted, *Preliminary Report*, p. 25.

The model suburb revealed that there was a possible consensus on how to live in a limited green space, of how to settle in where there had been no true enclosure or settlement before. It was easier in the Midwest to bring up the issue of increasing consciousness of manmade spaces and artificial objects, since there were previously so few natural givens to distract the attention. The open prairie actually gave the signal for Riverside, but just as in Wright's Broadacre City, it was transliterated in passing. It was not an "efficient" plan. Rather, it was a harmonious plan, without definite axes. The railroad line and Grand Avenue were not proper axes because they implied movement out of the suburb and into a much less desirable world. Olmsted himself had said of Riverside that "when contrasted with the constantly repeated right angles, straight lines, and flat surfaces which characterize our large modern towns, [it is bound to appear] thoroughly refreshing."[58] The yellow and blue greens of the ubiquitous foliage were fused, and the tree masses tapered off to where the lawns and roads spread continuously before them. The anxious avenues of American imaginative exploration and spec-

ulation were, for once, quite closed off, so that everyone within this particular place began to be more comfortable and content, with less of the urge to go on to ultimate distress.[59] Like Yosemite Valley of the Far West, Riverside was a genuine sanctuary, which dispensed an elixir for the recovery of self-confidence, except that this time the walls were neither of dramatic buildings or mighty cliffs, but clusters of simple trees. While the low trees massed in, the verandas, overhangs, and bays projected outward in a random attempt at achieving a consensus, an encounter within a deliberately limited precinct made quietly and conspicuously tangible on all sides.

[58] Ibid.

[59] That the suburb was not solely a design problem, as it has often been thought since, but also represented a crisis of the American conscience, is seen in the writing of the time, particularly that from Edward Everett Hale (author of *The Man without a Country*) and William Dean Howells, both then of Boston. After his *Sybaris*, a novel about achieving social reform through suburbs (1869), Hale visited Riverside. At the end (p. 48) of the 1871 Riverside prospectus there is a quote from his *Old and New*, singing the new suburb's praises. Howells, in his *Suburban Sketches* (Boston: J. R. Osgood & Co., 1872), p. 12, simply cannot get used to the comfort and security the new form offers, particularly when veterans of the Civil War come to his door in the suburb, with limbs missing, asking for handouts.

Wright's Taliesin and Beyond

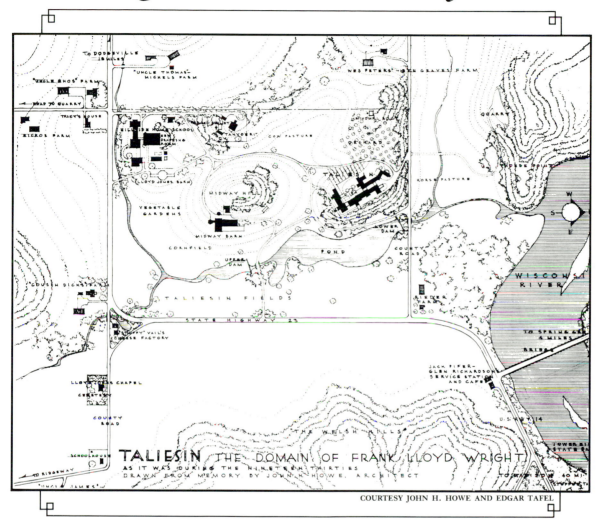

COURTESY JOHN H. HOWE AND EDGAR TAFEL

AMONG American architects of any time, Frank Lloyd Wright was the most committed to architecture as it applied to nature and the landscape. To be sure, he created brilliant designs for cities—the Guggenheim Museum, the National Life Insurance project, the Mile High Illinois, but his most prolific invention was reserved for the suburb and farmland (see map). It is necessary through those removed locations to ask how far he was driven psychologically from Chicago—to Taliesin, from Taliesin to Japan, to California and Arizona, or how much social content his more distant work finally retained.

What makes it difficult to absorb the legend of Wright into the conventional lore is that he often chose spaces which were not normally considered fashionable land-

scapes for the exercise of architectural skills as great as his—not the city, but the suburb, the hidden valley, the fertile field, and the remote desert. Did he follow the more native and persistent strain in American architecture, or did he lead his followers too far from the mainstream? He did not seem to care for the present. Was he able to join past and future, about which he was more concerned? What were his specific siting methods for making his contemporaries feel comfortable and safe, and yet more dignified and important, in the rapidly changing last half of the nineteenth and first half of the twentieth century?

THE valley south of Spring Green, Wisconsin, which Frank Lloyd Wright called home, was intended to be "a hope and a haven," where he could have a new beginning and end. Here, world disruptions, failures of omission or commission, and censures of his personal conduct were not to interrupt his creativity. Wright's autobiography "begins with a lyric depiction of the family farm where he was born in 1867 and ends with his vision of Broadacre City," with these "two agrarian tableaux" forming the "prologue and the epilogue of the story of his life."[1] The farms in the valley were small and real, but Wright interpreted them in an abstract, universal way. The Broadacre vision of an ideal community was patently unreal, but he spoke of it as if it were entirely feasible. He obtained more meaning by not being too literal.

Taliesin Valley is a modest size (Fig. 1), only two miles long and half a mile wide, but of customary midwestern dimensions, where the riverways, except for the huge Mississippi, Missouri, or Ohio rivers, move slowly through the land. The peripatetic surveyor Josiah Whitney of California fame, looked the state over in 1859 and described this locale from nearby Mineral Point as "a splendid farming region, rich rolling prairie, with plenty of groves scattered through it; ledges of rock handy, and no stones scattered over the soil—those domicks which dull the New England husbandman's tools so effectually."[2]

Wright described the basic contours of the Valley: "Lovable as it was, lying fertile between two ranges of diversified soft hills, with a third ridge intruding and dividing it in two smaller valleys at the homestead and continued as a wider stream on its course toward the [Wisconsin] River."[3] The hills rise only 200-400 feet above the floor of the Valley (Fig. 2), but it is an immediate rise. Thus there is a sustained and restful horizontality but also a backdrop of upright alertness. An aperture opens into the broader east-west Wisconsin River Valley, straight north to the town of Spring Green, four miles away. Through the aperture one can perceive more hills rolling along. Above, the sky remains brilliantly open. Mary Ellen Chase, a writer from Maine, affirmed this sky in her account of three years of teaching at the Hillside Home School of Wright's aunts Nell and Jennie, "We were watchers of the skies there."[4]

Wright's grandfather, Richard Lloyd-Jones, brought his family on the journey in-

[1] Robert Fishman, *Urban Utopias in the Twentieth Century* (New York: Basic Books, 1977), p. 97. Professor Fishman is right about the birth year, June 8, 1867, although Wright and his family favored 1869 (see Thomas S. Hines, Jr., "Frank Lloyd Wright— The Madison Years," *Journal of the Society of Architectural Historians*, XXVI, 4, December 1967, pp. 227-228), but Wright was not born on the family farm, rather in the nearby town of Richland Center.

[2] Letter to William Dwight Whitney, May 27, 1859, in Edwin Tenney Brewster, *Life and Letters of Josiah Dwight Whitney* (New York: Houghton Mifflin Co., 1909), p. 174.
[3] Frank Lloyd Wright, *An Autobiography* (New York: Duell, Sloan and Pearce, 1943), p. 5.
[4] Mary Ellen Chase, *A Goodly Fellowship* (New York: The Macmillan Co., 1942), p. 121.

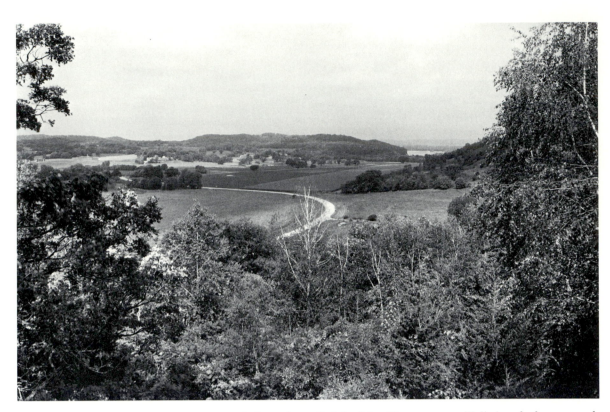

1. Taliesin Valley, Wisconsin, looking north from the roof of the John Howe cottage. Taliesin, the house, can be seen above the corner of the road. The chapel is in the little grove on the Ridgeway Road. The Midway barns are above it (Thomas A. Heinz).

land from New York City up through the Hudson Valley in December 1844, when A. J. Downing was in his prime, and the trip furnished a joyful premonition. "The brighter the sparks, the faster they went, up the Hudson past the great walls of the Palisades, Bear Mountain, High Tor, and on through country that reflected almost two centuries of agricultural settlement. The farms were sturdy and self-respecting, the fields fenced. There were cattle in the frosty pastures; orderly orchards, bare now, but healthy. Everything seemed promising, and the trip was a joy that they never forgot."[5] Like Jefferson, Wright never complained about the shortcomings of his inherited territory. With a house on a hill, they both could overlook the everyday changes, or follow the work of generations. Wright noticed that "landscape itself changes outside the windows as the sea changes, only these valley changes are more immutable than the sea, I think."[6] Wright, like Jefferson, was nurtured on the private "sea view" of his landscape; which was not actually beside the sea, but was assumed to share in its ever-shifting, mysterious, and rejuvenating character. The difference from Jefferson's sea view was that the passing hills came much nearer here, the "waves" splashed closer to the shore. There was less anticipation of what might happen in the nation at large

[5] Maginel Wright Barney, *The Valley of the God-Almighty Joneses* (New York: Appleton-Century, 1965), p. 30.

[6] Wright, *Autobiography*, p. 370.

2. Taliesin Valley in winter, before 1911. On the lower hill in the middle distance, Taliesin will eventually be built. At its foot the roofs of Uncle John's mill can be faintly seen. Above and beyond is the stone quarry, from which the material for the house was taken. The hill at the left is Midway (Probably by Frank Lloyd Wright, State Historical Society of Wisconsin).

than with Jefferson, since so much had happened during the nineteenth century and been found wanting by Wright. Both men were optimistic in their formulations, but while Jefferson strove to set up a correct model, Wright prepared a corrective last, to improve on unfortunate directions already taken. Much of Wright's impatience in this valley was also expressed over an impending loss of American individuality, even though he regretted the raggedness of the places into which the individualistic pioneers had sometimes settled in their compelling desire for freedom. Wright frequently referred to his grandfather's need for independence, as a Welsh heretic preacher.

The image was of a small Wisconsin valley belonging to a large Welsh family, "The God-Almighty Joneses." Wright was often familial, and eventually communal, in his self-centeredness, whether within the confines of Oak Park, in the Taliesin Valley, or in contemplating the supreme model of Broadacre City. A genius was to unfold in unlikely places. He took great pride in the fact that he could view the former farms of all five of his maternal uncles from the grounds of the Hillside Home School of his aunts, which was also the location of his

grandfather's original house, The Homestead, a quarter mile to the south and around the bend from his own later house of Taliesin. The balance he sought was between the past of a working farm and the future of an ideal society, also agrarian. The Valley would be a historical entity, a crucible into which different essences of time might be poured to see what bubbled up. The ocean-like feel of successive rhythms in nature, carried on the rising swells of time or space, would be indispensable to the process of reunification. The final ensemble[7] provided such a varied means of pictorial expression: "a rich pattern of woods, pasture, and plowed fields, dotted with red barns and laced with little winding rivers. It is quiet country—lush, heavy green in the summer, white with black trees and violet shadows in winter."[8] The trees were mostly second-

[7] At one point Wright bought 3,000 acres of the Valley, most of which were not contiguous to the Taliesin property. It was obtained as an endowment for the school. Approximately 600 acres remain in the possession of the foundation. Norman D. Hellmers, Thomas G. Balsanek, Randall J. Biallis, "Reconnaissance Survey: Taliesin, Spring Green, Wisconsin" (Omaha: National Park Service, 1980), mimeograph, p. 7.
[8] George Nelson, "Wright's Houses," *Fortune*, XXXIV, 2, August 1946, p. 117.

growth red and white oak and hickory, interspersed with soft red cedars and the bright chalk marks of birches. The succeeding seasons confirmed the impression of winning the Valley over and over. Below the tree cover came the cultivated fields. The Hillside Home School, the Midway Farm barns, and Taliesin itself, south to north, sit into the mounts in the center of the main valley on the third "ridge intruding," as Wright described it. He alluded to the seven hills of Rome with admiration in his writing. Above the Hillside Home School appears his Romeo and Juliet windmill of 1896, the highest object in the Valley, shown proudly in a photograph by him (Fig. 3). Immediately beneath was the summer home, Tan-y-deri ("Under the Oaks" in Welsh), of the architect's sister Jane (Mrs. Andrew Porter), designed by Wright in 1906 on four acres of Uncle John's former farm at the top of the hill.

A consistent shelving effect from the placement of these buildings in another carefully adjusted photo, probably by Wright for his aunts' school catalogue, recalled the stepped seating of a Classical theater (Fig. 4). From the Taliesin terraces one could look down on the progress of the seasons in the meadows below. The relation of audience to action was critical. Wright described how this proximity affected him: "Its elevation for me was the modeling of the hills, the weaving and the fabric of the woods that clung to them—the look of it in tender green or covered with snow [Fig. 2] or in full glow of summer that burst into the blaze of autumn. I was part of it."[9] His affection for the valley was partly because it gave room for dramatic interpretation. His sense of his family's destiny within it was very keen, and later intensified by the tragedies of the burn-

ing of Taliesin in 1914 and 1925, with the simultaneous murder in 1914 of his mistress Mamah Borthwick Cheney and her children by a berserk servant. This event was Grecian in magnitude. Such events were explained by him as tragedies of place. He spoke of his own fate only indirectly, and more about what the spirit of the place suffered. Soon after he brought Mrs. Cheney there, he tells us, "Taliesin raged, wanted to talk back—and smiled,"[10] against the outside slander.

The descending, stepped, theatrical rhythm of the Hillside Home complex below Romeo and Juliet was doubtless an early inspiration for the siting of the Taliesin house. Invisible radiants down from the sky or up from the meadows, focusing on the buildings, appear to justify his selection of a name for his house: Taliesin meant "shining" or "radiant brow" in Welsh, and indeed the meadows seemed to shine upward in the fall with their ripened crops. There was a tactile interdependence between nature and man in this Valley. Mary Ellen Chase thus described a typical Sunday gathering in the Lloyd-Jones chapel (Pl. 13): "Whether Uncle Enos, Aunt Nell, or Aunt Jennie was the preacher, or whether through them we heard words of Theodore Parker, William Ellery Channing, William Gannet [sic], or Ralph Waldo Emerson, the service was the same in its simplicity and reality. We were all there together in the silence of the fields without, covered with snow or springing into life."[11] An ambient, for once, paralleled the inner occupations and deeper thoughts of the inhabitants. The Unitarian chapel, east down the gently curving road from the Hillside Home School, was designed and built in 1886 by J. L. Silsbee, Wright's first employer in Chicago in 1887. It looks more like a truncated summer cottage than a tradi-

9 Frank Lloyd Wright, "Taliesin: The Chronicle of a House with a Heart," *Liberty*, 6, 11, March 23, 1929, p. 22.

10 Ibid., p. 26.
11 Chase, *A Goodly Fellowship*, p. 112.

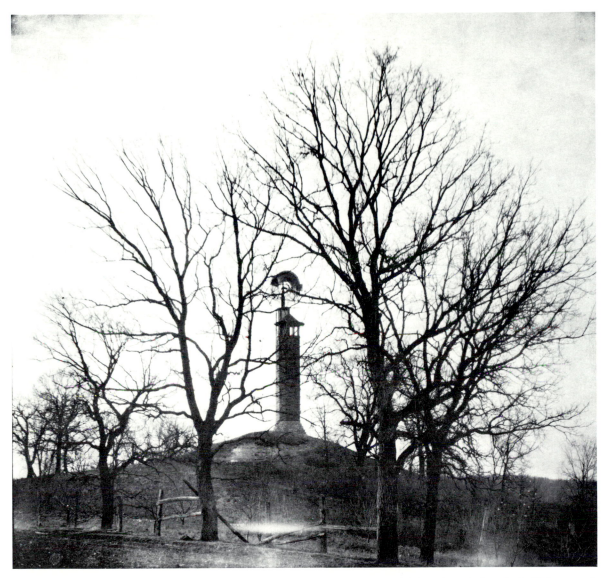

3. The Romeo and Juliet Windmill, Frank Lloyd Wright, 1896. The careful framing of the windmill by trees is typical of Wright's compositional sense in landscape (Photo by Wright, Historical Society of Wisconsin).

tional church, but with its burial ground, it could be seen southeast like a village church from Taliesin, from beginning to end of the Valley. When in the chapel,[12] the family in-

[12] An account of the chapel in connection with Wright's Lloyd-Jones family is in the *Frank Lloyd Wright Newsletter*, 3, 2, Second Quarter, 1980, pp. 1-4, by Elizabeth Wright Ingraham. It is also very good on the Jenkin Lloyd-Jones relationship.

evitably wept at a classic reading, a poem or song, or at the preaching of Uncle Jenkin Lloyd-Jones, visiting from his own Unitarian church in Chicago. When ceremonies took place, it was decorated with native flowers and branches, many of which were gathered by the youthful Wright, who also supervised the interior layout.

The family affinity for special, if informal,

4. The Hillside Home School complex. At the top of the hill is Romeo and Juliet. Tan-y-deri is slightly to the right of it, behind the trees. Directly below is the school building Wright built for his aunts in 1901-1902. In the upper right is his first commission, the Home Farm House, which became the first unit of the school in Queen Anne Shingle Style in 1887. Over it is a more conventional windmill. This was the past location of his grandfather's house, the Homestead. To the right is the roof of his grandfather's hexagonal barn. Wright had his apprentices demolish it in 1933 (Historical Society of Wisconsin).

arrangements, interwoven with nature, was encouraged by the curriculum of the Hillside Home School. For that enterprise Wright first designed the Home Farm House for his aunts in 1887, and the larger classroom and dormitory unit to the south in 1901. Tree and bird study, flower and nut gathering, and sky watching were legitimate investigations for the pupils there, in addition to the conventional subjects. Chase spoke of it as "a school as well as a farm and a home."[13] This was also the character of

Wright's own apprentice school, which he began by refurbishing the same large classroom and dormitory building, by then deserted, in 1932. His aunts had sold it to him in 1915 for one dollar.[14] Genuine creativity never seemed to spring out of only one experience or branch of knowledge as far as either generation of teachers was concerned, but required instead a mutual reinforcement from all such encounters.

From beyond the Valley came the impression that other immigrants had been less fortunate, had indeed blundered into the giant,

[13] Chase, *A Goodly Fellowship*, p. 115. Another account of life at the school is Florence Fifer Bohrer's, "The Unitarian Hillside Home School," *Wisconsin Magazine of History*, 38, 3, Spring 1955, pp. 151-155.

[14] Letter to author from Bruce Brooks Pfeiffer, Director of Archives, The Frank Lloyd Wright Memorial Foundation, October 3, 1980, p. 2.

hollow, reverberating, shell of Chicago, or other major cities, where they could no longer feel or see enough. Here they were supposed to see and feel everything. Taliesin Valley represented a reaction against midwestern bigness, whether industrial, political, or agricultural. By becoming landholders in a hidden valley, instead of urban immigrants, or big farmers, by being drawn straight to husbanding the soil, and the distinct virtues of a more particular place, the Lloyd-Jones family had come to belong. Wright's proprietary attitudes toward the land were therefore not only those of a native son, as so often portrayed, but also those of an immigrant's grandson. He proudly affirmed that "Grandfather's spirit lived on in a typical emigrant [sic] establishment on virgin American soil. A little Welsh clan, by himself set in this little corner of that enormous new ground dedicated to Freedom, and parceled out among all the breeds of the earth, stayed there with the ground."[15] The Lloyd-Joneses, in a manner of speaking, had arrived spiritually in America that much sooner. This priority even led to a more suitable architectural form, according to Wright: "There must be some kind of house that would belong to that hill as trees and ledges did; as grandfather and mother had, in their sense of it all."[16]

This same withdrawal into nature in alien circumstances could be witnessed in the career of the Danish landscape architect of the Chicago park system, Jens Jensen, who worked with both Sullivan and Wright, and who left public service in disgust over Chicago politics to found his own landscape school, The Clearing (to "clear the mind"), at the top of the Wisconsin Door County peninsula in Lake Michigan. Jensen purchased the property in 1919, but got underway with it only in the early 1930s, as

Wright also did with his school.[17] The pioneer need to begin over again recurred in education at the outset of the Depression in the 1930s. John Muir, the naturalist writer and polemicist of Yosemite, also came from an immigrant Scottish farm family around Kingston, Wisconsin, north of Madison. Muir, like Wright, attended the University of Wisconsin sporadically, and was often brilliant while there. His fear of great cities caused his retreat into the Yosemite Valley to conserve, commune with, and write about nature. The uncertainty and anxiety over what America would become deeply affected the Midwest's immigrant sons—Wright, Jensen, Muir, Carl Sandburg, Theodore Dreiser, and Thorstein Veblen among them. Landscape and architecture were two logical modes with which to express this, because they belonged to the earth, were less transient. It was not the specific ethnic background of these individuals that mattered, but rather their arrival in a chronically unstable milieu, which did not appear to know what to do with the arts or the artist. The issue was not the survival of ethnicity, but the fate of artistry.

THE REACTION TO CHICAGO AND THE SUBURBS

Wright's flight to Europe in 1909 with Mrs. Cheney was not the isolated and impulsive act that it has sometimes been described. There was a sustained pattern of behavior behind it from Madison to Chicago in 1887, from Chicago to Oak Park shortly thereafter, then to Europe, and back to the Taliesin Valley in 1910-1911.[18] Eventually it led to

[15] Wright, *Autobiography*, p. 8.
[16] Wright, "Taliesin," p. 22.

[17] See Mertha Fulkerson and Ada Corson, *The Story of the Clearing* (Chicago: The Coach House Press, 1972), pp. 11-14, and Leonard Eaton, *Landscape Artist in America: The Life and Work of Jens Jensen* (Chicago: University of Chicago Press, 1964), p. 211ff.
[18] See Wright, *Autobiography*, p. 167. How Wright came to take over this property from his mother is not

Japan, California, and Arizona, and ultimately to the schematic, ideal Japanese print and the ideal of Broadacre City. While other architects were striving to reinforce their first attempts in Chicago from the older cultures of Europe, Wright began in the opposite way, by seeking validity from everywhere except the European tradition. In his view, and contrary to any previous European timetable, decadence had arrived in Chicago ahead of its proper moment, and with no golden age preceding it. Hence he would have to make up his own arcadian age to offset it.

According to Morton and Lucia White, writing in the 1960s, "Even city-lovers who are irritated by his ideas must pay him the compliment of admitting that he saw and concerned himself with many of the problems of today's exploding metropolis."[19] Actually Wright was more concerned with recurring urban imbalances than with the "exploding metropolis," which often suggested standardized, blanket solutions such as public housing, mass transport, or Federal redevelopment. His own solutions were more flexible, less standardized, and covered more urban experience, and the root question with him was always how individuality might best be served in any setting, urban or rural.

Wright found Chicago impersonal and brutal when he first arrived as a youth from Wisconsin, and he never got over the David and Goliath scale. However, his response was by no means unique. The poet William Vaughan Moody and the novelist Robert Herrick, both recent arrivals from Harvard, also set out to resist the "cheapening ferocity" of Chicago.[20] Herrick's novel *The Common Lot* (1904) about Hart, a young architect who sacrificed everything, including his integrity, represented the city as a Moloch devouring ambitious young men. Worse, the city destroyed his curiosity, the most dangerous confiscation for him and his clients. His wife "saw, as never before, how Chicago had moulded him and left his nature set in a hard crust of prejudice. The great industrial city where he had learned the lesson of life throttled the finer aspirations of men like a remorseless giant, converting its youth into iron-clawed beasts of prey, answering to the one hoarse cry, 'Success, Success, Success!' "[21] The city not only threatened to mechanize, and ultimately to fossilize, his individuality; it had previously numbed his desire to reach for the highest and best result, to follow the call to urbanized beauty. It had remolded him into the lower form of opportunist and technician: "Though Hart had learned much in the past six years, it had been chiefly in the mechanics of his art: he was a cleverer architect, but a more wooden artist."[22] This was the opinion of Wright, an older architect, given no first name in the novel, after viewing Hart's major project up to that point.

clear, although all authors, including Wright, agree that he was first doing a cottage for her on the site, and that it reverted to him in 1911. She bought the land on which Taliesin stands from Joseph Rieder on April 10, 1911, for $2,274.88 (Iowa County Registry of Deeds, Dodgeville, Wisconsin). The initial document in the Taliesin Archives is 1104.01, a blueprint for a first-floor working drawing, entitled a "Cottage for Mrs. Anna Lloyd Wright," dated April 1911. It is accompanied by other details of April and elevations of June. These drawings led directly to those of Taliesin I. She does not mention the property in her will of 1920, made out in Tokyo (information from B. B. Pfeiffer, Wright Foundation).

[19] *The Intellectual versus the City: From Thomas Jefferson to Frank Lloyd Wright* (Cambridge, Mass.: Harvard and MIT Presses, 1962), p. 190. For another view of Wright's reaction against Chicago, which disagrees only slightly with the interpretation of the Whites, see Lionel March, "Imperial City of the Boundless West," *The Listener*, 83, 2144, April 30, 1970, pp. 581-584.

[20] Larzer Ziff, *The American 1890s: The Life and Times of a Lost Generation* (New York: Viking Press, 1966), p. 322.

[21] Robert Herrick, *The Common Lot* (New York: Macmillan Co., 1904), p. 406.

[22] Ibid., p. 262.

Would every action in Chicago breed an equal and opposite reaction? Would the ethic turn esthetic in a vain effort to overcome ugliness on all sides, auspiciously present and possessing the largest dimensions? The length of time that Wright's original reaction to Chicago sustained itself is particularly meaningful. Since he did not want to become merely a technician, he would have to move away and become a genius instead, setting honest arrogance above hypocritical humility, as he put it. The stressful Chicago setting implied that the individual might become a reborn Christian, like Hart, returning from Vermont (a seat of traditional virtue, we are told) to face the highly doubtful courts of Chicago; or he might flee the city, with his self-respect intact.

That a less tainted setting was wanted seems evident even from young businessmen, whose first refuge from the city was the club: "As soon as the day's work was over, their natural instinct was to flee from the dirt and noise of the business street, where the club was situated, to the cleaner quarters north or south, or to the semi-rural suburbs. Thus the centrifugal force of the city was irresistible."[23]

This "force" was capable of driving participants even farther away than the suburb, otherwise the last stop on the elevated or train, as Oak Park was. In Will Payne's novel *Jerry the Dreamer*, a young wife visits for a vacation her father at Broad Lake in Wisconsin. Her husband, like Hart, worked too hard and fruitlessly in Chicago. When the time came to return to the city, the refuge appeared even more appealing: " 'I ought to be awf'ly glad I'm going back home.' . . . '—only—well, it's so real in Chicago, you know: so brutally real. This isn't real at all; it's a lovely fairy story. You couldn't run street-cars and build sky-scrap-

ers and have rough granite pavements in this air—they'd simply melt away. . . . We like the beautiful far-away nowhere. And this is that.' "[24] The roiling steam of Chicago, swirling around the harsh realities, unmanageable through any means so far devised, would inevitably produce an explosion away from the city toward "the beautiful far-away nowhere." Hard to accept for Americans, then or now, was the evidence that the environment could actually twist or harm lives. Of his first marriage, Wright said that "when life there in the city in the spring of 1909 conspired against the freedom to which I felt every soul entitled, and I, thirty-nine years old, had no choice, would I keep my self-respect, but to go out, a voluntary exile, into the uncharted and unknown . . . get my back against the wall and live . . . I turned to the hill in the valley as my grandfather before me had turned to America."[25]

More surprising than his flight to Europe with another man's wife in 1909 is the fact that Wright can also be charged with being too moderate at first, toeing the line, right in the midst of the city. Wright has been seen as a bellwether for other Chicagoans in the Union Park District,[26] on Chicago's fraying western edge toward Oak Park. Within two years after he arrived in Chicago at eighteen, he had applied himself to marriage and the procreation of six children. He installed himself in an "intense" family situation out of disorientation, fear, and anomie. He undertook no premarital wandering, and married "one of the first girls he ever dated."[27] Unfortunately, "This marriage was a disaster for him later in his life, when Wright

[23] Ibid., pp. 52-53.

[24] (New York: Harper & Brothers, 1896), p. 204.

[25] Wright, "Taliesin," p. 22.

[26] Taking care of the tiny Union Park grounds was Jens Jensen's first job in the Chicago Park System (Fulkerson and Corson, *The Story of the Clearing*, p. 10).

[27] Richard Sennett, *Families against the City* (Cambridge, Mass.: Harvard University Press, 1970), pp. 192-193.

came to recognize it to be born out of fear, and the need to be immediately secure. . . . his founding of a family, as a bulwark against the new and alien social life in the city was something shared by the dominant group of Union Park family men."[28] In fact, much of the middle-class attitude toward Chicago in the 1890s derived from a sense of actual physical threat, particularly present in the late 1880s.[29] The peaceful Union Park residential area, where morality, intellectual excellence, and primness had previously flourished,[30] was the scene of an "epidemic of violence" during 1886 and 1888 (Wright arrived in the city in 1887), the type of change that, again, many Americans do not normally like to recognize, even when its happening. The Haymarket bombing of the police occurred on May 4, 1886, at the eastern edge of Union Park. Within, families withdrew "from the confusing, dynamic city that was taking shape all around the confines."[31] Sociologists concluded that these "cities were powerful agents of change, precisely because they replaced the controlled social space of village and farm life with a kind of human settlement too dense and too various to be controlled."[32] People felt that they belonged less, a feeling made plain by Theodore Dreiser in *Sister Carrie* (which he wrote while living in Union Park). There was an uncontrolled spread occurring from a large city, and Union Park was in its way. Oak Park, Taliesin Valley, and Broadacre

City, inner arrangements meticulously organized and contained, would each exhibit a large measure of retrenchment from the Chicago that Wright first saw in the 1880s, rather more than from what he saw in the 1930s, or the 1960s, when the Mortons thought he had taken measure of the urban situation.

At least four of Robert Herrick's novels came to a peak with a conflagration. In *The Common Lot*, a great hotel fire kills numbers of people through Hart's negligence. This novel was serialized in *The Atlantic* magazine at the moment of the actual Iroquois Theater fire in Chicago on December 30, 1903, from which Wright's two sons and mother-in-law were delivered into his white-smocked arms on the sidewalk.[33] That he responded to such catastrophic signals appears evident from the fact that he took extreme pains to make the Larkin Building in Buffalo of the next year as fireproof as possible, and in the next few years was often occupied with ideal designs for completely fireproof houses.

Sennett has remarked that Wright also put considerable emphasis on the "privatistic," or secluded and sheltering, character of his houses in Oak Park.[34] This emphasis is recognizable in their hip roofs, shadowing eaves, low ceilings, inner courts, altering axes, intimate inglenooks, and hidden entrances. Wright's collaboration with William Winslow (his client of 1894 on the remarkable Winslow House), during the winters of 1896 and 1897 in a private edition of *The House Beautiful* by William C. Gannett, Unitarian minister and friend of his Uncle Jenkin, emphasizes this goal, for it was supposed to move the reader to greater family harmony and "Dear Togetherness." But the suburban locale, despite its ostensible charm, turned out to be more consuming of

[28] Ibid., p. 193.
[29] Richard Sennett, "Middle-Class Families and Urban Violence," *Nineteenth Century Cities*, ed. Stephen Thernstrom and Richard Sennett (New Haven: Yale University Press, 1969), pp. 386-418.
[30] Deborah Slaton, "Then and Now: The Story of Union Park and Its Environs" (Paper, Architecture 491, University of Illinois, Fall 1980, pp. 5-8), used H. C. Chatfield-Taylor, *Chicago* (Boston: Houghton Mifflin Co., 1917), pp. 54-60, as her major source for this impression of the elevated first character of the Union Park area during the 1850s and 1860s.
[31] Sennett, "Middle-Class Families and Urban Violence," p. 410.
[32] Ibid., p. 417.

[33] John Lloyd Wright, *My Father Who Is On Earth* (New York: G. P. Putnam's Sons, 1946), pp. 46-48.
[34] Sennett, "Middle-Class Families and Urban Violence," p. 410.

Pl. 13. Chapel, Taliesin Valley, Wisconsin, J. L. Silsbee (Thomas A. Heinz).

Pl. 14. Looking northwest in Taliesin Valley toward Taliesin, the house (T. A. Heinz).

Pl. 15. Valley from Taliesin living room (T. A. Heinz). The frames bring the landscape nearer.

Pl. 16. Broadacre City Model, F. L. Wright (Wright Memorial Foundation).

time and individuality than Wright had banked on.

A passage in *The Common Lot* parallels Wright's absorption in production and creation at this moment: "The architect was a good provider: he enjoyed heartily the luxury that his money brought him, and he wanted his wife to enjoy it with him. He worked at high pressure and needed his bread and meat well seasoned with excitement. Once, early in their married life, Mrs. Phillips had volunteered to explain to Helen the philosophy of this masculine temperament.

" 'Some men need more food than others. They'd mope and grow thin if they dined at home on a chop and went to bed at ten every night. They must have something to make steam. Your young man was born to be a spender.' "[35]

But for Wright a second mood succeeded this age of affluence and feverish productivity.[36] Chicago had been affirmative in its economic opportunities, none better, but where were its social guideposts for the community of the future? Was the suburb the only solution? Was something further needed? Another reason Wright "left Oak Park to settle in rural Wisconsin was lack of personal privacy, a high priority for him and for the American middle class at the end of the 19th century."[37] He was withdrawing from his previous frame of cacophonous reference to seek a greater personal calm and artistic independence and immunity.

REMOVAL TO TALIESIN VALLEY

After his return from Europe, Wright announced on Christmas Day 1911 that hence-

[35] P. 165.
[36] See Robert C. Twombly, *Frank Lloyd Wright: An Interpretive Biography* (New York: Harper & Row, 1973), p. 102.
[37] Robert C. Twombly, "Saving the Family: Middle Class Attractions to Wright's Prairie House, 1901-

forth he and Mrs. Cheney would live at Taliesin. In Europe Antonio Gaudí was taking refuge in his Sagrada Familia church in Barcelona, beginning in 1906, as a reaction against the regimentation of the block plan of Ildefonso Cerda of 1859 for the expansion of Barcelona, as reiterated by Leon Jaussely in 1902. In the north, Eliel Saarinen had withdrawn to his Finnish arts and crafts colony of Hvitträsk (1902) on a lake some distance from the center of Helsinki, and he was later to found the Cranbrook art colony at Bloomfield Hills outside Detroit in the mid-1920s, where he became a friend of Wright's. These men were regarded, from central Europe, as on the very brink of the significant artistic world. At the same time, this ring of entrenched individualists, in which Wright should be included, although Taliesin comes a little later, was engaged in weaving cocoons about themselves. They assumed the worth of their activity to lie in the core of personalization, often accompanied by the presence of handicrafts in their buildings. It was not the display that mattered, however; the main purpose was documenting integrity and sincerity in a dishonest and wicked world, and hoping it had not been done too late.

The topography of the Taliesin Valley is distinguished by extended digits of hills between frequent hollows. Yet the upper rim of the Valley established a fairly level horizon, if one ignores for a moment the picturesque, rolling contours underneath, which make up the configuration of the Greek theater effect. The result of horizontal uniformity and variety is indicated by early views of Taliesin from the Hill Top Wing or from the stable roof down into the household courts (Fig. 5). These courts are a microcosm of the total enclosure of the valley itself. The roof drop of four feet in twelve feet of length is calculated to repeat the fall of the surrounding hills, which are close enough to participate in the visual mix of the domestic quar-

5. Courts of Taliesin I, c. 1912 (Architectural Record).

ters. One becomes aware of these relationships only by stages. Wright described Taliesin I in this way: "A clump of fine oaks that grew on the hilltop stood untouched on one side above the court [Fig. 5]. A great curved stone-walled seat inclosed the space just beneath them, and stone pavement stepped down to a spring or fountain that welled up into a pool at the center of the circle. Each court had its fountain and the winding stream below had a great dam of stones thrown across it, to make a pond at the very foot of the hill, and raise the water in the valley to within sight of Taliesin."[38] The final step in empathy from the hills down to house was to focus attention further on the water immediately below the

house. It was free form, unusually large, and also the only artificial element in the valley. It was fed by Jones Creek (Fig. 6), otherwise known as Lowery or Van Blarcum Creek,[39] and was entitled "The Water Garden" on the first map of Taliesin (Fig. 7), drawn and published by C. R. Ashbee of the English Arts and Crafts Movement after his visit in 1911,[40] the year Wright returned with Mrs. Cheney and the house was begun on the hill. The meadow below was the site of Uncle John's original mill, to the left of the first dam. This was also the location of some of the barns, later moved halfway up Midway Hill, and linked.[41] The stream had been

1909," *American Quarterly*, XXVII, 1, March 1975, p. 65.
[38] Wright, "Taliesin," p. 22.

[39] Letter to author from B. B. Pfeiffer, October 28, 1980.
[40] C. R. Ashbee, "Taliesin, The Home of Frank Lloyd Wright and A Study of the Owner," *Western Architect*, XIX, February 1913, pp. 16-19.
[41] This information was given me by John H.

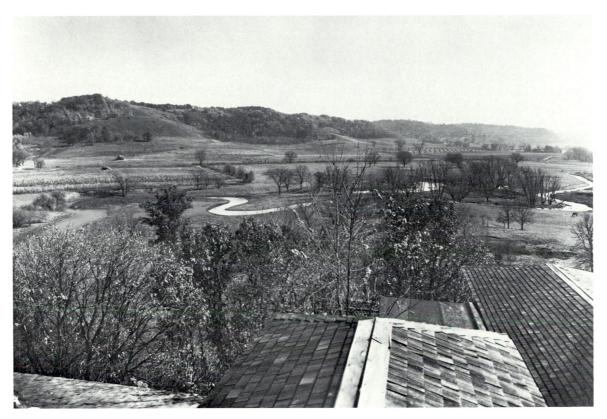

6. *From Taliesin looking south, before 1917. Jones Creek meanders through the meadow before the second dam was put in (H. Fuermann, Crombie Taylor Collection, courtesy T. A. Heinz).*

more heavily dammed by the time Ashbee arrived, and there was to be another dam placed higher up the stream in the late 1930s, which was then called the Upper Dam.[42] It added much more mirror (Figs. 8-9). From the ponds water was pumped by hydraulic rams up to a stone reservoir just above the hilltop garden,[43] which kept the spigots, fountains, and vegetable and flower gardens supplied with gravity flow. Having established an esthetic hierarchy down to the last mirrored surface, Wright next attended to the angles of horizontal vision. He rotated

the main axis of the house off the east-west line to face southeast (Fig. 7), always resisting point-of-compass axiality. This initiative was climaxed by the Bird Walk off the living room, of 1953.[44] This device (Figs. 8-9) revived a feeling Wright had had about the hill since his childhood, and accounts for the floating sensation one gets within his personal quarters (as well as in the Kaufmann Falling Water house earlier in the 1930s in Pennsylvania). The hill without the buildings had made it possible to soar forth in imagination when he was a child. "When you were on its crown you were out in mid-air as though swinging in an airplane, as the three valleys dropped away leaving the tree tops all about you."[45] The skewed axis of the

Howe, Architect, Burnsville, Minnesota, once head of the drafting room at Taliesin, in a phone conversation of December 6, 1980. The exact location of the mill can be seen on the Wyoming Township Map of 1915.

[42] Letter to author from B. B. Pfeiffer, October 3, 1980.

[43] Wright, "Taliesin," p. 22.

[44] Date in letter to author from B. B. Pfeiffer, October 3, 1980.

[45] Wright, "Taliesin," p. 22.

house made it possible to savor the length of the valley from a height, to reach out into it, and at the same time to escape visually to the northeast along the wider corridor of the Wisconsin River Valley (Fig. 8). The contour maps demonstrate that this effect was not accidental, that Wright advanced his living quarters to the farthest promontory so as to look in two or three directions at once, and thus command the entire scene. The living room, ennobled by the length of the basic views, is then differentiated from, but does not break with, the four courts behind, any more than the vertical Hill Top wing does. Like Jefferson, Wright juxtaposed unlike units without allowing them to detract from each other conceptually. This eclectic way of combining elements was very American.

The distances are more empathetical than mathematical under Wright's aegis, as they were with Jefferson. Yet they represented neat, contained pictures. Neither Jefferson nor Wright, Downing nor Olmsted, could suppress their wonder over the American scene, but for them the novelty came in picture postcard size. At the same time, this proportioning stirred within them the uneasy conviction that the scene could not remain forever in that same mode or size, as was perhaps first evident in Downing's Dans Kamer reverie about the passing of the Indians as framed by the limits of Newburgh Bay. The custodial function of the architect was sure to prove difficult, if not impossible, to fulfill, when the country itself was altering and expanding so rapidly. In his eagerness to keep the postcard-sized novelty of his own landscape intact, Wright must have a dialogue with everything in sight.

The conspicuousness of the later pond below the house suggests an influence from the vogue for reflecting pools between 1900 and 1910, which culminated in that for the Lincoln Memorial in Washington, D.C. Wright

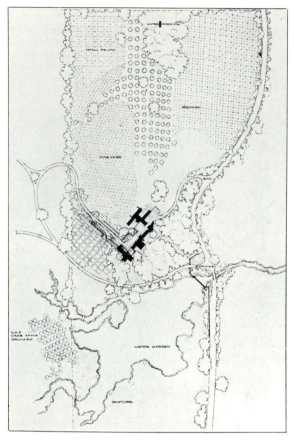

7. Layout of Taliesin I as seen by C. R. Ashbee in 1911. The grids below the house are vegetable gardens. The original south entrance is visible, as well as the first pool and dam (Western Architecture).

also connected water with the polished plate glass he was then investigating as an architectural medium: "The Mirror is seen in Nature in the surfaces of lakes in the hollows of the mountains and in the pools deep in shadow of the trees; in winding ribbons of the rivers that catch and give back the flying birds, clouds and blue sky. A dreary thing to have that element leave the landscape."[46] There was a need to catch everything on the screen of nature and render it poetic. The sky could be better observed by reflection in the water in periscopic fashion, and in so

[46] "The Meaning of Materials—Glass," *Architectural Record*, 64, 1, July 1928, p. 199.

256

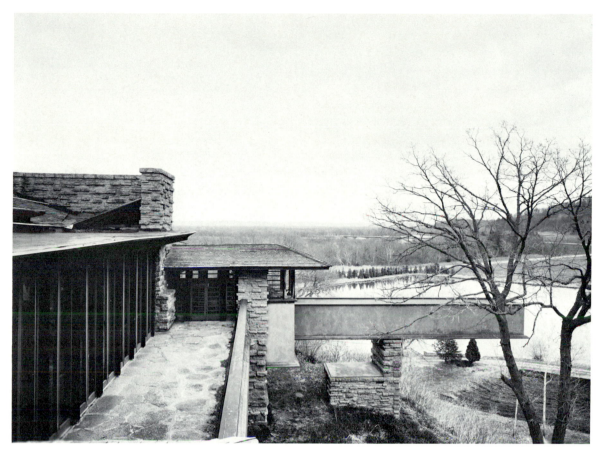

8. Looking northeast from Taliesin along the Wisconsin River. Wright had the bridge in the distance repositioned after the collapse of the previous one. He wanted it to be one of his butterfly designs, and from this distance it appears almost that way (T. A. Heinz).

doing it became bluer below (Pl. 14). On the Grand Prairie south of Wisconsin the dome of the sky and mounting clouds usually compose at least two-thirds of the open, expansive scene. But this part of Wisconsin was exceptional because the glaciers had passed it round; thus the hills were the two-thirds factor there. It was an older and more mature landscape, and more weathered. What transpired in the Taliesin Valley was hence an enrichment of the outer prairie effect. In the fall, when the grains are ripe and the leaves of the trees turning, the Wisconsin valleys appear to be of rediscovered gold (Pl. 14). Then one instinctively looks down from

the hills, catching the reflection of the paler sky in the bluer water, as well as taking in the golden fields. The freedom of the sky comes from above. On the prairie, one cannot look down, only forever out, as was noted in the "long" spiritual views from Graceland Cemetery in Chicago.

At Taliesin Valley, Wright removed some groups of trees, and planted hedges. Mrs. Wright encouraged him to augment her favorite trees, birch and pine, and many were placed in the valley after their marriage in 1924.[47] Wright furthered the notion that

[47] Letter from B. B. Pfeiffer, October 3, 1980.

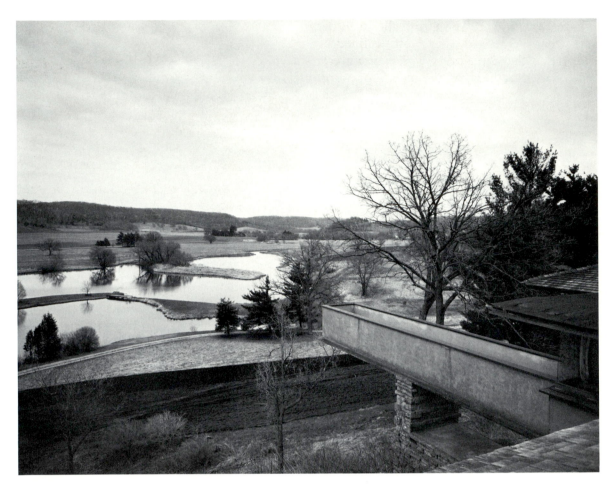

9. Southeast from Taliesin. The Bird Walk of 1953 is again prominent in the foreground. The chapel is in the grove at the end of the water (T. A. Heinz).

trees represented individualized totem poles of universal rhythms and the oversoul, which architects were called upon to excite. His attitude was Welsh, mystical, and Druidlike. He said of this sense affecting him in his boyhood in the valley: "And the trees stood in it all like various, beautiful buildings, of more different kinds than all the architectures of the world. Someday this boy was to learn that the secret of all styles in architecture was the same secret that gave *character* to the trees."[48] One could dismiss this metaphor about trees as idiosyncratic to

him, but one of the giants of Internationalism, Mies van der Rohe, also used it, and about Wright, of whom Mies wrote, "In his undiminishing power he resembles a giant tree in a wide landscape, which year after year, attains a more noble crown,"[49] and indeed midwestern oaks stand out against the horizon, or alone in the fields, or frame views, in the Taliesin Valley. Bruce Goff also likened Wright to a great tree, but one which he would rather contemplate at a distance than abide under! Wright asked Goff

[48] Wright, *Autobiography*, p. 27.

[49] An appreciation in the unpublished catalog of the Frank Lloyd Wright Exhibition of the Museum of Modern Art, 1940.

on three occasions to come to Taliesin to be his "second lieutenant," but Goff declined.[50] Muir had called the elderly Emerson a great tree at Yosemite, making the metaphor more an ornament of old age than youth. The tree was a symbol of long experience in the environment, of sustained dignity kept out in the open, with nothing to conceal. The alliterative quality of Wright's thinking can never be overestimated.

Wright advocated contour plowing, as Jefferson had. The farm roads and paths, on which he is sometimes mentioned or pictured on a grader pulled by a caterpillar tractor, are correspondingly curved to follow the contours of the fields and fit everything within a relatively small compass. As the valley is made to appear smaller and more interrelated, the range of referential experience in space or time can be greater. Wright must have striven mightily to overcome the thick pioneer mud and straggling lines and masses of the valley (Fig. 10). His lifelong devotion to sumptuousness and luxury may have been a reaction to this pioneer roughness and austerity.

He was greatly concerned with public byways and thoroughfares, which he could not control as much as his private land. He deplored the unsightly deep ditches at the sides. Where they were necessary, he wanted them kept clear of weeds, and he could occasionally be seen reworking their back slopes with his small road grader.[51] He preferred to have the field grass come all the way up to the highway, and he did not like the tree trimming of the power company.[52] He eliminated billboards on Route 14, along the Wisconsin River, which in the 1930s was

10. *Early view of road passing the chapel, looking west from Uncle James' farm. On the immediate left is the public school. Dimly seen to the right are the roofs of the Hillside Home School and the hexagonal barn, with the wings by Herman von Holst that Wright did not like (Courtesy T. A. Heinz).*

the main road from Chicago, carrying trucks and buses along a strip development to the bridge to Spring Green on the north side of the river. Any clutter or squalor disturbed him. On returning from a trip west in 1951 he objected strongly to a rural telephone line having been put up on Route 23.[53] He paid for the removal of two cross-arms carrying twenty-two strands of wire, providing horses to carry the materials into the woods to the east to reroute the lines, with student labor to help. On county road C to the north of his home, going east and west, he insisted that eight telephone wires not be placed on cross-arms, but instead be carried on brackets closer to the poles, which ought to be subsequently painted green to blend with the surroundings, "as it was once in certain areas in Europe."[54] He also negotiated with the Wisconsin Power and Light Company of Madison to bury its lines, including the one from the public highway up to Taliesin, hiding the rest in the woods as much as possible.[55]

[50] Conversation of the author with Goff, April 14, 1981.

[51] Phone conversation with Harvey Bryant, Patrol Superintendent, Iowa County Highway Department, December 9, 1980.

[52] Phone conversation with Andrew Greenbeck of Wisconsin Power and Light Company, December 12, 1980.

[53] Letter to author from Judy A. Erb, Public Affairs Assistant, General Telephone Company of Wisconsin, January 7, 1981.

[54] Letter to author from Judy A. Erb, February 3, 1981.

[55] Letter from Arthur Rafill of Madison, Wisconsin,

One can imagine Wright being physically, but not psychologically, close to either the new technology or the old pioneering conditions. Thus he shifted the main entrance of the house from south (Fig. 11) to north, after he bought the Joseph Rieder property (Map H) about 1925, because the county road C had run between Rieder's farmhouse and pig pens, and Wright did not want to approach his house that way.[56] Nearby, at the junction of state highways 23 and 14, coming over the bridge from Spring Green, Wright also bought out and demolished the service station and cafe owned by Jack Pifer and later Glen Richardson (Map H), which he felt to be dangerous in terms of the approach to the bridge. Further east on Highway 14, near the river, was the Log Cabin Tavern, belonging to "Stuffy" Vail, which Wright purchased in the mid-1950s. He also bought some of the old valley farmhouses, including the Reeves place across from the tavern. He then burned the tavern and the farmhouse simultaneously, much to the consternation of the Spring Green Fire Department.[57] Like Jefferson, whom he greatly admired, both agrarians, he had no tolerance for a farmhouse just because it was on a farm.

These semisymbolic acts of elimination appear of culminating importance because they represent what Wright wanted democracy, or his own vision of "Usonia," to make a break with—American indifference to architecture and landscape, lack of pride, and general confusion and drift. As a bucolic setting seemed to slow some pulses, it inevitably quickened his. He felt a right to intercede to change the manifestation of such structures. He believed that his country should be generating visible signs of nobility with which its pride could be shown forth uncompromisingly. The disadvantage with this quest, which he easily recognized, was that this region lacked good vernacular precedents, in the English or Continental sense of peasant homesteads previously tied to the land, and developed as types over many centuries. Furthermore, there was no well-educated upper class to provide superior country houses. The middle class was thus held in suspense, and the architect was badly needed to guide it out of the morass. Jefferson had fulminated against this peculiar affinity for temporization, speculation, and overall lack of seriousness in domestic architecture in Virginia, as had Downing and Church along the Hudson River, causing the latter to favor stone as a "serious" building material. This is what Wright actually had in mind when he decried the boxy homesteads and Victorian gimcrackery that he grew up with in the Midwest. They seemed too temporary, too superficial.

The Agrarian South, Jefferson's South, had created much more praiseworthy farm models before the Civil War, along with a good deal of folk architecture. But having lost its fortune, further elaboration was impossible. After the war the north grew steadily more prosperous on its more fertile soil, but the midwestern farmers and small-town inhabitants clung to their parsimonious, pioneer habits in domestic and communal architecture. Unlike anyone else, Wright wanted to reintroduce the warmth and dignity that once had graced the Old South. In this historical context Taliesin was symbolically a plantation.

The principle of nobility in the midst of agricultural fertility was further invoked in the butterfly bridge Wright designed in 1947 to go over the Wisconsin River (Fig. 8). It was to be a contoured, tan colored, and reinforced-concrete multispan without overhead members, running at 200-foot lengths. It is

retired employee of the General Telephone Company of Wisconsin, January 7, 1981.

[56] Letter to author from J. H. Howe, April 30, 1981, and Edgar Tafel, April 27, 1981.

[57] Letter to author from B. B. Pfeiffer, February 2, 1981.

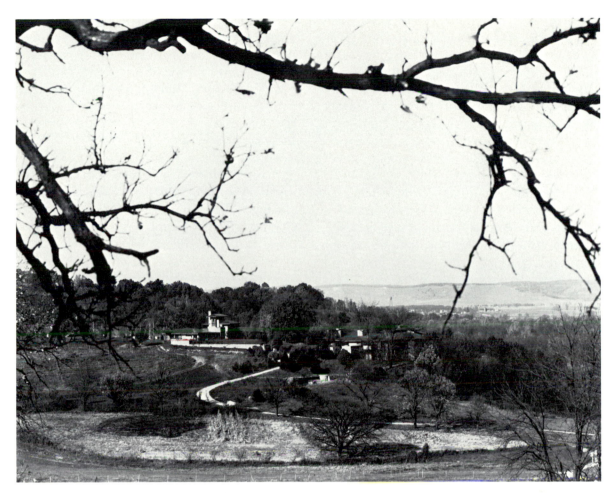

11. Taliesin II from Tany-y-deri and the south. The entrance road before it was moved to the other side in the mid-1920s, following the purchase of the Rieder farm. In the distance can be seen Spring Green with its water tower (Courtesy T. A. Heinz).

likely that he was influenced by Maillart's concrete bridges in Switzerland. The bridge as Wright envisioned it was never built, although the upper trusses of the one finally erected were left off at his behest and a beam structure substituted. It was relocated because he thought the turn at Jack Pifer's station too sharp, causing trucks to jackknife.[58] Wright's chagrin over the bridge affair is revealing. He came out flatly against "the commercialized high steel-truss main-bridges of

the Highway Commission," which "are about as becoming to the landscape as the poles and wires of utility companies—an outrageous imposition pardonable only in a pioneering era."[59] He got in both of his caveats—against the technology of poles and wires, and frontier thinking.

Wright used to stand at the windows,

[58] Letter from J. H. Howe, April 30, 1981. Telephone conversation with Howe, June 14, 1981.

[59] *Architectural Forum*, 88, 1, January 1948, p. 110. See also Madison *Capital Times*, November 16, 1948, pp. 1, 8, and November 25, 1948, pp. 1, 7. In the last, Wright mentions his interest in reinforced concrete Swiss bridges, but does not name Maillart.

musing about his land.[60] The extraordinarily small scale of the rooms facing the scene somehow makes the several luminous vistas more compelling, vibrant, and all-encompassing. These views take on the character of airy animated pictures, set in painstakingly proportioned architectural frames (Pl. 15). These views were among his favorite "postcards." Wright said about them, "Landscape seen through the openings of the building thus placed and proportioned has greater charm than when seen independent of the architecture. Architecture properly studied in relation to the natural features surrounding it is a great clarifier and developer of the beauty of the landscape."[61] The architecture was something to see the landscape *through*.

A magic realism prevailed, which appeared relatively uncalculated. Aside from the pond, it had no conspicuous feature. The magical effect is especially noticeable from Wright's bedroom and study (Fig. 12) at the southern tip of the living corridor. The lower ceiling there is only six feet, four inches high, contrary to all academic thinking. Normal ceiling height for Wright would be six and a half to nine feet. In any other, larger, room this might become oppressive, but, as in Wright's living room, the back wall and alcove appear to rise and recede, while the landscape rushes right up to the window. The final interplay is mostly horizontal, as if the distances were to be viewed by an intelligence set in back of the eyes, then carried forth through spectacle frames outward by stages, almost by hypnosis. There is a slow process of mental registration, as with Olmsted's landscapes. Wright looks at the pioneer scene retrospectively, giving it a Victorian effulgence. Even the landscape in its lushness appears to partake

of the luxury of his craft furnishings and outdoor, Oriental sculpture to gain justification. He had Art Robson's untidy welding shop, formerly the Lloyd-Jones Hillside Cheese Factory, and lately belonging to Stuffy Vail, torn down because it disturbed the continuity of his valley-length view of the chapel in its grove (Map H).[62]

Today Taliesin Valley has more vegetation and trees on its hillsides than twenty to thirty years ago because of the decline in grazing.[63] The Taliesin herds were sold off. Cows were a preoccupation with Wright because of their significance in the setting: they added a living harmony, which proved the legitimacy of the silence and peace of the valley. His esthetic attitude toward them is revealed in an anecdote by his one-time farm manager. Wright had complained that his Guernseys were not producing enough cash from their cream. The manager recommended the addition of a few Holsteins. Wright's reaction, after a pause, was "Jack, Holsteins are black and white! Black and white *on* green? . . . Black and white *do not* go on green! Never bring anything black and white, or red and white, in the way of an animal in sight of my eyes—coffee and cream, which are the colors of the Guernsey, on green, are the three most restful colors which you can find. This is why I've got Guernseys, and why I want nothing but Guernseys!"[64]

The herd, although animate and on the move, brought repose to all the rest, in Wright's view. It gave a reason to linger in the Valley. "Why is any cow . . . always in just the right place for a picture in any landscape? Like a cypress tree in Italy, she is never wrongly placed. Her outlines quiet

[60] Phone conversation with J. H. Howe, December 6, 1980.
[61] *Architectural Forum*, 68, 1, January 1938, p. 3.

[62] Letter from J. H. Howe, April 30, 1981.
[63] Letter from B. B. Pfeiffer, October 3, 1980.
[64] Speech of Jack Sangster before Central Illinois Chapter, American Institute of Architects, Decatur Club, June 12, 1976.

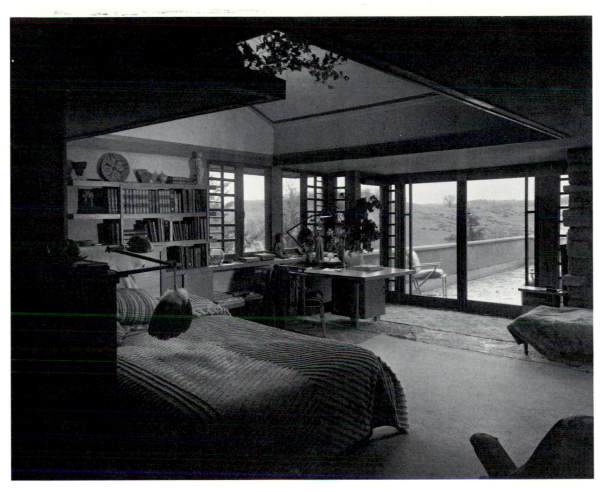

12. Wright's bedroom and study (Hedrich-Blessing).

down so well into whatever contours surround her. A group in the landscape is enchantment."[65] The aim was for a final, concerted effect in the environment on the way to an abstract, crowning revelation of the "organic." Despite its loftiness, however, the revelation still drew its real strength from the earth behind and beneath the animals: "Yet, to go through the herd lying on the grass, as the dew falls all quietly chewing their cud in peace together, is to find a sweetness of the breath as it rises, a freshness of Earth itself that revives something essential to life lying deep in the instincts of the human race."[66] His mother had told him, "If you have to choose, choose Truth. For that is closest to Earth. Keep close to the Earth, my boy: in that lies strength."[67]

THE ORIENTAL ASSOCIATION

Wright seems to have been seeking through Taliesin a confirmation of his warmer and truer instincts from youth, as Jefferson fol-

[65] Wright, *Autobiography*, p. 23.

[66] Ibid., p. 24.
[67] Ibid., p. 71.

lowed his at Monticello. Unlike Jefferson, however, Wright still wished to venture forth. Japan became the farthest point he could reach. He made it plain that the Japanese print, through which he saw a distilled version of the whole Orient, was to offer this other, most distant, inspiration. It remained close, like the bovine species, to the "organic" and "earthy." "Ever since I discovered the print Japan has appealed to me as the most romantic, artistic country on earth. Japanese art, I found, really did have organic character, was nearer to the earth and a more indigenous product of native conditions of life and work, therefore more nearly 'modern' as I saw it, than any European civilization alive or dead."[68] More verdant and less ruthless than Chicago was Oak Park; less stifling than Oak Park was the open and genuinely naturalistic valley in Wisconsin; still more rich and spreading in human associations, and less artificial than Europe, was the Orient of the wood block. Environments which did not entirely satisfy could be exchanged for art works. It never bothered Wright that these were not logically equivalent objects. Because nothing was mutually exclusive for him, he could be more creative.

His yearning to converse with someone, or something, about the dichotomy between East and West, was relieved in December 1950 when he wondered if the mottoes on the drafting room walls at Taliesin really conveyed the meaning of the repose he sought. His mission was becoming more and more lonely; he that much more isolated. He suddenly perceived, hidden in the shadows and therefore more reticent even than the mottoes, "the ancient cast-iron head of the Studio Buddha." Having discerned this "unequal, inanimate," object, he remarked, "sometimes in his expression there seems

evidence of the deep, beneficent inner quiet our Art so needs and that Taliesin covets."[69] He sensed a readiness of the Buddha to talk. They shared anxiety over what might happen to western civilization, with its increasing mechanization and corresponding loss of soul, featuring *force* and depending upon *fear* (Chicago again?). Besides comprehending the unwholesome aspects of American urbanism, Wright wanted the Buddha from the Orient to know for his own relief the exceptional values of Taliesin Valley: "Nevertheless see in the little green valleys between the long ranges of wooded hills of our country, love and reverence for Beauty. The humane growth you may find there where the hill-slopes are dotted with cattle or are alive with crops as little streams fed by flowing springs are running to the great rivers."[70]

The purpose of the urge away from Taliesin and toward the Orient[71] was to find an incontrovertible peace and balance in nature away from the uncertain and transient cultural situation, most visibly represented by American cities. However, this was the first time the imagery of another country had been taken up in order to refute or replace the present one. Usually an American region farther west had provided the alternative.

The buildings Wright did in Chicago, and at Taliesin, between 1909 and 1915, the period of the most notorious scandal and the greatest pressure upon his mind, have been described as "opposite" in style.[72] The abstract and playful Midway Gardens, where

[68] Frank Lloyd Wright, *The Japanese Print* (New York: Horizon Press, 1967), p. 91.

[69] *Architectural Forum*, 94, 1, January 1951, p. 105.
[70] Ibid., pp. 105-106.
[71] Tafel says in *Apprentice to Genius*, p. 98: "By 1913, in his mid-forties, he had outgrown Oak Park and the Midwest . . . Japan was his new frontier." However, Thomas Beeby in "The Song of Taliesin," *Modulus: The University of Virginia School of Architecture Review*, 1980/1981, pp. 3-10, places more emphasis on the Welsh and Celtic derivation.
[72] Vincent Scully, *Frank Lloyd Wright* (New York: George Braziller, Inc., 1960), p. 22.

Wright was working when the news reached him of the tragic murder of Mrs. Cheney in 1914, or the abstractions of the Coonley Playhouse, were tantamount to a long glance back at a Viennese Europe, but Wright's study of Japanese prints found him so immersed as to be hypothetically transportable on the instant to the ancient city of "Yedo" (Tokyo) among the early evening crowds hurrying along the street. Wright sought shelter in a teahouse away from the teeming and slightly sinister thoroughfare, with its roaming samurai, sumo, and komuso. Once inside, he moved in parallel to the jostling. The warm, well-lit, orderly interior of the house contrasted sharply with the gloom outside. "Pass, now, through building after building, separate buildings joined together with narrow open-sided corridors. . . . Glimpse little courts, as you go, filled with strange plants and flowers in graceful pots. Little cages of fireflies hang to the posts, as post by post we pass along the open corridors against the outside dark. Finally all will open along one entire roomside to an enchanted scene. The Japanese garden!"[73] This processional plan was calculated to banish all miasmas, emotional or physical. And this is the way it was at Taliesin. Enclosing court follows enclosing court to the brow of the hill,[74] except that it was the larger valley below which finally became the "enchanted scene" at the side, rather than the miniature Japanese garden. However much of a shining brow the house might appear from the valley, it is the quality of privacy expressed behind it by the courts which finally counts the most—historically, psychologically, and geographically. These four elevated enclosures make possible the miracle of being there, in Wisconsin, and at the same time somewhere else, in the Orient.[75] Wright's gift for joining fantasy to reality, or small scale to large, together with his unexcelled ability for escape, appeals to the American temperament because these capacities were so ready to move in time and space. The architect Richard Neutra was taken aback when he came from Vienna in 1925 to study at Taliesin and found what looked to him like "a Japanese temple district" in Wisconsin.[76] Taliesin is unlike Wright's Chicago buildings of the same time because it is Japanese, rather than Viennese, in allusion.

THE WAY WEST

THE BAD LANDS

Most remarkable among the many seeming contradictions in Wright is the fact that he fabricated fragile visions, but promptly affixed particular details and principles to them. These visions were apt to be full of literal details, and quite eclectic, contrary to what many think about his undiluted originality. The formula was useful mostly in that it gave him extraordinary creative range. He saw the Bad Lands of South Dakota (Fig. 13) in this light when he visited them in September 1935—immense, open-ended, and running free, much like the later 30-60-foot drawings of imaginary cities by his pupil Paolo Soleri, executed sensitively on a crude surface; ink and stencil on butcher paper. The West sustained the

[73] Wright, *The Japanese Print*, p. 117.

[74] For a careful plotting of the successive layouts of the Taliesin plans, see Sidney K. Robinson, *Life Imitates Architecture: Taliesin and Alden Dow's Studio* (Ann Arbor: Architectural Research Laboratory, University of Michigan, 1980), pp. 9-19.

[75] Tafel, *Apprentice to Genius*, p. 99, mentions that Wright spent his entire fee for the Imperial Hotel, Tokyo, $300,000, on Japanese art, which came to Spring Green in a trainload.

[76] Robinson, *Life Imitates Architecture*, p. 50. Thomas S. Hines, *Richard Neutra and the Search for Modern Architecture* (New York: Oxford University Press, 1982), p. 52.

13. Bad Lands, South Dakota (National Park Service).

broad topographical dimensions Wright was used to from the prairie Midwest, but it also broke out with great stone and earth improvisations in its vacant spaces with more ease and regularity.

Wright described how he first comprehended the extensive monumentalities of the Bad Lands by glancing over his shoulder upon leaving them. "Here, for once, came complete release from materiality. Communion with what man often calls 'God' is inevitable in this place. It is everywhere around him and when the man emerges to the brown plateau and looks back, as I did, the sun now setting, a pale moon rising in darkening rose and blue sky as rays of last light

drifted over, linking drifting water lines of dark rose in pallid creamy walls, gently playing with the sky line, with mingled obelisks, terraces, and temples more beautiful than thought, eternal, who knows, a strange sense of inner experience will come to him of a crisis in his perception of what he has termed beauty."[77] The Bad Lands were suddenly as all-inclusive spiritually as Yosemite when Starr King preached about it in the 1860s. Like Yosemite, the Bad Lands could

[77] As quoted in Frederick Gutheim, ed., "The Bad Lands," *Frank Lloyd Wright on Architecture* (New York: Duell, Sloan and Pearce, 1941), pp. 192-193. These words went to Robert D. Lusk, editor of the *Evening Huronite* at Huron, South Dakota.

not hold people for permanent living, but they nevertheless represented, ironically, astonishingly, "a vast gift of nature in terms of human habitation." However remote, their beauty was to be interpreted in social terms because they became one more of Wright's "as if" situations. Ideas were more important to him than the limits of reality. Yet he seemed to require not only local and specific stimuli, but also, again like Jefferson, borrowings from the remotest past, as a way of authenticating time in unregulated space. Around Charlottesville, Jefferson had had to strain his eyes to the mountains, to see imaginary Egyptian pyramids and live volcanoes. Wright said about the Bad Lands, "What I saw gave me an indescribable sense of mysterious otherwise—a distant architecture, ethereal, touched, only touched with a sense of Egyptian, Mayan drift and silhouette."[78] His references were far off in historic time, but he called them up in order to confer authority on his vision, for there were too few local reference points historically. The two-state area of North and South Dakota, including the Black Hills and Spearfish Can-

yon, brought him a mood of escalating puzzlement, followed by elation. To be thus far away, and yet still in America, was a challenge everyone sought before the advent of the jet plane. The detachment was nearly complete for him.

The Bad Lands offered a one-in-a-million chance: "Let sculptors come to the Bad Lands. Let painters come. But first of all the true architect should come. He would interpret this vast gift of nature in terms of human habitation so that Americans on their continent might glimpse a new and higher civilization certainly, and touch it and feel as they lived in it deserved to call it their own."[79] The degree of alienation from the American setting, always a first concern, would be reduced. Like Olmsted as a landscape architect at Yosemite, Wright wanted as an architect to make the Bad Lands something of an "advanced center" for other kinds of artists—a source of inspiration for all.

It was typical of Wright to turn his attention to the western wastelands. In the 1930s he ventured beyond one of his greatest mentors, William Morris, who in 1881 had said: "Architecture embraces the consideration of the whole eternal surroundings of the life of man; we cannot escape from it if we would so long as we are part of civilization, for it means a moulding and altering to human needs of the very face of the earth itself, except in the outermost desert."[80] Wright set out to make that outermost desert, dismissed by Morris as unreachable, bloom half a century later, as the cemeteries had blossomed in the unlikely locale of Chicago under the fingertips of Simonds and Miller, Jenney and Sullivan. Wright came to the end of Morris' English world and did not fall off,

[78] Ibid., p. 192. As David Lowenthal has indicated, there was a considerable tradition of this kind of seeing the West by intellectuals and artists in the nineteenth century: "The stratified sedimentary and volcanic rock formations of the West moved visitors profoundly because they reminded them of ruins of great cities, castles, temples, and other monuments of ancient civilization" ("Recreational Habits and Values," *The New York State Planning News*, 33, 4, July-August, 1969, p. 11). Paul Shepard analyzed a similar series of observations of "ancient cities" by people following the Oregon Trail before 1850, when they discovered the escarpments and bluffs along the Platte River in western Nebraska. He postulated a number of intriguing explanations for the phenomenon, among them that people from a humid climate see things with more perspective and brilliance when in a drier one; that there are memory imprints in the brain from larger structures, such as cathedrals, which would seem to work with Wright since his mother hung prints of English cathedrals in his nursery; and the American preoccupation with the idea of the Cycle of Empire, especially brought out in Thomas Cole's series of paintings *The Course of Empire* ("Dead Cities in the American West," *Landscape*, 6, 2, Winter 1956-1957, pp. 27-28).

[79] Ibid., p. 193.
[80] "The Prospects of Architecture in Civilization," lecture at the London Institution, March 10, 1881, as quoted in Leonardo Benevolo, *History of Modern Architecture* (Cambridge, Mass.: MIT Press, 1971), I, Preface, p. x.

instead remained musing over it, while as he said "alive and kicking." The American world had to be slightly more fantasy than reality to be enjoyed, as with Jefferson.

Yet Wright's desert venture also represented the last stand of the gifted environmental designer as he had been increasingly ignored or pushed aside in America, particularly as affluence and the emphasis on materialism increased and romanticized feeling died down. Like many artists and intellectuals of the post-Civil War era, Wright wanted more than material benefits to accrue to the citizenry from that disorder. The fratricide brought his Uncle Jenkin Lloyd-Jones, a northern soldier, to pacifism, and finally to venture forth as a leader on Henry Ford's unsuccessful peace ship to Norway in 1915 to try to stop World War I. The North had failed to gain spiritually after the Civil War, its idealism had collapsed after World War I, and its self-confidence atrophied with the Depression of the 1930s. The ingestion of esthetic idealism as a morale producing factor in a democracy ought not to be delayed too long, according to Wright, because it once had been a country with a pledge.

TALIESIN WEST

To appreciate Taliesin West, twenty-six miles northeast of Phoenix in Paradise Valley, Arizona, begun in 1938, one has to understand how Wright started on the very surface of the desert, and how his imagination then rose, circled, and soared above it. He came to the site after planning two projects—the E. L. Doheny ranch east of Pasadena, California, in 1921, and the San Marcos in the Desert resort in Arizona for Dr. Chandler in 1927 (Fig. 14).[81] For the latter he began with an experimental box-tent

camp at San Marcos near Chandler, Arizona, in many ways predicting Paolo Soleri's temporary structures for students at nearby Arcosanti. He named it "Ocotillo," the candle flame, after a scarlet desert bloom fifteen feet high. The camp was eventually carried off by the Indians. Wright conceived a great fondness for the state because it appeared to be an unspoiled California. He noted that some Californians were already wintering in the Salt Valley of Arizona to get away from the concentrations around Los Angeles. Taliesin was not only to be his private palace in the desert winter sun, modeled partly on the San Marcos resort—never undertaken because of the Depression—but also the true refuge at last from the rest of America. Could he really escape within these continental limits, as he had earlier outside them to Japan? He reluctantly acknowledged that "the inevitable boom accompanying such discoveries of the picturesque and climate in the United States will probably come, a rubbish heap, to set Arizona backward a decade or two."[82] And indeed the population influx to Arizona began in the boom right after World War II.

There was something everlasting, fundamental, and worth clinging to here. Barely eking out an existence in the desert, the saguaro cactus, the cholla, and the bignana stood at a sculptural scale, taller and nobler than man, like Le Corbusier's super-sized Modulor man with his arm held high. It was another Eden, as Oak Park had once been, but the components were more prominent because of the openness of the land, a "grand garden the like of which in sheer beauty of space and pattern does not exist, I think, in the world."[83] This time only the gratuitous monumentality of the Camelback Mountains intercepted his gaze, and he could see around the left side of them (Fig. 15). Mrs.

[81] "San Marcos in the Desert for Dr. Alexander Chandler," *Architectural Forum*, 68, 1, January 1938, p. 64.

[82] Gutheim, "To Arizona," *Frank Lloyd Wright on Architecture*, p. 196.
[83] Ibid., p. 197.

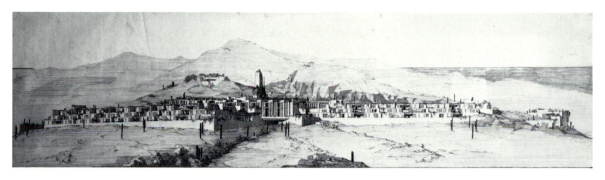

14. San Marcos in the Desert, project for Dr. Alexander Chandler, Frank Lloyd Wright, 1927. It represents a kind of remote magic city, like the Bad Lands (Historical Society of Wisconsin).

15. Wright's Patio, Taliesin West, Paradise Valley, Arizona, 1938—. In the distance are the disputed power lines. Beyond to the right is a desert dust devil. Beyond that are the Camelback Mountains (T. A. Heinz).

Wright reports that he ended one of his Sunday sermons to the students at Taliesin West with the challenge: "So let us now go on and walk over the mountain there on the other side. How many of you are capable of getting over on the other side? Over there is something beautiful."[84]

These mountains are profoundly blue, contrasted to the rosy desert. Wright's personal patio yielded up a rosy tint, which he believed came closest to the permanent "light on the desert floor." As at Taliesin East with its artificial pond in the meadow, so between patio and desert there is another green lawn and turquoise pool. These suggest a habitual desert refuge, an oasis, but their specific location infers also that Wright needed another platform, a launching pad, from which to begin any other of his conceptual journeys. The lawn is arranged diagonally toward the distant view in the progressive pattern outward to which he usually adhered. He had become indisputably famous and had evacuated his older bastion, Taliesin East, if only for the winter. Here, a relaxing, a further unwinding, is represented by his greater receptivity to warmer colors. Compare the lively, acid-brightened stereotomy of Taliesin West with the sobriety of the gray-brown stonework at Spring Green to catch the upswing in mood. He himself said, "The spiritual cathartic that was the desert worked—swept the spirit clean of stagnant ways and habitual forms ready for fresh adventure."[85] As Reyner Banham has written: "Yet it was in the desert, the true wilderness, that Wright was ultimately to achieve freedom in planning: freedom from axial symmetry, from right angles, from centralised spaces, which had persisted in the geometry of all his earlier

works, even when the functional relations and human use of the spaces were at variance with the formal plans."[86] Everything is made more vivid by the desert light and distinctive features. Wright turned adventurously to 30-, 60-, and 120-degree angles in his planning. He used his new desert dotted-line technique to pick up the surfaces and silhouettes.

Wright's satisfaction in this seclusion was to be challenged again, however, when in the summer of 1951 the power company erected towers and lines directly across his view (Fig 15), followed by a forty-foot dike wall on an irrigation ditch by the Central Arizona Water Project to satisfy the water needs of more and more people.[87] A great bellow of rage exploded from him, as when the butterfly bridge project across the Wisconsin River had been, in his view, sabotaged by the Highway Commission in 1947. He had "picked up" eight hundred acres of desert to be free of "nuisance building," but now "they" had erected towers there was no hope of concealing, eighty-five feet high: "Their mark-up of Cain is all over the forehead of our no longer young country."[88] He threatened to move his school to Tucson. His protestations fell on deaf ears. As he said ruefully of life at Taliesin West, "We loved the look of things more than most, I guess."[89] Considering his views, it is striking how moderate his protestations were. He saw in all-encompassing dream terms in the West, like the Bad Lands panorama, out in the open air. It was therefore the literalness of the intrusions that bothered him the most;

[84] Olgivanna Lloyd Wright, *The Shining Brow* (New York: Horizon Press, 1960), pp. 58-59.
[85] Frank Lloyd Wright, "Living in the Desert," *Arizona Highways*, XXV, 10, October 1949, p. 12.
[86] Reyner Banham, "The Wilderness Years of Frank Lloyd Wright," *Royal Institute of British Architects Journal*, 76, 12, December 1969, p. 516. See also Banham, *Scenes in American Deserta* (Salt Lake City: Peregrine Smith, 1982), pp. 75-77.
[87] Letters from B. B. Pfeiffer, April 13 and May 19, 1981.
[88] Wright, "Living in the Desert," p. 15.
[89] Ibid., p. 13.

there were no trees to hide them, as at Taliesin East. In his opinion, his concerns should have been the environmental concerns of the whole nation. But there were too few who could see and use those esthetic principles so comprehensively, or thought them so important.

THE WAY BACK

BROADACRE CITY

Many have tried to read Wright's Broadacre City model (1932-1934) as an essay exclusively about the Great Depression. The book on "Architecture and Modern Life," which he wrote with Northwestern University professor Baker Brownell and published in 1937,[90] illustrated that Wright was well aware of the placebos of the 1930s. Many had been spawned or endorsed by the New Deal. The book referred to ideas as various as those of Henry George and his single tax; Ralph Borsodi's revival of cottage industries in Suffern, New York; the Resettlement Administration with its Greenbelt towns; the Federal subsistence program; the TVA with its Norris Village and Dam, to raise the southern standard of rural living through cheaper power; and Henry Ford's decentralized assembly plants in small towns, where the industrial workers could have access to gardens, but would also sustain the high wages of the Ford employee.

Yet the proposal finds its greatest meaning only when recognized as an attempt to fit Wright's frustrated past to a happier and more adequate national future, just as with the two Taliesins. In some respects, Wright was most useful simply because he never fully accepted the American present, as so many Americans were now beginning to do

by settling for less. And because he lived so long, his extraordinary memory came often to dominate his thought. One of the sharpest critics of the book at the time, Meyer Schapiro, put his finger precisely on the wellspring of Wright's inspiration for Broadacre City. He abhorred Wright's design because it derived from "a grotesque parody of the views of the 1880s." Wright was too dependent in Broadacre on the middle-class house, since it held "such strong and deep memories of security and the restoration of the home appears in itself a radical social cure."[91] Those by now remote feelings *were* current in Wright's own thought, however one assessed them. Frances Willard, professor of esthetics at Northwestern University and founder of the Woman's Temperance Union in 1879, had championed "a reorientation of American values about the home as a social setting and a physical environment. Many of the concepts had been expressed in the 1880s. But it was the decade of the 1890s that inaugurated a period of almost frenzied reform activities, programs for participation and efficiency in every area of American life." Willard and her associates looked upon all public reform as a better kind of housekeeping for a "Homelike World."[92] They believed such "minor" units as houses could count at a major scale. Because of the sudden appearance of the many suburbs around Chicago after the fire of 1871, such an outlook would be more feasible there than in New York City. Civic improvements would begin in the nucleus of the family and ripple outward. Thus Wright "responded to the more abstract desires for family stability, community life, and the preservation of individuality, all symbolized in residential de-

[90] *Architecture and Modern Life* (New York: Harper & Brothers).

[91] Meyer Schapiro, "Architect's Utopia," *Partisan Review*, IV, 4, March 1938, pp. 45, 47.

[92] Gwendolyn Wright, *Moralism and the Model Home: Domestic Architecture and Cultural Conflict in Chicago, 1873-1913* (Chicago: University of Chicago Press, 1980), pp. 106-109.

sign."⁹³ But, "Eventually the imagery of the modern, simplified model overshadowed the original social aims of the crusaders."⁹⁴ The return to Neo-Colonialism left Wright and his Prairie School contemporaries marooned, with the earlier thrust of the social causes played out.

But Wright himself never gave up. Through Progressivism, arising out of the civic design enthusiasm of the 1890s, came the ambition to plan whole suburbs and larger sections of actual metropolitan districts. There was a renewed dedication to broader environmental causes via the house unit. The improvement of any city would therefore have to be fundamentally based on the multiplication of domestic virtues.⁹⁵ The suburb, after 1910, was intended to be "an organic entity, as the house had been in the 1880s. . . . The inspiring influence of the community plan—simultaneously individualistic and democratic—closely resembled the aura the house itself once supposedly cast over its inhabitants."⁹⁶ Finally, following through on the 1880s in the 1930s, Broadacre City was supposed to cast such an aura. So it was that "Frank Lloyd Wright, Robert Spencer, Walter Burley Griffin, and other architects who specialized in residential design could now tolerate the idea of a prototypical dwelling—provided that they had a strong hand in the design of a larger city or suburb where the model would be utilized."⁹⁷ Wright then, as he appears at

Broadacre City, is not such an isolated individualist after all.⁹⁸ Genius or technician, he belonged to a larger movement and took license from a prior social reform.

Carl Feiss, an enlightened housing expert of this era, reexamined Broadacre City with sympathy, but pointed out that Wright appeared to be working in reverse—from building, to site, to people.⁹⁹ According to others, Wright had prepared a place for "The People," but it was difficult to visualize any people in the place. The uninhabited look of Broadacre City was due to the first priority Wright had placed upon design. It was his colorful trump card, which the experts did not want him to play in this game, the Japansese print perfectionism which he continued to pursue as the old line reaction to Chicago in particular, and the rest of America and Europe in general.

The presumed lack of relevance of Broadacre City caused the critics Paul and Percival Goodman to attribute less meaning to it than to Le Corbusier's Paris or Algiers plans: "Viewed as a whole, the scheme for Broadacre City has no plastic interest whatsoever."¹⁰⁰ The plan was not avant-garde

⁹³ Ibid., p. 137. Norris Smith follows a similar line of thought over Wright's conservative and ethical bent in "The Domestic Architecture of Frank Lloyd Wright," *Four Great Makers of Modern Architecture*, ed. Adolf Placzek (New York: Trustees of Columbia University, 1963), pp. 76-83.
⁹⁴ Ibid., p. 148. For Fiske Kimball's evaluation of Taliesin in the midst of the distraction of the succeeding Colonial Style, see "The American Country House," *The Architectural Record*, 46, 4, October 1919, pp. 341-344.
⁹⁵ Ibid., p. 267.
⁹⁶ Ibid., p. 291.
⁹⁷ Ibid., p. 292.

⁹⁸ The basic books by Wright on Broadacre City are *The Disappearing City, When Democracy Builds*, and *The Living City*. The best article by Wright is "Broadacre City: A New Community Plan," *The Architectural Record*, 77, April 1935, pp. 243-254. Important reassessments by later critics are Stephen Grabow, "Frank Lloyd Wright and the American City: The Broadacres Debate," *American Institute of Planners Journal*, 43, 2, April 1977, pp. 115-124; and George Collins, "Broadacre City: Wright's Utopia Reconsidered," *Four Great Makers of Modern Architecture*, pp. 55-75. Donald Hoffman's *Frank Lloyd Wright's Falling Water: The House and Its History*, introduction by Edgar Kaufmann, Jr. (New York: Dover Publications, 1978), also has a good discussion of Broadacre City, pp. 12-16. Anthony Puttnam has put out a very good set of graphs and facts for the Wright Foundation in mimeograph. The best summary of the ideological, social, and economic side of Broadacre City is the chapter "Broadacre City" in John Sergeant's *Frank Lloyd Wright's Usonian Houses* (New York: Watson-Guptill, 1975), pp. 122-136.
⁹⁹ Carl Feiss, "Broadacre City Revisited," *Progressive Architecture*, XL, 7, July 1959, p. 182.
¹⁰⁰ Paul and Percival Goodman, "Frank Lloyd

enough for them. Wright had experimented since 1901 with the quarter-mile section of the prairie, when he first came forth with a quadruple-block plan of four houses to articulate it with further divisions.[101] This made him more amenable to a foursquare than to Corbusier's linear town solution. Wright's most complete effort in this direction before Broadacre City was "The Ideal Midwestern Subdivision," to be located eight miles out of Chicago, about where Oak Park is. This was published in 1916, with a peevish quote from Thomas Carlyle: "Fool! The Ideal is within thyself, thy condition is but the stuff thou shalt use to shape that same Ideal out of."[102] The conventional prairie grid, the "condition," would be made to yield a rich norm for settlement, dependent upon the fertility of the soil beneath.

The Ideal Subdivision and Broadacre (Pl. 16) models offered two more intangible qualities in place of the cleancut high-rise residential towers of Le Corbusier's ideal cities. One was the subtle weaving of the ribbons of the land plots. The other, following from the same underlying condition of the earth, was the impression of a multi-layered, glowing, lapidary accretion, somewhat like mosaic or cloisonné. Most conspicuous as a stripe in Broadacre City was the twelve-lane superhighway on the former railroad right-of-way, which was to carry below it triple truck-lanes on each side. Looking down on the model it is almost impossible to distinguish among random nature, cultivated agriculture, or manmade buildings.

The moral was that this banded settlement rested amicably on fertile soil, while Chicago depended on squared land that had become sterile by over-usage. In the Ideal Subdivision, Wright located trees and hedges at the edges of the plots to align and frame larger patterns. This conformed to the earlier midwestern practice of protecting the fields from wind and storm through hedges of Osage orange. The pioneer landscape furnished the first clues even though he would not accept the "as is" pioneer farmhouses, mud, and clutter. In Broadacre City the "reforestation" strips of useful rather than ornamental trees, none of which is directly on streets, are wider than those in the Ideal Subdivision. The communal pattern is thus distinctly regular, but also quite indistinguishable, mute, and mysterious as to detail. Wright's geometry was American because it engendered mystery, whereas Corbusier's geometry was used to further the Cartesian rationale. This difference undoubtedly explains at least part of the Goodmans' frustration with the Broadacre model. The 1930s wanted clearer and simpler statements for its problems, so it was more sympathetic to the European view. However, with his relatively even distribution of forms and accents, Wright was able to communicate an all-pervasive unity too, found after one has looked carefully for it.

The traffic circulation of Broadacre City was based on the farm grid; the house lots were an acre, or larger; public buildings were scattered, rather than concentrated in a downtown; and automobile circulation would be aggravated. Since the city was intended to cover only four square miles, three of them flat and one hilly, and have a population of 7,000, why the need for a monorail train going 220 miles an hour down the center of the freeway, or for an upcoming shower of helicopters (called "aerotors" here and not yet invented, although its forerunner, the autogiro, had appeared)? The an-

Wright on Architecture," *The Kenyon Review*, IV, 1, Winter 1946, p. 26. The model of Broadacre City, which did have nine skyscrapers, was built in the courtyard of Dr. Chandler's original inn in Chandler, Arizona. See John H. Howe, "Reflections on Taliesin," *Northwest Architect*, July-August 1969, p. 30.

[101] Frank Lloyd Wright, "A Home in a Prairie Town," *Ladies Home Journal*, XVIII, 3, February 1901, p. 17.

[102] Alfred B. Yeomans, ed., *City Residential and Land Development* (Chicago: University of Chicago Press, 1916), p. 96.

swer was that the town unit was supposed to be repeated in squares across the prairie in utopian fashion, with wide fields in between, much like the early, unfulfilled visions of the Englishman Robert Owen for the land around New Harmony, Indiana, in the mid-nineteenth century.

In all of Wright's precincts of concern, including Taliesin East and Taliesin West, there were held programs for social enrichment. Mere existence or subsistence were never enough for him, and may be another reason why he often seemed reluctant to live in the present. The recommended activities at Broadacre City were to be part of the social pageant, like picnics and sleigh rides at Taliesin. There was to be an extraordinary spread of amenities for recreation, made possible by Wright's concern for openness along the ground. He formed a nosegay of internal delights, such as a zoo, an aquarium, an arboretum, a music garden, a polo field, a country club, a stadium, and a football field. "Much is made of general sports and festivals," he admitted.[103] No monotony was to be permitted in the untrammeled existence of this community, surrounded by a slough of national despair. Inside the almost luxurious citadel of Broadacre City a new joy of life was to spring up—like the happy expectations of the Lloyd-Joneses as they came through the Hudson Valley in 1844. Such incandescent visions ought to have durability, Wright thought.

The schools, which were to have art galleries, gardens, and a concert hall, appeared at the central spine of the model, arranged "in the interior spaces of the city where the children can go without crossing traffic,"[104] an intervention for safety which was undoubtedly borrowed from the Radburn circulation system of Clarence Stein and Henry Wright of the early 1930s, as was pointed

out by their friend Lewis Mumford at the time.[105] The idea of prefabricated bathrooms and kitchens as starter elements for the houses came from Wright's acquaintance, Buckminster Fuller.

A stream and lake offered another amenity, the mirror pool, as in the Taliesin Valley. This time they were definitely on the diagonal, to relieve the grid system of the city. There is a strong affiliation with the features of Taliesin Valley in Broadacre City. A low hill in the upper left corner is labeled "A Taliesin (Equivalent)," beholding all the rest, including the artificial pond. The repeat of the essential position of the Hillside Home School, expressing the Classic overview, indicates how fundamental the orientation of the school had been for Wright. From this new hill "the county architect-in-residence" (Wright at Taliesin, grading his roads, planting his trees, and burning his old farmhouses) could again exert the whole of his favorable influence on the terrain. At the very top of this hill was "an automobile objective" for another outlook, indicating how important the car had become, at least to Wright.[106] Without its "decentralizing" potential, Broadacre City could not have occurred.

The house types were listed as one- two- three-, and five-car units, another token of middle-class status, for which note of extravagance in a depression Wright was upbraided. The largest dwelling type was called "the house of machine-age luxury." In addition, there were small apartments over model factories near the highway, and a motel, a hotel, neighborhood guest houses, and

[103] Wright, "Broadacre City," p. 249.
[104] Ibid., p. 254.

[105] Lewis Mumford, "Mr. Wright's City—Downtown Dignity," *The New Yorker*, April 27, 1935, p. 63.
[106] Mark Reinberger "The Sugarloaf Mountain Project and Frank Lloyd Wright's Vision of a New World," *Journal of the Society of Architectural Historians*, XLIII, 1, March 1984 sees the Sugarloaf project, 1924ff, as an important forerunner of the Broadacre automobile objective, pp. 46, 52.

cabins in the forest. The fact that everything was predetermined as "little" meant that any component could be easily lifted, rearranged, dispersed, or infiltrated. Chicago had failed to produce such modest buildings, or such a suffusion of greenery and amenities after the fire of 1871, despite the fact that its motto was *Urbs in Horto* and it was called "Garden City" in the popular literature. The phoenix was adopted as its symbol after the fire, but the newer, greener imagery, the dream, had been forced out of town into the open "country we have here been calling Usonia,"[107] which would always be "everywhere or nowhere" according to Wright, or, according to the alienated wife in *Jerry the Dreamer*, "the beautiful far-away nowhere," where "this is that." It was the same kind of intricately compensating imagery as affected the creation of Graceland Cemetery and Riverside.

The Broadacre purpose was to contain as much variety and energy within a compact and regular shape as possible. Wright said: "Wherever repetition (standardization) enters, it has been modified by inner rhythms either by art or by nature as it must, to be of any lasting human value."[108] He wanted to inundate the "ugly scaffolding" of the land, the too elementary grid on the flat piece of paper. Despite its agricultural fertility, the Midwest had uncritically accepted standardization—in the skyscraper frame, the balloon frame, and the farmland quarter section. The Broadacre model was a conscious effort to introduce variety within this regional frame of reference. It might be taken as a luxuriant turf to walk on, since the mown lawn was still a novelty in rural Wisconsin during Wright's boyhood. Or it could be understood as a twelve-by-twelve-foot abstract painting, a Navaho blanket

(such as he liked to collect in the Southwest), or a latter-day Bayeux tapestry in which he could record his past architectural trials and conquests. Wright explained that his proportional unit system of planning would be "like tapestry—a consistent fabric woven of interdependent units, however various."[109] Even today the Broadacre model hangs like a picture in the Hillside Home Gallery. Wright recognized its superior decorative qualities, and was pleased that he had not made it too tall to fit under the ceiling.[110] The larger imagery typified the Midwest.

While others cut back to Depression-generated humility, utility, and minimality, Wright moved up to elaboration, and fantasy, carrying each aim toward a crowning conclusion—that agricultural motifs should matter most in "the city democracy will build." He constructed a large field plan as might fit corporate agriculture—agribusiness—and then introduced on top of it a careful settlement, replete with warmth, color, and amenity. The Olympian joke of Broadacre City was that its final focus was on the farm as an urban unit: "the farm itself, nothwithstanding its animals, becomes the most attractive unit of the city."[111] It was back to the in-town lots of the Puritans in the Connecticut Valley; back to Downing's Highland Gardens in the Hudson Valley, with its orchard, vegetable garden, and nursery of trees on the border of the town; back to the inner "Garden City" of Chicago before the disastrous fire of 1871. To bring urbanism under control, Wright needed only to make the city over into a farm, complete with grazing animals! But this exchange was not the final transformation—the real and more constant meaning derived from the

[107] Frank Lloyd Wright, *The Living City* (New York: Horizon Press, 1958), p. 191.
[108] Wright, "Broadacre City," p. 135.

[109] Frank Lloyd Wright, *A Testament* (New York: Horizon Press, 1957), p. 220.
[110] "Broadacre City—Discussion of Model and Impact on America," Dana Gallery, Hillside Home School, A Day at Taliesin, September 13, 1980.
[111] Wright, "Broadacre City," p. 247.

permeation of one "worthwhile" value by another. Thus, the eternal fertility of the prairie would percolate up from below: "the ground will determine the shape and even the style of the buildings in Broadacre City. . . . With this—the ground motive—variety in unity will be infinite."[112] There would be no hope of such an inventive aspiration in a conventional city, for the soil beneath it would be conceived as already sterilized by its own asperity. It could no longer burst into blossom architectually.

Wright referred to the irrational crowding of skyscrapers in the metropolis as the great "pig pile." Ignoring their invention in Chicago in the early 1880s, he asserted that their prototypes were the grain elevators and the farm silos: "The uncorrupted towers of America rise from the western plains and prairies as well as from the larger towns. In Wasco, Illinois, or Lily Lake, on Simpson's farm west of Clinton, Iowa, above the valley floor at Black Earth, Wisconsin, they may be seen. . . . Tower after tower pins down the continent on its base of soil and rick. . . . They are the grain elevators of concrete and their smaller colleagues, the silos."[113] The telling antiurban adjective here was "uncorrupted." These are the skyscrapers surrounded by space (so that they can be clearly seen). He introduced nine of them into Broadacre City, but they did not derive from the Chicago type, according to his explanation, and their purpose was very different. They were symbolic stakes to keep the midwestern soil in place so that it would not be blown away and wasted in the scouring winds: the fear of dust storms from the high plains was considerable there in the 1930s. They were tall, but generally low enough to remain proportional to other forms—a "wholesome negative" waiting to affirm "the

substance of an indigenous American architecture." Here, the key adjective was "wholesome." With Wright there was always the hope that it was not too late, but if so, then history could be rewound to start over! The artist must size up and spread the American canvas, as Frederic Church had tried to do with the prospects of the Hudson Valley, as Thomas Cole did when he painted *The Architect's Dream* for architect Ithiel Town in 1840, as Downing tried to do with his Dans Kamer essay of 1835.

Wright wanted to add "exuberance" to life. Yet when the ebullient Franklin Delano Roosevelt pressed a golden key in Washington to open the Industrial Arts Exposition at Rockefeller Center where the Broadacre City model was first displayed in 1935, Wright's message did not sound optimistic, perhaps because of the reality of the metropolitan setting: "A tragic breakdown stares us in the face. American leadership was too ignorant or is too blind to be entrusted with the might we got by way of machine success. . . . We live in economic as well as esthetic and partially moral chaos."[114] He was offering a powerful icon with the presence of Broadacre City in New York City, as he was later to do with the Guggenheim Museum.

In the last paragraph of *Architecture and Modern Life*, Wright declared, "I might add that until the artist is more the society he serves than the society is itself, he is not a great artist."[115] This statement reinvoked the nineteenth-century concept of the architect as a precocious reform leader. In his definitive article on Broadacre City he wrote, "The old success ideals [of Chicago, among other places] having no chance at all, new ones more natural to the best in man would be given a fresh opportunity to develop naturally."[116]

[112] Frank Lloyd Wright, *The Disappearing City* (New York: William Farquhar Payson, 1932), pp. 48-49.
[113] Ibid., p. 16.

[114] *New York Times*, April 16, 1935, p. 23.
[115] *Architecture and Modern Life*, p. 335.
[116] Wright, "Broadacre City," p. 254.

It is evident that Wright was now in direct line with the American romantics and a succession of English esthetic reformers, beginning with the Industrial Revolution and the late eighteenth century. At this moment a peculiar economic condition had developed in America that called into question the assumption that material consumption could increase indefinitely. That assumption had been the excuse for the tolerance of so much temporizing and physical ugliness generated up to that time, especially in the cities after the Civil War, but in the countryside too. Wright felt that the 1930s was the decade in which to reassess this assumption. The tradition of ethical-economic reform, based on new images, had begun with Augustus Welby Pugin's pictorial *Contrasts* of medieval cities of 1440 with English industrial cities of 1840, then carried on through John Ruskin, William Morris, Ebenezer Howard, and Sir Raymond Unwin's designs for English Garden Cities.[117] Unwin (1863-1940) was, of course, Wright's (1867-1959) contemporary. The reason for giving priority to visual means, Wright thought, was that they offered the only channel for a better and more cohesive synthesis in the dull torpor from the Depression. The English Garden Cities were esthetically guided pilot studies from which the more socially programmed New Towns evolved after World War II, so the conversion from esthetic to societal preoccupations was not so onerous or burdensome as might first be thought. Wright made no bones about the fact that he was ready to spread the principles of Taliesin Valley, Broadacre City, and Usonia all across the land, to furnish "a great unity in diversity." It was not so much that commerce, industrialization, or technology had failed outright (Wright too liked to exploit new materials and technologies), as it was that no better method had been devised to control them. The specter of spreading gigantism and corruption in American society from after the Civil War, as opposed to the hope, radiance, and romanticism of the period before it, represented by Jefferson and Downing, made it appear even more urgent that beauty and nobility be supplied at least one corner in which to flourish. Wright wanted favorable, even choice, places from which to survey and evaluate the surrounding scene. This had been the American rhythm, to keep shifting position in order to locate *somewhere* from which to obtain a more advantageous and sympathetic view. What was unique in Wright was that he traveled farther, and resorted to the flat farm field, the arid desert, and the print and model, in addition to Taliesin East and Broadacre City, in order to capture new vistas, and that he put so much store by architecture to enhance them.

Although Wright had early international stature and reputation as an architect, having influenced Walter Gropius and Mies van der Rohe in Germany; the Dutch, such as Gerrit Rietveld and Willem Dudok, whose town of Hilversum probably came nearest to Broadacre City; Carlo Scarpa and Bruno Zevi in Italy; and a few of the Finns, such as Eliel Saarinen, his reputation ended up on the very edge of national awareness, like that of those who were more or less closely associated with his approach, such as Paolo Soleri, who came to him in Arizona in 1947

[117] There have been several attempts to rediscover Wright's intellectual roots. Two excellent ones, although they do not entirely conform to this author's views, are Richard P. Adams, "Architecture and the Romantic Tradition: Coleridge to Wright," *American Quarterly*, IX, 1, Spring 1957, pp. 46-62; and Vincent Scully, "American Villas: Inventiveness in the American Suburb from Downing to Wright," *Architectural Review*, 115, 687, March 1954, pp. 168-179. Scully suggests Ruskin, Owen Jones, Whitman, and Viollet-le-Duc as Wright's major predecessors. Wright was not an intellectual in the academic sense, though his mind was so alert, and the attribution of direct influences is sometimes futile. For him, it appears more to have been a matter of getting the "feel" of a direction of thought.

out of the dislocations of postwar Italy; Alden Dow of Midland, Michigan; Bruce Goff, his best pupil of those who never studied under him, he said; or E. Fay Jones of Arkansas, who created the transcendent Thorncrown Chapel in the woods at Eureka Springs in the early 1980s, in the spiritual character Wright long sought.

The talent was there. The ideas had been generated. But room had not been made available for the thoughtful architect, who worried about the culture. Contrary to the expectations of Jefferson's French colleagues, America *had* produced geniuses, at least in architecture and landscape architecture. And contrary to what Americans believed about themselves, these geniuses *did* learn from each other by generations. But they had all been driven to withdraw too far to obtain more perfect spaces. What could be more isolated and arid than Soleri's Arcosanti City in Arizona, sixty-five miles north of Phoenix at Cordes Junction, in the open, uninhabited, country? Or Jens Jensen's school "The Clearing" at the top of the heavily treed Door County peninsula in Wisconsin? These incipient leaders took exception not only to every usual architectural rule, but to every ordinary site and situation. Many of them, like Wright, were not direct "problem solvers" so sought after amidst the alarms of the 1930s and 1940s, nor appreciated for their administrative abilities, as were the architects who commanded large governmental and corporate commissions during the 1950s and 1960s. They

were the image makers, idea men, painters and sculptors of visions. They were not looking for the perfect system to be published in a book, but for the perfect space or location in which to actually build.

Yet had the fragments of American perfectionism and purism, finally exploding in exasperation, as in Wright's case, flown too far, even into the desert, to the great national park, to the top of a mountain in a national forest? Where had the aspiration for nobility and joy in ordinary, everyday habitation gone? Jefferson had sought to assure dignity for everyone with all the white columns at his command, just as Wright had tried to inculcate it in his bijou Broadacre model with its tiny wooden blocks of many, many colors, and many simulated amenities. Had the republican geniuses drawn their visions too subtle and fine? Were all the ingredients there except enough visual conviction for a common destiny?

Jefferson and Wright, and all those in between, had overcompensated with architecture in an attempt to keep the American spectacle alive and in a legitimate position on the landscape. They could sometimes detect public attention waning, becoming distracted by other issues. To save the integrity of the landscape scene, they had, in their separate ways, to make its buildings its major rationale, so as to call up to it the ever renewable attention it deserved. For so long, the American public had built far below the gift of its landscape heritage.

Conclusion

WE have explored ways in which the American intellectual, turned artist, came into conjunction with his own land for public usage. The precocity of the artist in the landscape, from Jefferson on, was in showing others how to speed up a wholesome adjustment to it, philosophically as well as physically. Exceptional landscapes were recognized or created to provide better precedents. The individual gave; the group received. Jefferson's thorough reading and wide experience made him the first champion of landscape rules and precedents in the United States. Romanticism supplied him, Downing, Olmsted, the Eliots, and Wright, with the indispensable zest for nature which ameliorated the tedium of rule-making. Romanticism applied to nature as anticipation was a more useful, longer-lasting, and larger-scaled emotion here than in any other nation. No other made its romanticism so public.

Jefferson, Irving, Downing, and Wright recreated their childhood experiences in idealized forms on the very plots where they had once played. As a result, the final scenes incorporated more nostalgia and attachment than they otherwise might have, and a more youthful freshness and vigor. Wright's vision of Taliesin Valley had a special meaning because his grandfather had been an immigrant, and Wright fervently wished him to belong on his own place too as *the* ancestor, together with the uncles and aunts, and his mother. It meant a lot of belonging.

There was no previous tradition for handling such a diversity of spaces as first confronted the settlers as they moved west. Unleashed wonder began to fill the vacuum, and thus a degree of over-compensation in the interpretation. Everything was seen so intensely that mirages began to occur. The architects felt the absence of ruined Rhine castles on the Hudson, or conjured up in compensation, as Wright and Soleri often did, deserted Maya cities out of the fancies generated by cliffs in the dry air and deep canyons of the West—the perennial El Dorados that earlier pioneers had also visualized on their way west. Jefferson saw Egyptian pyramids or live volcanoes on his horizon. The absence of recognizable historic traditions forced intellectuals to take strength from specific configurations in nature, such as valleys, streams, trees, stones, prairies, and especially mountains and cliffs. Through geology, geography, and nature studies they brought everyone closer to those landmarks. They tied themselves to the "timelessness" of geology and historical styles in architecture. To treat directly with the landscape was to acquire a firsthand knowledge of it, to write about, paint, or compose poems about it, and to seek psychological reassurance from it.

Americans doted on the lost city and hidden valley, the Shangri-La, like the Yosemite or Taliesin valleys; or on the domicile lost among the trees or set far up on the distant hill, like Monticello, Sunnyside, Idlewild,

279

Highland Gardens, Olana, and Taliesin; or on the chapel in the woods or the camp meeting, such as with Fay Jones' Thorncrown Chapel of 1981, Lloyd Wright's Wayfarer's Chapel of 1951, or at the two Taliesins; partly because they were incorrigible romantics, but also because the presence of cities had come upon them so suddenly and overwhelmingly, and had seemed so brazen when it materialized. Only in the suburb of Riverside was there a truly successful effort to balance the two components—urban and countryside factors, public and private concerns. The unreal, abstract shine and lilt of the imagery resembled that made up for London in William Morris' *Earthly Paradise*, which had been the real start of Garden City feeling:

> And dream of London, small and
> white and clean,
> The dear Thames bordered by its
> gardens green.

As its influence on the English Garden City suggests, it was, like Broadacre City, a suburb looked upon not alone as a suburb as much as a viable work of art testifying to another possible kind of city. It was not then a question of which was more real. How could city *or* suburb in those decades appear real? It was a matter of which place made a better "city" in the sense of providing a setting for a more humane effort and exchange. Otherwise, there was always a tendency for romantic idealists to sift out only the finest, purest, and most undisturbed places, such as Yosemite with its cliffs or Mt. Hood with its snow, or the Bad Lands with their striations, before pronouncing them fit for human habitation, which then occurred more as a "democratic" recreational invasion. The interesting exception to this purification process was the Fens in Boston, which was recovered and purified, because of the surviv-

ing Puritan conscience, turned naturalistic from Unitarianism, from the muck and mire of the approaching city and suburb, Boston and Brookline, to each other.

These spaces were attractive to many people because they stimulated emotions not readily permissible elsewhere, such as the appreciation of solitude and tranquility from Yosemite or Charlottesville, with their blue haze; or admiration for the dazzling white and glossy green silhouettes of the Cascades and Mt. Hood, so apparently uncorrupted; or the gaiety, even joy in being, from the pride taken in Timberline Lodge or the model of Broadacre City in the midst of the Depression; or the encouraging prospect of a spacious unity providing for communal exchange and the right to belong, as symbolized by the Connecticut Valley with the view from Mt. Holyoke, the Hudson Valley with the bold outlooks from the terraces of its estates, or the view from Taliesin, the house, on Taliesin, the valley. Publicly, they were prototype assertions that America could be mastered. The expectations aroused by the overviews of the two river sequences, and even more from the vicinity of Jefferson's Charlottesville, were bound to be ultimately blurred by extraneous factors, but at least they offered for a thrilling moment the phantasmagoria of a large enough stage for an epic.

There was a modern conviction of increased superiority from knowledge which exhibited itself in the eclecticism of Hudson Valley Classic, Gothic, or Italianate villas, in the Swiss houses of Riverside, and in the too-monumental tombs of Graceland Cemetery in Chicago, such as those of Pullman or Potter Palmer, or the sculptured monuments by Lorado Taft. That American world was proud, but lacking in self-assurance, so convincing enough models and types in architecture were hard to come by. Sullivan provided two model tombs of genuine assurance

at Graceland that went on to become small town banks in the land of the living. Such general conceptual deficiencies would have to be made up by, and in, nature, and through an improved domestic architecture associated with it. Wright finished off that very old conviction with Broadacre City, where the houses took most of their meaning from being understated in Usonian terms; just as the plain houses had once belonged to the Connecticut Valley; and the villas of the Hudson Valley and Riverside had tried to blend with their naturalistic surroundings.

The Fens was conceived as an esthetic hint to Boston to bring back yesterday's direct contact with nature; Jefferson's University of Virginia was a well-defined "academical village" around a green, in which learning, rather than ignorance and parsimony, would be promoted for the enhancement of the sensibilities of a democracy; Riverside Suburb and Graceland Cemetery were imagined as restful alternatives to Chicago's endlessly frenetic and hard-edged atmosphere; while Wright's Broadacre City, coming out of Taliesin Valley, was fashioned to see if the city might find its more proper distribution from the patchwork quilt of an open farmland! Wright, like Olmsted at Riverside, never accepted the finality of the urban or rural grid, most pronounced in the Midwest, and set about refreshing both by combining them. The positivism of the designs gave new hopes and resolves, either in the wake of the Civil War as in Riverside; or in the midst of the Depression, as with Broadacre City.

These landscape gentilities were counter comments on conditions that were less to be evaded than redirected, complemented, balanced, or enhanced. The Hudson Valley complemented and even enhanced New York City before it became, like Chicago

and San Francisco in their times, so absolutely and exclusively unique. These "comments" were not intended to be alternatives or make-overs in exact proportion to the urban agglomerations, since the latter had become so large and difficult to decipher in themselves, but rather as turns of landscape phrasing, addenda, which might make it possible to induce closer and more compatible relationships among people, and for people in their associations with either nature or cities. The gnawing anxiety was that a continent that had promised so much might end up with no overall pattern or character. The anxiety over absence of character was always back of Wright's insistence on individualism, as when his grandfather's or mother's behavior would tell him how to design buildings for his valley. Romanticism, and the great size and variety of the developing countryside, made for a tremendous diversity of fresh encounters, but also for a greater allegiance to particular places, once discovered, and for a more effective employment of artistic and intellectual skills in providing the identification of person and place together.

Because the country was so soon occupied, and generations had constantly to adapt to it, the belief has been that there was no continuity among its shapers. Only by extreme novelty could it progress. But *these* novelty makers *did* rely upon one another to gain a better understanding of the past of the land, for Downing learned from Jefferson and Dwight in that respect, as we have seen; Olmsted learned from Jefferson, Downing, and Dwight; Jenney learned from Downing; Sullivan learned from Emerson and Thoreau in a profound way, as did the Eliots; while Wright learned from Sullivan, Jenney, Olmsted, Jensen, and Jefferson, and almost anyone else who happened to precede or parallel him, from whom he felt there was something to learn.

Index

LIBRARY OF CONGRESS CATALOGING IN PUBLICATION DATA

Creese, Walter L.
The crowning of the American landscape.

Includes index.
1. Landscape architecture—United States—History.
2. Architecture, American—United States—History.
3. Space (Architecture) 4. Landscape—United States—History.
5. Landscape assessment—United States—History.
I. Title
SB470.53.C74 1985 712'.0973 84-26243
ISBN 0-691-04029-X (alk. paper)

Walter L. Creese is Professor of Architectural History
in the School of Architecture at the University of Illinois,
Urbana-Champaign